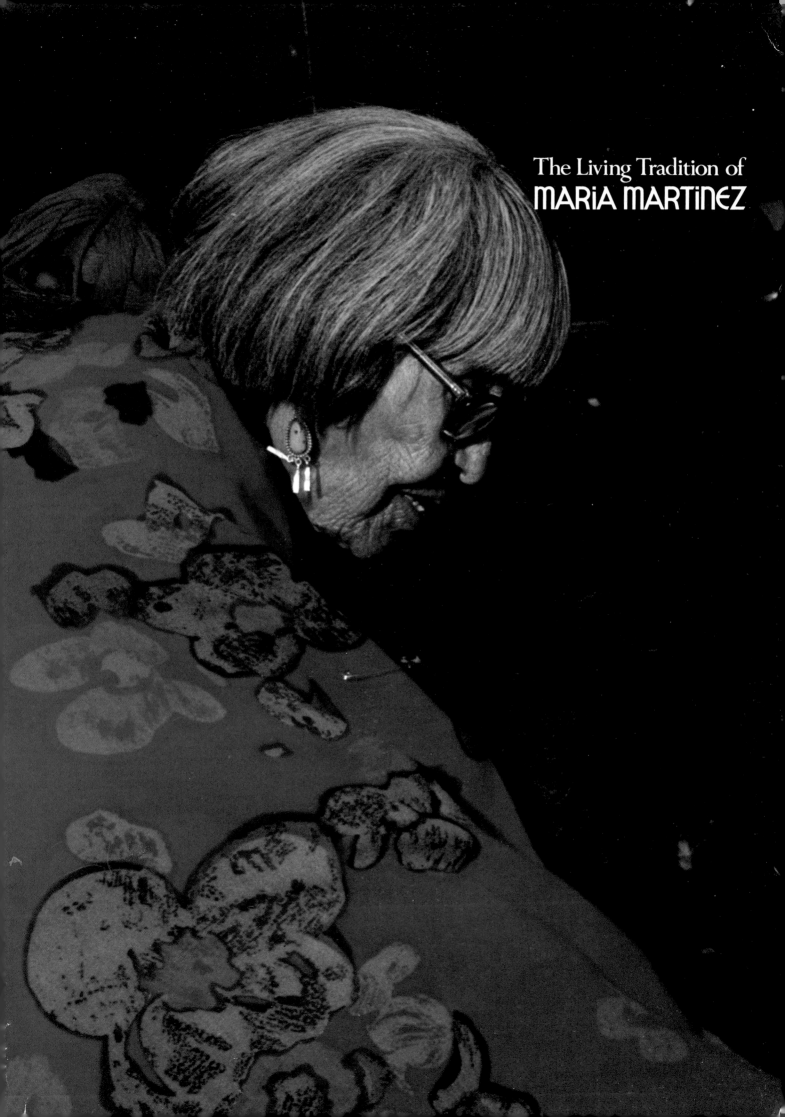

The Living Tradition of
MARiA MARTiNEZ

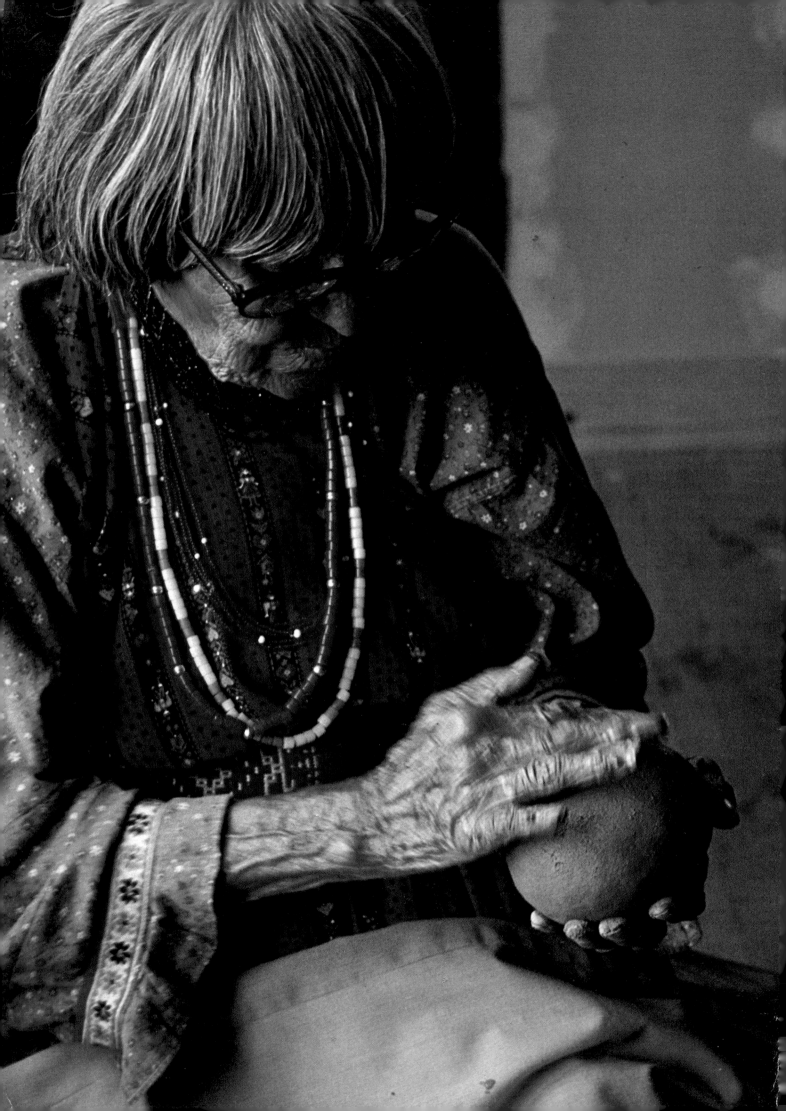

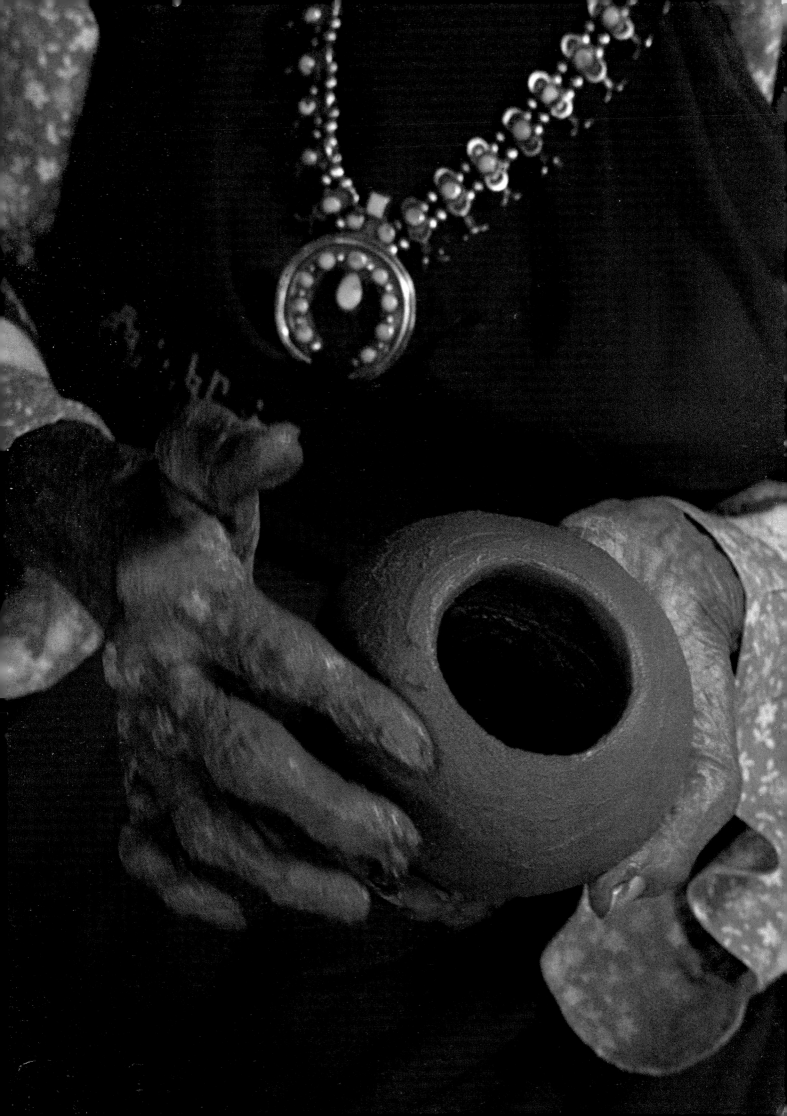

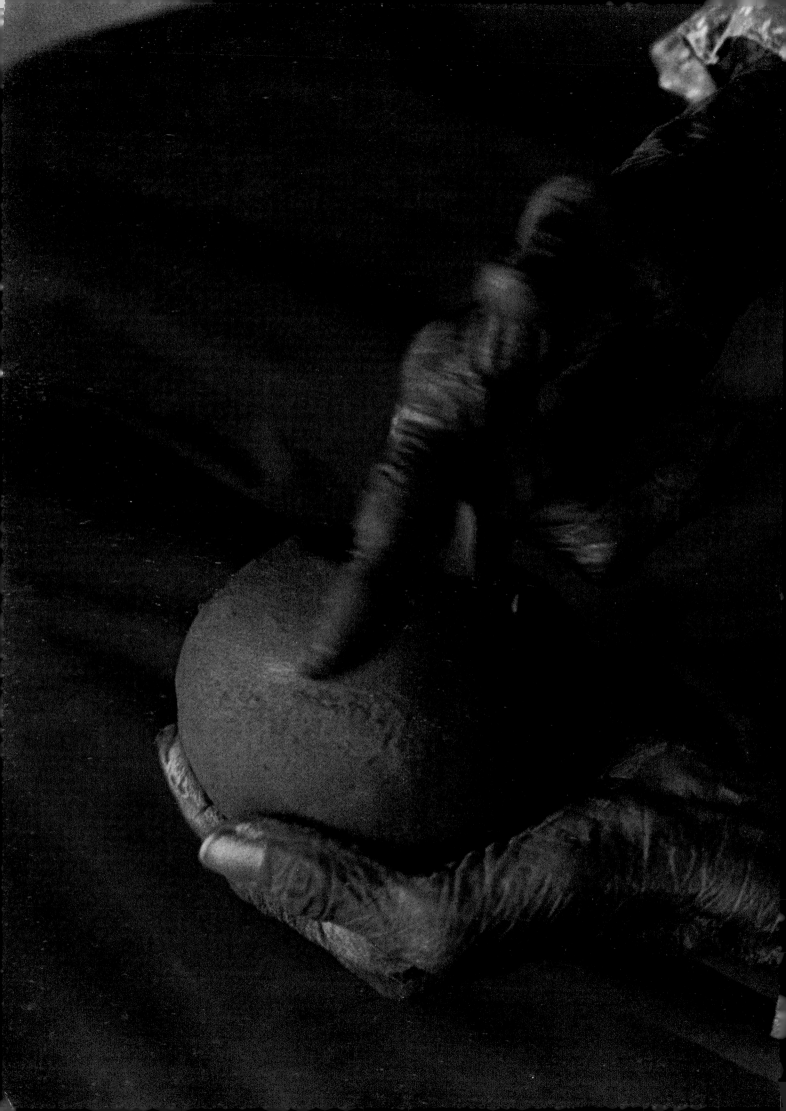

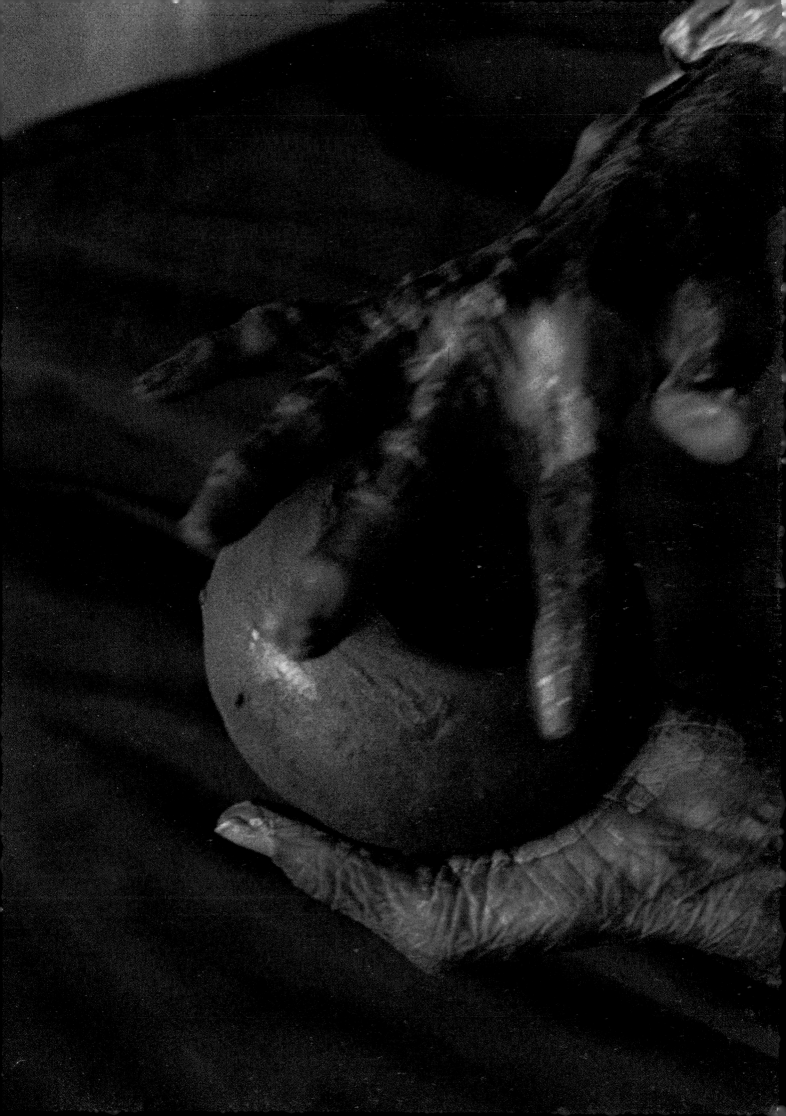

The Living Tradition of

MARiA MARTiNEZ

Susan Peterson

KODANSHA INTERNATIONAL
Tokyo, New York & San Francisco

The poems appearing on chapter half-title pages are from Songs of the Tewa, *translated by Herbert Joseph Spinden, reproduced by special permission of The Sunstone Press, Santa Fe, New Mexico.*

Distributed in the United States by Kodansha International/USA Ltd., through Harper & Row, Publishers, Inc., 10 East 53rd Street, New York, New York 10022.

Published by Kodansha International Ltd., 12-21, Otowa 2-chome, Bunkyo-ku, Tokyo 112 and Kodansha International/USA Ltd., 10 East 53rd Street, New York, New York 10022 and 44 Montgomery Street, San Francisco, California 94104. Copyright in Japan 1977 by Kodansha International Ltd. All rights reserved. Printed in Japan.
LCC 77-75373
ISBN 0-87011-497-2
ISBN 4-7700-0951-8 (in Japan)
First paperback edition, 1981

Contents

Introducing a Ceramic Celebration

The American Southwest with its rich history, colorful people, and picturesque places actually represents one of the venerable civilizations in the world, featuring a remarkable continuity of culture, most likely the oldest in what is now the United States.

The so-called Pueblo people have an aesthetic and artistic tradition that goes back to the dawn of time in these areas. As agriculturists, builders, craftsmen, and philosophers, their rich culture reflects a significantly beautiful life-style.

Among their most enchanting arts and crafts is their remarkable manufacture of ceramics. This creative industry, deeply rooted in a long prehistoric past, measures up to the finest pottery produced anywhere in the world from ancient times until today.

Maria Martinez, the remarkable potter of San Ildefonso pueblo, is part and parcel of this ancient tradition. Known throughout the world as a gifted and inspired artist, she rightfully occupies a place quite unique in the annals of American ceramics.

Maria Martinez and her family have not only enriched the history of pottery in the world today but are directly responsible for many innovations. She and her relatives have been outstanding teachers, willing to share their techniques with students who have admired their work from every corner of the world. For the first time, and after many years, she and her work have now come into their proper aesthetic focus and evaluation.

Susan Peterson is the right person at the right time, after years of study and appreciation, to create this much-needed work on Maria Martinez and her extraordinary artistic productivity. As one of the oldest and most useful institutions of its kind, Southwest Museum deems it a privilege to salute and congratulate Maria Martinez and Susan Peterson on their work and contributions to mankind's constantly evolving culture.

<div style="text-align: right">

Carl Schaefer Dentzel
Director, Southwest Museum

</div>

Los Angeles, 1977

MARIA—A MEETING

I am going to turn my mind back twenty-five years to a visit to meet Maria Martinez and her son Popovi Da at the pueblo of San Ildefonso near Santa Fe. Hamada, my friend from Japan, was with me, and Sōetsu Yanagi. My two companions were founders of the craft movement in Japan, and we were travelling America together. We were giving a series of lectures at the opening of the Folk Art Museum in Santa Fe. A very nice friend, Laura Gilpin, the American photographer, took us out to meet Maria.

We went to the adobe cottage—nobody there. Light snow was falling, the air was cold in the afternoon. The others wanted to go back because of this. I said, "Please wait a minute, let me look around." And I looked for smoke, and sure enough from a building at the back I saw smoke emerging. I said, "That may be it. Let's go around and see." And there stood that American Indian lady poking at the remains of a bonfire. I saw gleaming amongst the ashes a black pot, shiny black. I stood and watched until she was free of mind to turn to us, and we were introduced. Immediately I was impressed. It was the sense of reality, a sense of belonging to that landscape.

She returned to the bonfire and extracted with a bit of bed iron, a pot, which was matt in pattern on a shiny black. Austerity. And it belonged to America. North America—it was arresting. We began to talk. Before leaving, I asked Maria if she would come to the first lecture. She accepted and asked if she might bring her son, and we gladly assented.

And then let me jump to the impression we all three had, I think. That night she was in her finery of vegetable dyed wool, of silver ornaments, necklaces, and all; beautifully illustrated, illuminated. The mixture in her clothing of black and of red and that green, it was very fine! It was more than a European would attempt. And talking with her was so gentle.

Well, I did my introductory talk and then came down because the seat next to her

was empty. I went and sat next to her, and said, "Good evening, welcome." But she was already bending forward because Hamada had taken a seat on the potter's wheel and was beginning to use it. She bent forward and she was totally engrossed. I do not think she had ever seen good professionals throwing on a wheel before.

I thought that of all the people in that room these two Indians, North American Indians, belonged to their landscape. Her way was so different. She had already shown that she had worked long at this craft of coiling, not using the potter's wheel. I believe it was Popovi Da who did the decorations with some juice, and the firing was not a kiln at all. It was burning sticks! Then the fire was covered with ash so that the flame did not heat and smoke was made. It was the fact that there was not access of much air that caused the pots to become black. It rather depended on the will of the wind and the will of the fire.

We went again to visit them. There was an immediate accord between us. How shall I say the reason of it? We found this now to be a great adventure, to be able in spite of distance, of range and form, to be able to get into close contact. And she was so charming. She knew that our hearts were behind our words.

She gave me some of her polishing stones. Polishing the clay when it was hard like cheddar cheese with this pebble that had been worn by water, meant rubbing to a very bright surface. For her to give me her tools was an act of great friendship.

This is one of the ways in which heart can speak to heart. As craftsmen, many of us have had a similar experience. I hope that such friendship between people, especially far distant people, different people, will increase—that distances will break down.

Maria, we have never forgotten you and we never will.

Bernard Leach

St. Ives, Cornwall, 1977

Acknowledgments

My knowledge of San Ildefonso and of Maria's family in particular, covers thirty years, including my recent association with the family at the University of Southern California's Idyllwild campus. Partial funding from the National Endowment for the Arts made possible summer workshops there since 1974, with the Martinez family in pottery, Fred Kabotie in Hopi silversmithing, and with Bertha and Fred Stevens in Navajo weaving and sandpainting. These workshops have been innovative in presenting Indian art to a non-Indian culture.

The decision to do this book sprung from discussions with Maria and her family during those workshops and a recognition of the need to document their special art. Serious study of American Indian culture and art is only recently popular.

I have learned an important lesson. Indians preserve what they have within themselves. Writing down is not their way. I had learned a similar lesson from Shōji Hamada, the "living national treasure" of folk pottery in Japan. I have come to the conclusion that things true of one particular folk or communal art are true of all folk art. The Southwest Indian pottery phenomenon is no different from banana fiber weaving, or Egyptian goldwork, or medieval cathedral carving. All are arts of the unknown craftsman, purposefully and joyfully done.

When I began this book I went about the country attempting to document Maria's pottery, her antecedents and her heirs. However, after two years of researching, documenting, and photographing the early Martinez polychrome pots—made by Maria and decorated by Julian, Alfredo, or Maximiliana—I find that Tonita and Juan Cruz Roybal, Florentino and Martina Vigil Montoya, and many others made excellent pottery at the pueblo at the same time. It takes a practiced eye to tell the difference, and then often one is not certain.

This is an art of the people. The art of Indian pottery, whether it is for domestic

15

or tourist consumption, is rarely accomplished solo. There is no precious quality. Rather, these pots are traditionally a blending. Of course there are characteristics definitely attributable to Maria and to Julian, as well as to the other potters of San Ildefonso, and there are marks of talent and perseverance, refinement and sophistication, which set these particular artists apart. Still each piece may have passed through more than one hand.

The succinct element, I believe, is that theirs was a communal art, a happy and a shared art. There are aspects of ancient and historic pueblo pottery and of contemporary Indian pottery that make them belong to the major arts of all time.

The work of this book has been shared, too. I thank all the Martinez family members at San Ildefonso who have patiently and lovingly assisted in nearly everything I asked: to Maria, Clara, Santana, Adam; Anita P. Martinez, Barbara, Kathy, Evelyn, Sylvia, Sunset, and their husbands; to Mary Daisy, Marvin, Beverly, Lupita, Mella; to George, Eddie, Julian, Frank and their families, for showing me themselves as much as they could. I am particularly indebted to Barbara Pino Gonzales, Maria's great-granddaughter, for very special help, for sharing her poetry, and for assisting in reading the manuscript. All in the family were extraordinarily kind and helpful to me, with an openness to this outsider that must have been difficult. *Our* book has taken a great deal of time and frequent visits to the pueblo during the past two years, has been more complicated than any of us thought, but also more rewarding.

My own immediate family follows—my parents Dr. and Mrs. Paul W. Harnly, and my children Jill, Jan, and Taäg—whose assistance in many diverse areas I gratefully and fondly acknowledge.

To all the museum and archive sources, my thanks. Most particularly to the following staffs: the Southwest Museum, Los Angeles, where photographing of the collection and research was done with always the most courteous and immediate help; the Laboratory of Anthropology, Museum of New Mexico, Santa Fe, where I photographed and also used the extensive library collections; the Museum of the American Indian, Heye Foundation, Bronx Division, New York; the Smithsonian Institution, Library of Congress, and Indian Arts and Crafts Board, all in Washington, D.C.; the Museum of Natural History, and the Public Library, New York.

Researchers and assistants without whom I could not have accomplished this task and to whom I am very grateful include: Mrs. Mildred Wolkow, together with her husband, Israel, and daughter Lisa, for library research, for aiding with the bibliography, for collating, and for many other important contributions; Laura Michel of the Laboratory of Anthropology, Santa Fe, for her work on the bibliographic compilation; Susan Babson, Mark Logan, Linda Metzger, and Jay Ray, for devoted help.

To my colleagues and students at the University of Southern California, at the Idyllwild School of Music and the Arts, and at Hunter College, New York, who have assisted in the last several years; to Marquerite Courtney; to Dr. Bruce Rolf; the Norman Tobacs; Dr. Herbert Zipper; Bill Lowman; the Wendell Keiths; the late Homer Boelter; Robert Hart, General Manager, and Myles Libhart, Director of Exhibitions and Publications of the Indian Arts and Crafts Board, U.S. Department of the Interior; to the National Endowment for the Arts, Visual Arts and Crafts Section; Mrs. Stewart Udall; Dr. Bertha P. Dutton; Dr. Carl Dentzel; Bernard and Janet Leach; Shōji Hamada and family; Joan and Malcolm Watkins; Elena Canavier; Dr. Francis Harlow; Mr. and Mrs. John W. Watson (Mrs. Watson is the daughter of Charles Faris); Laura Gilpin; Jerry Collings; to the American Crafts Council staff, in particular Dr. Donald Wyckoff, Rose Slivka, Paul Smith, Lois Moran, and Aileen O. Webb; to the New York and Tokyo staffs of Kodansha International, particularly Mr. Saburo Nobuki, Managing Director, Mr. Kei Suzuki, U.S. Sales Manager, and Mr. Tadashi Akaishi, Vice-President; and to all those who allowed me to photograph work in their collections—my very grateful thanks to everyone.

Much of the photography of pots and people in this book is my own. Certain of the pueblo photographs are the work of Dr. Robert M. Krone, to whom I am indebted; some of the black-and-white photographs were done by Virginia Garner and Leonard Farwell at Idyllwild. Particular credit must be given to the New Mexico Tourist Bureau, Department of Development, Santa Fe; the Museum of New Mexico photo archives; the Indian Arts and Crafts Board, Washington, D.C.; the Southwest Museum, Los Angeles, and Laura Gilpin, Santa Fe, who have allowed the use of photos without publication fees. From these sources and from the Martinez family, come most of the historical photographs herein.

I am writing this preface in Mashiko, Japan, where I have come to visit Shōji Hamada and his family. Hamada spoke of his several visits to San Ildefonso, the last one in 1966 with Mrs. Hamada and his daughter Hisako. He voiced again his original impression that the indigenous work of American Indians is among the great folk arts of the world. His own folk art collection includes a fine selection of Mimbres pots, early Navajo blankets, Canadian stone carvings, Southwest baskets, and much more.

Hamada says that these are living works, and of the American Indian potter, Maria, he says that she herself has been a part of a living tradition. He is pleased that he was able to see with his own eyes how she made pottery and how she fired it at her pueblo.

It is my hope that none of us will forget the part in the life of the world played by each of these unique people—Hamada, Leach, and Maria—in preserving and articulating the work of previous traditional patterns.

Susan Harnly Peterson

Mashiko, Japan
March, 1977

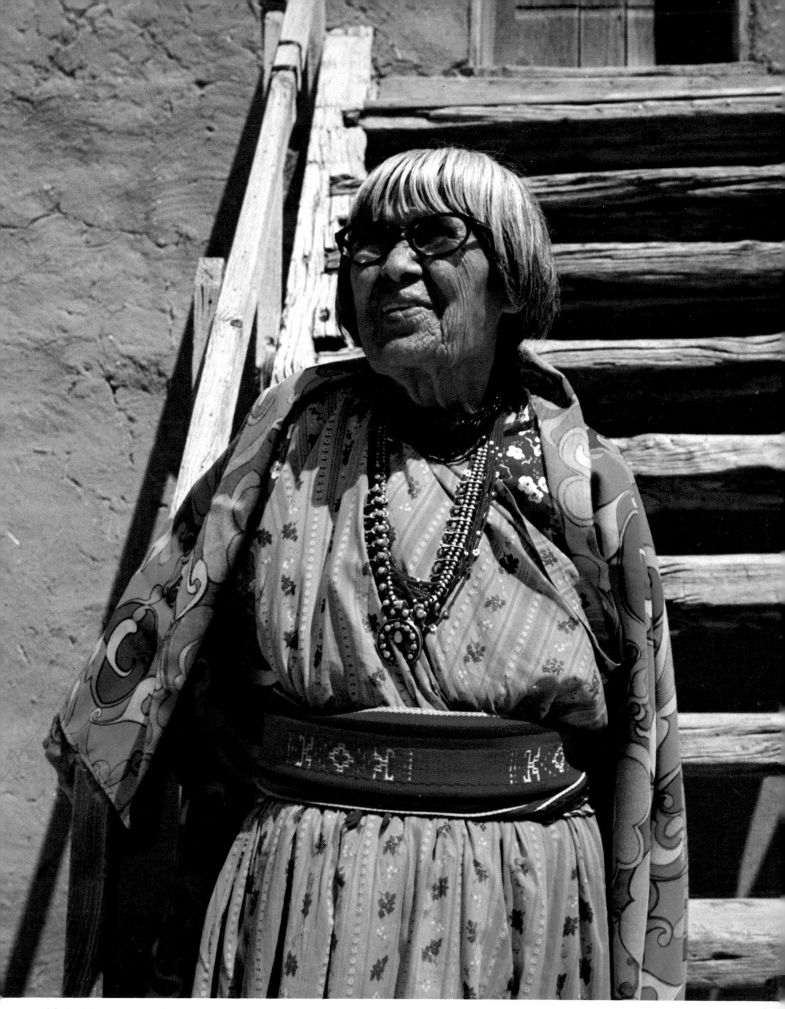

1. Maria Martinez, 1976.

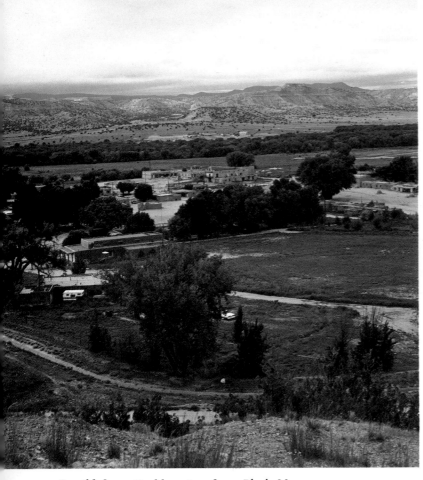

2. San Ildefonso Pueblo, view from Black Mesa.

3. Black Mesa.

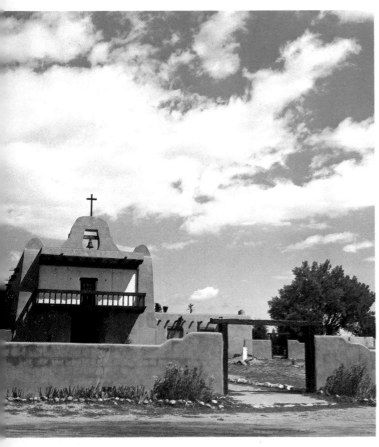

4. Church, San Ildefonso.

5. Santana and Adam Martinez' house and adjacent kiva (with steps).

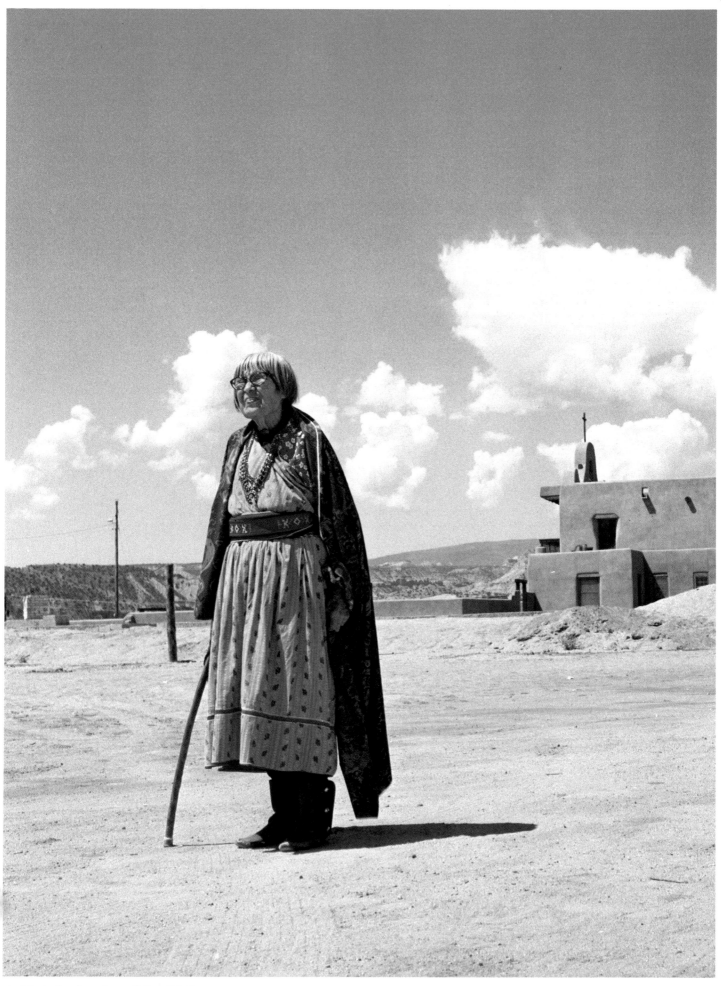

6. Maria in the plaza of San Ildefonso.

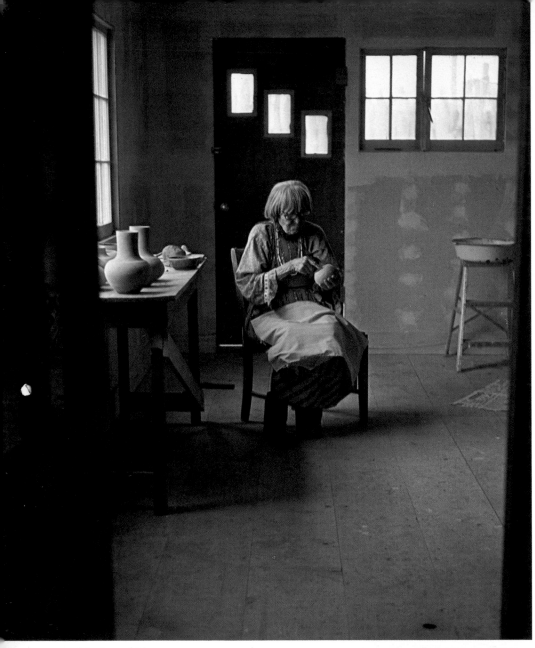

7–11. Maria making pots.

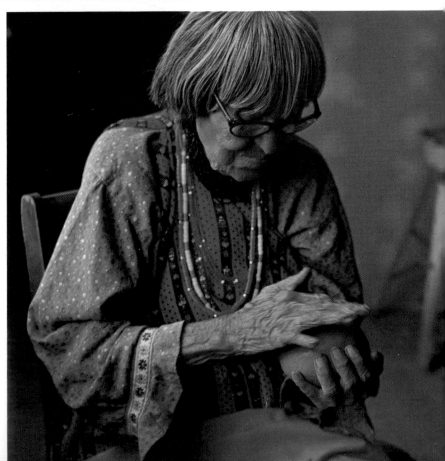

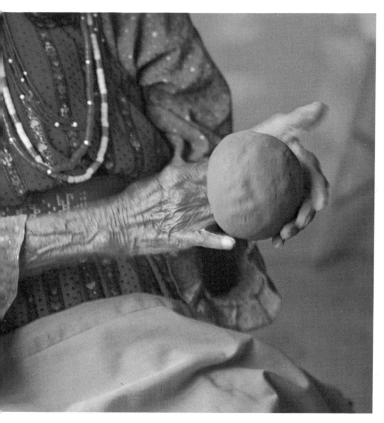
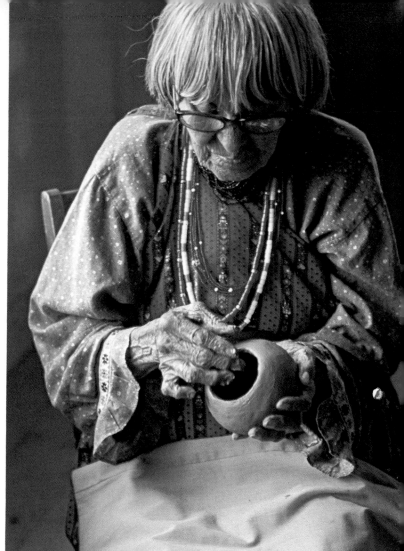
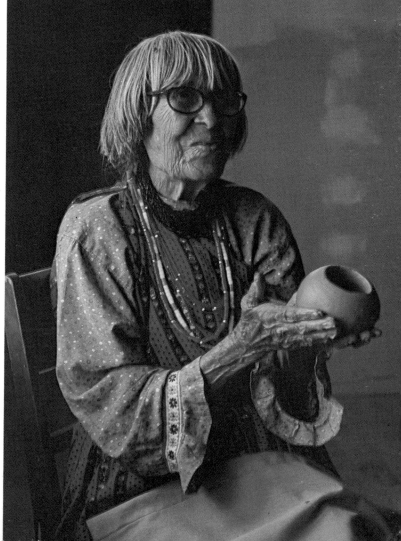

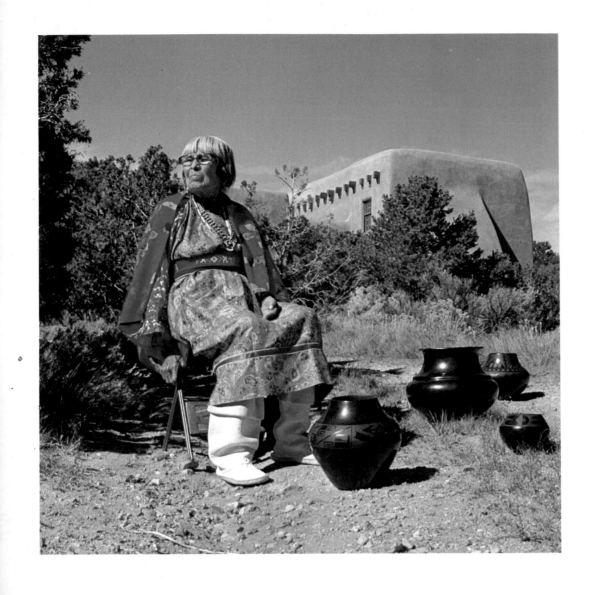

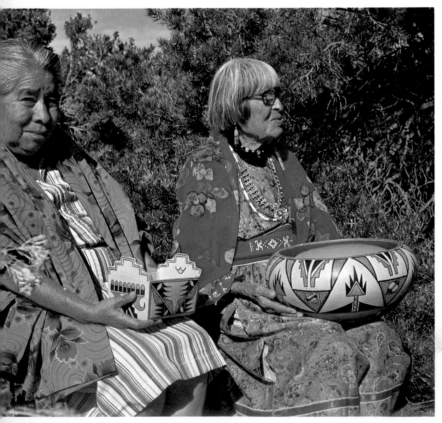

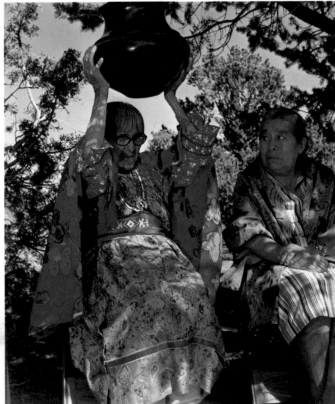

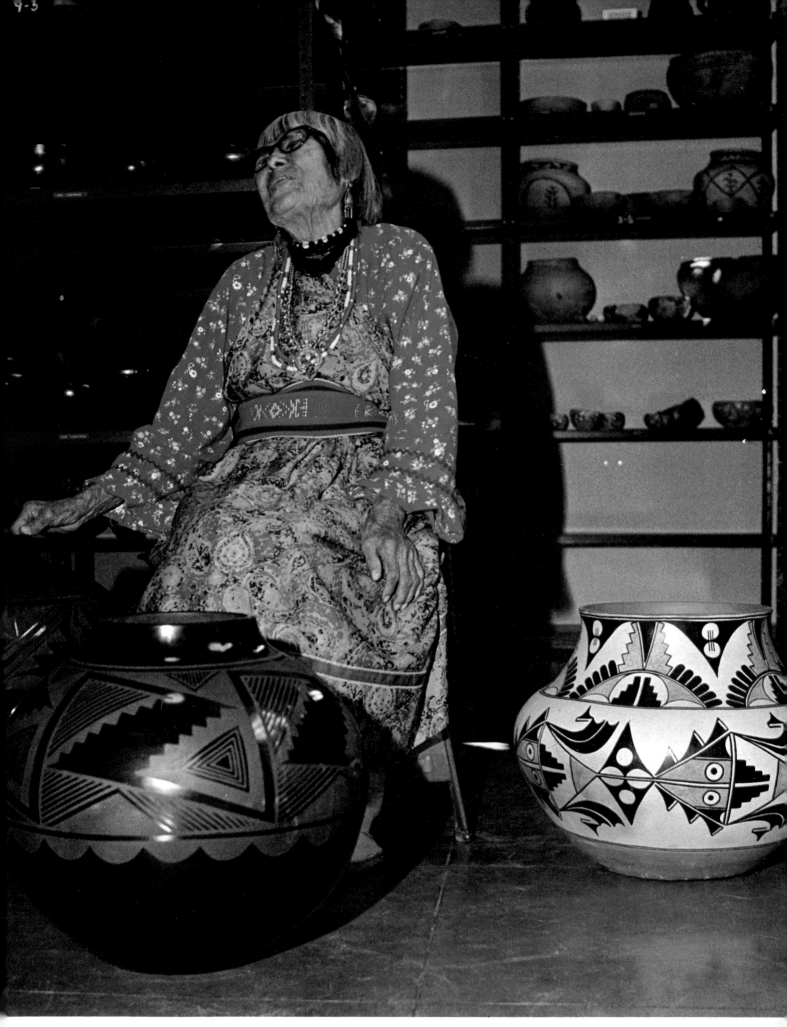

12-15. Maria and her sister Clara pose with early Maria and Julian pots.

16. Santana's pottery room window, looking out on the plaza.

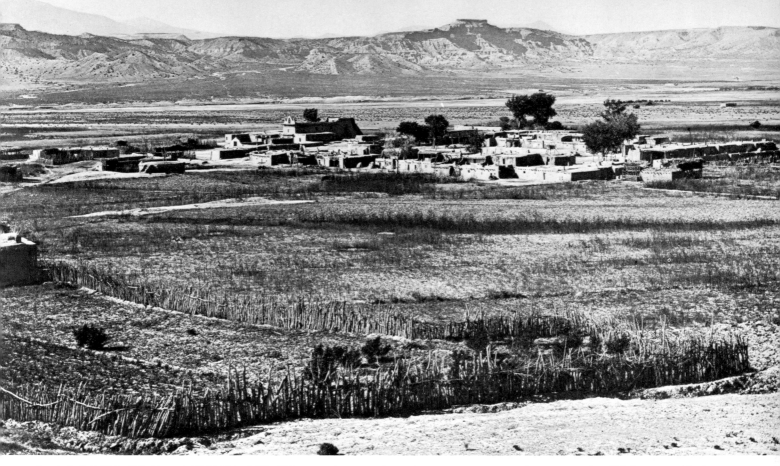

17. San Ildefonso pueblo in 1879,
a few years before Maria's birth.

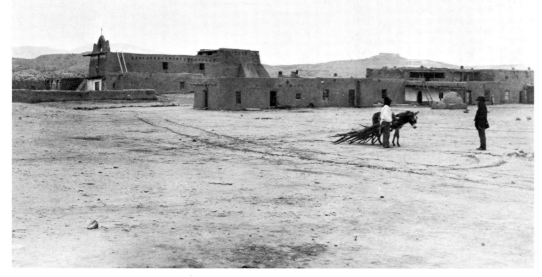

18. The plaza at San Ildefonso,
1908.

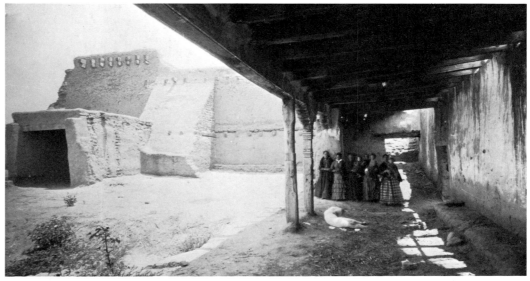

19. Portal of the old convent,
San Ildefonso. Photo by C. F.
Lummis, about 1900.

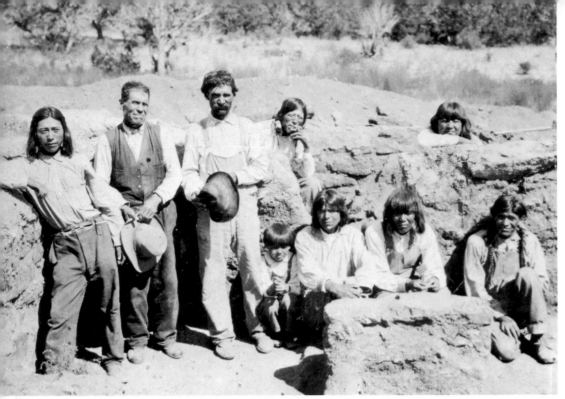

20. At the Frijoles excavation, 1908.

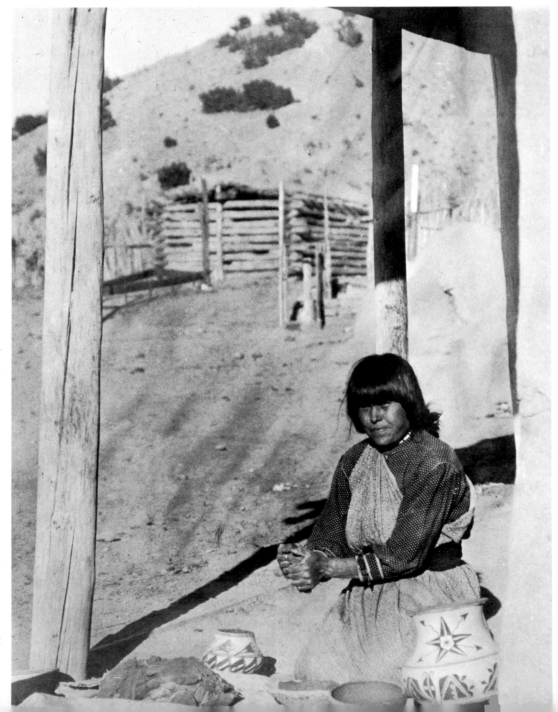

21. Maria making pottery at her house, about 1905.

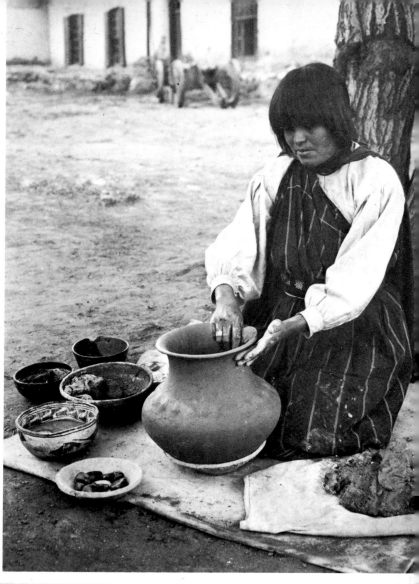

22, 23. Maria, her sister-in-law, and sister Maximiliana working at the Palace of Governors, Santa Fe, 1910–15.

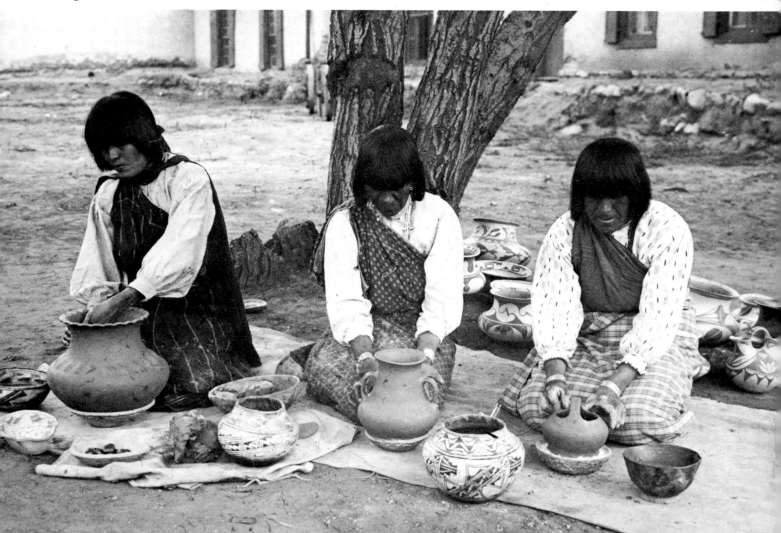

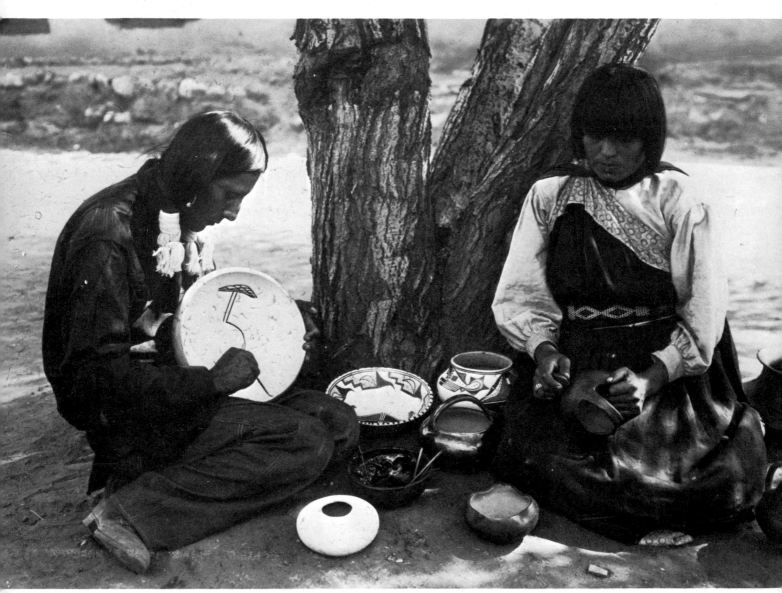

24. Julian Martinez painting polychrome and Maria polishing,
Palace of Governors, Santa Fe, 1910–15.

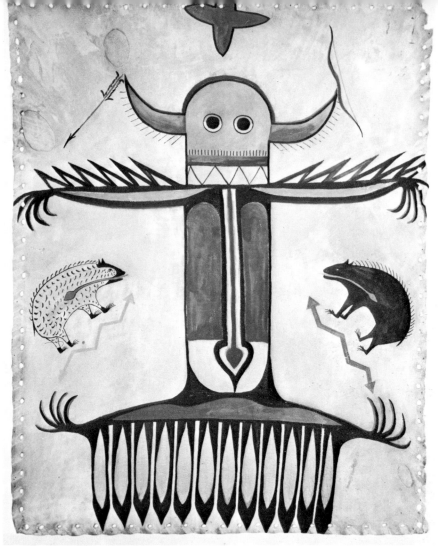

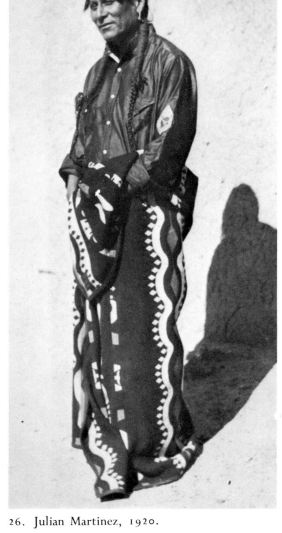

25. Painting on deerskin, by Julian Martinez, about 1920.

26. Julian Martinez, 1920.

27. Julian and Maria; various stages of the black-on-black process, 1920s.

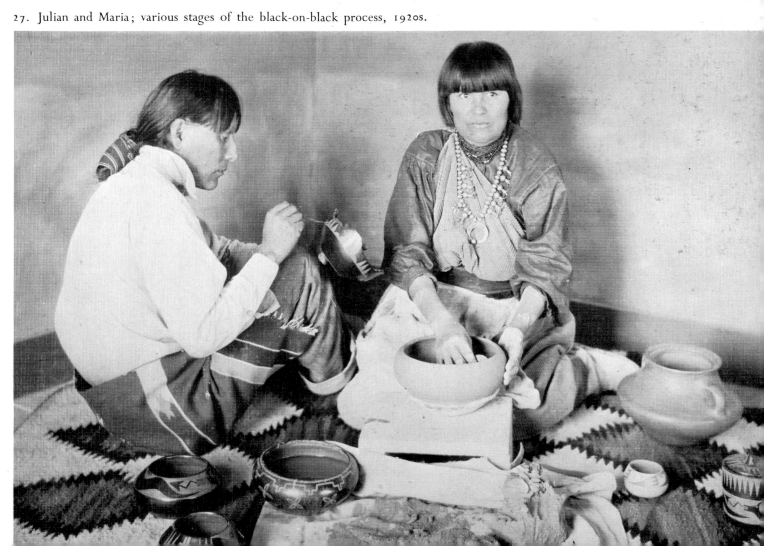

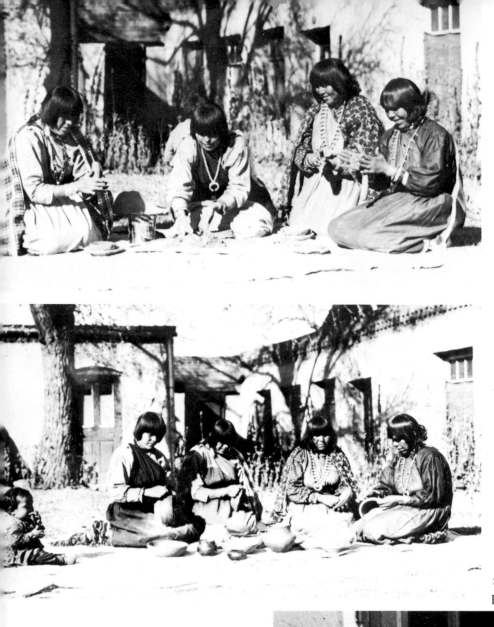

28, 29. Maria and San Ildefonso ladies making pots, Palace of Governors, Santa Fe, about 1919.

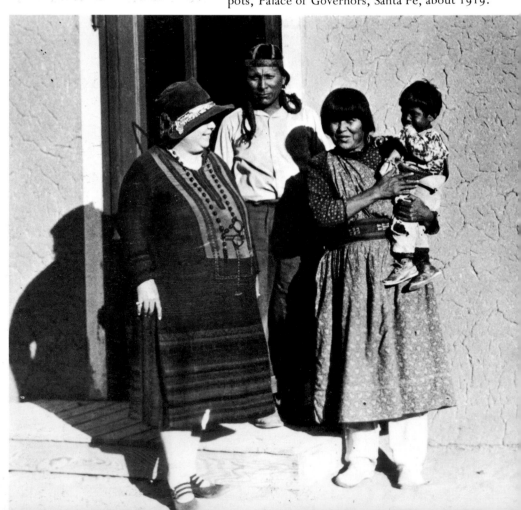

30. Julian and Maria with son Popovi; ady identified as Ann Murphy, 1920s.

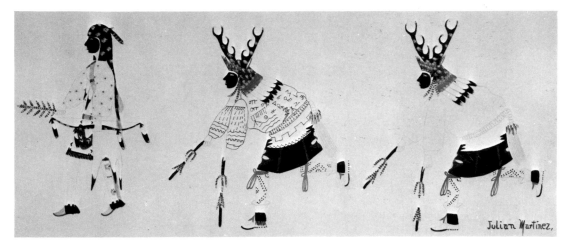

31. Watercolor painting, *Hunter and Two Deer Dancers*, by Julian Martinez, 1922.

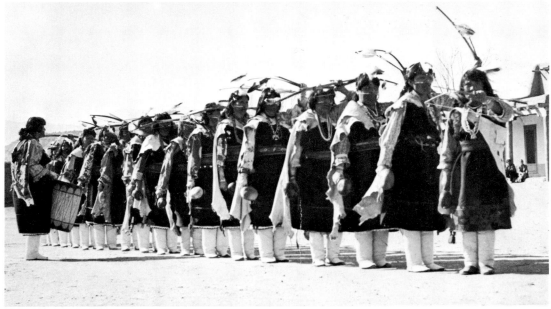

32. Women's Dance at San Ildefonso. Maria is beating the drum, about 1930.

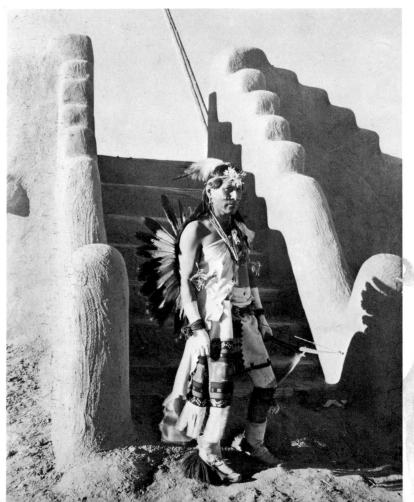

33. Julian in front of the steps of the old kiva, about 1915.

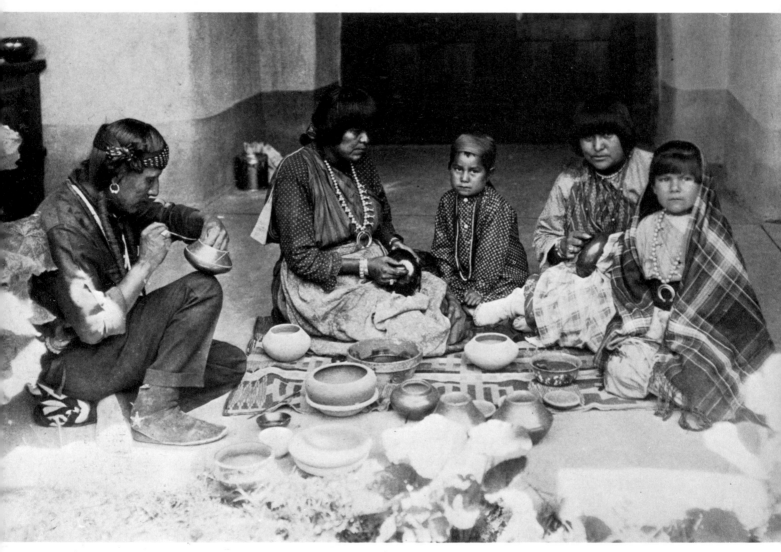

34. Julian, Maria, son Popovi, and Maria's sister Desideria and her daughter,
Palace of Governors, Santa Fe, about 1925.

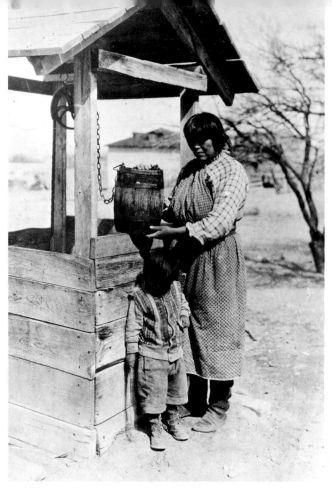

35. Maria and son Felip at the old well, San Ildefonso, about 1932.

36. Julian and Maria, 1931.

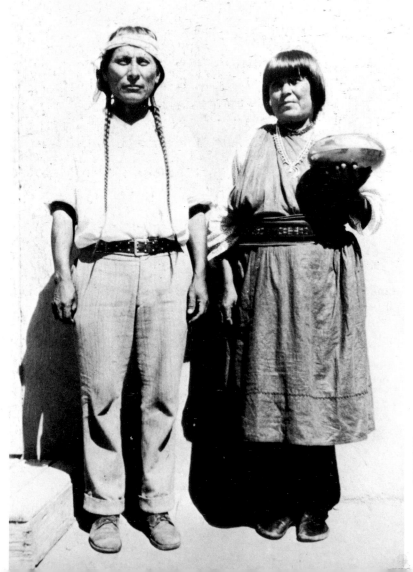

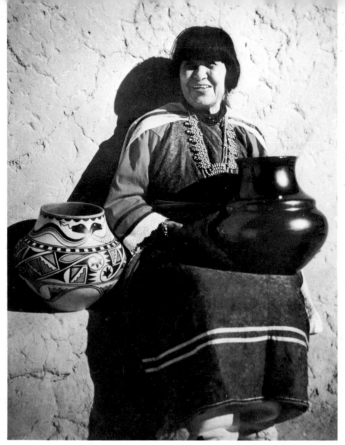

37. Maria, 1940s.

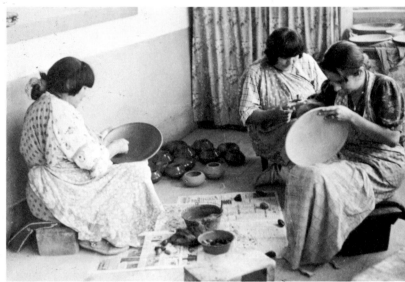

38. Maria and sisters Desideria and Clara burnishing platters at home, 1930s.

39. Another posed Maria and Julian picture, in their house, 1930s.

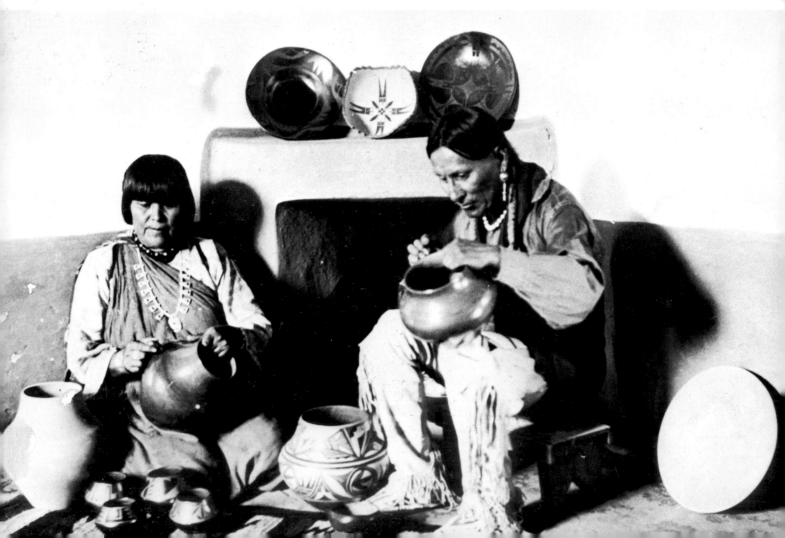

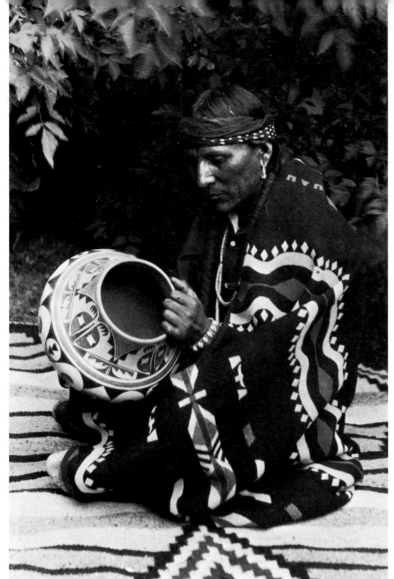

40. Julian and a polychrome piece he has painted, about 1925.

41. Julian and Maria, probably 1942.

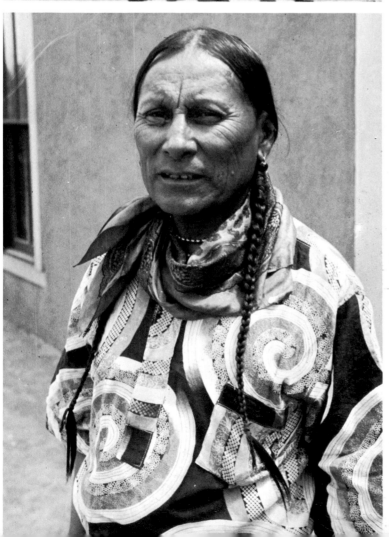

42. Julian at San Ildefonso, about 1940.

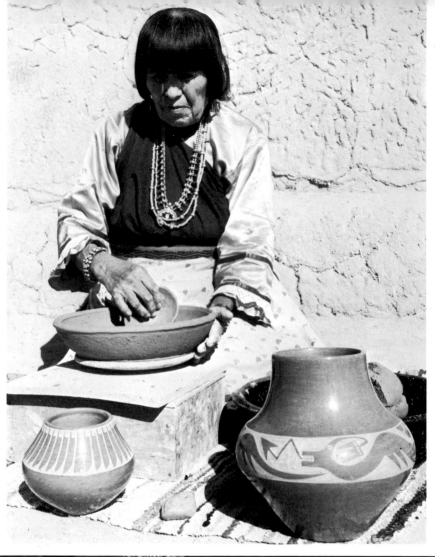

43. Maria demonstrating forming techniques, 1950s.

44. Maria and Popovi Da at a lecture-demonstration by Bernard Leach and Shōji Hamada, Santa Fe, 1952.

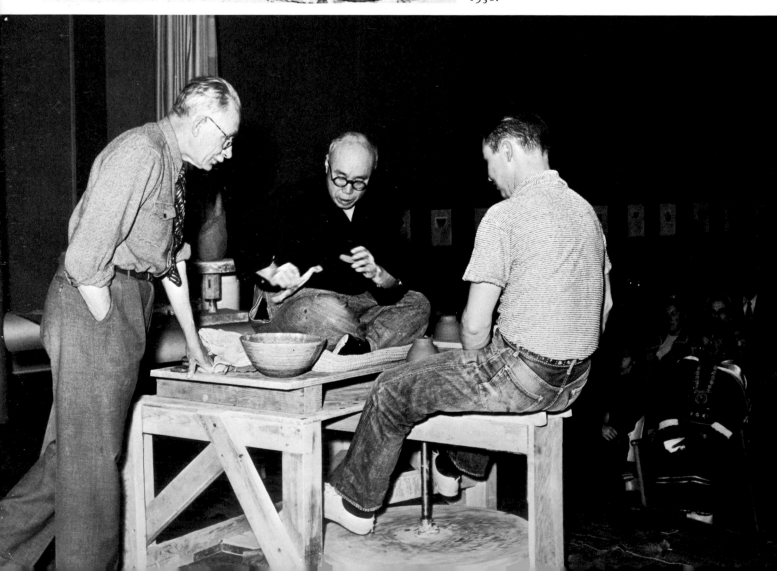

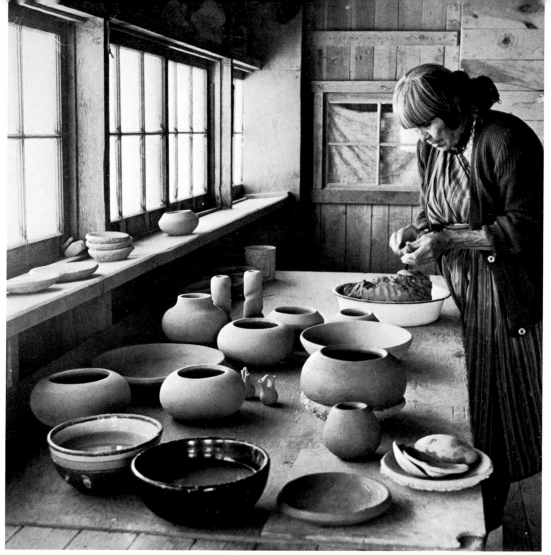

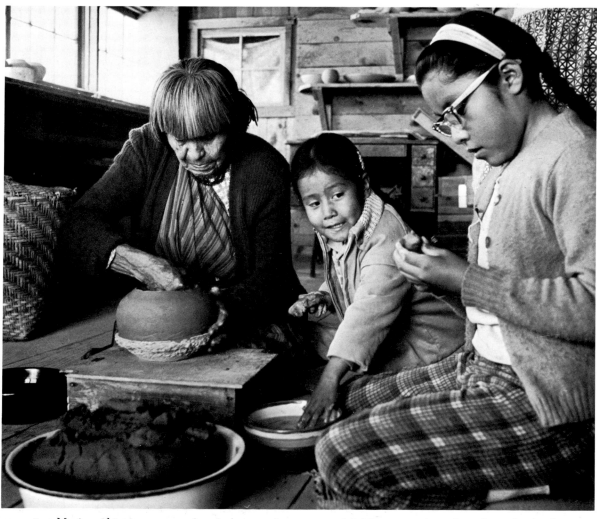

45, 46. Maria making pottery at her house, with great-grandchildren Beverly and Evelyn, about 1964.

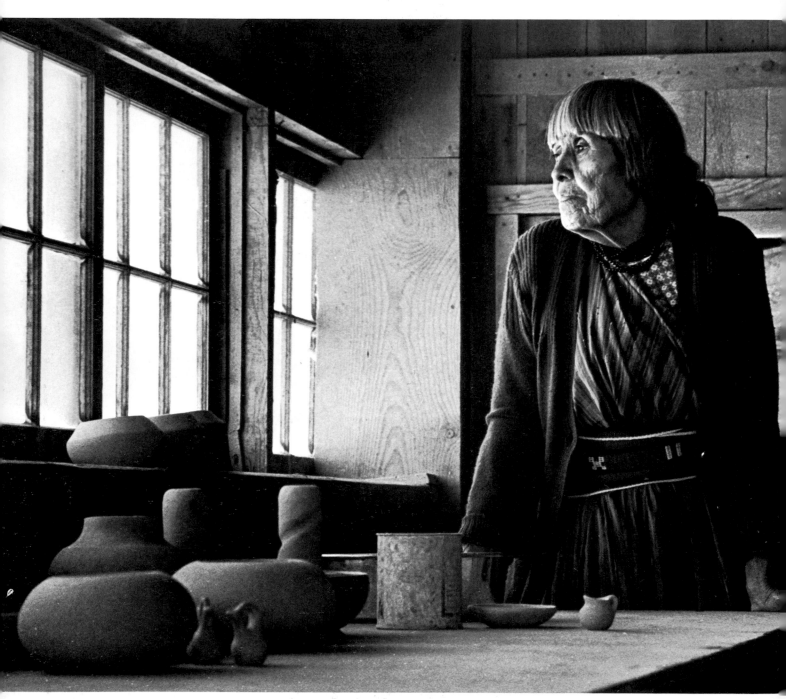

47. Maria, about 1964.

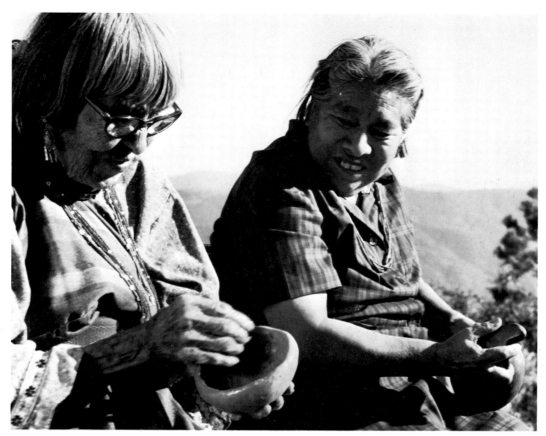

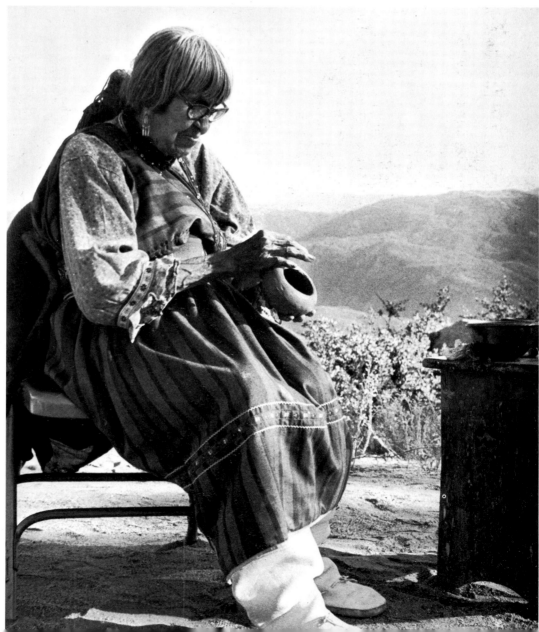

48, 49. Maria and Clara,
Idyllwild, California, 1974.

50. Maria, 1975.

51. Santana and Adam at their wedding, 1926.

52. Santana and Adam with children Anita and Frank, 1930s.

53, 54. Adam in two poses, late 1920s.

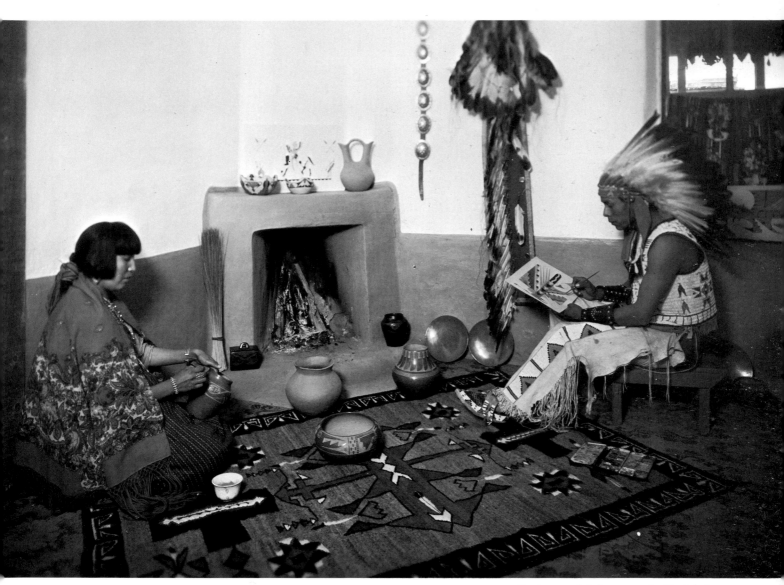

55. Santana and Adam pose in Maria's house.

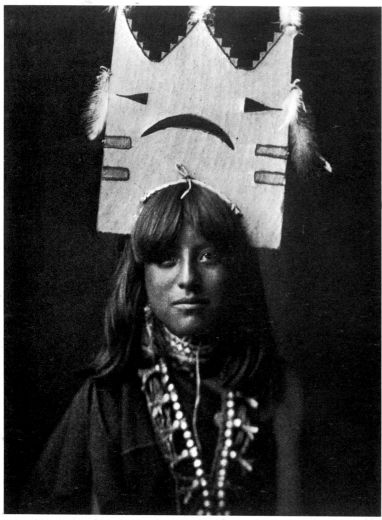

56. Tonita Roybal, Santana's aunt. Photo by E. S. Curtis, 1905.

57. Tonita Roybal with daughter Tomacita and nephew Ralph, 1920s.

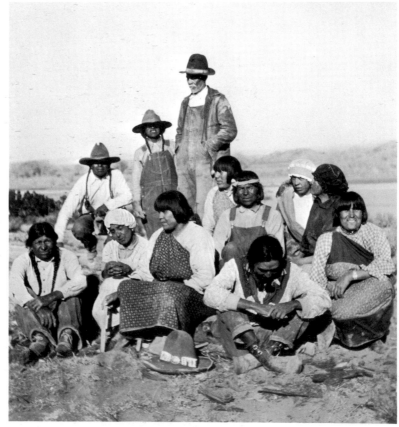

58. Maria, sisters, relatives, nonrelatives, etc., after a day of plastering the house, perhaps early 1920s.

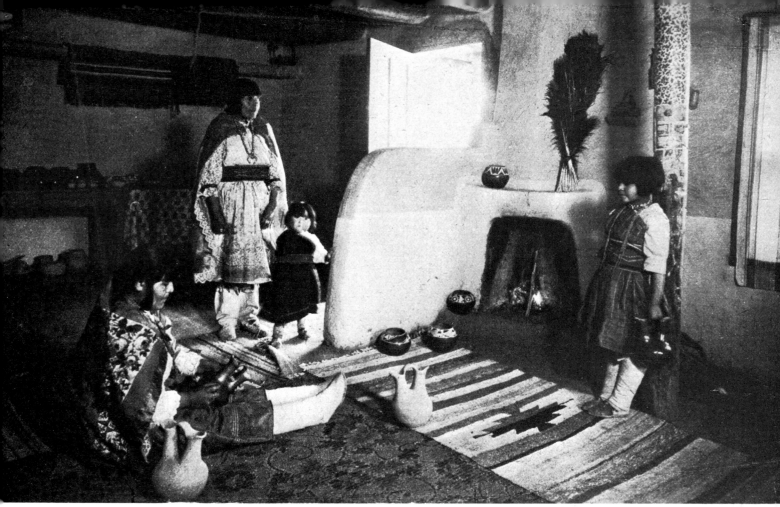

59. Isabel Atencio (seated), Maria's cousin, and family, about 1920.

60. Santana and Adam's house at left; adjoining kiva under construction, about 1930.

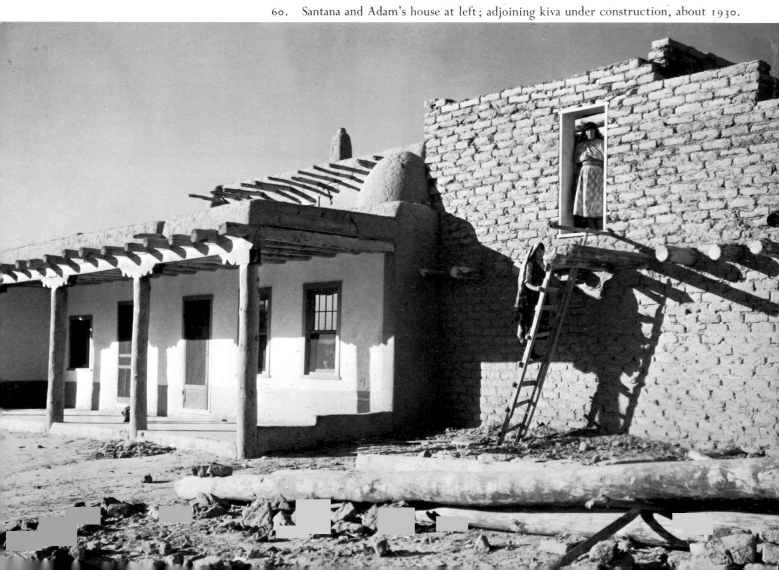

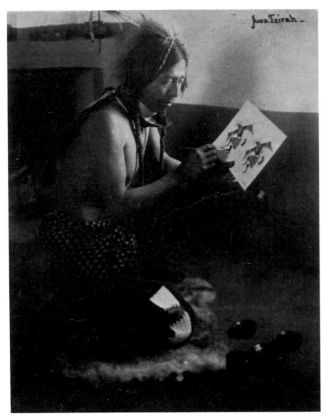

61. Awa Tsireh, Santana's brother, one of the most famous Indian painters.

62 *Shalaco Dancer*, by Awa Tsireh.

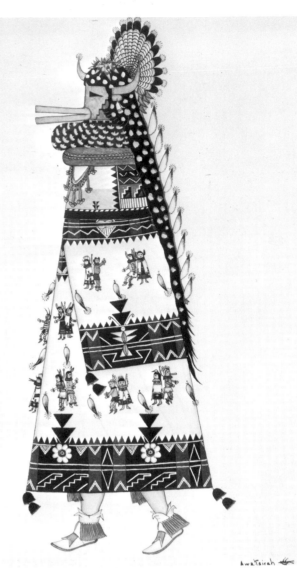

63. *Buffalo Dance*, by Awa Tsireh.

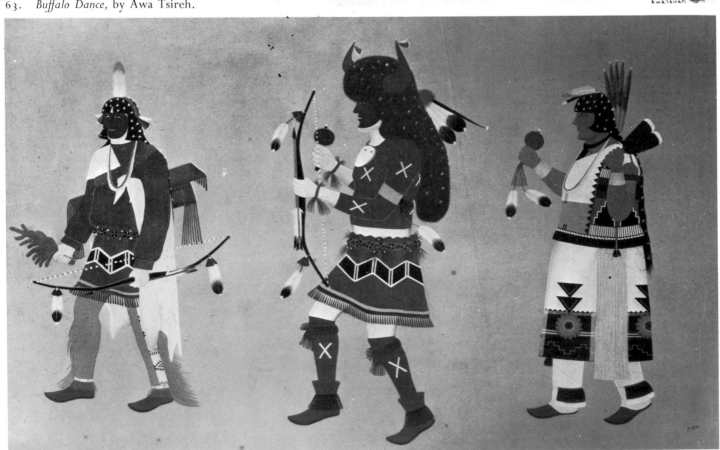

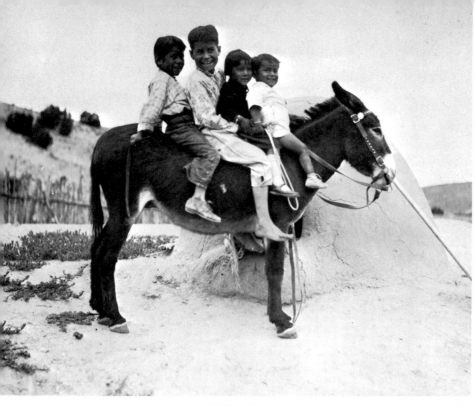

64. Donkeyback, with Maria's sons Felip and Popovi behind and Santana's children Anita and Frank in front, 1930s.

65. Coming down the kiva steps during the Commanche Dance; Santana is midway on steps, 1960s.

66. Maria and son Popovi Da, about 1964.

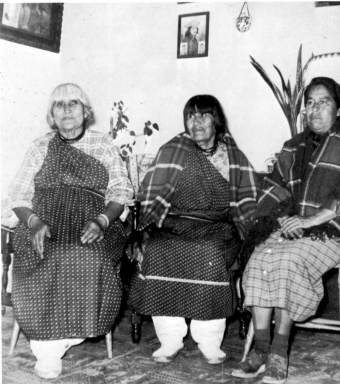

67. Maria between her sister Desideria and Clara, about 1960.

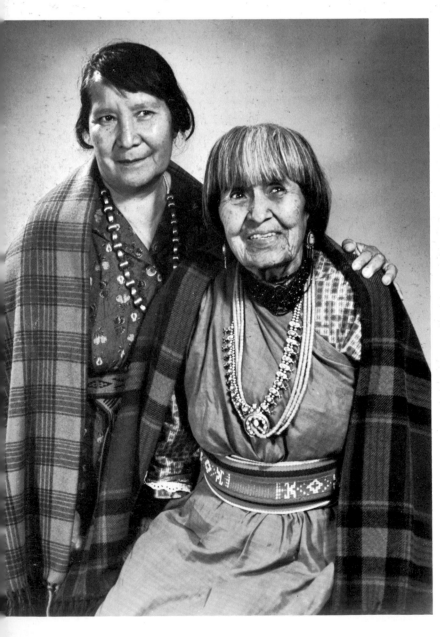

68. Santana and Maria

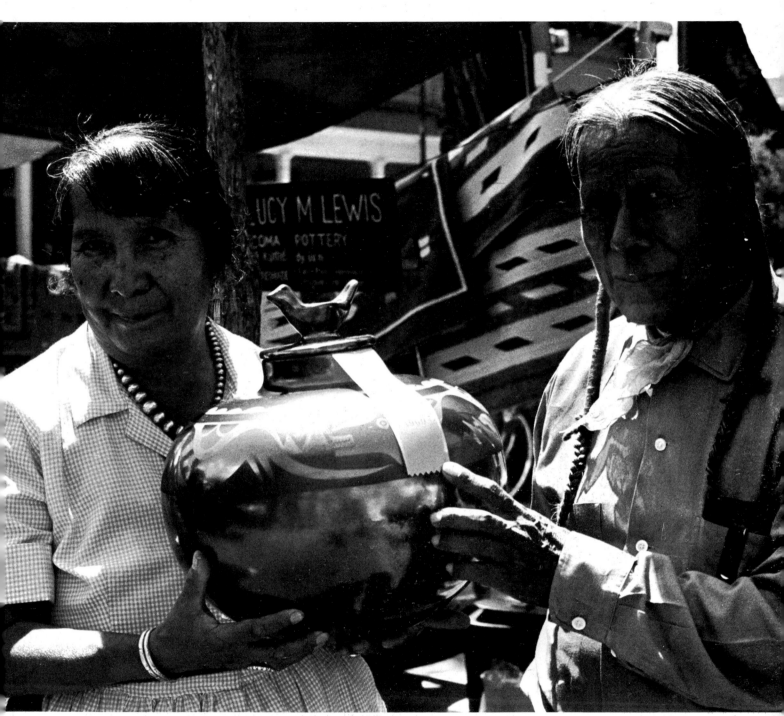

69. Santana and Adam at an Indian fair, where they took first prize for this lidded jar, 1969.

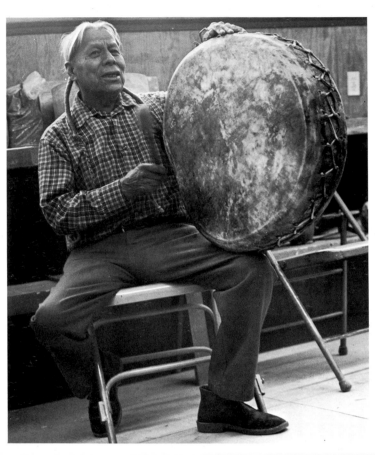

70. In the pottery studio at the Idyllwild School of Music and the Arts, 1974.

71. Adam drums for his grandson Marvin, Idyllwild, 1974.

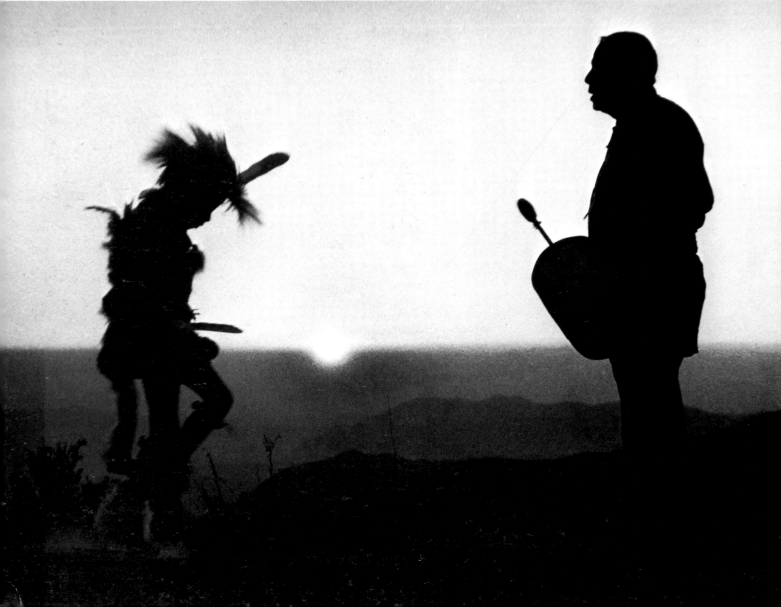

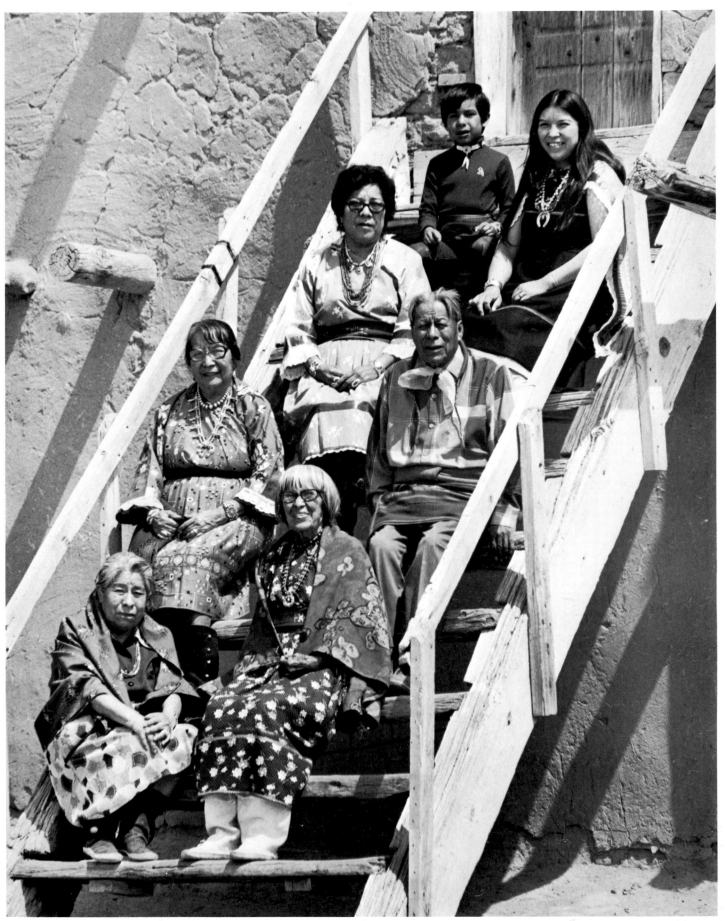

72. Family on the kiva steps, 1976.

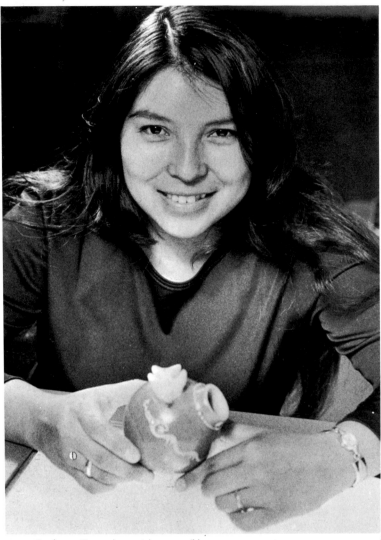

73. Barbara Gonzales with one of her pots.

56 74. Marvin Martinez, Maria's
 great-grandson, applying slip.

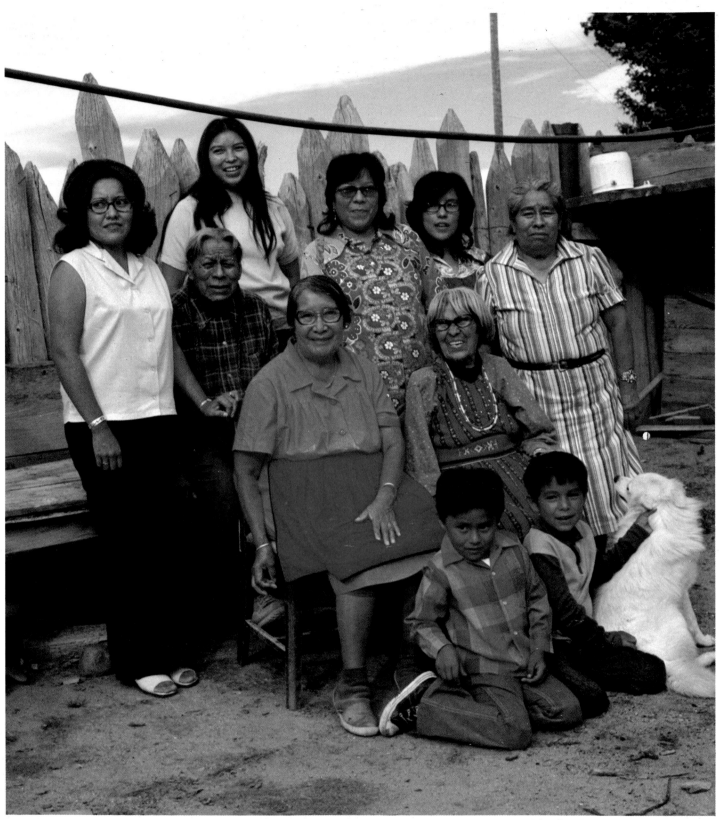

75. The family at San Ildefonso, 1975.

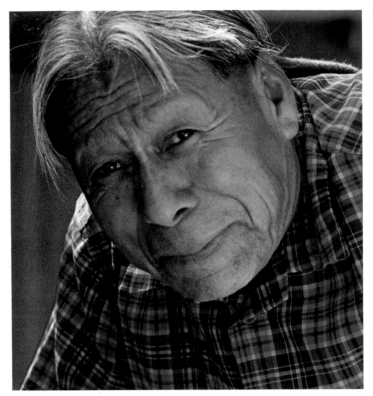

76. Adam Martinez

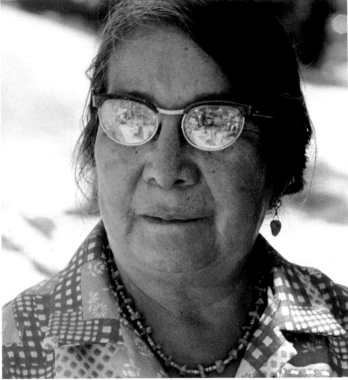

77. Santana Martinez

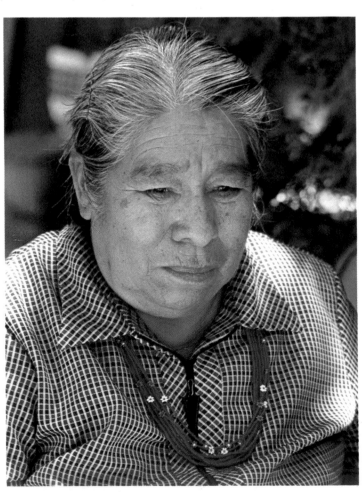

78. Clara Montoya

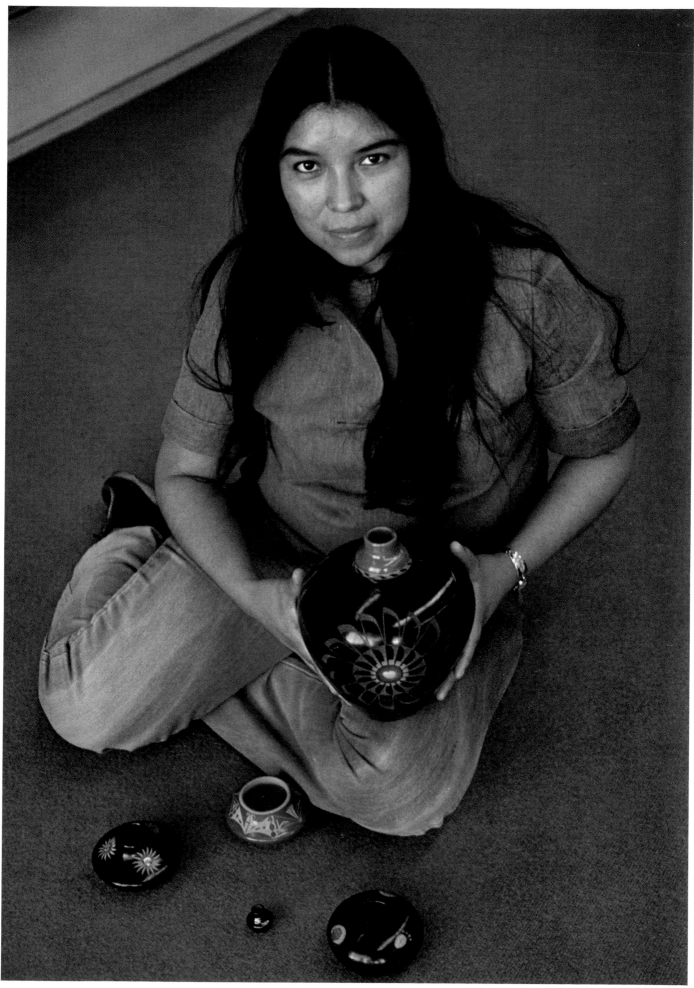

79. Barbara Gonzales

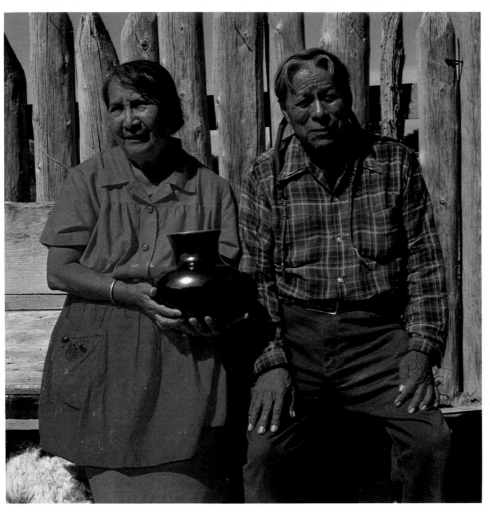

80. Santana and Adam

81. Anita P. Martinez

82. Marvin Martinez

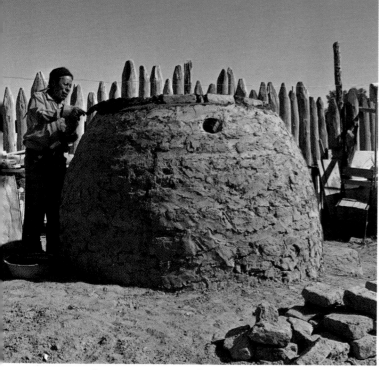

83–85. Adam constructing a bread oven.

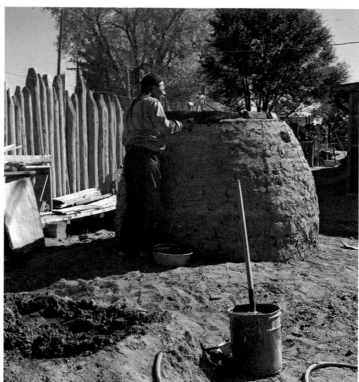

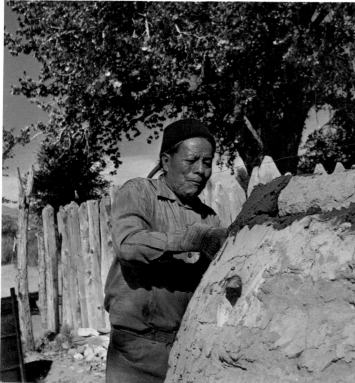

86. The completed oven after first use.

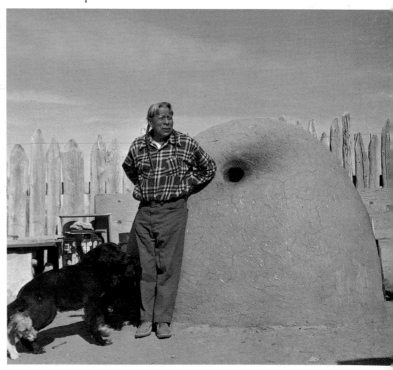

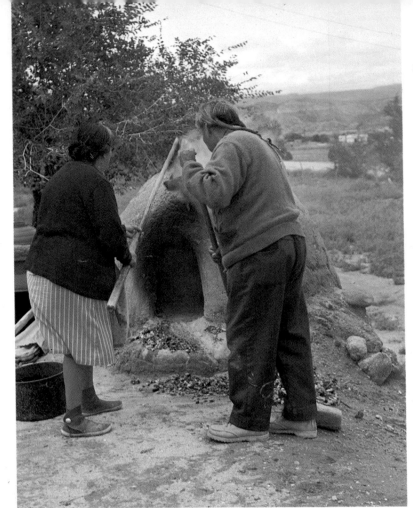

87–92. Baking bread for a ceremonial.

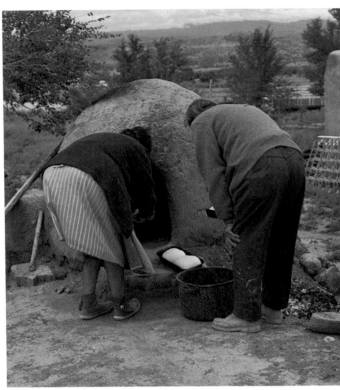

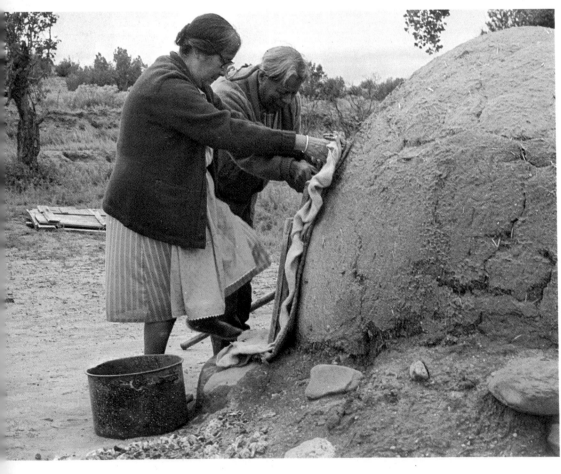

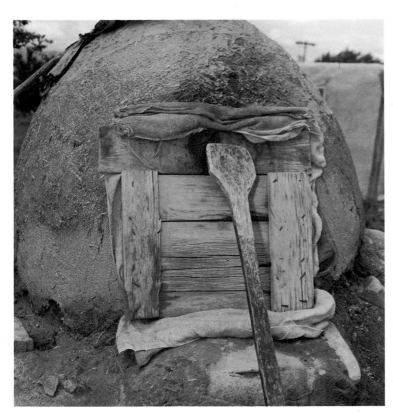

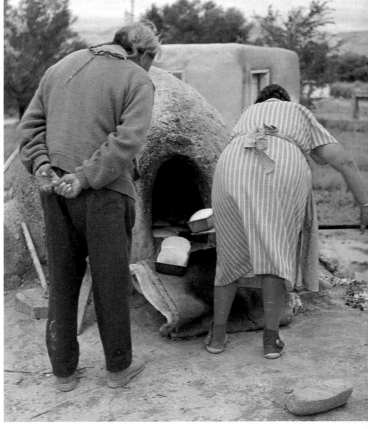

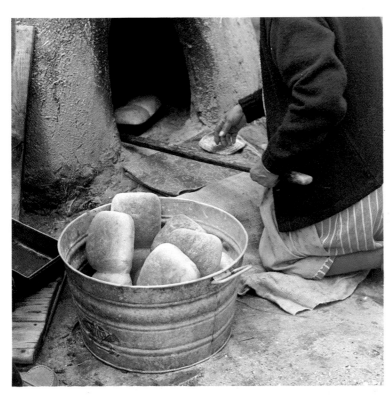

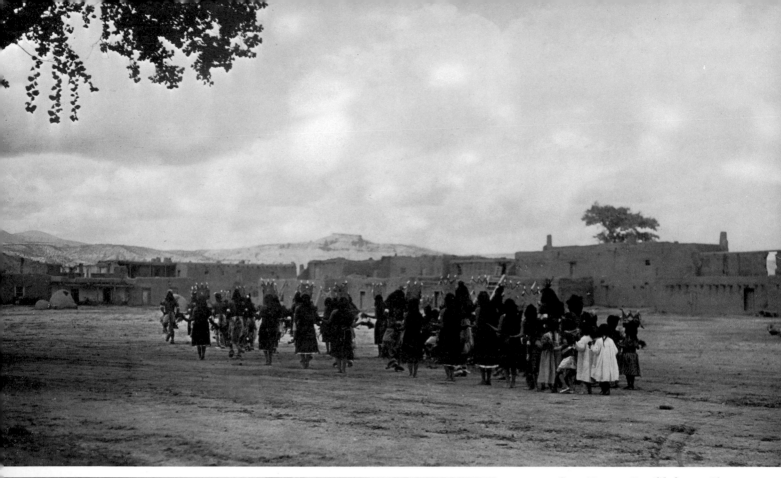

93–95. Corn Dance, San Ildefonso. Photos by E. S. Curtis, 1905.

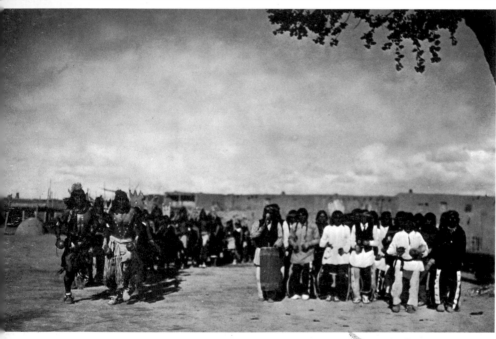

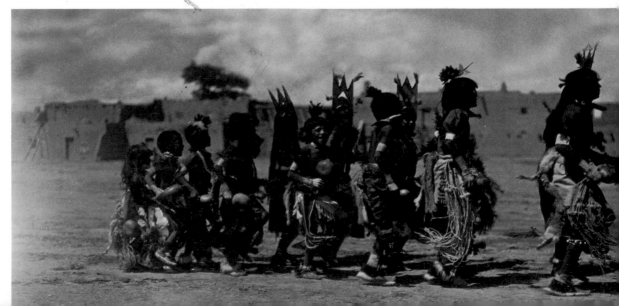

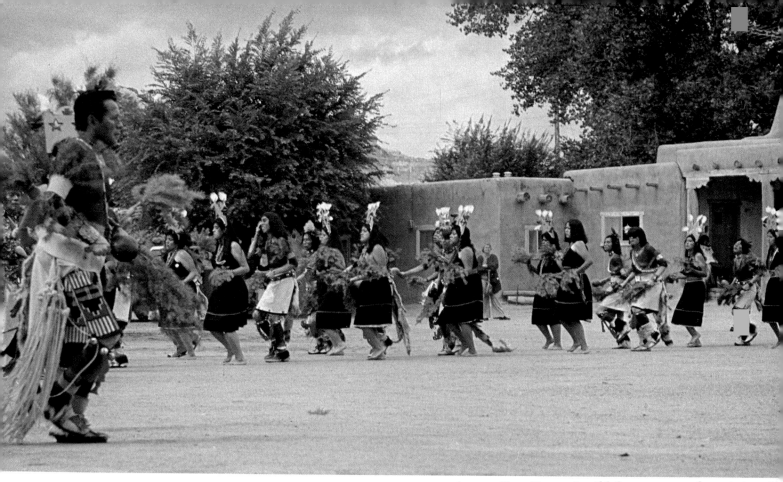

96, 97. Corn Dance, San Ildefonso, 1975 and 1976.

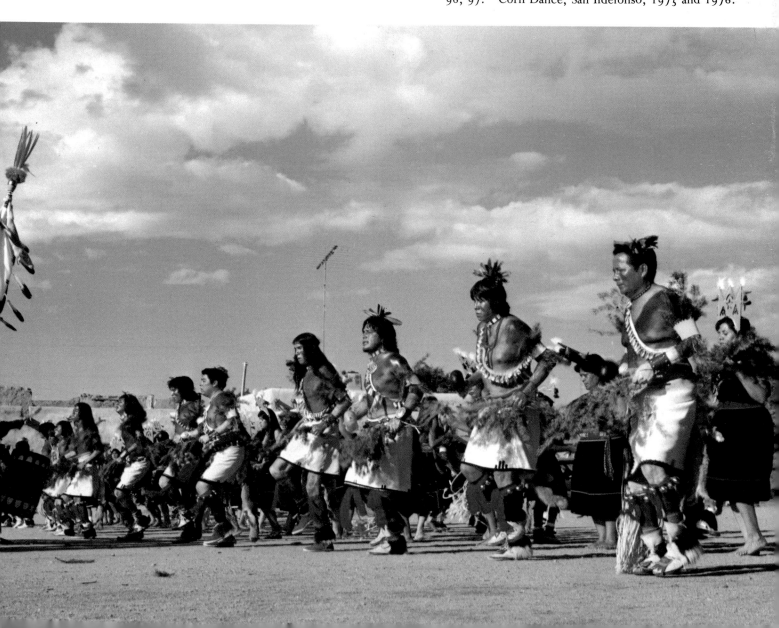

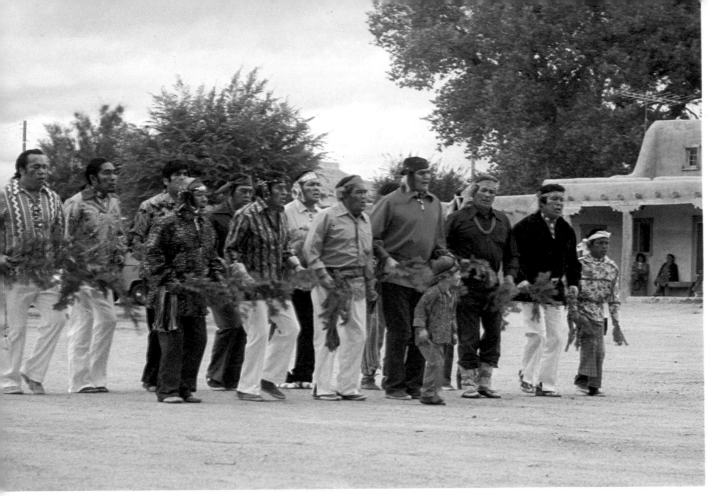

98–103. Corn Dance, San Ildefonso, 1975 and 1976.

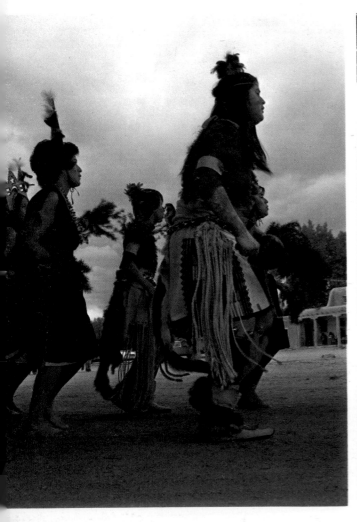

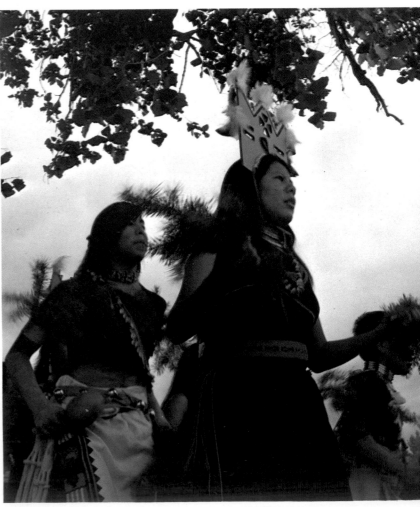

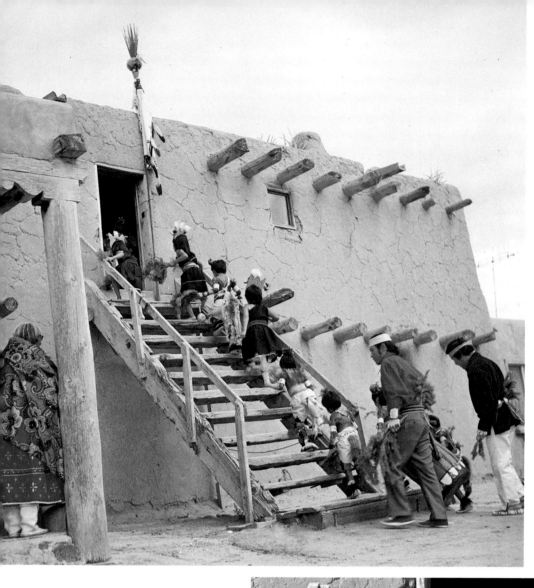

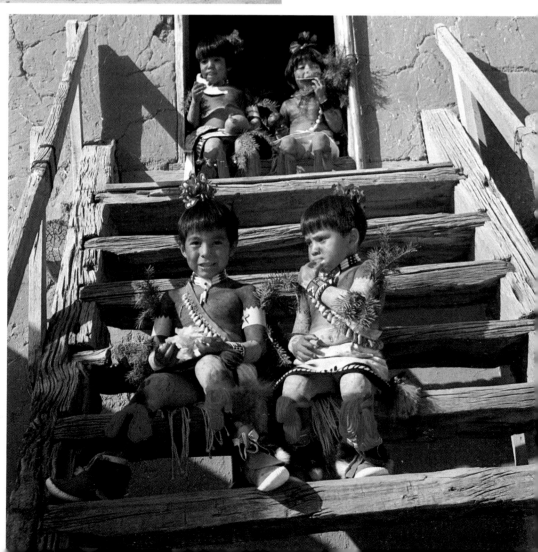

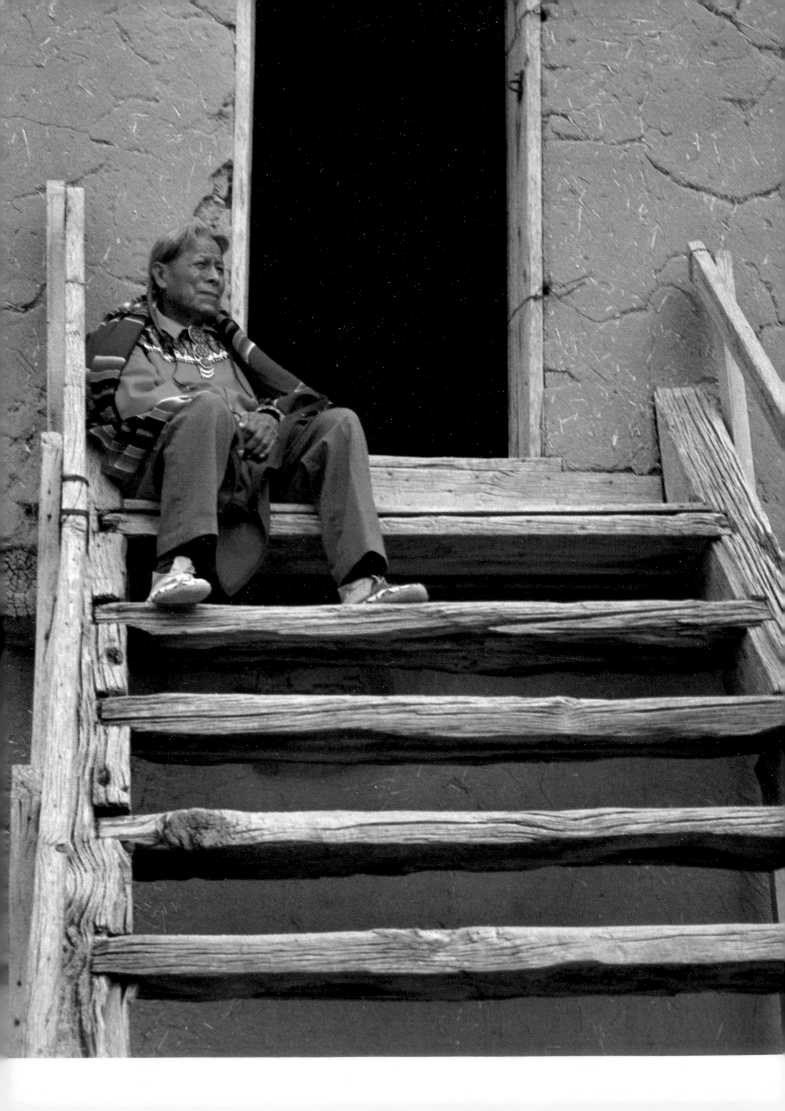

Song of the Sky Loom

O our Mother the Earth, O our Father the Sky,
Your children are we, and with tired backs
We bring you the gifts that you love.
Then weave for us a garment of brightness;
May the warp be the white light of morning,
May the weft be the red light of evening,
May the fringes be the falling rain,
May the border be the standing rainbow.
Thus weave for us a garment of brightness
That we may walk fittingly where birds sing,
That we may walk fittingly where grass is green,
O our Mother the Earth, O our Father the Sky!

Maria

As you drive down the Los Alamos road, which branches west at the Nambe corner off the highway between Taos and Santa Fe, you will find yourself crossing the Rio Grande valley between the warmly colored mountain ranges of north central New Mexico. About a mile to the left of Route S-4, not far beyond the Rio Grande Bridge, you will see a large yellow sign in a wooden frame with red and black letters. It is one of the colorful highway signposts familiar in New Mexico for indicating historical sites. This sign carries the legend SAN ILDEFONSO and notes that this is "the home of Maria Martinez, perhaps the best-known of Pueblo Indian potters."

The valley of the Rio Grande here is a great trough lying between two roughly parallel ranges of the southern Rocky Mountain province; to the east the Sangre de Cristo range rises to peaks of 13,000 feet, and to the west the Jemez range, slightly less formidable, is characterized by broadly rounded contours and elevated valleys. The river keeps to the western side, along the Pajarito Plateau, in an expanse of broken country, naked bluffs with caves in some places, and gravel-colored hills topped with a peculiar geological structure of clay and tuff.

At the historical marker, you make a right-angle turn from the highway onto the road that leads directly to the pueblo of San Ildefonso.

The landscape in this part of the Southwest is quiet: blue-purple hills, pink sand, gray-green sage, and mesquite as far as you can see. In spring, patterns of cadmium- and citron-yellow flowers overwhelm the cobalt and turquoise blues. White cloud billows in the cerulean sky and mesas of lavender give background to the solitary river path and the stony arroyos where water only sometimes flows. The shimmery green-white of cottonwood leaves and the occasional deep green of piñon pine punctuate the landscape.

The road winds, and the scene unfolds slowly. Horizontal planes of ochre color are

dotted with tumbleweeds blown across scrub juniper and yellow-green mustard. Cloud shadows move over the light earth. A filigree of tree branches follows the river, and snow-patches crown faraway peaks. In Maria's youth, corn and bean plants covered the hills; now they are barren.

The pueblo, a circle of adobe houses shaded by a few trees, lies exposed and spread out in the sun ahead. Some distance behind the pueblo looms the landmark of this area, Black Mesa, called Tunyo by the Indians. It rises like an ominous green-black table, mysterious above the low hills, visible for miles.

San Ildefonso belongs to the small group of Tewa-speaking pueblos on the upper Rio Grande River. In Tewa the name is Po-wo-ghe—"Where the water cuts through [or down]." Geographically and culturally, San Ildefonso is also near Santa Clara, San Juan, and the nearly abandoned Tewa villages of Nambe and Pojoaque. But artistically San Ildefonso is unique. It is the community where Maria Martinez and five generations of her family still make pots in the old Indian way.

The paved surface is replaced by dust and dirt as the road nears the pueblo and its plaza. The pueblo itself contrasts strangely with the bright highway marker announcing it as the home of Maria Martinez. Here there is an overpowering sense of loneliness and seclusion. The plaza is starkly open and vacant. It is softened and warmed by the curves of the old ceremonial kiva, a low, circular structure standing alone near the edge of the plaza with the long wooden ends of its ladder jutting into the sky. It is the oldest building on the pueblo. The severity of the empty plaza is also relieved and broken by the frequent domes of Indian bread ovens, which dot the space in front of square houses. Everything is adobe, the same ochre color as the ground.

No one is about. Only a dog or sometimes a child walks outside. There is no movement around the houses or at the old church at the far side of the plaza. When one has come to know the village, one understands that most of the life goes on inside the thick adobe walls, except when the plaza fills with motion and music every few months for the ritual of traditional ceremonial dance.

Maria Martinez, one of the best-known potters of our time, sits on the low porch of a house on the far side of the plaza. Dressed in Indian tunic, unnoticed and unmoving, she looks out across the open space, past the one venerable old cottonwood

tree to dry mounds of earth rising up to purple-blue hills. She has told me that as she sits on this porch she always sees in her mind's eye the deer and the buffalo coming down from the hills at dawn, as they did when she was a child more than ninety years ago. Maria says she is surprised to have lived so long.

In the early years of this century she discovered, with her husband Julian, a way to change the iron-red color of polished clay pots to an incredible shiny coal black in a bonfire. She has probably made more hand pottery and become personally better known and admired than any other American Indian artist.

Today her experienced hands still hold and form balls of clay into fine spherical pots. Vessels she has made for seventy years or so have been catalogued and collected by museums over the world. In an era when a serious new interest in North American Indian art is beginning, Maria has become a symbol.

There is no record of her birth, and Maria is not concerned with her age. Doubtless she is more than ninety years old, but there is controversy as to the exact year she was born. In publications it has been variously listed as every year from 1881 to 1887. Maria does have a certificate of baptism dated 1887, but she says she remembers the event—that she was a child not an infant when baptised. She has chosen April 5 as her birthday, and someone always makes her a cake. Except for a physical frailness, there is little evidence of such advanced years.

Before crossing to her, I take a moment to watch. Her physical being is in a harmony with her presence, and I am impressed with it anew each time I see her. She is dignified, with great strength in her bearing. Head held high, her body is straight, always commanding attention. Her steel gray hair is cut in bangs across her brow and bound at the back in a loose bun held together by a wapping of purple yarn. Her eyes glisten with life, and her smile draws forth your smile. Her long arms and strong hands are quick to move in gesture, accenting her opinions, her memories, her joys. Often she spreads her fingers wide on each side of her face in glee, punctuating the radiance she shows when she is happy. In conversation her eyes are intent, asking you to share her strength and drawing you into her world.

Her costume enhances her presence. Today she is wearing a blue shawl printed with red roses, a yellow cardigan for warmth over the green-striped dress, long neck-

laces of red beads and jet, and silver earrings and bracelets. Her dress is the traditional pueblo manta, sleeveless and caught only at one shoulder. It is made from bright printed cotton and cut to fall in soft folds over a blouse, which has long sleeves touched with lace. A hand-woven red, green, and white Hopi Indian sash is wound twice around her waist. She wears tall brown moccasins now, but for important events she wears loose white deerskin boots patterned years ago by her late husband Julian.

Maria loves to dress up, to "look pretty" as she calls it, and to put on special clothes for special occasions. At those times the mantas and the blouses may be made of silk or satin fabrics, festooned with ribbon trim, and the shawl over her head will be one of bright colors in an ornate pattern. No matter what the cloth, today as in the past, these traditionally styled costumes were all sewn by Maria or members of her family.

She puts out her hand, and we greet each other warmly. Each time we meet, the conversation seems to begin where we left it, no matter how long the separation.

After so many visits over the years to this pueblo, I generally know where to find her; either, as now, at the house of her son Adam and his wife Santana, or with her granddaughter Anita, or sometimes in her old home on a hill above the plaza, which she made with her husband and where she gave birth to four sons.

She lives simply in Adam's house, with her daughter-in-law Santana and with Clara, the youngest of her three sisters. Clara, who is perhaps thirty years younger than Maria, was born only a few weeks after Maria gave birth to her second son. Their mother, Reyecita, died almost immediately after Clara's birth, and Maria took care of Clara along with her own children. Deaf from a childhood accident, for a long time now Clara has been Maria's self-appointed handmaiden. She rarely leaves Maria's side. The two sisters have a special relationship that is honored in the pueblo.

Adam Martinez, Maria's oldest and only surviving son, lives here with his wife Santana. Now seventy-three, calm and shy of manner, he is a strong protector with a long history of fulfilling this role for his mother. It was Adam who was always called on to give of himself to his father and brothers. A handsome man, he wears his strands of steel-gray hair long and plaited tightly in thin braids, which he wraps each day with colored yarn to match his shirt, or sometimes, as he says, "his eyes." When necessary, he safety-pins the ends of those braids together at the back of his collar.

His infectious smile, his violet-brown eyes, and his handsome nose, which wrinkles when he laughs, all show a fun-loving, mischievous man. But it is his strength and stability of character on which his mother has relied ever since the death of her husband in 1943. Adam leavens this family group with grace and humor. He understands how important his vitality is in a family that has no other male leader, but the loneliness of this role rarely shows. His father and three younger brothers all died in the prime of life. He has chosen to remain in the pueblo, taking the place of his brothers, Juan Diego, Popovi Da, and Felip. His finely chiseled features quite resemble those of his father with whom he painted and farmed and whom he loved and emulated. Today he serves in the community as a wise and respected advisor in the role the Indians call elder. Yet this dignified title does not prevent his sometimes outrageous jokes and his storytelling. His drum playing and singing of Indian songs are his particular claims to fame, especially on ceremonial days.

Santana Roybal, Adam's shy wife of fifty years, also comes from a storied family. Her grandfather was a Navajo infant abandoned near San Ildefonso after a raid; her late uncle Crecencio and brother Awa Tsireh were the most famous early painters of this pueblo. Tonita Martinez Roybal, Santana's aunt, was a well-known potter, a contemporary of Maria's. Today Santana is known for her own work in the black pottery techniques made famous by Maria and Julian, which she learned in 1926 when she began assisting them after her marriage to Adam. After Julian's death, it was Santana who decorated Maria's pottery.

Santana, in her quiet way, is active in the daily life of the family and pueblo, unobtrusively handling responsibilities that were once Maria's. Reserved yet warm, secure, and protective, she and Adam are important advisors in the pueblo and in the extensive Martinez family. Together they are influential and command respect. They have raised seven children of their own and one adopted daughter, from whom have come two more generations, including more potters. They have twenty-three grandchildren and eighteen great-grandchildren. Santana and Adam are necessary to this Indian community.

San Ildefonso, the reservation where they all live, is about twenty-five miles north-

west of Santa Fe, New Mexico, a state inhabited by many Pueblo Indians. This community has probably been on this site four hundred years. The area of the reservation is roughly forty-one square miles, 26,200 acres, of which the pueblo proper is only a small part. The population of the pueblo numbers about 475.

The whole reservation is situated below Los Alamos, the town that gained fame for its role in the atomic energy development and altered the lives of all nearby native Americans by giving them a type of work and outside experience they had never had before. At the time Los Alamos came into existence, the land at San Ildefonso was arid and could not be farmed. It became more rewarding for the men to go off the pueblo to work. Julian was among them, but he continued to help Maria as well.

San Ildefonso today looks as it did when I made my first visit in 1949. Santa Fe was the closest real town, well known for its community of artists and writers. Before that visit, I had already seen Maria's shiny black pottery in a fine collection in Wichita, Kansas. I had read the early book about her and had listened to others who had visited her. I was anxious to see the work and the place myself.

Maria's third son, Popovi Da, ran a small grocery store on the pueblo with several shelves of pottery. I was surprised that summer at the variety of names on the black pots on display. But I could see nothing of Maria's there. When I asked for something of hers, he went to a cupboard and took out three pieces, saying that there were many potters in San Ildefonso. He revealed what I was to understand better years later. Maria was helping the other women of the pueblo to sell their pots, too. I bought the three pots for about fifty dollars, and Popovi gave me a lampshade he had stretched from a deer skin and then painted in blue and black designs. The shade split apart years ago, but it still remains in my studio.

Today Maria is the matriarch of five generations of potters and has been honored with more prizes than she can remember. She has been famous since the second decade of this century for the unique process of dung-fired pottery that resulted in the highly valued black-on-black ware. She has been invited to demonstrate at all the world's fairs up to World War II, and she has been feted by presidents at the White House. She holds two honorary doctorates, and laid the cornerstone of Rockefeller Center.

Intermingled in the life of this uncommon woman are both ancient and modern

cultures. She is unpretentious, unfazed by worldwide acclaim, preferring to exemplify the pure Indian way of life for her son Adam and his wife Santana, her thirteen grandchildren, her thirty-two great-grandchildren, and her nineteen great-great-grandchildren.

For some years after Julian died in 1943, Maria continued to live in her home, although her children were grown up and gone. When Maria gave that house to a grandson, she and Clara moved to stay with Adam and Santana. Adam's house is box shaped and not different from any of the other houses except for the wide porch and blue-painted window sashes and doors. Julian began it years ago, and Adam added to it, using twelve-inch-thick adobe blocks for construction, slurrying the smooth surface with soft mud. The foundation was built in the traditional manner of hard packed dirt, which was then leveled, covered with plastic, and floored with wood and linoleum. A kiva was built next door.

Inside the house the adobe brick walls are cream colored and smoothly plastered. A simple entrance leads to the living parlor, one step up, carpeted in green, with a couch and lounge chairs. There is a wooden stand for special objects, gifts from friends or members of the family who have been away. Above the door are plaques with gold seals and ribbons from the president of the University of Southern California, expressing appreciation for the Idyllwild workshops. Another room has an oilcloth-covered oval table, used for serving food on special occasions and also for decorating pottery. Here the walls are covered with mementos and framed photographs, graduation pictures, and portraits of the family. An old polychrome pottery prayer bowl, with some cornmeal in it, stands in a wall niche. When I was first there years ago, the walls were plain and there were no mementos.

Everyone sits around the kitchen table to eat daily meals or at the oval table in the other room when there is company. Family style, food is set in bowls in the center and passed or reached for. Service is casual, and the food is good. This night for supper Santana has made potatoes fried in an iron skillet. Into a small amount of water in the pan she broke eggs for poaching. When that water evaporated, in went the potatoes that Adam had just peeled, to steam. Then Santana put fresh chili peppers under the broiler until they were soft and slightly singed. We all sat around the kitchen table

peeling peppers and burning our fingers. We each ate the egg-potato mix in bowls with crisp cucumbers and added beans on top. Clara's tortillas accompanied the meal.

Maria's own room has a bulletin board of things she favors: a picture of President Kennedy, some newspaper photos, a snapshot of herself, and a small basket she likes. Maria points at Apache baskets hanging on the wall. She used to buy them for $2.50 or $4.00 or so, and one that took a prize sold in Gallup for $7.00. "You know, we were the first to go to Gallup to perform ceremonial dances. We sold our pots so cheap there. Now the prices are so high, but I can't make as many as I used to. It just breaks my heart, but it's all right. The young people get more now, and I am glad for that."

Maria's personality, as I have discovered through the years, is a joyful combination of humor and quick wit, with a positive attitude toward life. She is at once childlike in anticipation and worldly in judgment. She is intuitive about what has worth for its own sake, even if it is only a small kitten or another of the many animals that are an important part of pueblo life. Generally when she sits alone, not speaking, her head is upturned expectantly, as if she is listening for and also hearing sounds from some other time. Her memory is infallible. She thinks in Tewa, Spanish, and English, and she can quickly give other family members clues they need when trying to recollect a person or a place.

Whom else do you know who can call forth exact dates from the early 1900s? Maria can remember details from the excavations of Frijoles Canyon, beginning in 1908. She remembers that in 1909 an unusual cluster of strange black shards was found; that on a particular Tuesday, Dr. Edgar Lee Hewett, "a wonderful man" from the museum in Santa Fe, brought a special rare find to her at the pueblo, miles from the excavation; that Charles Faris, of the Santa Fe Indian school was the one who packed her work to send to Chicago for the 1933 World's Fair, where she got so homesick in four and a half months that she wanted to go home; that a particular pot someone brings to her now for verification, or a museum director asks her about, was made in 1922 or some other specific date; it is also likely she will remember something about how it was fired; or she may recall a specific occasion like the one fifty years ago when Dr. Kenneth Chapman picked out the pots for the Rockefeller

collection. Events of historic importance are remembered in their time and place in the same way as incidents of daily life.

"I used to make big, big pots for $1.00 or $1.75," she says. "This lady who was a millionaire asked all the potters of San Ildefonso to make pots for her new home. I made one in polychrome about two feet tall. The museum came and was to take the pottery, and you won't believe how much I sold it for to the lady—$8.00." Maria says she made hundreds of large pots, but I have not been able to find many of them in museums or private collections. Pieces fourteen to eighteen inches high in polychrome and also in black, which Julian decorated, are not so rare.

Maria may not know the prices now being paid for the black-on-black ware or polychrome pottery that she and Julian made for so many years; or for the pottery that she and her son Popovi Da made, or the pottery she made and Santana painted. Today their old works, if and when they are found, are being sold for increasingly higher prices. Pieces on the market are becoming more and more scarce. Such prices, which will become history in two or three years, are partly artificially inflated by a buyer's market and partly the result of a healthy demand for and appreciation of Indian art. Though hand-wringing is futile, I can certainly wish that these beautiful pots had been properly evaluated much earlier. At the Southwest Museum we saw a magnificent plate with eagle-feather pattern signed "Marie/Santana." Santana said that in 1947 they probably sold it for $20. Today it is likely to bring $1,000! Adam told me how his father would take only the very best of the pots to sell, the most perfect ones. In the 1930s, he would get about $60 for thirty pots.

Maria's immediate family and Maria herself have only a few of the thousands of pots she has created over a period of seventy or more years. They were all sold as fast as they were made; the family needed the few dollars each pot would bring.

"Long time we never thought of keeping pottery of mine or giving it to the children," Maria says sadly. "We didn't think of that . . ."

There was so much else to be thought about in those days. The weather, the farming, the crops, the gradual loss of the older men to the outside world, where they were able to find work. Eventually the loss of the younger men, the many other changes in the pueblo, and the many chores of the women.

"Of course we don't work pottery all the time, especially the winter time," Maria continues. "It's too cold. And every few weeks we practice for the dances. Two weeks ago we had the bow-and-arrow dances. It is not always the same dances, except for Christmas. The Christmas dances are the same."

Maria has made a factual statement, and I have watched the time-consuming preparations for the rites of the sacred dances many times. I am also aware of the countless other demands made on these people's time, because of the extreme isolation of the pueblo. For instance, I know that laundry must be taken thirty miles to Los Alamos, to be done in the automatic washing machines. But it has taken me about twenty years to recognize the truth of the words I have just heard: these people do not work in pottery all the time, in fact, they do so hardly at all. The necessities of daily life, such as the preparation of food, the rearing of children, the sewing of clothes, and the preparations for ceremonials take most of their days.

"What was it like making those big pots in the old days?" I want to know. "Oh, I polish those big ones fast! I polish a big one in two hours. I am fast and strong." Maria draws herself up proudly and continues. "Really the biggest ones I polish in quarters and it would take a day to do half. All the big ones we had to make outside, not in the house. In only one day they dry in the air, stiffen, and I add more coils, like Adam builds his adobe oven. Then to scrape and sand takes a very long time. Decorating my pots, Julian would take maybe three to four days. Nobody can work steady making pots. We have to do other things."

"When we fire big pots, we carry them outside in a shawl. Two people carry one pot. I used to do as much work as I could outside," Maria laughs. "So when people come they could see me. La Fonda Hotel used to bring buses! My sister Ana [Maximiliana] painted my polychrome sometimes, just as Julian did. Julian and I did the firing."

I ask Maria about her travels, a favorite topic.

"Of course I visit Texas and all those kinds of states. In the old days we would go in November and on the Fourth of July to Oklahoma for the Indian powwow. They don't call it that now. You know, once I got clay from many states and carefully I made a pot with each clay from those states. When I fired them I gave them to Mr.

Faris. I wish you can see the clay from all the states." It is important to Maria that the clays from many locations are all in one place, that they were made into pots. She reveres the clay; it is Mother Earth.

I have seen those pots made from the clays she collected in 1934 from seventeen states as she, Julian, their son Juan Diego, and Charles Faris went to the tribal exposition in Alabama. Julian decorated each pot symbolically according to his view of each state, such as mountains and fields for Virginia, feathers for Oklahoma, wind for Texas, sun and rain for Illinois, a river for Washington, D.C., and with wry humor, he left the Kansas pot plain.

During the past thirty years, Maria and I have visited together many times at San Ildefonso. The first time we saw each other away from the pueblo was when she was brought to Los Angeles in 1968 to receive the American Ceramic Society's highest award for lifelong dedication to clay. She stayed for three days. My family and I took her sightseeing, which she loves. At the public ceremony where she received her award, she stood regal in her blue satin Indian dress and pink shawl, and gave her acceptance speech in Tewa. She also coiled a pot. I became interested in the importance of mutual involvement, and made a proposal to the National Endowment for the Arts to fund a Martinez pottery workshop. In 1973 we received the initial grant.

So it came about that Maria, when she was over ninety years old, with Clara, Adam, Santana, and Maria's great-granddaughter Barbara Gonzales, agreed to demonstrate for the first time in a non-Indian environment. They came for a four-week session at the University of Southern California's summer workshop, called the Idyllwild School of Music and the Arts (ISOMATA), in the San Jacinto Mountains east of Los Angeles.

At the time I conceived the idea and then requested the grant, I did not realize what a difficult situation this would be for the Martinez family of San Ildefonso. This trip posed great personal problems for them. Pueblo Indians, living in such isolation, are shy people. As a group they had never been away from their home or traditional environment for more than a few days; they had not associated long or with any intensity with non-Indians. Lastly, they had never done any teaching.

Their acceptance, therefore, was an act of reaching out and a real sign of their desire to communicate, regardless of their deep shyness and reserve. The growth in understanding between these people of San Ildefonso and the many people who have worked with them at Idyllwild has created an enduring bond, a lasting closeness.

The evening meal at the pueblo is usually a light one, and Maria retires early. But my visit will last several weeks. We find time together "as it comes." Sometimes we go to Santa Fe in Adam's truck and sometimes in my car. In the evenings we talk for awhile, usually on the porch, but occasionally in her room with its bulletin board covered with mementos.

Maria's eyes brighten as she remembers that she has received thirty-two, possibly more, awards, but she cannot remember exactly what each one of them was, although she has a good memory for places and faces. Her feeling today is that no award is as important as the one she might give herself now for long life. Maria has had her share of sorrow, so that honors and awards give her strength as well as pleasant memories.

Life changed drastically in the close-knit community as soon as a daily commitment away from the pueblo became a reality for the men of many of its families. These new associations with non-Indians produced problems in all areas of Indian life. Maria, among many other pueblo wives, watched erosive pressures influence their communal society and sacred ceremonial observances. Yet all through those years of change and a hardship different from any that had gone before, Maria helped hold the pueblo together. Santana and Adam do this now. Today Barbara Gonzales, Maria's thirty-one-year-old great-granddaughter, is convincing when she tells me that her children and grandchildren will carry on in the Indian way.

Barbara Gonzales is a beauty by any standards. She possesses a smooth complexion, eyes the color of dark earth, and a wide, mischievous smile. She lets her long, jet-black hair flow loosely about her shoulders, but pins it back if it might get in the way of her work. Barbara is the youngest of the Martinez family of artists, and the mother of two sons, Cavan, age seven, and Aaron, age five.

"We are all making pottery now and every day people come to buy," Maria says proudly. "Blue Corn is young, and her mother is still younger than I am. Carmelita

Dunlap is my sister Juanita's daughter. Carlos is Carmelita's son, and he makes pottery with his mother. Isabel Atencio, my sister Ana's daughter, also makes fine pottery. And so do Rosa Gonzales and her son Tsepe, who are not even related to us."

Teaching is not a word these people use, although there is a kind of qualified instruction taking place, which Maria has carefully structured. When I asked Maria how she learned pottery, she was quick to respond.

"I watched my aunt, Nicolasa, my mother's sister who had married my father's brother, so we are all in the family. Nicolasa is—was—one of the best potters of all."

"And did she teach you?"

"She didn't teach," Maria says carefully. "Nobody teaches pottery. I was about ten or twelve. I used to go to visit my aunt and watch. My mother said, 'Don't stay long; your aunt may get tired.' But I stayed until it was time to go home for supper. They didn't make black then, just polychrome. There were other good potters, too. My grandmother made cooking pots, and I remember Martina Montoya and her husband Florentino. They were very good potters. Nobody can touch them. They made those great big pots with lids. I did not make lids. That Montoya was my father's cousin. And before Martina married him she was Martina Vigil. She made the best big pots! There are two big ones at the museum on the plaza in Santa Fe with lids.

"Nicolasa, Martina, and my grandmother—they didn't teach. Nobody teaches. But in 1932 much later, someone took me to the government Indian school in Santa Fe and told me to teach. I said no, I come and I work, and they can watch."

This kind of observation-instruction is continuous in the structure of each day, in the isolation of pueblo life, for all who are part of it. It is real direct learning—learning by imitation, from demonstrations, by watching. Although this kind of learning theoretically takes place best in unstructured natural situations, Indian daily life is organized so that it sets up sequences of repetitions that become frameworks for a subtle educative process. In this way Maria and Julian continuously showed others in the pueblo their method of making black pottery, so that those others could make it for themselves and involve their own family members.

Maria loves the Tewa language and wishes all pueblo members would learn it.

"I also speak Spanish since I was very young. My father spoke Spanish and he taught all of us, me and my sisters Maximiliana, Juanita, Desideria, and Clara. My father was a good farmer and carpenter and cowboy. He was a worker! He was born at San Ildefonso too."

Silences in our conversation occur from time to time. Maria will speak when she feels like it.

"Julian was born here, too. But there was no school then. Now they have Head-start and everybody speaks English. Those little things, too," Maria exclaims, pointing to the children playing. "Tewa is learned only at home now and not taught in school."

Most of the elders and many of the young parents are sad about this. They realize children at home are not using their Indian language and will not understand and pass on the religious ways, which come only through Tewa. But there is no way for the language to be taught formally in school. Now the younger people go away to high school. Some go on to college far away.

"I wish they all learned Tewa," Maria laments. "So many cannot speak it today! *Our* children can, though. And Julian and me, we didn't have much school."

I laugh softly and remind Maria about what happened in the car just yesterday. I was driving, Maria beside me in the front seat, Adam in the back; we were returning from Santa Fe. We passed the large yellow sign on the highway marking the turn into the pueblo, the state historical marker that announces that San Ildefonso is the home of Maria Martinez, "perhaps the best-known of Pueblo Indian potters." I pointed to the sign and made some comment.

Maria peered through her glasses. "No, I don't read much," she said, "But Adam reads."

Adam laughed from the back seat. "Maria may not read, but she sure sees everything!"

Maria and I glance at each other, wordlessly aware of the paradox of learning and losing: about going to school and learning to read English and in the process losing one's native language and with it, one's history.

After a moment her face lights up, and she tells the story of her "doctor's degree."

"When my son Po tells me that the University of Colorado wants to give me a doctorate, I say, 'Tell these men I don't want to be a doctor! I never medicate anyone!'" But she did go to Boulder to receive the honorary Ph.D. for outstanding artistic achievement. She wore a cap and gown for a part of the ceremony, but in the end she removed the academic robe, keeping the cap on, so that everyone could see her beautiful dress. She took the cap home with her.

Maria breaks another silence. "Since I was little I always like people, and they like me. We had a neighbor Spanish lady who lived next to us for many years in my house up there. And when her husband died she wanted to stay with me—her boys lived in Santa Fe—and she stayed with me for thirteen years. When she got sick the doctor told me to get her sons, and I did. And they all—the poor sick woman and her sons—wanted me to have her house and her land and her things. But I told them I have plenty of land from my father and my husband, and for them to divide her property three ways or whatever, and so I didn't take any. I kept taking care of many—my mother, my sister . . ." Her voice trails off. "I used to have a little grocery store to feed the people. The Spanish people say I was good to help them. They owe me money or something, I just forget it. I say I gave it to God."

Some association reminds her of the car she and Julian bought in 1924.

"That was the first car in the pueblo!" She puts her hands to her mouth and laughs. "It was a black car, all black. I can see the designs Julian put on that car. He painted it all around just like the pots. You be surprised what I do with that car. We take everybody who is sick. And we get food. We help everybody with that car. And oh, everyone in Santa Fe looked when we came!"

How I would like to have seen that marvelous car covered with black pottery designs. What a wonderful affirmation.

Aesthetic expression is the most conspicuous aspect of Indian culture. But, paradoxically, the Indian does not speak much about his culture, does not write it down, gives no formal instruction in it. He lives it, expressing it in dance, ritual, music, art, and symbolism. Indian children on the pueblo assimilate the culture in the same way as they breathe. It is participation in life, rather than the non-Indian approach of learning about life.

The daily occupations of the people of this pueblo conform more or less to the ceremonial order. In a fixed pattern, they are concerned with simple everyday problems of living rather than of acquiring material possessions.

Maria's own history is a perfect example of the Indian ideal of conformity as a way of life. Feted by the outside world, she has chosen without hesitation to remain on the pueblo and to enclose herself and her family in their own culture and way. This requires that they remain in isolation. Some may think this is too great a price to pay for the survival of one's ideals. But Maria has always had an uncanny inner knowledge, which makes her aware of the full meaning of her commitment. She knows that the Indian communities must guard their own cultural resources to preserve them for the whole of the country and all of its people, until such time as we latter-day Americans can recognize and learn from the worth of these original peoples' indigenous ways.

Maria has fantastic energy. She greets visitors who come to the pueblo, regardless of the hour. "Last night two big busloads of people came to see me wa-a-a-a-y after dark," Maria says, lengthening the vowels as she often does for emphasis, and raising her soft voice high in tone. "But I went out anyway. They came from Detroit."

One of her grandsons, Julian—Santana and Adam's first son and her husband's namesake—works at Los Alamos but lives on the reservation with his wife and children. He has told me on occasion, in quiet conversation, how important it is that all the members of his pueblo come together, even those who do not live there, every few months for the ceremonials, where, in addition to learning the meanings of their rituals, they can see and speak with Maria. Maria is important to them because she has lived so long, teasing and cajoling all those around her into practicing and preserving the Indian way of life, which she holds in such reverence. He tells me how she passes on the ancestral stories and how they all still learn from her. This grandson says they are all sad when someone dies who has not left anyone behind trained in his special knowledge and skills, for then those ways will be lost. Maria is still hard at this training for those who will come after her.

"Maybe I was born for people," she says. "I like people. I don't hide."

Song of Avanyu, the Storm Serpent

Storm serpent, Old Man
Come hither now
For here we are dancing;

Laden with rain
Now you arrive!

Black Pottery

Maria speaks often of the Pajarito Plateau excavations at Tyuonyi and Frijoles Canyon, near San Ildefonso, in 1908 and 1909. These were led by Dr. Edgar Lee Hewett, a professor of archaeology and Director of the Museum of New Mexico, who became Maria's mentor and friend. Hewett was commissioned to research ruined pueblos of the Tewa and ancient burial mounds; this work resulted in findings of exceptional interest. His party included, among a group of ten scholars, Dr. Kenneth M. Chapman, an artist who was later Director of the Laboratory of Anthropology in Santa Fe, Jesse Nusbaum, an anthropologist, and John P. Harrington, a specialist in Tewa ethnogeography. Hewett's excavation, one of several conducted in the ruins around San Ildefonso over a period of years, turned up a kind of pottery not hitherto found historically in the Southwest. The shards were jet and charcoal black in color, and some of them were polished. They were quite different from the characteristic black-on-red or black-on-cream or undecorated wares, although some of these types were found in this district too, both shards and whole pots.

Hewett was especially impressed with the black shards. He wanted to find an Indian woman in the vicinity whom he could ask to make pots the way she thought these pieces would have looked when they were whole. He was recommended to Maria Martinez as one who could make the thinnest, roundest pots in the least time. He visited her at the pueblo with some of the unusual shards.

This was the beginning of the now famous black pottery of San Ildefonso that Maria and her family have developed and perfected for more than half a century. The ware as it looks today has a mirrorlike luster without benefit of glaze. Maria has told the story of her discovery thousands of times. Her reverence for Hewett and the men who came to her pueblo, whose interest in her and her artistic husband Julian changed forever their fate, makes her happy to tell the story a thousand more times.

"It was 1907 or 1908 or along there," Maria says. "Dr. Hewett brought Mr. Chapman and Mr. Bradfield along, and those others—Harrington, and Nusbaum, and La Farge, a Frenchman, I think. They came first to me. Harrington didn't work in the ruin. He came to learn the language. He sure can talk Tewa! Sometimes Julian used to say the words in another way, but Harrington could always tell. Julian was just like Adam is now, always joking."

I learned later the mischievousness of this humor, which also contains a desire to maintain the Indian's privacy by gently misguiding the curious non-Indian. In a sense, it also puts the interloper to a test. Julian was evidently a master of sly jokes. And his son Adam takes after him.

"One time Harrington was asking Julian about a lady who made belts at home. He wanted to know her Indian name. And Julian said it a little different and Harrington said, 'Oh, Julian, I know what that means!' " Maria paused, sad for a moment at the memory of her husband after her delight in telling her story. "And now today only five villages speak Tewa and one Hopi-Tewa village, Hano they call it. Only six villages in the whole world can understand each other."

Maria returns to the men who excavated the ruins in Frijoles Canyon and the pottery they found. And she remembers that an old Santa Clara man, Santiago Naranjo, "a friend of Dr. Hewett's," cooked for the men. After they finished the Frijoles dig they started at Puye. There they found a quantity of historic Frijoles pottery. These were complete pots, not pieces. Maria and Julian also worked on the excavations, Maria dusting pots as they came from the dig.

"It was black pottery, not good black, poor black. And there were polychrome pieces too. It wasn't all black."

Maria said she could make the forms Dr. Hewett asked her to make, according to the way she thought the shards would have looked before they were broken. But she did not know how to make the clay black. However, Julian, after some experimentation, which included smothering and smoking the fire surrounding the pottery, was able to produce black ware. These first pots they fired, probably in 1910, were undecorated and not thought of as anything but the answer to Hewett's request. A few examples of these are in museum collections today. Unsigned, but attributed to Maria

and Julian, they show experimental polishing marks and a rugged, spontaneous quality not found in the later refinements.

After the first few bonfirings, Maria hid the black test pots and did not show them to visitors because she felt they were not true San Ildefonso pottery and was very wary of their acceptance as such. But Dr. Hewett brought some museum people to San Ildefonso, who accidentally saw the coal-black pots on a back shelf. They exclaimed over their beauty and the glowing surface sheen.

Originally Maria and Julian's black pots had no decoration and were only for Dr. Hewett's experiment (Pls. 300, 301). Now they received real encouragement, and experiments continued. However, it was not until 1918 that the first decorated black ware, painted by Julian, was made and fired. These initial pieces had matt backgrounds with polished *avanyu* designs (Pls. 259, 299). The *avanyu* is the horned water serpent, which Julian interpreted as the first rush of water coming down an arroyo after a thunderstorm, a symbol of thanksgiving for water and rain. Through Julian the *avanyu* became a common motif in the Southwest, almost with the qualities of a mascot. Barbara has told me that there are always four humps on Julian's water serpent.

Two black pots that supposedly are from the first firing of decorated black-on-black wares in 1918 (Pl. 299) are now in the collection of the Museum of New Mexico's Laboratory of Anthropology at Santa Fe. Maria says that it was very difficult to burnish a design while leaving the rest of the background unpolished. Experiment followed experiment, and after a few more firings, the background and design effects were reversed. The first treatment showed matt background surfaces for highly polished designs. Now the whole background was polished first and the matt decoration was painted on. This is the style famous today.

There is a type of black pottery made in old Mexico now, and historically there are examples of black ware from a variety of villages in Africa, India, and South America. However, most examples of these wares do not have a highly burnished surface; the clay generally has been scraped with a tool and wiped with a rag preparatory to firing in dung. This results in a sheen quite different from the San Ildefonso burnished effect.

Maria's black pots were much finer, more highly polished, and blacker than the shards from the excavation, and they became more refined as she continued to prac-

tice. In addition to perfecting the polishing, Maria paid attention to quality of line and form with unusual dedication. She also struggled to make larger pots and became highly skilled with big forms, perfecting symmetry without a wheel.

The Indian peoples of both North and South America never developed the potter's wheel. Yet the diverse New World cultures and civilizations have produced some of the world's most beautiful and refined pottery. Even today the Indian potter prefers to coil rather than throw.

To make thin-walled pots of perfect symmetry by coiling alone is a major accomplishment. I know the difficult clay the Martinez family uses. No modern studio potter, with access to supply house catalogs, would dream of working with such stuff. Yet Maria coiled monumental pots, thin and perfect, with this material.

Western ideas of mastery over materials do not apply. The pueblo potter has a true understanding, a harmony with his materials. Europe may have had this once, but no longer does. The Indian people are still making pottery in their own way—their intuition for their materials is still alive.

Maria perfected her burnishing technique so that the surface was absolutely unblemished, with no strokes showing. She and Julian kept experimenting with the firing to get the most intense black and the highest shine. And Julian continued to decorate. The black-on-black ware, as it was eventually called, was made by painting designs in a refractory clay slip after the pot was polished, and then smothering the fire with manure to carbonize the clay black. But it was the silvery black color, with or without the matt patterns on the pots, that brought the worldwide distinction the Martinez family has today.

Family is of great importance. As early as 1920, Maria and Julian began to be sought out for their black pottery, and there was more work than they could do alone. So it became necessary for members of the family to help make the ware, which, until now was their own secret technique.

Maria also was aware that the pottery and the financial success of the Martinezes were not so well accepted by the rest of the pueblo. She asked Julian for permission to show anyone at San Ildefonso who wished to know how to make and fire the black ware, and she encouraged the selling of pots made by other women of the pueblo.

Her inspiration and constant enthusiasm spread. Maria and Julian's inventiveness and sharing helped keep the art alive.

Maria remembers that in her childhood she had seen another kind of black pottery. "Those Santa Clara Indians always knew how to fire black—long before we discovered how to do it. But theirs was not the same exactly. At home in those days, we only made red, white, and black polychrome, or white with black, or red with black painting. When I was just a little girl, I was a baby sitter at Santa Clara pueblo sometimes. I liked to watch them make pots over there. They made ollas for water and kitchen, which they fired black, but nobody polished the way we do. I never saw anybody polish clay the way we do. We get better and better! Ours is so smooth. Our clay is very fine. Santa Clara clay is more sandy. Still it is our long, hard polish—we work very hard—that makes ours so pretty."

Maria has been speaking of the ware that has been made at nearby Santa Clara pueblo since the nineteenth century and is sometimes confused with the pottery of San Ildefonso. Traditionally the Santa Clara black pots are without painted decoration, having, rather, carved surface patterns or pressed-in designs, the most familiar one being the "bear claw." Santa Clara is a pueblo with a large population and many potters, comparatively speaking. In deference to Maria and Julian, it is said that the Santa Clara artists did not make matt-painted black pottery for many years, although today some do.

Maria smiles and remembers another link in the black pottery story. After she and Julian were well known for their dung-fired ware, she was taken to Oaxaca to meet Rosa, one of Mexico's most famous folk potters.

"Her pottery is black, but funny, her clay is also black," Maria said, with a note of astonishment in her high voice. "It's strange. That Rosa just uses a rag for polishing, no stone, as we do. I spoke Spanish to her, and she didn't think I was Indian."

I suggested to Maria that the reason Rosa's clay looked black was probably that it had natural carbonaceous, decomposed organic material in it. This black color would burn out in an ordinary fire because it would oxidize. But the clay would stay black if Rosa smothered the fire, which of course she did.

Maria told me that she showed Rosa how to use a stone instead of a cloth for polish-

ing. It is a technique requiring great skill. Maria showed her how to hold a round stone so that only a small point of it touched the surface of the pot. Several years later Maria saw some pottery that Rosa had done, using a stone for burnishing.

"But it wasn't so good," Maria said. "Because Rosa didn't have the patience to polish like we do. My sister Clara has, oh, so much patience for polishing," Maria sighed. "That Rosa said to me once, 'I wish I could visit you at your home.' But she knew she couldn't." Maria reflects on this. Then her eyes light up. "I'm lucky! People take me all around. I go to so many places, a long time. I travel many years."

The people of the Basket Maker culture (100–500 A.D.) made the first fixed, adobe dwellings in the Southwest. They may also have daubed baskets with clay to make them watertight and dried them in the sun. Scholars agree that true pueblo pottery probably emerged in what is called the Modified Basket Maker period, 500–700 A.D. This ware was undecorated, being mainly cooking vessels. After about 700, the first decorated pots—black designs on a white ground—appeared; polychrome wares were made after the twelfth century. From her own experience, Maria says that cooking pots were not decorated "because that clay has mica in it and it shines anyway."

Indians in the Southwest have been painting pottery for over a thousand years. Maria and Julian studied and adapted from designs they saw on the ancient vessels at the museum, from remote pueblos including those of the Hopi in Arizona. Dr. Hewett suggested they use only indigenous designs from the Tewa ruins at Puye and Otowi, where their ancestors had lived.

Maria and Julian accepted the suggestion. They built their forms and decorations on the basis of the art of their own people, adding some embellishments from the nearby pueblos as they researched. Some of the old stylized patterns are thought to be mountains, clouds, rain falling both near and far away, lightning, birds, feathers, leaves, seeds, pods, tracks of roadrunners, and mythical symbols such as the water serpent. Santana makes a series of upward zigzags, which she calls kiva steps. Although one can see symbolism in the pottery designs, the names the Indians give to the patterns are primarily for the non-Indians who ask for meanings. The meanings the designs really have to the people who paint them probably remain undisclosed.

The ancient pots that formed the background against which the potters of San Ildefonso worked are among the finest and most spectacular made by any culture anywhere in the world. The shapes were for domestic or ceremonial use: storage jars, water jugs, bowls of various shapes, and lidded vessels. If not left plain, they were colored with rust-orange, brown, and black paintings on a white ground. More understated wares had black drawings on cream-colored clay, or black designs on a burnished red background. I have never seen any two pieces painted exactly alike.

Pottery processes over the centuries remain the same. But it is the discovery of new clays or pigments of surpassing excellence or the innovations of such potters as the Martinez family that cause the striking mutations over history.

What we have come to term "folk art" does not involve the making of a major, original piece of some kind each time. Rather, it is a continuous process of repetitions, the permutations appearing like the branches of the same tree.

The power of Maria and Julian's artistry allowed them to draw on their own heritage and, in effect, to create a tradition of their own. They have set high standards over a long period of time. Out of this came the refinement they have passed on, and the dedication. The development in the ware was, of course, partly commercial, but it could scarcely have taken place as it did without artistic development among the Indians themselves. Nor could it have brought about such fine results without the inspiring example of exceptionally gifted leaders.

In San Ildefonso, polychrome pottery was dominant from the late 1880s through the next thirty years, and this ware is what Maria made at first. A red clay was used for the body of the pot, different from the one used now for black-fired wares, but mixed with the same ash. Over this, a white clay slip was applied and polished. The white clay occurred in lumps and had to be ground, soaked, and screened. The very low humidity of the high desert country allows a strong bond between different clays.

Cochiti slip is the familiar name of one of the white clays used for this purpose. Maria says this does not mean that all white clay comes from the pueblo of Chochiti. The name merely describes a type of clay that is polished in a certain way. San Ildefonso has some light-colored clays too.

"You can't touch the white clay when it is on the red body for polychrome," Maria states, shaking her head. "Fingerprints show. And this makes it so hard to decorate and so hard to take care of before the fire. It happens with the clay we use now for black pots, but not as bad."

In those days Julian used a variety of iron-bearing red clays for painting the polychrome vessels, so there might be several rust and brown hues on a finished pot. The rich black decorations and outlines on San Ildefonso polychromes come from a special pigment. The Indians make it from the Rocky Mountain bee plant, a wild spinach they call *guaco* (Pl. 252). Large quantities of the young plants were gathered in July. After removal of the woody parts, they were boiled several times into a thick black residue. This syrup was poured into corn husks to harden, to keep indefinitely.

When it was needed for painting a pottery design, a black cake of *guaco* was moistened with water, like Japanese sumi ink. Not all pueblos developed the use of the boiled spinach plant for black pigment. For instance, the well-known pottery of Acoma pueblo uses a manganese-containing natural clay for black. And the bright orange-rust used at that pueblo comes from a clay San Ildefonso does not possess.

There are very few vegetable pigments known that have sufficient metallic oxide content to retain color after being subjected to the heat of firing. The use of this sort of material is rare in the annals of ceramic history.

When Julian began experimenting with painting matt designs on polished wares for black firing, he first used *guaco* because he was familiar with it in the polychrome painting. But juice burned out when used alone in the new type of firing. Finally he learned to mix *guaco* with clay, because clay was sticky and helped the bond as well as gave a thickness to the painting. Eventually this mixture was supplanted when he found a pure clay that was suitable by itself for the matt designs.

Along with the black ware, Maria and others in the pueblo continued to make polychrome pots of traditional design, but Maria and Julian less and less frequently. Maria produced many different shapes in polychrome—ollas, prayer meal boxes, bowls, and large storage jars. Julian decorated most of Maria's pieces, but her sisters Juanita and Maximiliana and the latter's husband Crecencio and son Alfredo also painted some of her work. Polychrome pots were made primarily for ceremonial use; ordinary

cooking pots were unpolished and undecorated. The first, experimental black pieces were also undecorated; their discovery on Maria's back shelf was fortuitous.

"And it is easy to understand why they all like it," Maria says, smiling. "People think that black goes with everything."

Maria and Julian also discovered that black wares were easier to do than polychrome pottery. The black decorated pieces were generally conceived as tourist items and not as ceremonial or utility pieces for use at the pueblo. Yet this work never lost its integrity as Pueblo Indian pottery, even when nontraditional shapes such as vases (Pl. 306) were made to please visitors or to fill orders. This same integrity is seen today in the work of the youngest Martinez family potters, with their adventurous and wide-ranging experimentation.

Neither the oxidizing nor the reducing fire make pueblo pots watertight. The bonfire temperature is not sufficient to produce a dense and vitreous clay body. The body remains porous, and pots will not hold water for any length of time.

After working for thirty years with mirrorlike surfaces and carbonized clay, Maria experimented with polychrome again in the 1950s. This time it was decorated in stylized patterns by her son Popovi Da. She also revived polished "red-on-red" wares, which were decorated in the same era by Santana and oxidation fired.

Visitors came from everywhere to see and admire and buy the extraordinary black pottery. Maria also went outside the pueblo to sell pots. Today her great-grand-daughter Barbara Gonzales has childhood memories of going with Maria to the plaza in Santa Fe and to the railroad station in Albuquerque to sell black pots. Barbara also sold picture postcards of Maria. Soon she was accompanying Maria wherever her great-grandmother was demonstrating.

"For the big polychrome pots we used to make," says Maria, putting her hand out flat, three feet above the floor, "if I was lucky I got maybe $10.00. Pots like for one [to carry] on your head maybe $1.50, and they were all decorated. Now that I'm not making pottery like that, they cost a whole lot!" And she waves her hands in a fly-away gesture and raises her voice high. "When I made the big pots I would sit outside and people would be very lucky if they would come by when I was doing that."

Julian was a fine artist, and Maria was always very proud of him. She knows that it

was probably difficult for him to choose between painting or decorating pots. His painting and graphics hang in major American museums that have Indian collections. But he is best known for the designs on Maria's pots. His variety of decoration, his symbols, geometric designs, and representational scenes filled with inventive flourishes and embellishments are a delight to study and serve as a continuous source of inspiration to the other potters of the family.

Julian was the painter, but Maria was an exceptional potter. By 1915 she had surpassed all other potters in skill. She could make three pots while other women made one, each pot perfect in execution.

Probably a great deal of the innovation in the black pottery development was due to her creative attitude, although she always credits her husband. Today she says she never painted pots, but according to early reports, she did. Maria apparently yielded those skills to Julian and others in order to involve them more in the craft.

No early polychrome, and even the earliest undecorated black ware pots, were signed prior to firing. There is no reason to sign a ceremonial or utility pot; pueblo pots were never signed until signatures were demanded by the purchasers. Actually, signatures were suggested to Maria in the mid 1920s by Chester Faris, director of the Indian school in Santa Fe, and by Kenneth Chapman. The decorated black ware had begun to have commercial value. Still, Maria did not always sign her pottery.

Her first signature was "Marie," because Mr. Faris suggested it was a name more familiar to the Anglo public. About three decades later, she changed this to "Maria." For over half a century she has used the following assortment of signatures: Marie; Marie Poveka (spelled in several ways); Marie/Julian; Marie/Santana and Maria/Santana; Maria/Popovi Da; Maria Povèka (the most recent signature). Maria's name always appears above the decorator's name, and the two names are separated by a line.

Attempts have been made to order these signatures into a clear sequence and also to assign stylistic periods to Maria's pots. I have not been able to find clear dates when one signature stopped and another began; there seem to be many opinions, among both the Indians and among specialists. The "Marie" signature in all combinations seems to have been used up until the fifties. Some family members think it was Popovi Da who convinced her to change her name from "Marie" to "Maria" in about 1954.

Santana's name first appears with Maria's (Marie/Santana) after Julian's death in 1943. Maria worked with Popovi Da mainly in the fifties and sixties. Undecorated pots are signed only "Marie" until 1943; thereafter, the signature is "Maria Povèka."

A stylistic progression can be found in both the polychrome and black decorated wares. This is intangible and needs much experience with the pots in order to see it. Maria's potting always was and is superb; the decorations tend to develop along with the virtuousity of the painter from soft, rather spontaneous flowing patterns to sharper-edged, more consciously conceived and crystalline designs. Only the taste of the beholder determines which is better.

Maria attaches no particular value to her signature. She is happy to sign in pencil or felt pen any pot that might have been made by her. There is, of course, no way to really authenticate any of the originally unsigned pieces, but one can learn to distinguish the hand of certain decorators. Julian's painting was free in feeling and expertly done, with a high-spirited elegance. Maria's sister Maximiliana's painting has more abandon, and one can make a similar analysis of all the painters of Maria's pots.

Maria enjoys, as do Santana and Adam, being taken to museum storage rooms to look at the many old unsigned pots in the collections. They can generally pick out the pottery of their own pueblo, although not always the name of the potter or decorator.

When a person like Maria has lived so long, worked so hard, and accomplished so much, it is asking a great deal to expect her to identify all the thousands of pots she has done. No doubt there are "Marias" that still go unidentified and other pots she did not make that are attributed to her. Maria herself has been in the habit of crediting everyone in the same breath as herself.

Casualness about origin is a familiar aspect of folk art everywhere. The concept of a signature occurs when a craft leaves the true communal formula and objects are given connoisseur value not related to their original utility. Today pueblo pottery has become an art form executed by artists whose names are known, although they remain in their communal society and still practice its principles. Maria delightfully and wisely mixes both the communal and the "name artist" attitudes.

That the price of pots goes up according to who says what, enlivens interest. A practiced eye can discern a piece's age and maker, if it matters. On recent visits to

museums, I have found old pots signed by Maria that may not be Maria's work or Julian's painting, but Maria wishes to help all Indian pottery along. When I first came to know Maria, I would not have known whose pot was whose; now there are certain ways by which I think I can tell. But my final realization is that we can appreciate the beauty of a piece whether or not we know who made it.

Today five generations of Maria's family make pottery. Maria; Santana and Adam; their daughter Anita Pino Martinez; Pauline, their daughter-in-law, and Beverly, represent three generations. In the fourth generation are Maria's great-granddaughters, Barbara, Sylvia, and Evelyn, daughters of Anita P. Martinez; and teenage Rachel, the daughter of Frank and granddaughter of Santana and Adam. Then there is Marvin, Maria's great-grandson, who is the son of Sunset, Santana and Adam's daughter. Marvin has lived part of his years with Maria, Adam, and Santana; he travels with them, and dances to Adam's drum in the ritual tradition his grandfather has taught him. In the fifth generation are Cavan and Aaron Gonzales, Barbara's young children who make small animals in childlike fashion. All these family members work on pottery at least some of the time in the Maria-Julian polished black-fired tradition.

Beyond this initial tradition, but from its core, is another kind of black pottery. Gaining wide recognition and respect for their innovative claywork are two exceptional young people of approximately parallel age but of different Martinez generations. One is Tony Da, Maria's grandson, son of Popovi Da, and the other is her great-granddaughter Barbara Gonzales.

This genealogy of potters is a lineage with similar counterparts among Indian families in other pueblos. But the artists of the Maria Martinez family have worked in more diverse, although related, styles. Maria herself has been a special person, able to make a unique contribution and to become a symbol for all Indians. She has helped members of her family and of the pueblo to develop individual images, receive recognition, and in some cases to earn international reputations.

It has been the work of her life.

The Corn-Silk-Women's Song

Ones of the Northern Lake
Corn-Silk-Women ye are,
And now ye come to us.

Then lay long life at once upon us,
And upon our children
The love of all the gods!

May our children have many children
And our girls live long!

And now we seek to hear
The Corn-Silk-Women say
Such words as we have said!

Long life now we ask,
And to be loved,
And to rear many children,
And to be given kindly fates!

Maria and Santana

Today is the day of the ceremonial Corn Dance, an event that brings the entire pueblo together, including the Martinez family—from Maria to the smallest children, such as Barbara Gonzales's little boys, Cavan and Aaron, who are old enough at the ages of seven and five to take part in the dances. There are also some toddlers wandering about, in costume, and if they are boys, with body paint like their elders. The long ceremonial begins at dawn and will continue through the late afternoon.

Maria and I sit on Santana's porch, facing the plaza where the dancers will perform, glimpsing the hills beyond. Clara, Santana, and Santana's sisters Mella and Lupita are also with us. Maria is deeply pleased with her large, loyal family and also with the air of festivity. She hums and taps her foot in anticipation of the drone of the chants and the thrumming beat of the drum. She says she has always loved the songs and the dances ever since she can remember.

Today's Corn Dance and other pueblo dances can be held nearly any time, according to the tribal council's decision, but Maria tells me that there is one dance that must occur on a certain day.

"On January the twenty-third we have to have a dance. Rain or shine, we do. The patron saint for the pueblo is San Alfonso. The other important ceremonial days are at Easter, Christmas with Spanish guitars, and June and September."

Today Maria is dressed in her own breathtaking mixture of flamboyant colors and traditional Indian ceremonial dignity. Her manta is a bright red cotton print, one of her favorite colors. Beneath this she wears a brilliant lime-green blouse with full, eyelet-trimmed bell sleeves flaring wide at her wrists. In usual Indian style, this blouse would be short, but Maria wears it boot-length, so that it sometimes shows beneath the sleeveless manta, which is fastened over one shoulder. Falling softly in great folds, the whole costume is tied with a wide Hopi belt wrapped around her waist. She wears

an old silver squash blossom necklace with small turquoise stones and she clutches the corners of a fringed purple shawl, printed with red and yellow flowers, draped over her shoulders and nearly covering the dress. Shawls are mementos for Maria, gifts from friends and admirers, reminders of long-ago times and places and previous grand occasions. She changes shawls more often than gowns.

The colors she puts together are most often pinks or magentas with green and various blues. On special occasions such as this one, she wears the white buckskin boots that Julian designed for her some thirty years ago; her everyday moccasins are brown. The women of Maria's family can all dress in this way, but they seldom do. It is one of the tensions, one of the stresses between the old people keeping the old ways and the young people rejecting these ways.

This Corn Dance brings a lot of people together, including members of the pueblo who work outside and some who also live outside the pueblo. Maria's own immediate family is impressive: her sister Clara and another sister Desideria; Santana and Adam and their numerous sons, daughters, daughters- and sons-in-law and offspring—their son George and his wife Pauline and their two boys; Stephen and Adam; Julian (namesake of Adam's father) and Mary with four children; Frank and Annie with four children; Edward and Virginia with three children; daughter Sunset and her husband Johnny Cruz and their sons, Johnny Junior and Marvin; Anita Pino Martinez, who has eight children, six of them married, five with children of their own; and Anita's sisters, Mary Daisy, who is a reserve captain in the United States Air Force, and Beverly. All of Santana and Adam's sons are working at Santa Fe or Los Alamos but live here in the pueblo and participate fully in the affairs of the Indian community. Santana's sisters Mella and Lupita are here; as well as a few of the children of Maria's late sons Juan Diego and Popovi Da, and Barbara Gonzales' family. In addition there are cousins, aunts and uncles, and in-laws of all, and a few visiting friends.

The preparation of food for the ceremonial dances is similar to that for any big Indian feast, such as a wedding. Families freeze as much as ten bushels of chili peppers at a time to be used on these occasions, and perhaps a cow is butchered. A great deal of red chili with pork and beef will be prepared, and potatoes, pies, and cakes. Everything is set out in bowls, and all who are there will eat.

Part of the ritual is the baking of bread in the big round adobe ovens outside of each house. Several mornings prior to this dance Santana and Adam were up at 4:00 A.M. to prepare the dough for the bread. Twenty-five pounds of flour (white mixed with some whole wheat), eight packages of dry yeast, two pounds of lard, salt, and water were laboriously mixed and kneaded and set aside to rise. While they were working the dough I asked how many loaves it would make. Santana said she did not know, maybe thirty to forty loaves.

"I never count, that's not our way, to count," she stated flatly.

"Only Anglos count," Adam said, grinning.

The dough was rekneaded and shaped in pans to rise again. Santana says they really like the bread best when it is baked right on the floor of the oven, as they used to do, but pans are easier now.

From dawn until midmorning, the round adobe bread oven was warmed to the desired temperature by slowly burning a pile of wood inside. This dries out the oven and forms a bed of coals. The oven entrance is sealed with burlap and a wide board and held tight with a wooden paddle.

When the oven was hot enough, Adam scraped out the fiery coals. Santana brought out the forty or so bread pans and quickly set them inside on the hot floor. The opening was closed again with the board and paddle.

The residual heat in the oven bakes the bread. It was still early morning. During this time we all relaxed in the kitchen with strong coffee. Mella, Santana's sister, who helped in this process, told me that the bread in each pueblo has a different flavor.

"If you're around here long enough, you can tell whose bread you are eating. Each pueblo bread has a different flavor. I don't know how they do it, but they do. It's just like the way people dress, too. You know right off where they're from by how they dress. It's the same with the hair style. The way Maria dresses is Tewa style. For each pueblo, somehow there is something different with clothing and food, so you can tell. Maria's boots, the white ones that Julian made, they are something like Taos boots. But take a good look and you'll see the difference."

Santana checks the oven once, and in about an hour—Anglo time—she, Adam, and

Mella take down the door and with the wooden paddle take out the pans and dump the loaves into tubs. The hot golden brown bread has a delicious aroma, but all the loaves are saved to be used at the feast. Depending on the occasion, this process is repeated two or three times, in twenty-five-pound batches of dough. The bread is wrapped and stored in a cool place, and on the day of the dance, in addition to the loaves eaten some will be given away as gifts. Once these ovens, said to have been introduced by the Spanish, were used to bake the daily bread of the pueblo, but now they are used only for special occasions.

Women prepare the food and participate in the dance, but men are clearly the leaders. The life of the pueblo is impossible for outsiders to truly understand. It is wound around and through the ceremonies of dance. Days before each ritual, there are practice sessions for learning the songs and dances and their meaning. Repetition is part of this learning; the experience gains depth with each ceremony, each dance enhancing the previous years' and setting the stage for the ones to come.

It is said that Pueblo Indian dances are among the only indigenous dance-art forms of consequence in America. Maria has told me about their dances. The Eagle Dance on King's Day; the Corn Dance, performed in the spring and fall, offering prayers for rain, fertility, and abundant crops; and the Buffalo-Deer and Comanche dances, done alternately each January 23, are the most important ceremonials at San Ildefonso. Nearly everyone in the pueblo participates, including the youngest children. Some dances are repeated during the year. In the week before the ceremony day, everyone in the pueblo practices his or her role.

"We all go to meetings before the ceremonial," Maria says. "Long meetings. I go, too, sometimes. But I don't talk so much these times, just listen. Other ladies talk, younger ladies."

For the Corn Dance today Adam has repaired and painted the traditional headdresses of the women and girls, the colorful, terraced, cloud-patterned vertical crowns called *tablitas*. For many years Adam has been the one to fulfill the artistic and functional needs of costume for the north plaza. He has made shell belts, shell chest pieces, and bells for the anklets. When he can, he collects yellow, orange, and green parrot feathers and any others he can find for the tall standards, for male dancers to wear in

their hair, and for various dancers to hold in bunches in their hands. He hunts for Mexican dark olive shells, which he uses for making headbands for the men. Today at the ceremonial he is instructing and supervising in the kiva.

This ceremonial building is adjacent to Adam's house; its doorway on the second floor is reached by a flight of wide wooden steps. The round kiva on the south side of the San Ildefonso plaza is not in use today.

Adam emerges from the kiva. He is dressed in a lavender shirt made with a full yoke and with full sleeves caught in a tight cuff. He has his mother's sense of color and style. His shirts are often made by Santana or her sister Mella. Adam has tied a short orange scarf at his neck, and blue yarn in his braids. His beaded moccasins, made by Minnesota Indians, are worn for the dance, and the middle of his body is wrapped in a thigh-length kilt, pueblo style.

When I see Adam in this costume at the Idyllwild School of Music and Arts it means he is going to play his rawhide drum and sing Indian songs in his stirring deep voice, and that his grandson Marvin, dressed in the Eagle costume, will dance. Today Adam is not dancing or playing the drum. His son Edward is leading the dance, and another son, Julian, has the honored position of drummer. In fact, all of his sons and their wives are dancing and most of their children.

Young ones are costumed exactly like the adults. Boys and men wear woven white kilts embroidered with cloud and rain symbols tied at the waist with a tassled white sash. They dance in boots, and each wears a fox pelt tied in back of the belt, symbol of man's common ancestry with animals. Girls and women wear a black manta, tied with a red and green Hopi-style sash; they dance barefooted all day. The hair of the women falls free, symbolic of the long wisps of summer rain that sweep over the land, and each one carries evergreen boughs as a symbol of everlasting life.

The dances continue throughout the day in stylized control, with intense impact. All dancers move as one, a whole people synchronized in a massive statement. The beat of the drum is steady and thrilling; the clatter of gourd rattles symbolizes the sound of falling rain; and the chanting chorus of male voices is a constant sound. There are probably two hundred dancers. At times I am conscious of a subtle change in the rhythm of the drum and the movements of the dance. It is an unreal spectacle,

one of fascination and delight for those of us who are visiting. For the Indians the dancing and music are filled with special meaning.

Maria, sitting on the porch, listens raptly. I am reminded of the times at Idyllwild, with Adam playing the drum and Marvin dancing. Maria, thrusting her chin up, would sing out in her high voice, tapping her moccasin boot hard. As mother and son chanted rhythms and words, Santana often joined in quietly. Occasionally Santana and Clara would do a women's dance. I am a bit nostalgic for the warmth of those times, when I felt a sense of participation rather than the awe of this spectacle.

There are a few empty chairs on the big covered porch of Santana's house, where Maria and I sit. Most of the family and friends who arrive at the ceremonial pause on this porch to greet her while the dances go on. Maria seems to accept an almost regal role among her people, from respect due to age and experience, if for no other reason, and she handles it casually with outsiders as well. She is perfectly at ease as she tells me about the famous people she has met or those who have come to visit her over the years. Each memory is sharp, and she goes straight to the point of each reminiscence with childlike candor.

"Rich people are very funny," she says, with a chuckle. "Long time ago that Rockefeller came to San Ildefonso. Mr. Chapman brought him to see me. Mr. Chapman said, 'Maria, go ahead and bring those nice pieces that you have. This man has lots of money.' But when he chooses his pots he counts his money and it is $8.00 short. I told him and he gave it to me. Mr. Rockefeller had a young boy with him, same size as Marvin now, about twelve years old; and that boy came later when he was married, and he said, 'I still remember what you said to my father.'" Maria laughs again at the memory she has relived.

"I meet many people, movie stars, very nice people. They do nice things. They took me to Hollywood! Long time ago they made movies here. They bring Santa Clara and Santo Domingo Indian people, too. We were all in it. They made *Texas Ranger* here and other movies, and there were Joseph Cotten, Linda Darnell, Greer Garson, Cornell Wilde. Oh, so many! They had a big crowd of people, and they built the gate by the church to make everything look like the old way."

<div align="center">※※※※</div>

Some of these stories I have heard her tell over and over to students and visitors, new acquaintances in our summer workshops at Idyllwild. Many Indians of Maria's generation have spent all their lives on their pueblo or not far from it, but Maria has traveled over most of America and been part of every world's fair, starting with St. Louis in 1904.

"Julian and I spent our honeymoon there that summer," she smiles. "And New York World's Fair. I don't know what year, but there in New York, Santana's brother Awa Tsireh took a prize in painting. Oh, oh, we were in fairs in Chicago, San Francisco, Columbus, Ohio. . . . If I only know how to write I would put the dates on."

If the dancers and the chorus are feeling tired and hot, they do not show it. But I know from previous experience that there are certain programmed rest periods in the dances. I am again aware of a subtle shift in rhythm. Maria nods her head, her right foot tapping the porch floor slightly, and continues with her memories. World's fairs, although she admits that she suffered considerable homesickness during some of them, were her way into the outside world, a world that most of her contemporaries could never explore.

"At the Golden Gate fair we stayed at Yuerba Buena Island. I had a picture of the redwood tree and me standing in that big tree, but I lost it somewhere. One of the nicest fairs was San Diego. It was in 1915 and we went back again in 1916 and stayed all year."

"No homesickness?"

"No. Dr. Hewett and his boys built a big pueblo. It was an Indian village—oh, a big size pueblo—Tewa, Hopi, Navajo, Taos, and Acoma. They even built a round kiva like at home. So we stayed like home there, about six families from San Ildefonso and the other pueblos. People came to watch, and we danced. You know how I like that! There is where I met that Geronimo, the fierce Apache. He was already old, a big man. We talked in Spanish, because we didn't know each other's Indian. He showed me his broken bone in his neck, and many scars."

Several visitors climb the porch steps and greet Maria, who finds no trouble switching from past memories to the present moment's courtesies and, after her visitors have left the porch, returning to the past.

109

"When I was in Chicago that Indian Fire Council gave me the award, the second one. A man won the first one. I have the picture. This was for a perfect round pot. My pot was thirty-two inches around and they told me it was absolutely a perfect circle but I got the second prize."

I ask Maria if they always made pots at the fairs.

"Yes, if we had a place. But it was polychrome, we didn't make black." She says it made no difference to her if they made pots or not; she just loved to sing and dance. "And we always do that!"

As if the singing and dancing were not all that was important, even though they seemed to be her most outstanding memories, I remind her that it was partly through all those appearances that she became famous. She shrugs her thin shoulders and looks at me wide-eyed.

"Well, yes! There was a man from Germany and he took a picture of my hands, and he said they have some of Julian's and my pottery in their museum. Also in France they have our pottery in a museum. So they send me an award from France. That was not lately. It was in 1915 or so. But just lately—when was it?—the French ambassador came to visit me. He brought me a medal, here at home." One never knows, listening to Maria, whether the slight pause in her conversation will mean her thoughts will span a country, a continent, an ocean, or more than half a century of time. It is her life.

"When they built the Golden Gate Bridge in San Francisco, I was there. And in Berkeley when they built the colosseum I was there. And I go to New York to place the cornerstone for that Rockefeller Center, that same Rockefeller who made the mistake of the $8.00!" She giggles, and her eyes glisten behind her thick glasses.

"The last time I was in Washington, D.C., they were building that airport, biggest in the country. And they took me out there and I put my hands on a big glass, for some kind of dedication. I stayed a week there with Mrs. Johnson. I have been there before with President Roosevelt. That time we were two from each pueblo, also Navajo, Apache, and, oh, a lot of other Indians. Julian, our son Juan Diego, and I went. In the White House they had like a potluck, how you call. But the best was Mrs. Roosevelt. She gave us a talk. I like her so much. She said, "Keep on the Indian way. Send

your children to school but keep your own way!" Maria's voice indicates that she will never forget Mrs. Roosevelt's words.

At certain predetermined intervals the dancers stop dancing and come toward us in line, two at a time. This happens now, and it is a cue. Santana, who has been sitting with us on the porch watching the dancing, goes inside her house to the kitchen. Maria rises from her chair and goes to stand at the edge of the porch.

She stands there alone, leaning against the wooden pole that supports the porch roof. She frees one hand and pulls her brilliantly patterned shawl around her, and watches intently the procession of dancers. The dancers move, two at a time with great dignity, up from the plaza toward the ladder that leads to the kiva. They face Maria as they pass. And at this moment there is a silent and special communication during which Maria's eyes meet the eyes of each one of the performers. Then, looking straight ahead and very serious, each dancer mounts the ladder, including the children who are participating in the ritual.

As the long line disappears into the kiva, the women who have been watching the dancing follow Santana into her kitchen and return with bowls of chili, bread, and *posole*, which are sent up the ladder into the sacred room. Adam has laughed many times at the amazement of tourists when they see all the people come out of the kiva, astonished that so many can fit into this unpretentious looking adobe. Because non-Indians are never allowed in the kiva, they are often unaware of the deep construction reputed to be under the ground of these ritual rooms. All we can see is the astonishing number of people ascend the steps and disappear into this small place, and experience an almost childlike amusement again as we watch them come out. I look around for Adam, who gets such delight watching the faces of tourists as they witness the great number of dancers disappear.

The plaza is quiet and the atmosphere on the porch is relaxed while the dancers remain inside the sacred adobe. Santana returns to the porch after supervising the platters of food that were brought to the dancers. The three of us—Maria, Santana, and I—sit next to each other on a board bench, our backs against the rough adobe wall. Maria seems grateful to be seated again, and as if there had been no interruption,

�](✹✹✹✹✹

continues what I now think of as her "memory talking," though I can tell from her voice that she is tired.

"It was on a trip to Georgia that something important happened for my son Juan Diego. Julian and I and Juan Diego met a military school superintendant. And this man asked if we would allow our son Juan Diego to go to his school there in Georgia. Julian and I discussed this together alone, but of course we could not make any decision."

Maria and Julian were not an indecisive couple, but obedient to Indian ritual and pueblo custom. Maria had to ask the tribal council. Finally, after due deliberation, the council agreed that young Juan Diego could go to school in Georgia. Later, when Juan went to Stanford University in California, she worried about his playing football. "I don't like him to play. And he says, 'Mama, I take care of myself.' And he did. He didn't get hurt."

She stops short here, as if to say more, but she does not continue. I have learned that Maria's grief over the family tragedies, at the eventual loss of this son and her other two sons, is never discussed, at least with outsiders. As far as I can understand it, this is the Indian way. There was one exception. Once Maria said to me that she did not know why all her boys "had to go so early."

Although I have had a close association with the Martinez family three summers in the California mountains and often at the pueblo, I am aware that a time such as this, watching the spectacle of the ceremony while sitting together and reminiscing here, in Maria's world, is a rare opportunity and beautiful experience. Maria's storytelling sees through to the core of things. I am struck by her grasp of the present, her belief in fate, her sense of humor, and the wisdom of her insight.

"Maria, did you ever go to Europe?" I ask.

"Oh, no, I'm scared of the ocean. To Denver, Clara and I flew twice. Minneapolis, too. It's so long in the train. I don't like to fly in the plane. But I don't look down, I just pray. Clara looks, but I don't."

Maria's beguiling innocence is most apparent when she pokes fun at herself. Today, for instance, Maria saw the Catholic priest from the pueblo church, holding the statue of the saint for today's ceremonial, seated across the plaza in the bower in front of

the cottonwood tree. This single glimpse of priest, statue, and Ildefonso's great old cottonwood reminded Maria of the time when she was at La Trobe Pa, a meeting place for the Catholic clergy. Maria went there with her son Popovi Da and his young daughter Joyce.

"One time in the morning we came out from the church. When I saw it, I knelt down and I started to say a prayer to this statue, and Joyce said, 'Grandma, get up! He is not a saint, he's just a man. He's just a man who used to own this place.' A sister who saw this came by and told me, 'It's a good thing you pray for him, because he is surely a saint in heaven now!' "

Santana turns to me and smiles at Maria's story. She has been quietly watching the dance.

Santana Roybal Martinez is a wonderful woman; she is steadfast, yet very different in personality from Maria. She has many roles in this large family, which she performs with great tact. Santana is the daughter-in-law of the famous Maria Martinez and an artist in her own right; she is the wife of the mischievous and staunch Adam with his practical jokes and knowledge of Indian tradition, the mother of eight children, and a mothering grandmother. She is now sixty-eight years old, healthy and jolly, with an oval face, brown eyes, and a quiet, warm smile. Her usual attire is bright cotton print dresses and aprons. Strangers also feel her basic warmth and sense her ability to take up where Maria left off. Naturally shy and reserved, she does not communicate with the same directness as Maria, whom she calls Mother and whom she respects also for her worldly experience. This shyness and reserve gives her great dignity. She and Adam have spent many years in the center of this story, the Martinez legend.

In folk traditions such as this one, where the potters have been women, the pottery craft and its secrets generally pass from mother to daughter or to some other young female relative in each generation. Each potter develops in her own way, but her wares will often resemble those of the person who taught her. Good potters develop as the product of long apprenticeship backed by tradition. In this case, it is Maria's daughter-in-law Santana who carries on what Maria and Julian began.

Santana turns to me. "The plaza used to be different. Once the houses were in a

square. Now it is one big open place. I know. I was born here in 1909, and I lived with my grandfather Santiago and my grandmother Dominguita in that old grandmother's house that you and I saw this morning." She is speaking of a small, very old adobe house with a sign stuck in the ground saying "Old Grandmother's House." It is indeed one of the oldest houses in the pueblo, but the sign must be there for tourists. Santana's sister Mella, the family seamstress and a librarian by vocation, sometimes sets up a shop in this house; or Barbara Gonzales uses it for a food-treat shop for children, giving the proceeds to the day school. Santana's grandparents' house is well used even now.

"In summer when I was a girl, we went to our summer house, where my grandfather did all his planting," Santana says. "Corn, beans, pumpkins, onions, tomatoes, melons, green chili, wheat, alfalfa, oats, barley. That's a big place." These crops are not grown on the pueblo now, but they are the staple foods of the diet, augmented with sugar, bacon, eggs, and a few canned goods. Fruits were and still are dried, to be used in winter for compotes or pies.

Santana's voice is soft and pensive. The words come slowly and deliberately. Little smiles cross her face as she sits quietly, remembering the past and trying to tell me about it.

The summer house she is describing was a cool building constructed by her family at the beginning of the summer and taken down at the end. It was similar to their house at the pueblo, but lighter in construction, situated in a fertile valley where there were trees and shade. The family went there to live when the weather in the sandy open pueblo became too hot.

"We would go in May when school was out, mainly to plant the fields. We always came back to the pueblo for the ceremonial dances, but just for that one day. Then we returned to the summer house. There was plenty of water then. I remember we used to go up to the mesa to plant, and we depended only on the rain for growing. We, the children, would help plant. Sometimes we got water from the arroyo. In September we would harvest; we carried lunch to the fields and stayed all day. We used to raise everything we needed in those days, and only went to Santa Fe once or twice a year!"

At harvest, women helped the men gather the corn, handpicking the ears and putting them in their aprons, then piling them in the wagon for the drive to the plaza, where they would be shucked. The pueblo plaza was swept before the corn was brought home. It is said that corn is the same as people and that the plaza must be clean so that the corn will be glad when it is brought in. Everyone shucked together, and the stalks in the field were cut down by the men and boys with stones and scythes. Seed corn for the next crop was kept unhusked until spring, when the kernels were sown. It was stored in pottery vessels. Corn husks were used for making tamales.

"My grandfather on my father's side, Diegito Roybal, was a weaver who made a lot of white sashes for the dances," Santana continues. "Now my sister Lupita makes white rain sashes for the ceremonials. My brother Alfonso, who in Indian was called Awa Tsireh, was a very good artist. When we say artist we mean painter. He became famous for his painting (Pls. 61–63) and also his silver. But he died young. My uncle Crecencio was also a famous painter of the pueblo." Santana is proud of her brother's accomplishments, and she fondles the two silver bracelets on her arm that he had made. Awa Tsireh's paintings are prized by collectors, and many now hang in museums. Reproductions of them are often found illustrating Indian books. None of the Martinez family possesses any of these large paintings. They only have the greeting card prints made and sold by the museums.

"I went to day school in the pueblo. We just had kindergarten to sixth grade. One year of elementary school I went to St. Catherine's in Santa Fe, but only for one year. I didn't like it. So I came home. After sixth grade, if you wanted more you went to the Santa Fe Indian School. We had to stay there until June, all year all the time. We only came home for the feast day for our patron saint on January the twenty-third.

"There were no cars then. They would go for us to Santa Fe in wagons, a whole day trip. I went to eighth grade there. It you go past that, you go to Shalaco in Oklahoma or to the Indian School in Riverside, California. I didn't do that because I didn't want to go away."

Santana speaks quietly of her marriage to Adam, fifty years ago last November 3, and of their courtship. Of Adam, she states, smiling, "I let him think a little while if he really cares for me." The "little while" was four years. But before her grand-

father passed away in 1924, he told Santana he liked Adam. In 1926 they were married.

Santana also remembers old Tewa songs.

I asked Julian, the namesake and grandson of Julian Martinez, to translate two of them for me.

A Morning Song

As the early morning comes
On Flower Mountain top the young Indian boys sing.
As the early morning comes
On the Flower Mountain top the young Indian girls sing.
Below in the valley in the willow trees
The male and female birds sing.
This brings the new day with happiness.

Santana says, "This song is about starting another day. Just one person would sing, as they did in the old days. Get up early and they would be singing. They don't do that anymore."

A Dance Song

Toward the North lightning strikes
 thunder sounds, rain falls, and fog settles.
Toward the West lightning strikes
 thunder sounds, rain falls, and fog settles.
This is the reason why we are happy and dancing.

Santana says, "Every dance song has to have north, south, east and west at the start of a song. Usually in summertime we dance for rain, so that's how we start the songs with the clouds and lightning, thunder and rain."

The dancers are still in the kiva, and I wonder again at Santana's artistic gifts, where and how she came to work with clay.

"Santana, when did you start making pottery?" I ask.

"My aunt Tonita Roybal made pottery. When I was little, I watched her; I never did try it myself, but I helped her polish. She died while I was too young to think

116

about pots. My mother, Alphoncita, made pottery, too. It was decorated by my brother Alfonso, who was called Awa Tsireh, the famous painter who won the prize. My mother died when I was in school. I only really learned pottery later, after Adam and I were married."

Just as Maria watched her aunt Nicolasa make pottery, so Santana watched her aunt Tonita Roybal. She was seventeen when she married Adam and became Maria's daughter-in-law.

"Tonita was my mother's sister, and Juan Cruz Roybal's wife. She was the same age as Maria; I remember her making polychrome, and polishing, and decorating. And Juan decorated, too. I didn't see Maria do pottery until I was married. I used to watch them do polychrome, but I never did it. Maria has wanted me to try lately and she says she will help me. I want to try, but I know it is very hard."

Santana has said that Maria was always busy making pottery, from morning to night, except for the times of the ceremonials. She did very little of the ordinary work of the house. Clara did that, because there was so much demand for the pots.

Of the old days, Santana says, "We would all make pottery for awhile, thirty to thirty-five pieces, then put them aside, and set a date for polishing. Everybody would come. And while we do that, Julian will be decorating. And while everything is being done, we'll be getting ready to fire, and then we don't do anything for maybe two weeks. We mostly make pots in summer, when it's warm."

"Julian decorated Maria's pots, and I helped polish," Santana continues. "We all work together. Julian was the first to do the *avanyu* decoration, that water serpent. It means that when there is a flood it goes like this," she says, making a wavy line with her hands. "And the tongue is the lightning. I think he got it from paintings on old pottery from the ruins. And he also got the eagle-feather pattern that we all use so much from old pottery. Julian was a real artist, a real painter. He used to fill little notebooks with ideas for designs—he carried it wherever he went. I still have one of them."

The dancing has begun again; again we hear the drum and the gourd rattle.

"I remember especially when Julian passed away in 1943. I finished decorating one big pot he had started, like the one they have now at the Fenn Galleries in Santa Fe."

Gazing out at the dancers, Santana fingers her shawl and remembers how Julian taught her to hold the yucca brush so still and straight and absolutely controlled in order to execute the perfect lines. She says that Julian's drawings were always different on the pots, and that he could just start painting anywhere and add onto any design. Santana has kept her painting simple, although she sometimes uses some of the ideas Julian developed, with slight changes. For instance, Santana makes three lines around a feather decoration; Julian made four.

The eagle feather and the *avanyu* are still the basic designs that Santana uses, embellished simply with her own decorative variations. Though Santana is the quiet one in the family, she has had powerful teachers: her aunt, her mother-in-law, and her late father-in-law, Julian. She can create a pot as Maria was once able to do, from the clay gathering to the firing. And she is still doing what she learned from Julian and Maria when she was Adam's young bride.

We are watching the young adults in the dance and the dozen or so very small children at the end of the line. These little ones keep their feet moving in the rhythm and maintain the pace most of the day. Santana says happily, "People are coming back to the pueblo to stay. Young people. Los Alamos is helping by giving jobs to our boys and girls, working in the labs there. Only our Indians can live at San Ildefonso pueblo, but Spanish do live on the reservation."

Pottery holds the pueblo together economically. The ceremonials unite the community with tradition. But my observations indicate that life is hard in the Indian way.

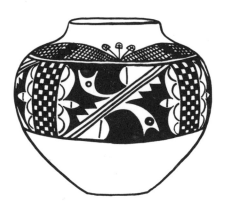

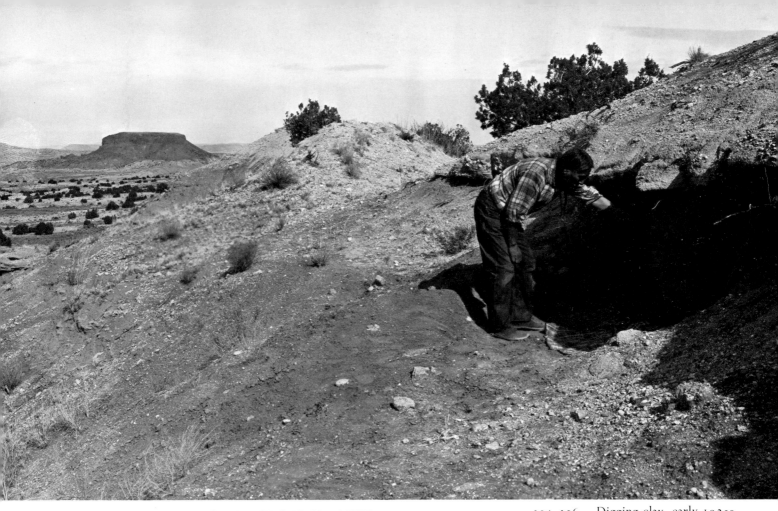

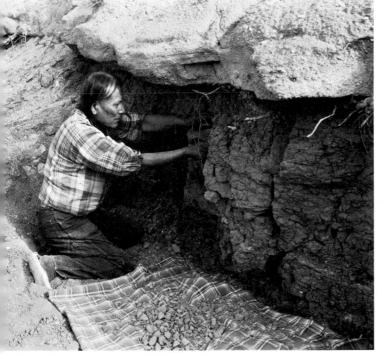

104–106. Digging clay, early 1920s.

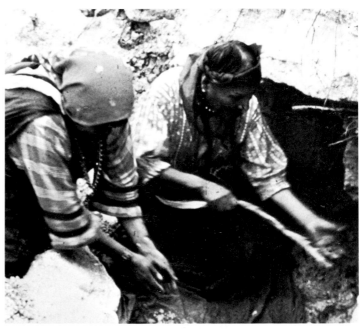

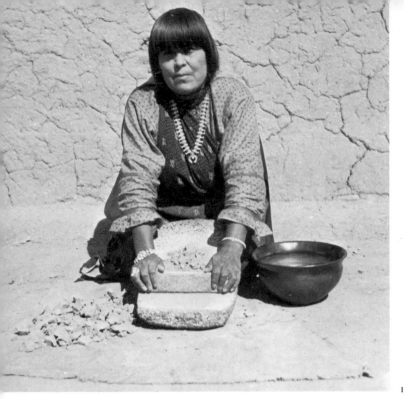

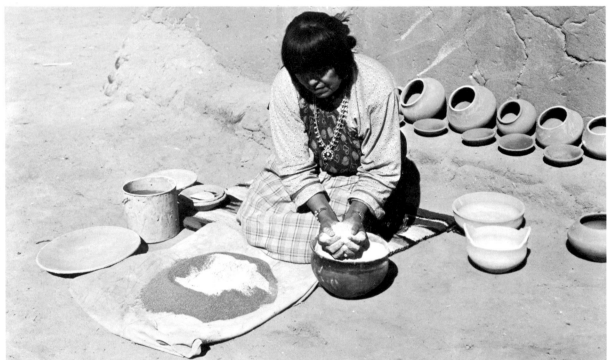

107–109. Grinding clay; adding volcanic ash and water, 1930s.

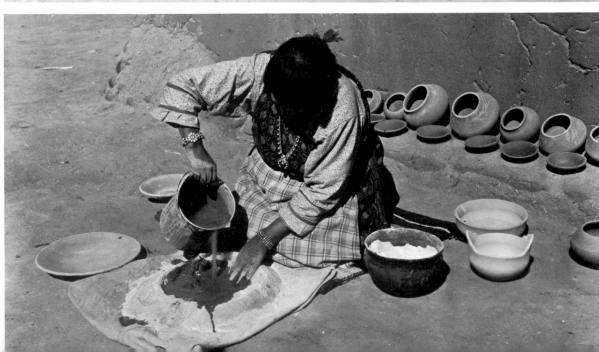

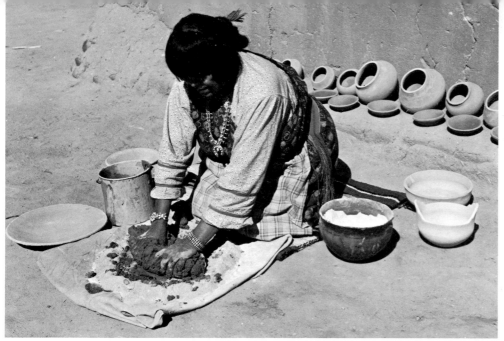

110–112. Kneading; preparing a clay pancake to fit into the *puki*.

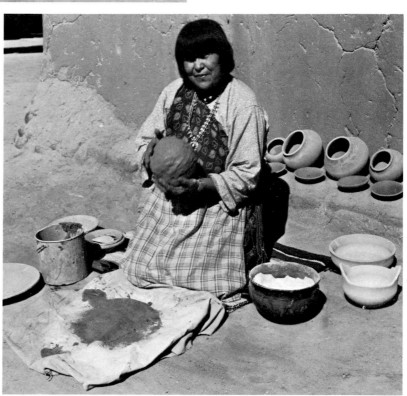

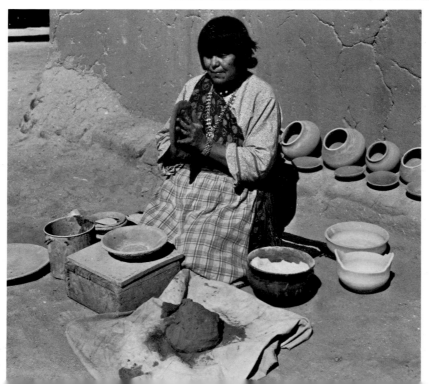

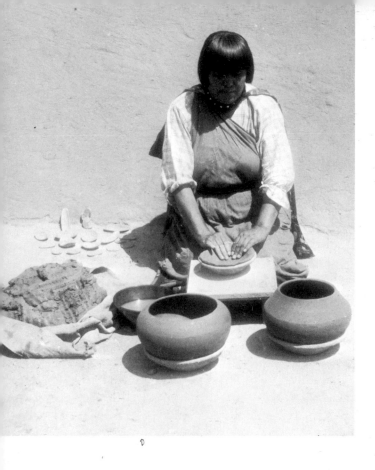

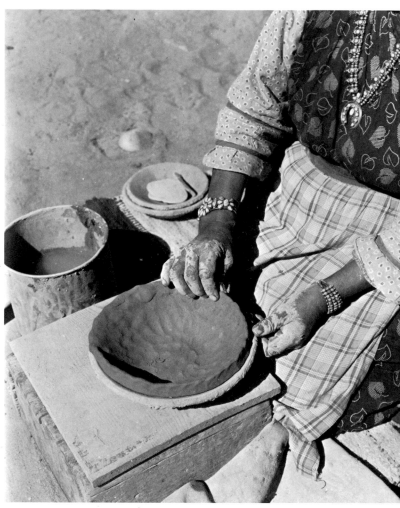

113–115. Pinching up the clay in the *puki*; coil building.

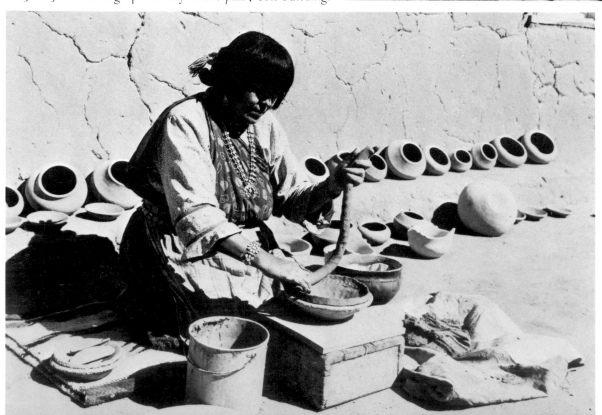

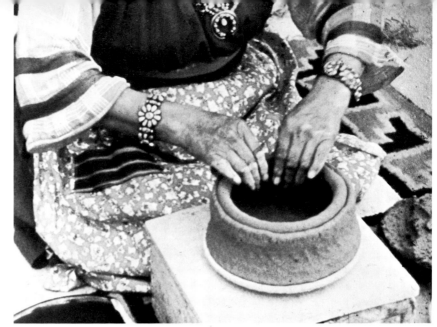

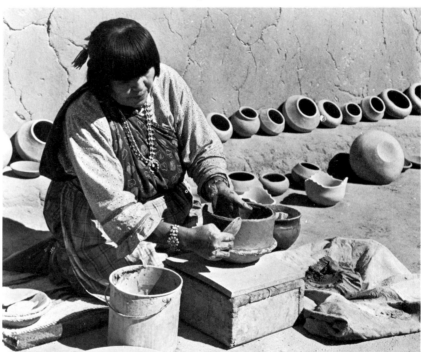

116–118. Coil building; thinning and pushing out the form with a gourd rib.

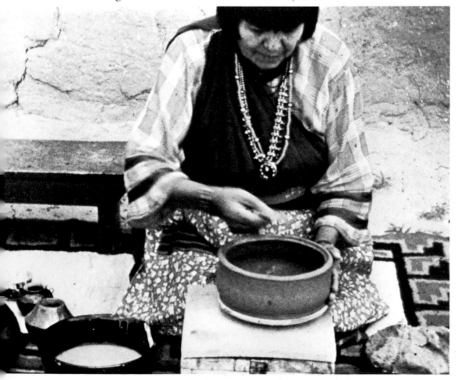

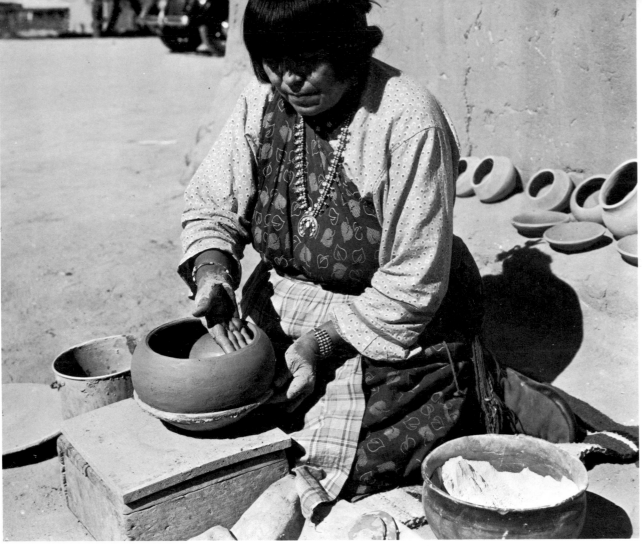

119, 120. Pushing out the form with hand pressure.

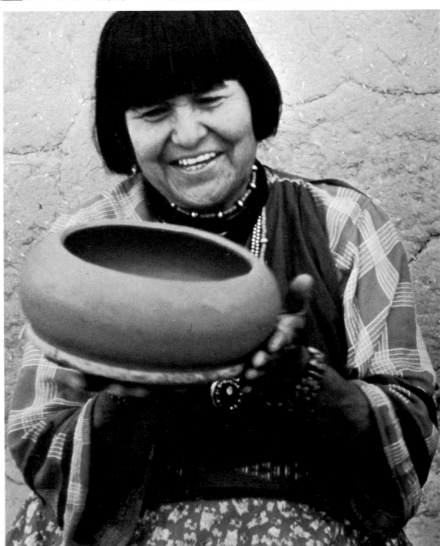

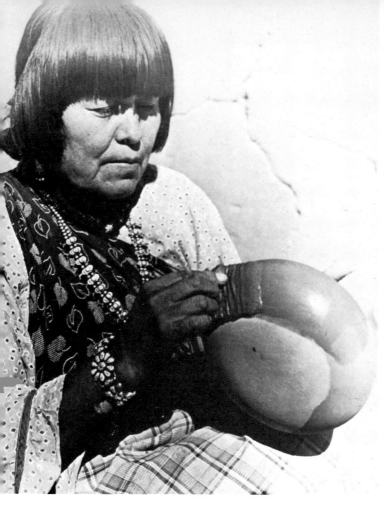

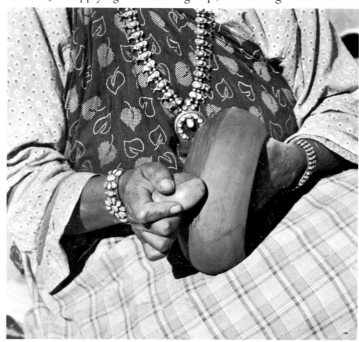

121–123. Applying iron-bearing slip; burnishing with a stone.

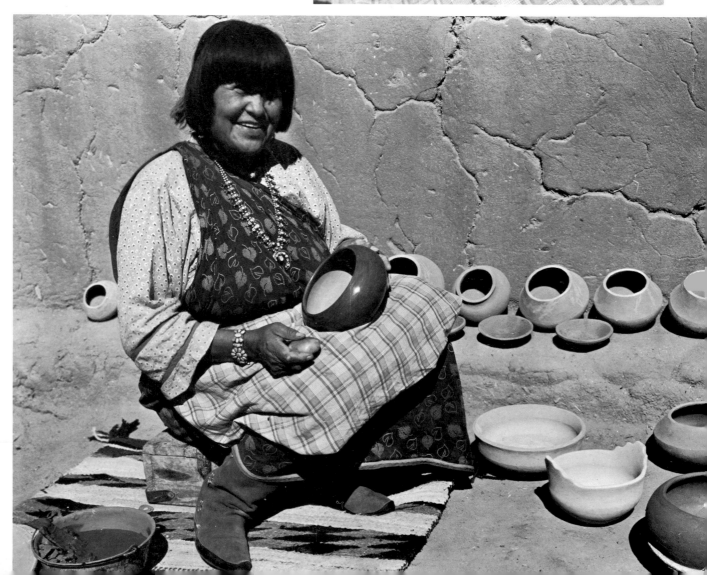

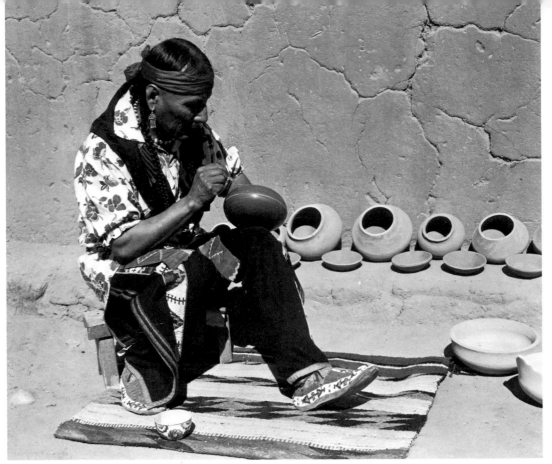

124, 125. Julian decorating, 1930s.

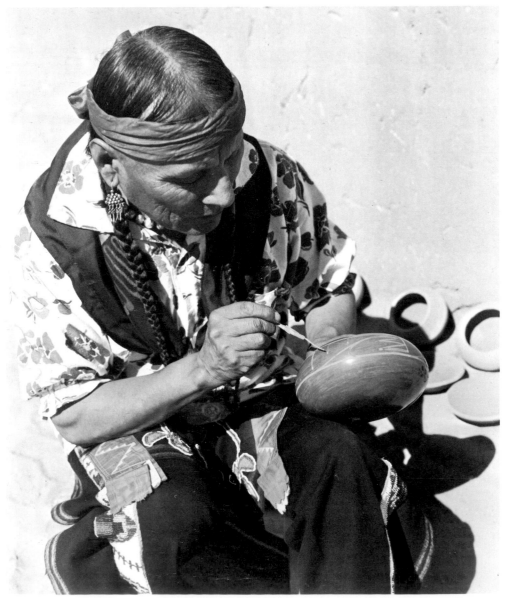

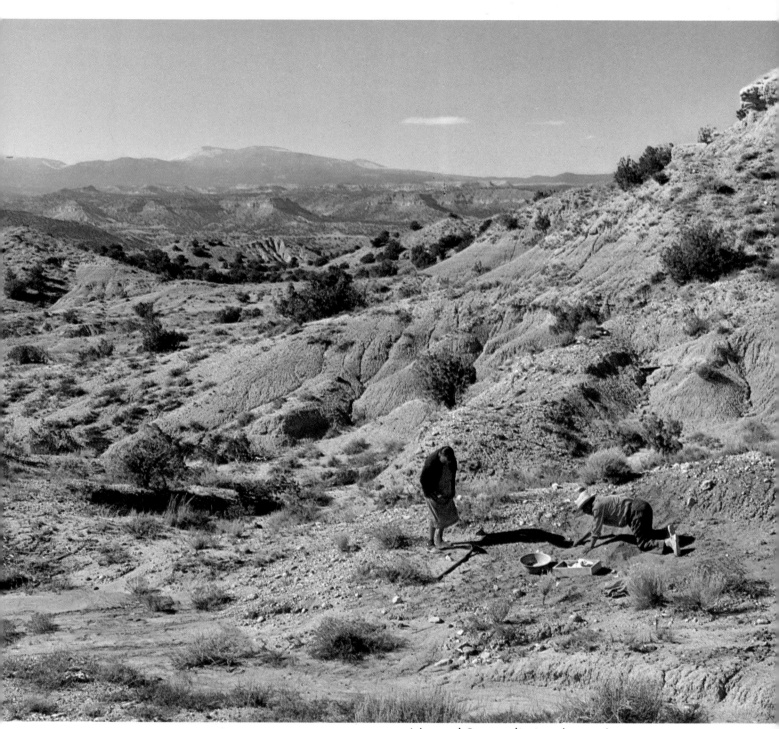

126. Adam and Santana digging clay on the reservation, site one.

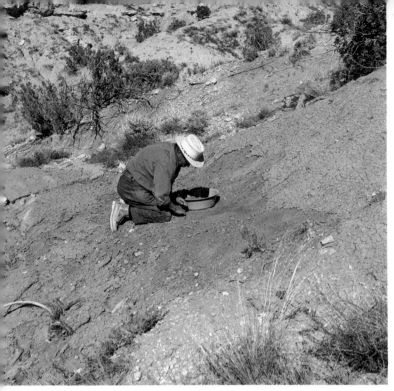

127, 128. A different clay is dug from a site nearby the first.

130

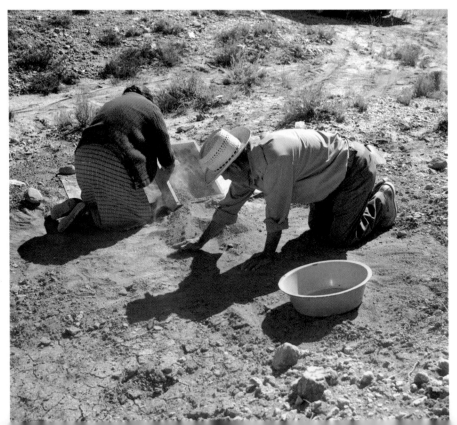

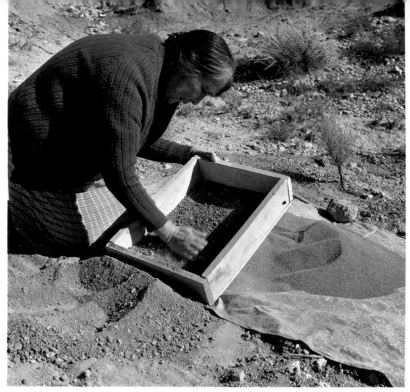

129–132. Clays from both sites are screened together.

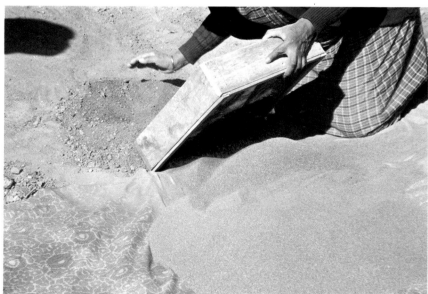

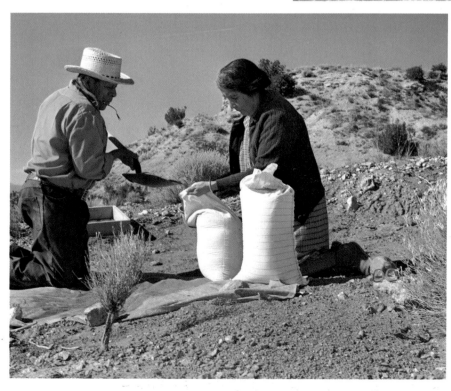

131

133–135. Volcanic ash is found some miles from the clay sites.

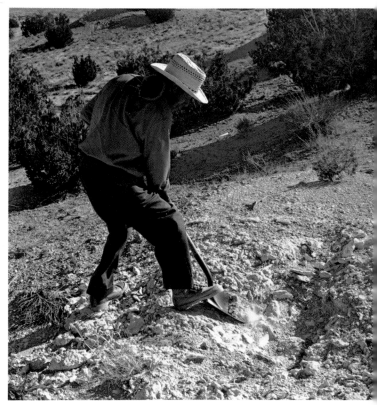

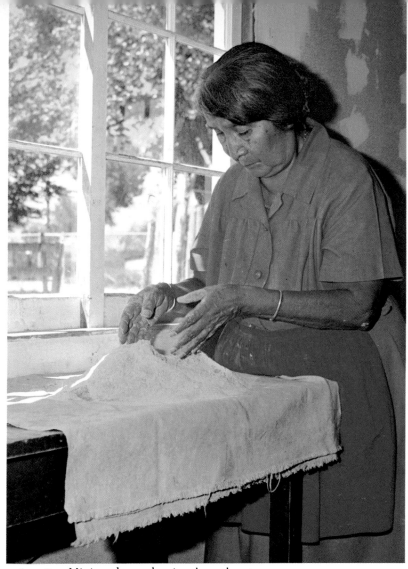

136–138. Mixing clay, volcanic ash, and water.

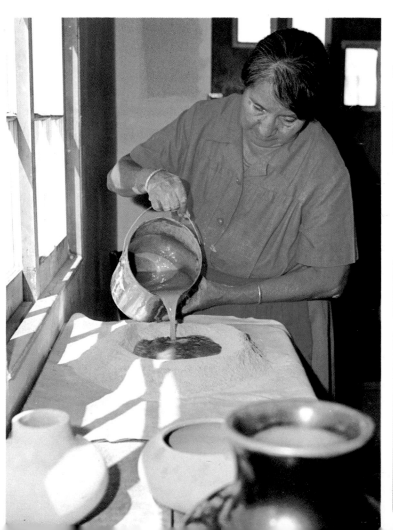

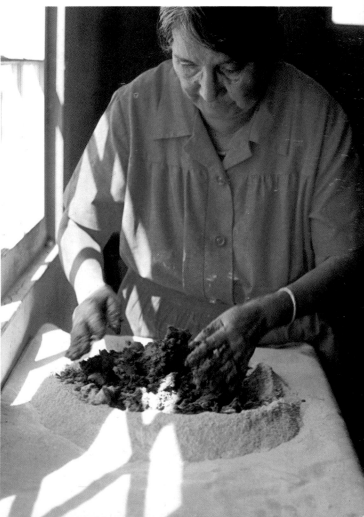

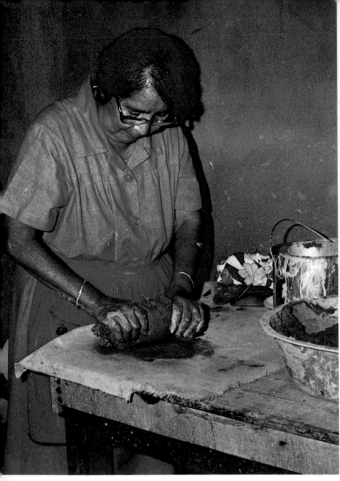
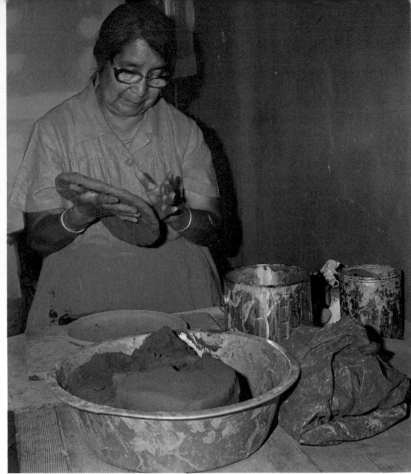

139–141. Kneading; making the clay pancake to fit a *puki* for a plate form.

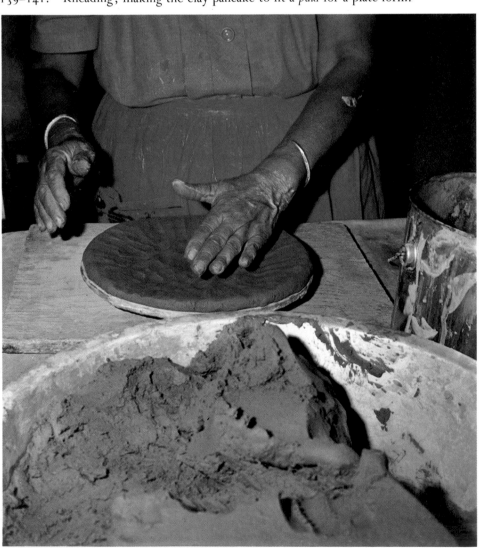

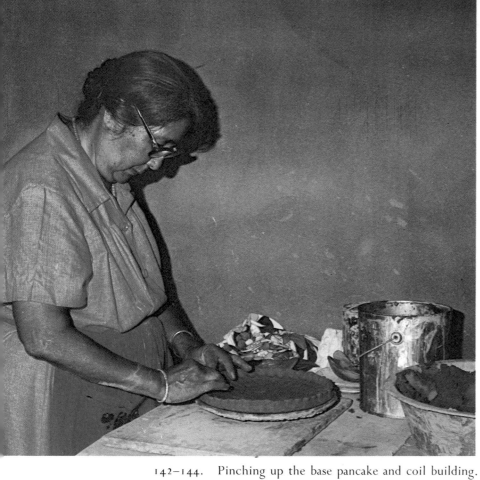

142–144. Pinching up the base pancake and coil building.

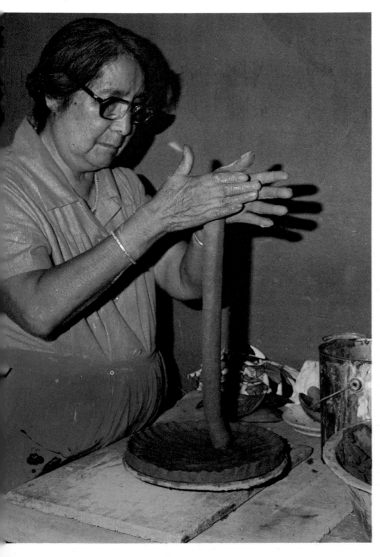

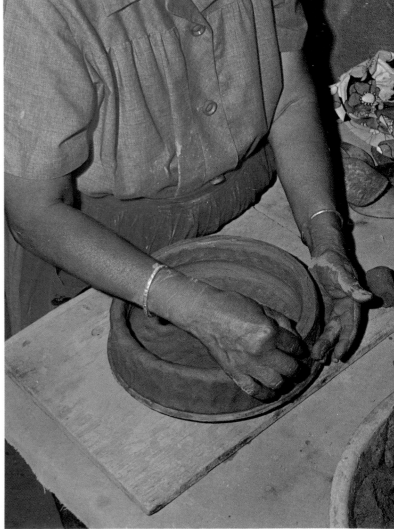

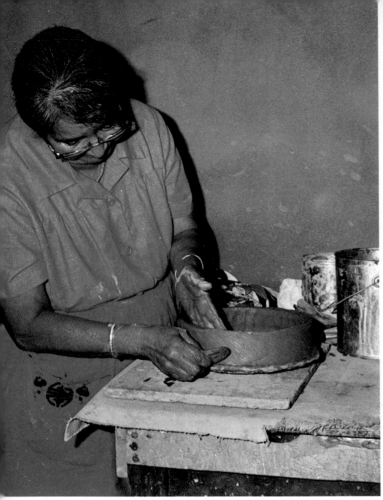
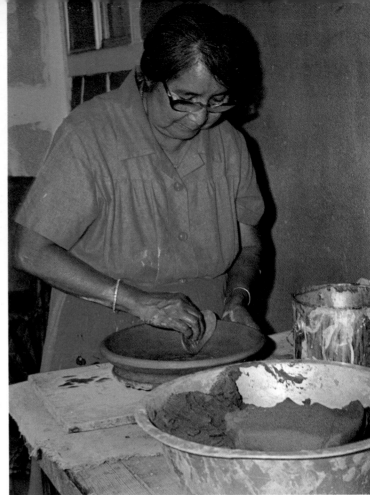

145, 146. Coil building and smoothing a low cylinder, which is pushed out to form the plate.

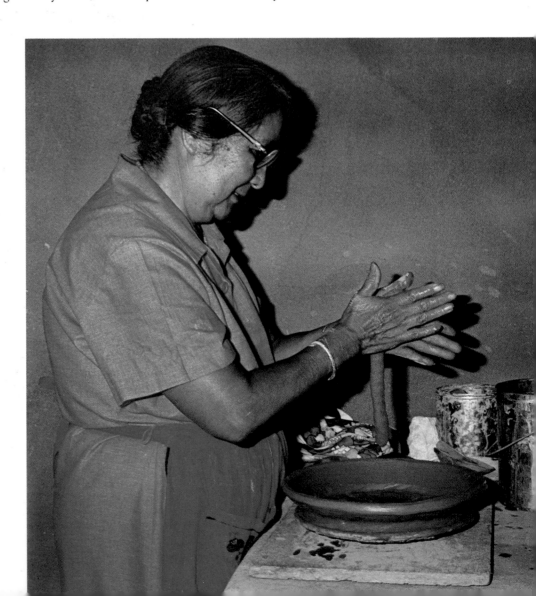

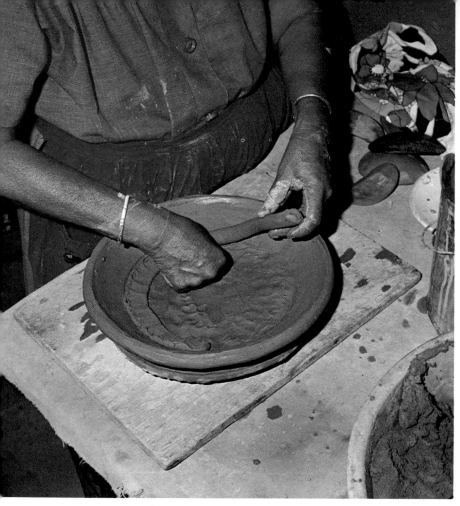

147-149. Reinforcing the inner joint and smoothing the plate.

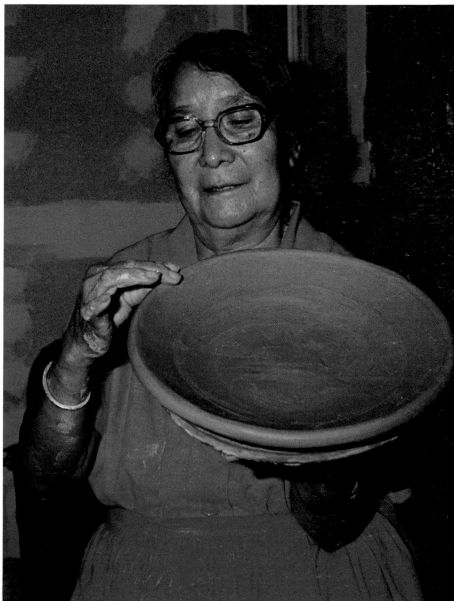

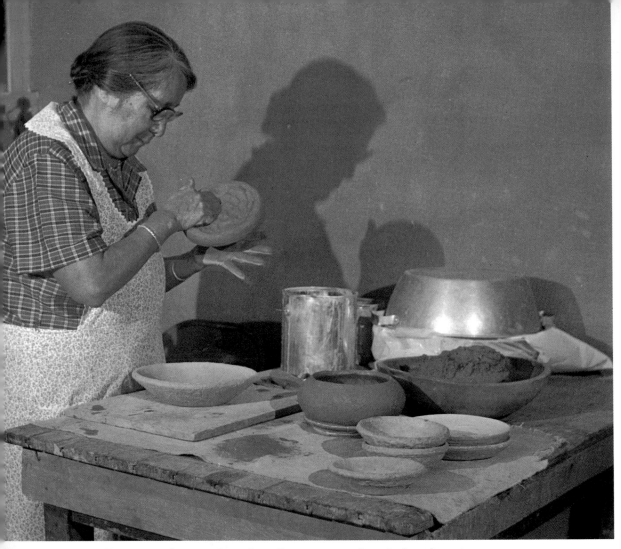

150–152. Forming a clay pancake and pinching it up in the *puki* for a large jar.

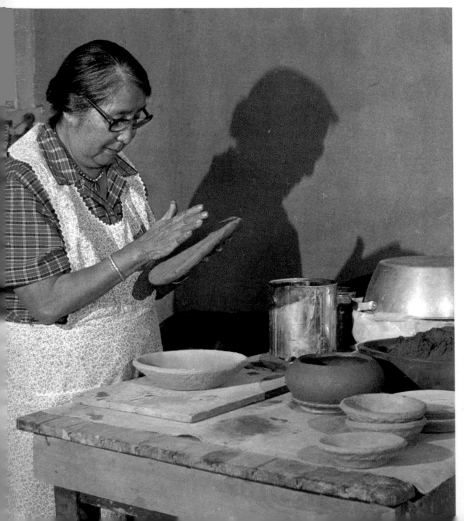

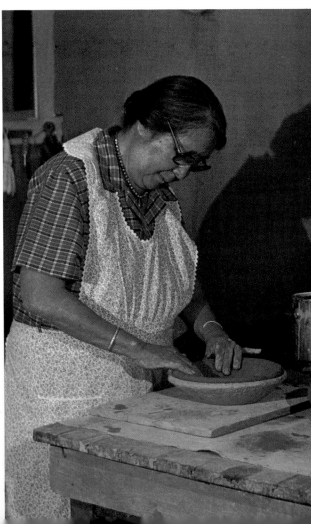

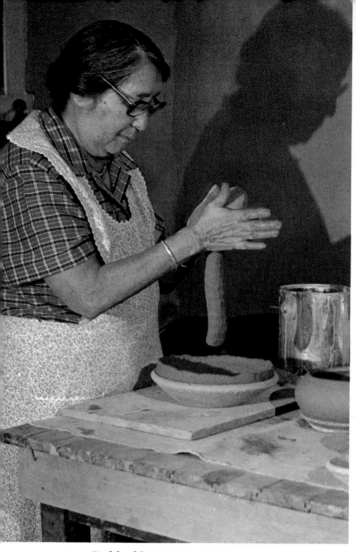
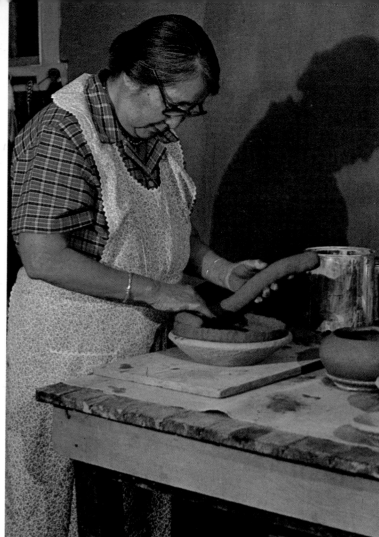

153–156. Coil building.

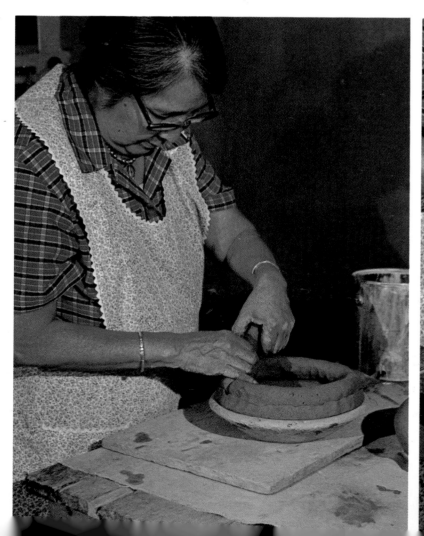
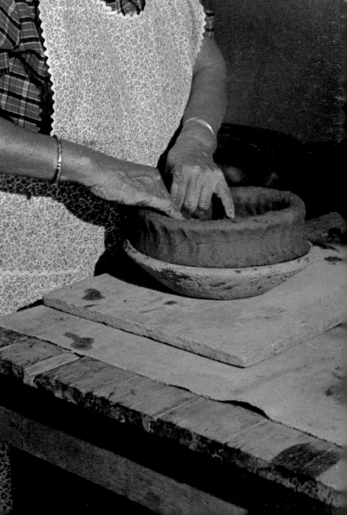

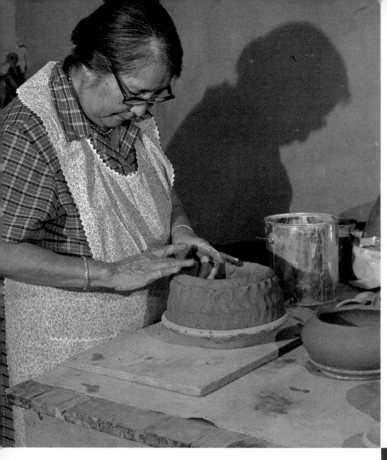

157–161. Building up a cylindrical form.

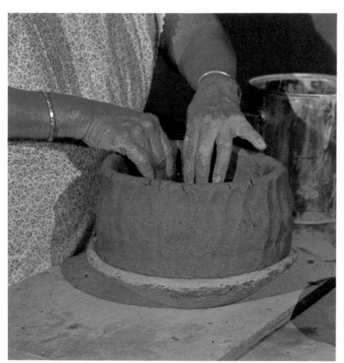

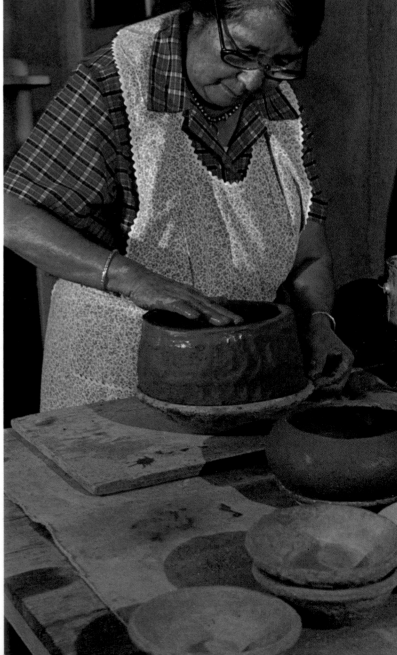

140

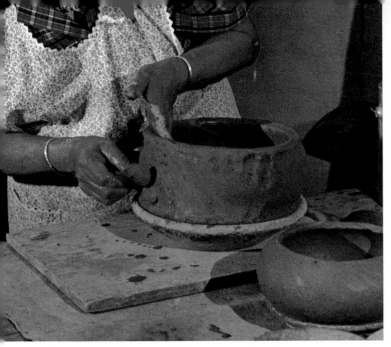

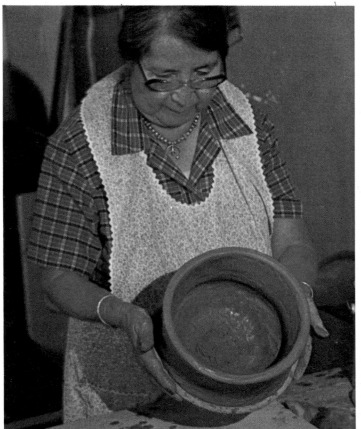

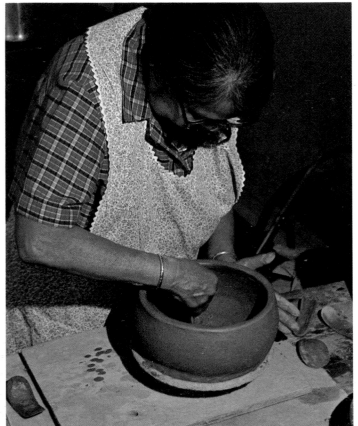

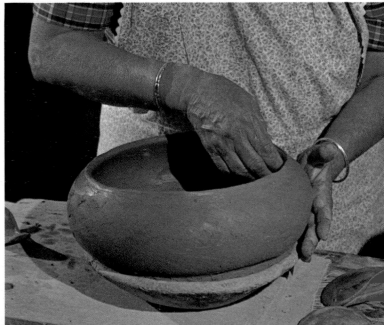

162, 163. Pushing out and refining the jar body shape.

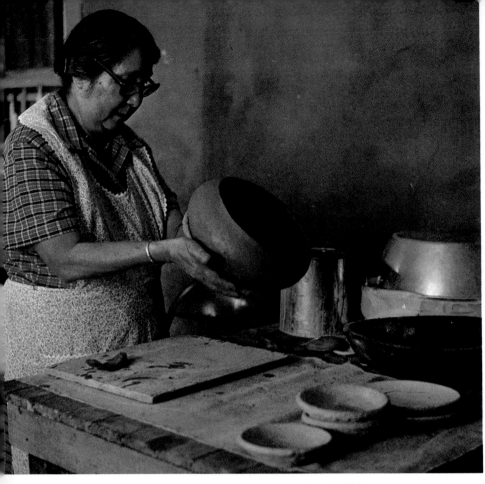

164–168. Pinching, adding coils, and forming the narrow mouth of the jar neck.

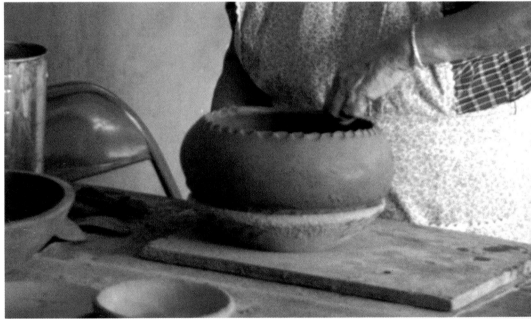

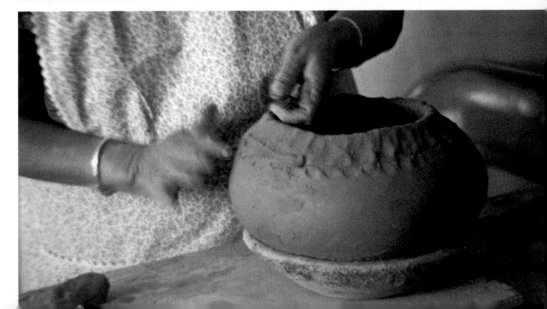

142

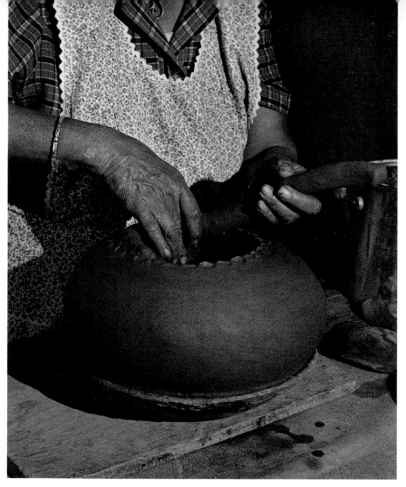

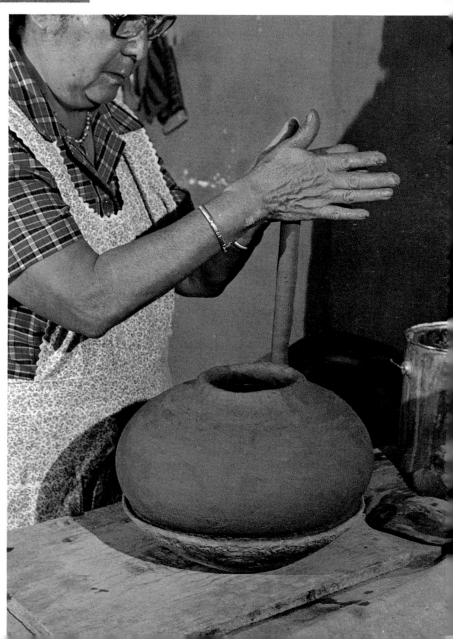

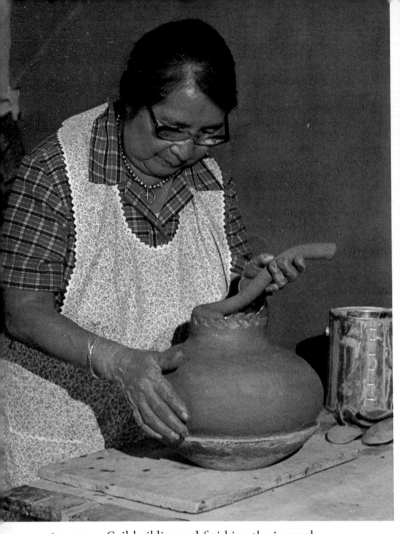
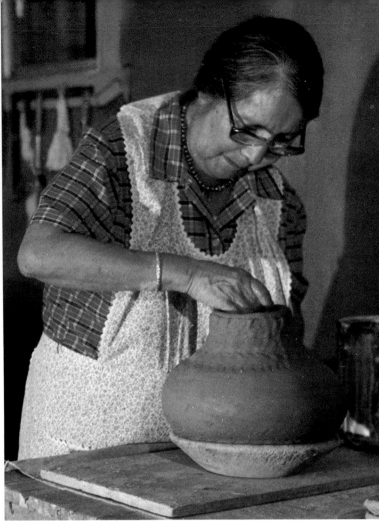

169–173. Coil building and finishing the jar neck.

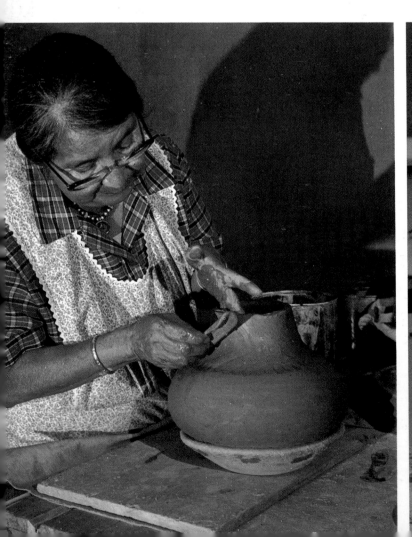
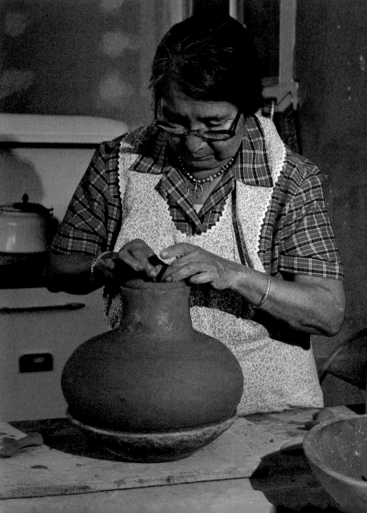

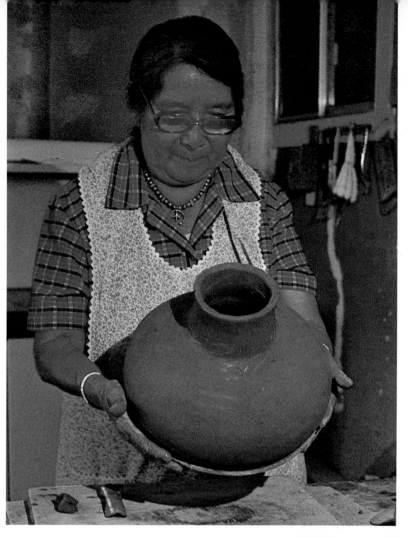

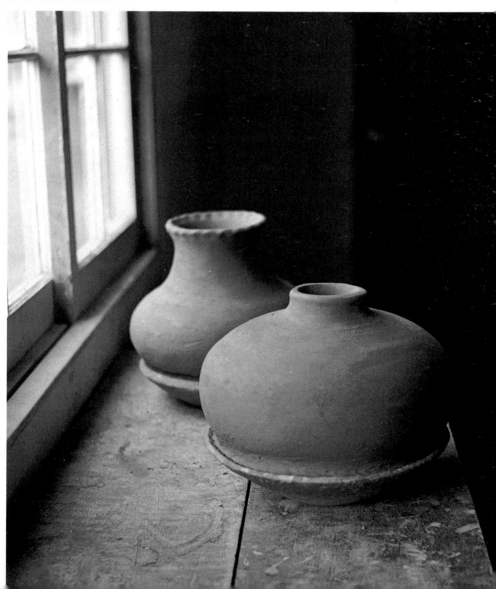

174. Drying pots.

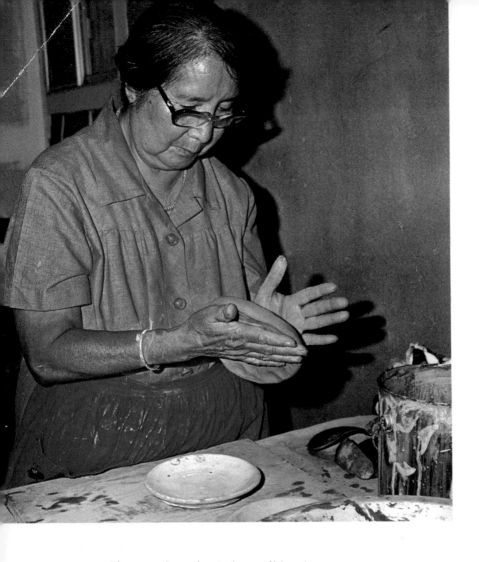

175, 176. Clay pancake and *puki* for small bowl.

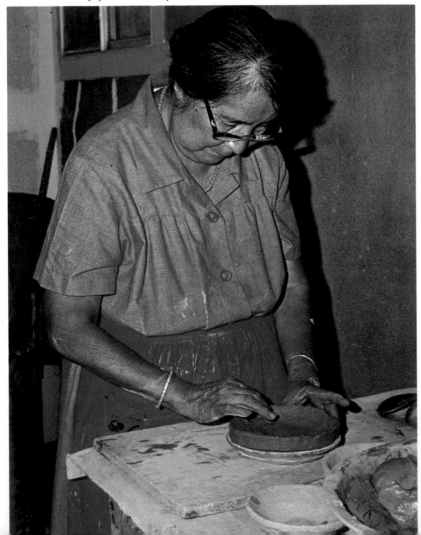

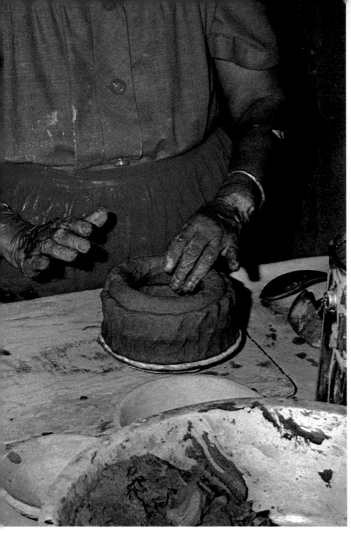
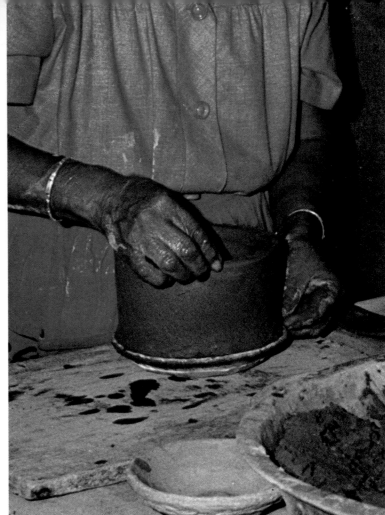

177–179. Coil building a cylindrical form.

180, 181. Pushing out a bowl form.

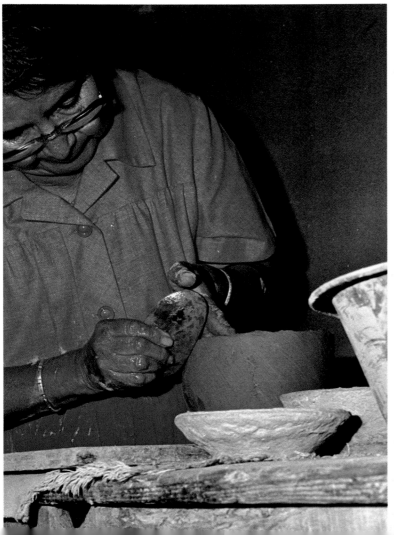
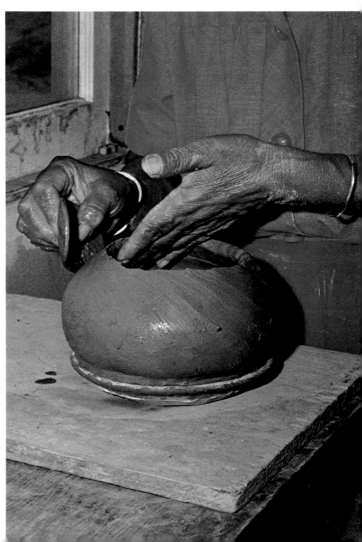

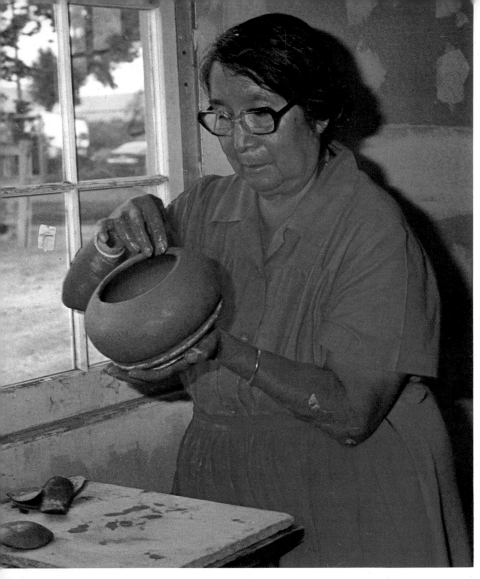

182, 183. Smoothing the bowl.

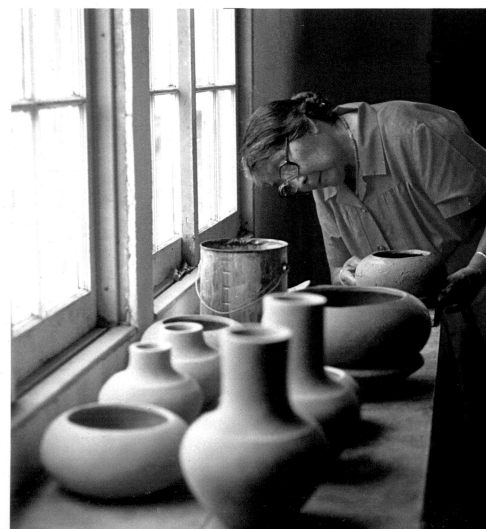

148

184. Gourds provide a source of tools for San Ildefonso potters.

185. Gourd ribs and scrapers; burnishing stones.

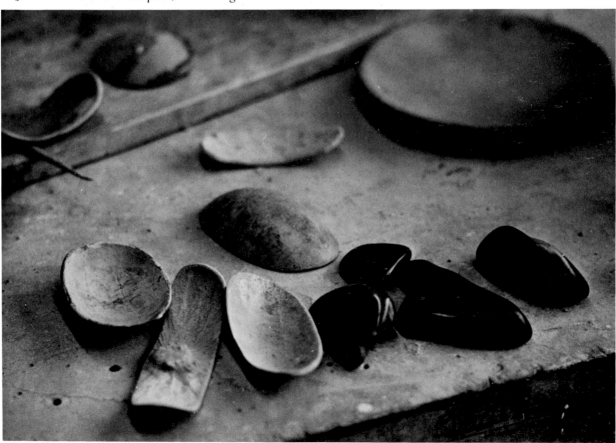

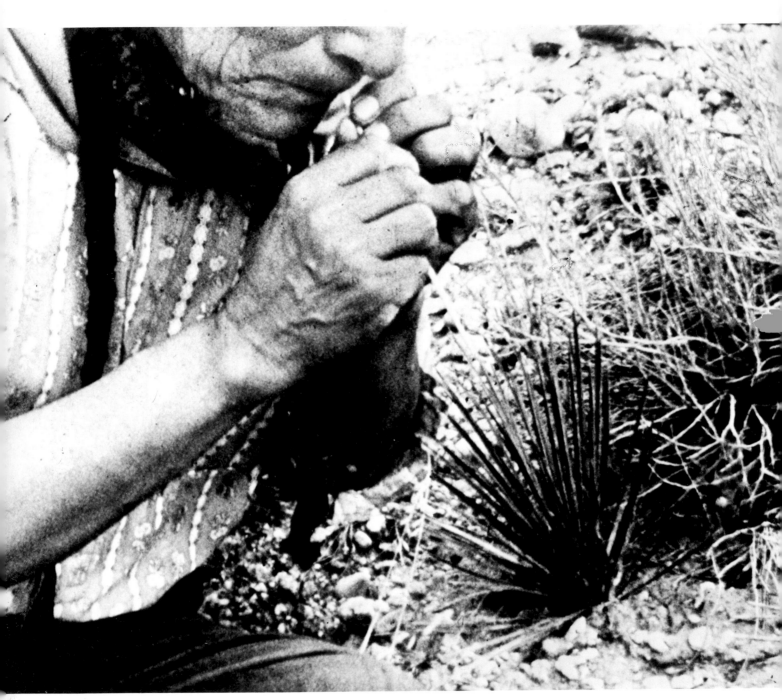

186. Julian chewing a yucca frond to make a brush, about 1935.

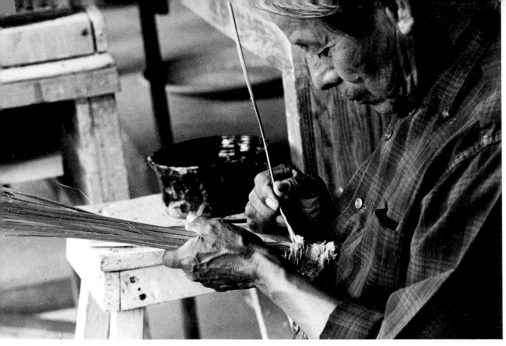

187–190. Adam making yucca brushes.

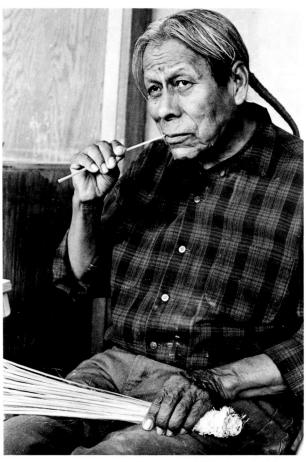

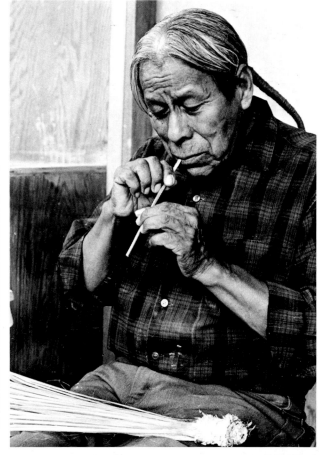

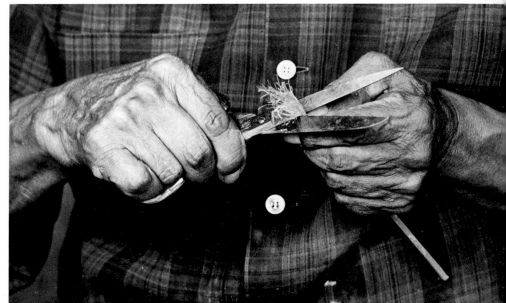

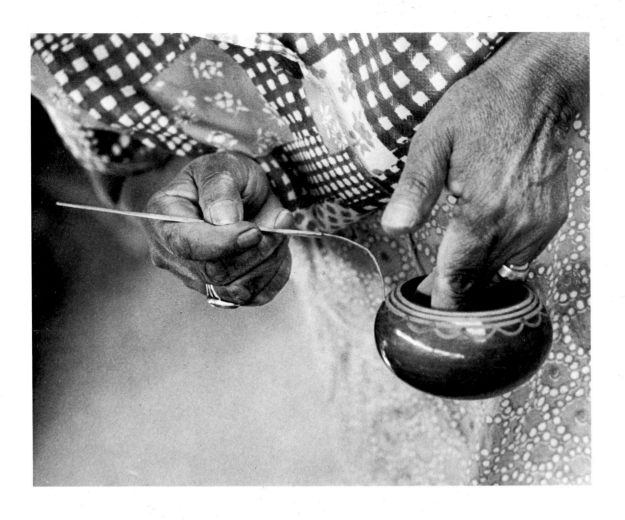

191, 192. Decorating with yucca brushes.

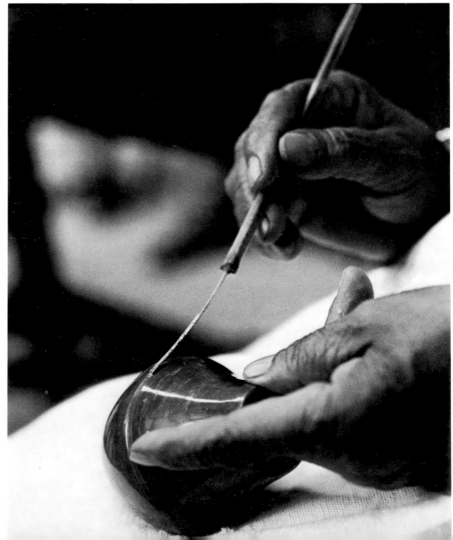

152

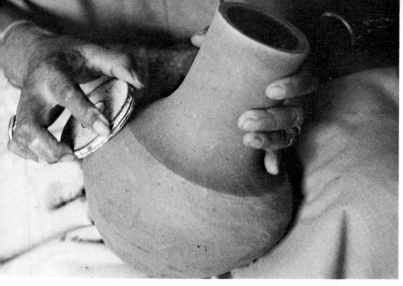

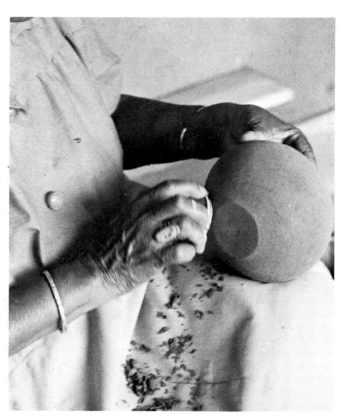

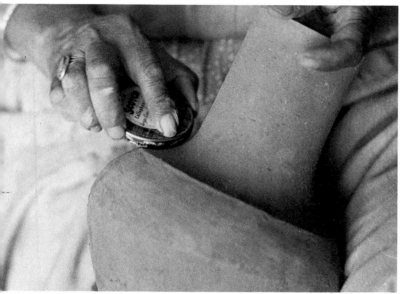

193–196. Using various sharp-edged can lids as scrapers.

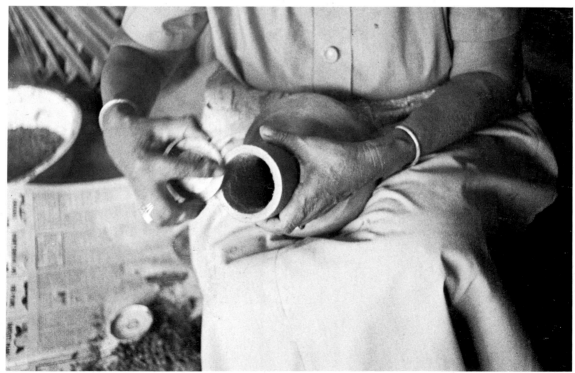

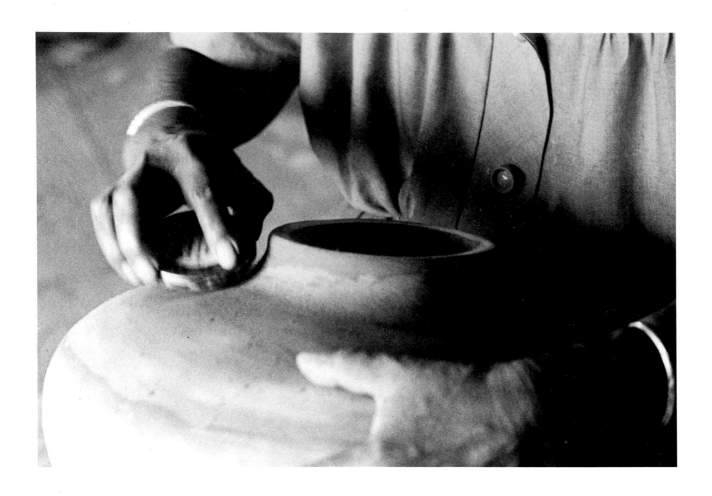

197, 198. Can lid scrapers used on different forms.

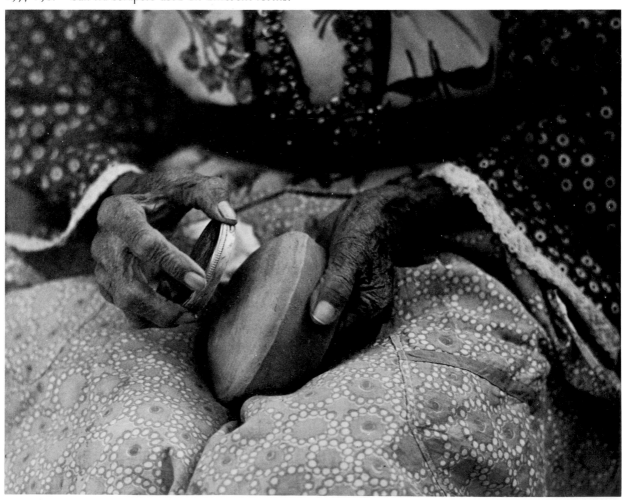

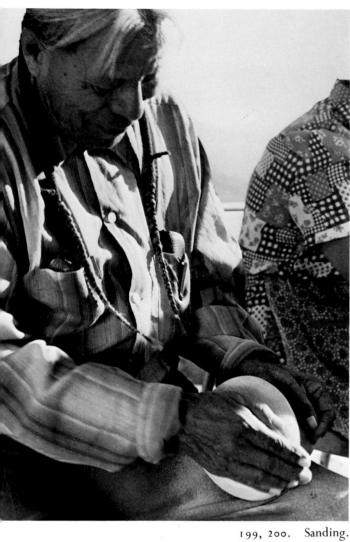

199, 200. Sanding.

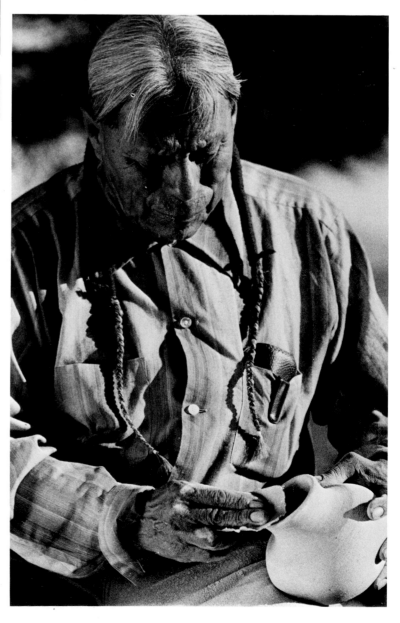

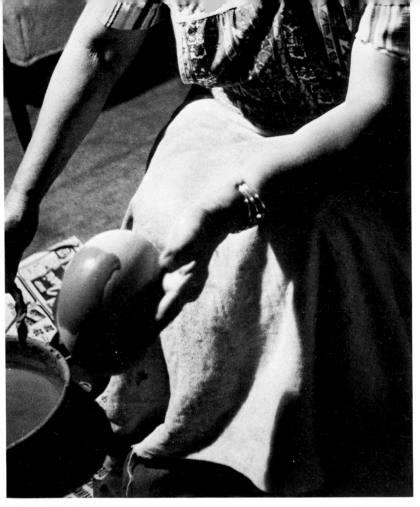

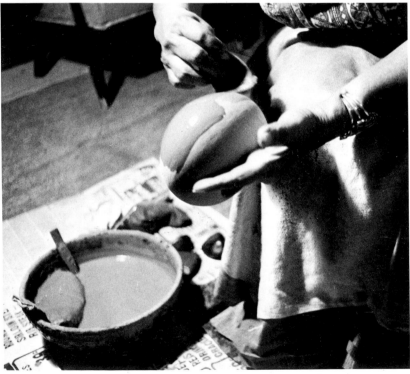

201–203. Applying iron-bearing slip.

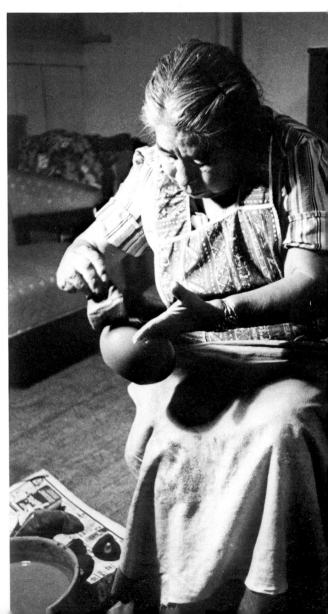

156

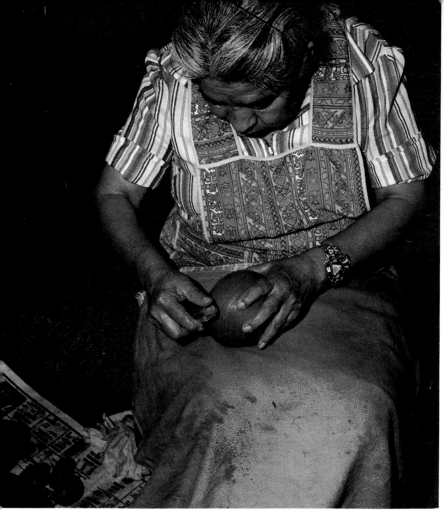
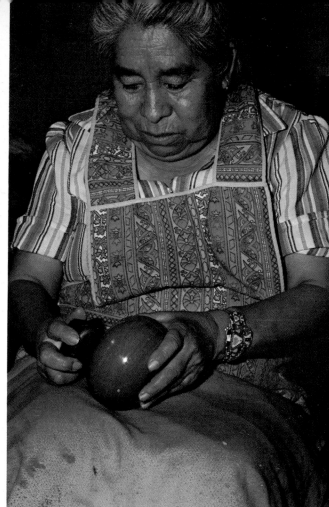

204–207. Burnishing the slip-covered pots with stones.

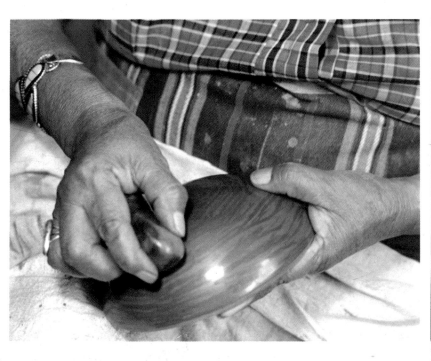
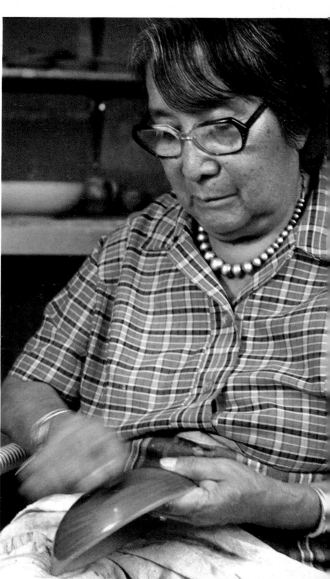

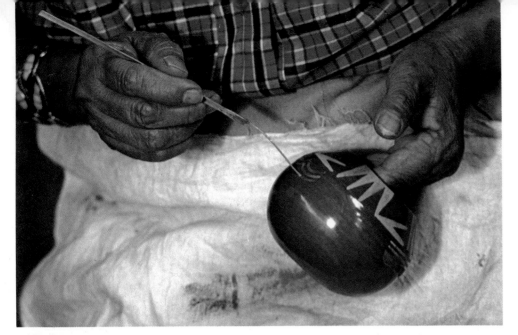

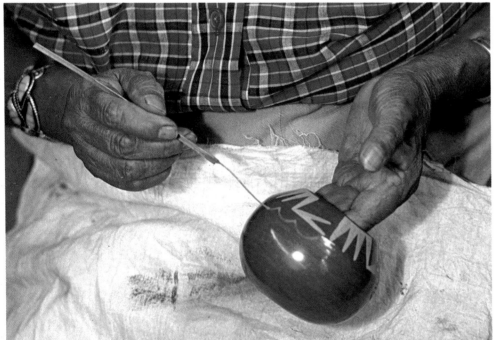

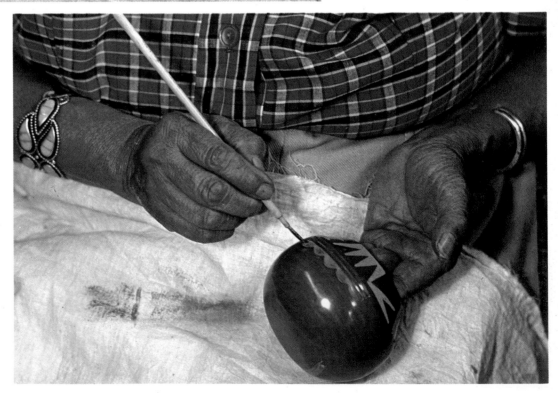

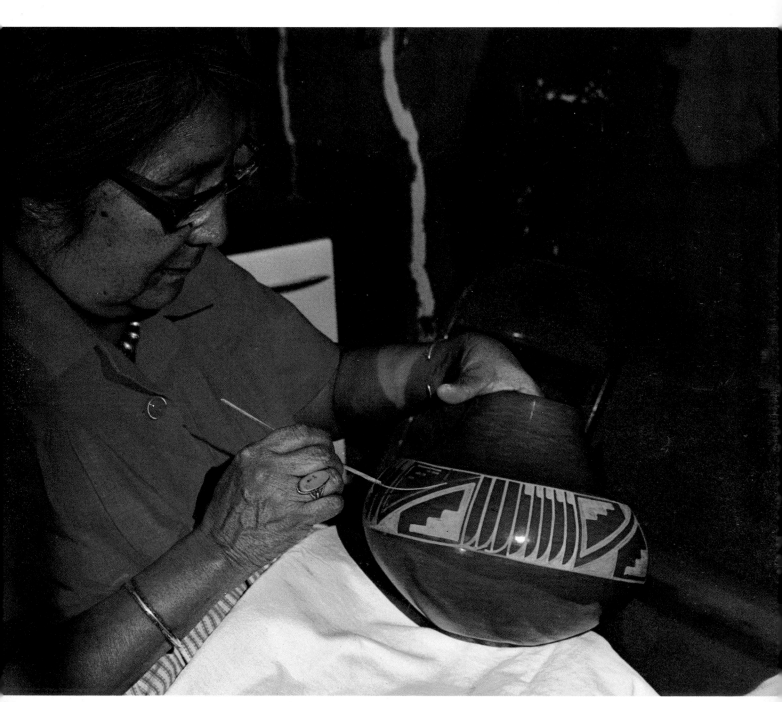

208–211. Applying decoration to the burnished pots with two kinds of brush.

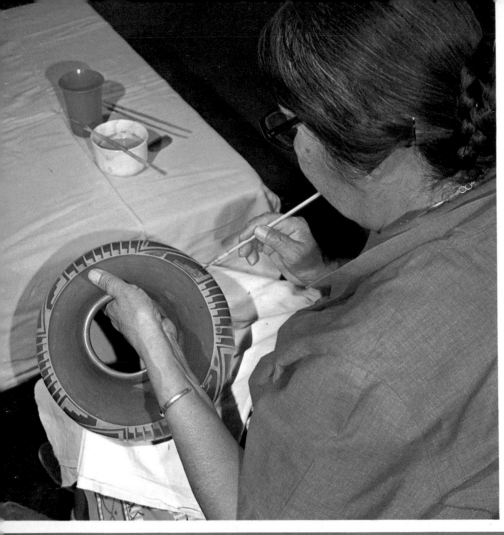

212, 213. Decorating; pots ready for firing.

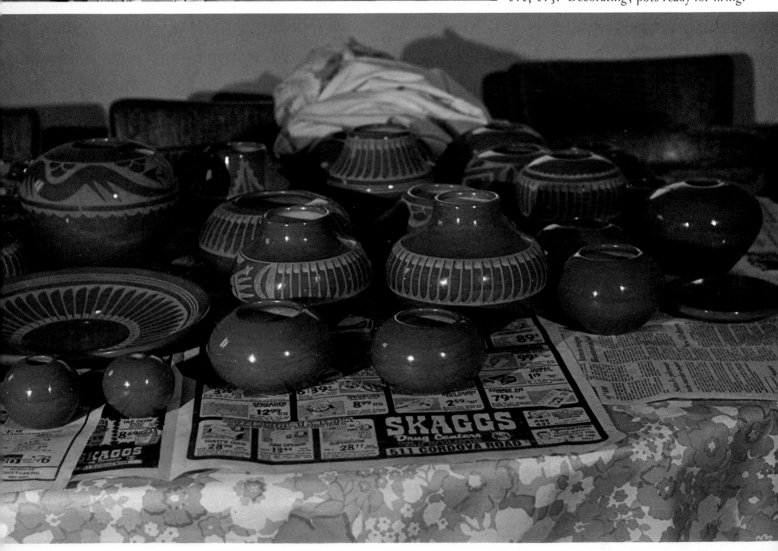

Over there in your fields you have
Musk-melon flowers in the morning.
Over there in your fields you have
Corn-tassle flowers in the morning.

In your fields now the water bird sings
And here in your village the fogs
And the black clouds come massing.
They come here to see! They come here to see!
Mhe'e a-ha we-o-'e

Making Pots

Santana and Adam have constructed a room for pottery making at the back of their house. It is small and filled with natural light. Curtains can be drawn for privacy, although one hardly ever sees another person outside on the plaza, or for that matter, anywhere on the pueblo. The view from the windows is of the old church on one side and the adobe bread oven in the back.

The floor of the workshop is pine. There is an oversized white-enameled wood cookstove in the room, on which Adam frequently puts up a pot of strong coffee. Santana says that everything tastes better when it is cooked with wood fuel. The fire is kept burning in the stove when they are working, if it is cool, and the oven door left open for warmth. By the window framing the view of the church there is a tall, weathered wood table where Maria enjoys sitting to look out and where sometimes she makes her palm-sized pots. Here Santana mixes clay and works her pots.

On the opposite side of the room is a square table, and in the corner a large Mexican chair. This is something of a place to congregate. Children run in and out of the back door, quietly, because that is the nature of Indian children. Pet dogs, often picked up as strays and then cared for, also wander in and out. The room is kept bare and neat until it is used for clay.

Making pottery the Indian way is no longer really a communal activity, although sometimes the polishing is. Maria remembers that she and her sisters Juanita, Maximiliana, Desideria, and Clara all used to get together to polish, a long time ago when they were young.

Today the potters of this family generally work alone anywhere inside their houses or in a special room. Some of them find and experiment with other clays in addition to that from the clay area they have always used.

Burnishing of the pottery is also done inside the house, although Maria used to work

on her very large pots outside. Now Clara does much of the stone-burnishing for various family members. Her room at Santana's house is often filled with unpolished pots, separated on shelves and tables. Family firing is done in a shed near Anita's house, behind Santana's house, usually with some of everyone's pots.

Black pottery making involves six distinct processes, each one as important as the other for the finished product. The first is finding and collecting the clay; second, forming the pot; third, scraping and sanding the pot to remove surface irregularities; fourth, applying the iron-bearing slip and burnishing it to a high sheen with a smooth stone; fifth, decorating the pot with another slip; and lastly the firing.

I know that the clay and volcanic ash, or blue sand as the Indians call it, are gathered now by Santana and Adam in the special place where San Ildefonso Indians have been getting clay for as long as Maria can remember. I had despaired of ever seeing the site. But one crisp morning, early, when the day was cool and quiet and there was no wind, Adam came into the kitchen, where I was drinking my coffee, asked, "Would you like to see the clay? This is a good day."

I was almost afraid to reply, but he continued. "Usually we get the clay once a year, in October. It has to be dry. The place is on our reservation, but far from here. Blue sand we have too, but it is hard to get it. We always got it from a nearby pueblo. They used to give us all we want; now they don't give us much. They charge us. But they have lots of those hills full of blue sand. Come along with us, if you wish."

I am excited at the prospect of going for the clay and accept with pleasure. I also tell Adam that his comments on the blue sand remind me of Shōji Hamada, the Japanese "Living National Treasure" who works within a folk tradition in Mashiko, the pottery town a few hours travel north of Tokyo. Hamada needs a great deal of wood ash, the principal ingredient of his traditional glazes, and which many neighbors used to save for him from their daily hearth fires. Hamada's clay, also, comes from the hills of the town. The Martinez family is acquainted with Shōji Hamada, because he and Bernard Leach, the famous British potter, made a visit to San Ildefonso in 1952, with Sōetsu Yanagi the philosopher and founder of the Japanese folkcraft movement.

Adam continues, "We have hunted for materials on our land, experimented. You know, you saw the white ash we brought in from our reservation, and it works. But

it is so hard to get that we still buy from those other Indians as long as we can. We have to buy the red slip too, for polishing, from another pueblo. The decorating clay is different also, and comes from—I don't know where they get it."

Adam leads the way to his truck, tossing in a pick and shovel, and Santana puts in a basket filled with bright fabric and a big wood-framed wire screen. We drive the bumpy road out of the pueblo, out to the highway, and east to a place where Adam turns off and stops before a gate in the fence. Adam says, "This gate says 'Indian Land'!" But I cannot see the invisible sign. He hops out, hunts in his pocket for a key to open a big padlock, shoves back the gate, drives through, and locks it again. Then we are riding a road made only of wheel tracks, over the red sand and up into the hills. Beside a patch of soft dirt Adam brakes the truck and begins a series of backing maneuvers.

"We have to back four times," Adam says. "It's magic."

It is always hard to tell if Adam is joking.

After we've unloaded the tools and pans, Santana looks over the area and says that this mountain used to be higher, that it is nearly gone (Pl. 126). Then she takes some cornmeal from her apron pocket and throws it onto the ground, as a blessing for the clay they are about to take.

Santana spreads a bright shawl on the ground. Adam drops down on his knees. Pushing aside rocks and sticks, he removes a top crust and smoothes the dry area with his hands. The whole deposit has a coarse, even texture, which appears to have washed down from a higher mound. Santana shovels the clay dirt into the fine mesh of the screen. Then she kneels down and begins to shake the dry material through the wire and onto her shawl, where the screened clay collects in a small pile. She tosses the lumps of residue left on the screen over her shoulder.

Adam disappears over a hill, and I discover him digging in a different place (Pls. 127–29). He brings back a bucketful of coarser clay, which Santana dumps onto the screen and mixes with the finer particles. The dry clay is still coarse after it is screened, but it seems fine because of the evenly screened particles. The clay Adam brought from the neighboring area seems to have more iron content than the clay in the first location.

As the shawl fills, Santana holds a white flour sack while Adam shovels in the mixed and screened clay composition, until finally they have four full sacks. They are careful to save every last bit in the shawl, allowing none of the screened dirt to fall back on the ground (Pls. 130–32).

I have heard Santana's granddaughter Barbara Gonzales, who is one of the best Indian potters, talk about prospecting for clay by herself. She has driven over the miles of area between San Ildefonso and the town of Española and over the back areas of her reservation, gathering clays. She has tried many clays, but found very few with the necessary quality of thermal shock resistance. Only the clay in this one place where they are digging now seems to work just right.

Oh, there is plenty of clay. The geology of the whole vicinity is clay, as Santana and Adam often tell me. But apparently just this one area has the chemistry of proper bond or some mysterious inner additive that yields the necessary resistance to the direct heat of the Indian's bonfire and also has the proper plasticity for fabrication.

Barbara also prospects in her car for new areas of volcanic ash, or pumice, like the blue sand, which is used half and half with the clay for temper, for resistance to thermal shock, and for flux. I think it also serves to make the pots harder in the low temperature bonfire. On the San Ildefonso reservation, the ash outcroppings are bright green and some are white as salt, but the hard, crusty rock is difficult to dig (Pls. 133–35). The bluish ash they buy now is so fine that it would screen through silk, yet it has a gritty feel. Barbara says that good clays are much more difficult to find than good ash. Most ash tends to work well, but the clays do not.

Back in the pueblo, Adam stores the flour sacks of clay and the ash he had pick-axed on this trip from another special spot on the reservation. The storage place is a weathered old adobe building near their house. He brings some of the clay into the pottery room for Santana. On the table by the window she lays out a cloth, pours out a mound of the gray-pink clay, fists out a hole in the center, where she puts an equal mound of the blue sand, makes an inner hole in this dusty mass, and pours in some water. Then, as if it were bread dough, she kneads it into the plastic stage, picks it up in the cloth, deposits it in a wash pan, and covers it with a towel to prevent the moisture from escaping.

Adam has rejoined us. He builds a wood fire in the stove and puts on the coffee. Lunch this day is bread, green chili, and frijoles. Santana stops the clay process to make more green chili because while we were out a man came by and Clara bought a large basket of peppers.

Usually it is best to let clay stay wrapped up for a day or so after it is mixed and before it is used. But Santana is going to start right away to build some shapes. Adam goes to the storehouse and returns with several *pukis*, the fired clay forms in which all pots are begun. He places them in a stack on the table. There is water in a coffee can, a dry cloth for the hands, and the oval-shaped pieces of gourd called *kajepes*, which are tools used for forming and scraping the pots.

"All paths of life join," say the Tewa. The origin of these tools is ancient, and variations of the same basic ideas are found in each pot-making society the world has known.

The *puki* is a supporting mold, a dry or fired clay shape in which the round bottom of a new piece can be formed (Pl. 141). Coil-building with the alkaline clay used at San Ildefonso requires support. A dish or old broken pot would do, but most Indians prefer to make their own supporting molds, each type of pot having a *puki* of the appropriate shape and size. Probably one of mankind's earliest methods of constructing clay pots, thousands of years ago, was to use baskets for support. The basket weave left a textured surface, which could be smoothed out if the potter wished. It is thought that clay *pukis* have been used in the Southwest since about 1000 A.D.

Indian pot bottoms are customarily round for functional reasons. The round form sits well in the sand or on the rocks of a cook-fire. A slightly indented foot conforms to the contours of the head, making the pot useful for the traditional method of carrying water.

The gourd shaping ribs and scrapers used by the pueblo potters vary in size and shape, depending on the job they are used for and the pot being made (Pl. 185). Those used by the Martinez family are cut with a hacksaw by Adam from big gourds (Pl. 184) along pencil marks he has made on the surface, then filed smooth. These will be soaked in water before use.

Pottery is not made in a day. This morning's outing produced the raw material.

Now Santana works at it on the wooden table, standing, as she always does, her dress covered by an apron. Elsewhere in the house Maria is taking a siesta. Clara may also be resting.

We have been talking while Santana and Adam prepared for the pot making. If I was not here, Santana would work in silence. But now the three of us chatter informally in close communication. There are certain issues under discussion on the pueblo about which they converse seriously for a few minutes. They ask for my comments. As I attempt to answer, I realize how different our lives are.

The pueblo's problems are not made easier by the ever-present stresses involved in the desire to preserve their own society and ways under the pressures from the Anglo world and the influences of a changing society. Obviously, any community has problems. These people perhaps have more than their share, yet it is clear that any solutions must be their solutions.

For instance, Santana thinks women should have a vote in tribal government, which they do not.

"If we let the women in," Adam says seriously, "no more San Ildefonso. In old times no one spoke English, only Tewa, so the Bureau of Indian Affairs take care of everything, Now young men go to school and learn English and we take care of ourselves."

"But women should participate equally in the political tribal government," Santana says, "And not be ignored like today. *All* adults should be equally recognized."

"Do you think someday the women will get the vote, Adam?" I ask.

"I hope so."

"But you said it would destroy the pueblo."

"Well, OK, let it. We'll go forward."

The questions are rather quickly put aside, however, as the momentum of beginning to make pottery takes hold. These sessions in the pottery room are times of easy affinity and rapport for us. With clay as the connecting link, I am allowed to gain insight into the complications facing them as they struggle to preserve some of their deep-set traditional values.

And this was a time to discuss recipes! I have watched Clara make batches of thick

tortillas every two or three days. A few hours ago I helped Santana put green chili peppers under the broiler until they were singed, then we peeled and chopped them hot. The peppers will form the base for a spicy sauce, with tomatoes, onions, and perhaps pork. This is the staple food served at nearly every meal and often eaten just with bread or freshly baked tortillas.

Today I ask Santana for her recipe for "fry-bread," which is made for company and which can be eaten in a variety of ways, salty or sweet.

Fried Bread

3 cups flour
pinch salt
1 teaspoon baking powder
1 tablespoon shortening
("Some use yeast—my mother used yeast.")

Mix everything and knead as much as you can handle. Roll out to about $\frac{1}{4}$-inch thickness, cut it into little-finger sizes, fry in deep fat, then eat. This is not exactly precise; I do not know how hot the oil is, or, for that matter how many this will serve. When Santana told me the recipe, she said use six cups flour (double the recipe) "for a lot."

While we are talking, Santana has been building a jar, a shape about eight inches wide, bulging at the base then narrowing in at an angle halfway up. She began with a ball of clay, which she formed into a pancake shape by patting and slinging it rhythmically between her palms. This pancake she fitted it into the shallow, curved form of the *puki*, and with thumb and forefinger pushed up a wall about an inch high around the edge (Pl. 152). Then she rolled a fat coil between her palms; she attached this to the soft edge of the base. Turning the *puki*, she squeezed the clay together with her fingers and used one of the gourd ribs to smooth the vertical wall. Two more coils were added, and the gourd rib was utilized in crisscross motions to make the wall thickness even (Pls. 153–56). Occasionally Santana patches air holes with small marbles of clay, smoothing the wall and evening the thickness with her gourd as she turns the form slowly in its *puki*. Then she lets this pot sit and begins another; she will return to it when it is stiffer.

This is not an ordinary clay. In the plastic state it is thixotropic, which means that it tends to get watery when it is worked. The cause is the highly alkaline volcanic ash that constitutes 50 percent of the body material. The problem this creates is that the clay can be worked only a little while before the constant action of fingers and tool makes it too soft and impossible to control. Left alone, it will stiffen and can be worked again. Even for small pieces this is a difficult clay, but for large pieces much skill and control are required.

Maria was probably the most skilled of all Indian potters at making large pots. Other generations of the family have not seemed as interested in accomplishing the same scale for which Maria was famous. Rather, they have elected to develop their own styles within the framework of the tradition. Santana tried a very big jar last year, but left it outside to dry. A rain came suddenly, destroying the pot, and she has not yet attempted another.

For several days now Santana has been constructing pots of various forms, setting them aside from time to time and working each again periodically until the form is finished. Later the dry pots will be scraped and sanded to make the rough surfaces satin smooth.

A platter is begun with a twelve-inch clay pancake, extending two inches beyond the edge of the *puki*. A straight-sided cylindrical shape is built up with moist coils, usually three fat ones, and the wall is smoothed with the gourd tool (Pls. 136–49). When this low cylinder has stiffened for a few hours, it is pressed outward from inside and flattened, a little at a time as the *puki* is turned, until a shallow plate form is completed. Turning and pressing evenly requires great skill. Deft potters can achieve a perfect circle, at the same time keeping a controlled wall thickness. Santana rolls a fat coil between her palms and squashes it down to fill in and strengthen the curve where the base and flare of the platter meet. She smooths the lip edge with moistened fingers and shapes the inside again with rhythmic motions of the kidney-shaped gourd rib. Pots are thinned in stages. As they stiffen, and later as they dry, they are scraped to unblemished smoothness.

For jars, whether large or small, and for large round spheres, Santana pinches up the clay pancake just inside the edge of the *puki*; the first coil rests inside this pinched-

up support (Pls. 152, 153). This technique is important for making a strong joint. The pot wall is always built up straight and vertical and pushed out later, from a cylinder form, into the curves desired (Pls. 162, 163). This seemingly strange technique is necessitated by the sandy, nonplastic nature of the clay body. Very tall pots are also built in this way, but in several stages. Necks are added by pinching coils upward after the belly of the pot has been formed (Pls. 164–73). The large percentage of ash in the body composition results in another positive property: wet clay can be added to very much drier clay without creating shrinkage problems.

For weeks, as the potting in the workshop continues, through the back window I have been watching Adam build his own creation. This is an adobe brick bread oven he has been constructing for several months (Pls. 83–86), just a few steps from the back door. The adobe bricks measure about three by ten by five inches. He has laid these up slowly, course by course, mortared with wet mud he has mixed on the ground. He also spread the mortar smoothly over the joints. The process is nearly the same as creating a huge pot, upside down. When he began, Adam drew a circle on the ground with a hearth jutting out on one side; rough supports for the arch were used, but there was no template for constructing the round form.

As the dome rose and closed in, he relied on his unfailing eye and on the profile line to engineer the curve so that the wall would not collapse. After each course, the mortar must dry hard before the next can be added. This is exacting work and is as much an act of creativity as the pots that the women potters of the family make. Adam is building this oven bigger than their last oven; the first time they will use it is for the January ceremony, San Ildefonso's patron saint's day.

The brick form is finished now, and he is beginning to smooth over the whole surface with adobe. I have looked at the other ovens on the pueblo and I realize this one of Adam's has outstanding impact. Years ago Adam was a painter and helped his father execute pictorial commissions. For instance, he worked on the room decorations at the La Fonda Hotel in Santa Fe. But the responsibilities he has had at home as Maria's eldest son have prevented the complete exercise of his artistic talents. Watching him build the oven for several months has shown me that he has not lost his sensitivity for proportion and form or his feeling for craftsmanship. And I also remem-

ber the painted wooden *tablitas*, the ceremonial crowns worn at the Corn Dance, and the feather and shell accessories he has made for all the other ritual dances.

When I asked Santana how many pots she makes in a year, she said she does not count. She added that if she *had* to count, perhaps one hundred. Usually she works in a series of perhaps ten pots at a time over a period of two weeks—tall jars bulging wide at the base with narrow necks, short spherical bowls, a platter or two, and possibly one form of unusual size or shape.

Maria has told me that she made many hundreds of pots in a year when she was working at her best. After all, the prices she received were embarrassingly low, and it took a great many pieces to give her an income. Santana has raised twice as many children, her circumstances have been different from Maria's, and her output has been less. The fact remains that there is a limit to the number of pots possible for one person to make in one year the Indian way. The process is simply too complicated.

The largest pieces Santana makes, such as the twelve- or fourteen-inch-high olla shapes, take one day to make if it is a good dry day—"not muggy like this September day," she says. But today, regardless, she did make a big pot. Here is an example of how experience with and feeling for materials allows a craftsman to work successfully, regardless of adverse conditions.

When the finished pieces are dry, usually after a week or two, they are in condition to be scraped and sanded. Santana gathers a group of pots around her on the floor and sits near them on a low stool.

Scrapers for finishing pots have historically been sharp edges of such things as sticks or rocks. Nearly every excavation of ancient pueblo sites yields potsherds with edges ground similar in shape, from which we may assume that even fired clay tools were employed. Some potters utilize knives or pieces of metal for scraping, but this family likes tin lids. Santana and Maria prefer the sharp edge of Calumet baking powder tin covers, and they scavenge antique shops and yard sales to find them. For the mirror-smooth surface on their finished pots, the scraping and sanding process is very important, and going after tin lids becomes a search of significant worth.

Typewriter ribbon cases, Scotch tape can lids, and fruit jar lids are also used. The

varying diameters of these fit the curves of particular pots. Only the very edge of the tool must touch the clay in order to smooth rather than to gouge. Santana turns the pot on her knee or in her lap as she works; the rhythm of scraping must be constant and even. The roundness of the foot and the seam mark from the *puki* are scraped first. A narrow tobacco can lid, oval at the ends but with straight sides, is the shape she uses to scrape the interior of long-necked jars, and a round lid turns the inside lip. Newspapers spread on the floor receive the dry shavings, which will be moistened with water and made into plastic clay again. Nothing is wasted. In their minds the clay is Mother Earth.

It takes a long time to scrape a pot smooth. The form must be made perfectly symmetrical; the lid scraper is employed with fast criss-crossing movements. Scraping broad curves is very difficult, but smoothing the tiny curves and crevices of knobs, handles, wedding-vase flares, lid edges, or rounding the lip of any piece is even more challenging. These skills, and learning to recognize wall thickness so as not to scrape through the pot, require long practice and patience. Finally, sandpapering in circular motions will make the surface satin smooth and is vital to the success of polishing.

A great deal of smoothing was done with gourd tools during the forming of the wet clay, but most of the thinning is achieved by scraping and sanding. Adam says he is used to doing this part of the finishing, but that last summer he sanded two vases so much that Clara polished right through the wall.

It takes unusual intuition to sense how thick somebody else has made the wall of a narrow-necked vase, when it is not possible to actually feel it inside. Now Adam says he will not sand anymore; he would rather build bread ovens. I laugh and remind him that if he does not continue to sand-finish pots, he will not be able to use that joke he enjoys telling our Idyllwild students: that he uses a very special sandpaper ordered from England. I believed him the first time I heard him. Then he winked mischievously, and I knew that he gets his sandpaper from any local store.

Scraping then sanding the dry pots to unflawed smoothness prepares the surface for burnishing, which gives them the final high shine.

Clara is very skilled at this technique and polishes for a number of the potters in her family. The clay slip, which is applied wet and polished when leather hard, is

made from a richly colored iron-red clay from a nearby pueblo. This special clay does not flake off the pot when it dries, and it will change from its terra-cotta hue into jet black in the smothered bonfire. Most clays the Indians have tried for this surface sheen do not have good bonding properties. Additionally, the metallic oxides present in the natural clays determine how black the clay will become in the carbonaceous firing. This clay appears to be a kind of shale, dark brown-red in its raw hue, and it works perfectly. It is taken from the deposit in chunk form. A small bowl full of it is slaked to a paste several hours in water and screened before use.

Clara applies the clay slip on a pot with a soft cloth folded into a square (Pls. 201–03). Burnishing is accomplished before the slip dries by rubbing it briskly with a hard, smooth stone (Pls. 204–07). Only the amount of wet slip that can be polished immediately is applied at one time. The clay is touched periodically with a trace amount of lard on a cloth, to keep the surface moist and lubricated and to enhance the sheen.

When everyone is working on pottery, Maria sometimes joins the group in the back room, but Clara works in her own room diligently burnishing the pots brought to her by the family. Of course the potters polish their own pots too. Barbara Gonzales, especially, likes to do her own burnishing. The stones they use, handed down from Nicolasa and Tonita and Alphoncita, have been held so often, so long, these many years, that they seem worn into perfection for the job they do. New, water-smoothed stones are all right, but do not compare. As with sanding, polishing the slip to a mirror shine in the small curves and crevices is especially difficult. No fingers must touch the high shine, for the oil will leave marks; the pot is held and turned with a cloth. If the piece is very thin, pressure may destroy or crack it. If the slip begins to dry, the stone will scratch it, and there is no way to repolish; the coating must be sanded off and the whole process begun again. If the slip is not a compatible clay, it will flake and peel from the pot during the burnishing or in the firing. One of the most difficult technical problems in the black pottery technique is to find a clay that will burnish to a mirror shine while at the same time bond perfectly without flaking.

When the clay is to be smoked in the fire to make the black pottery that Maria of San Ildefonso and her family are famous for, the particular iron content in the red

slip will achieve the blackest black. When the finished pots are to be iron-red (instead of black), the bonfire is oxidizing all the way. This means that the flames burn free and are not smothered. Smothering prevents oxygen from reaching the clay and traps carbon in the clay surface. Smothering the fire at peak temperature was the technique that Julian and Maria tried and perfected so many years ago. The potters in the family today are all artists, experimenting with clays, ash, slips, tools, designs, and colors.

Barbara Gonzales has tried a variety of clays for use in burnishing, as she has with clays for forming the pot. Different clays, if they work, add the excitement of a varied palette of colors when oxidation fired. These hues depend on the chemical composition and metallic oxides—such as those of iron, manganese, titanium, and nickel—the clays have acquired in nature. The variety of earth-red colors include warm red, yellow or orange-red, blue-red, dark and light reds, bluish pinks, coral and salmon reds. All are possible. In the case of the white clay used for the polychrome pottery background, its purity and absence of metals is essential. Barbara cares about finding and using different clays in her pottery, but much experimentation is necessary to find the right clay bond and polishing properties as well as the fired color.

Barbara says, "Normally when we are working with pottery, it is so quiet you can hear a pin drop. And what you do depends on the mood you're in. If you are in the mood to make big pots, you'll make big pots. The same is true for driving around looking for these different clays to try. I have looked over almost every inch of our reservation and gathered many different colors of clays. Some I haven't tried yet, but I like having lots of clays, and I know where there are lots more."

When the pots are polished, some will be decorated and some will be left with only the beauty of their form and gleaming surface. Another clay is used for painting designs, a more refractory greenish-gray clay, which leaves a matt finish against the polished surface after the firing. If the decorated pots are oxidized, the result will be a non-shiny pattern against a burnished red background. This red is the luxuriant burnt-orange shade of iron rust, which studio potters are enamoured of, but which no one can handle better in an artistic sense than the Indians of North and South America. If the same pot is smothered with horse manure during firing, the result will be a matt design on a shimmering black background.

Painting designs on the pottery requires special brushes, which money cannot buy. They are made from the midrib of the slender spiked leaves of the yucca plant, cut to a length of about five or six inches. Adam pulls off one of these yucca quills and begins to chew it. He continues chewing it for several days. When it has been softened sufficiently, he will trim away the fibers until only a few are left, wide enough for the line he wants this brush to draw, long and pliant with a little spring (Pls. 187–90). It is hard to imagine a more difficult brush. There is no pointed tip; only the side of the supple fibers near the flat brush end touches the pot surface (Pls. 191, 192). Santana tells me they also make soap from the yucca plant, especially for washing their hair, and believe that this is what keeps hair black.

The "eagle feather" and *avanyu*, with variations, are among the basic elements of decoration that Santana paints on her pottery. A zigzag design is sometimes called "clouds" or "kiva steps," even though she does not like to give names to the motifs. She continues the patterns she learned from Julian and is especially adept at painting his version of the mythical rain-serpent wandering around a pot or on the flat surface of a platter, with the wiggly stroke of lightning coming out of its mouth. Julian was a scholar when it came to analyzing old pueblo designs and he would playfully combine motifs from various other Indian groups whose pots he saw at the New Mexico museum. Sometimes he would draw decorations on paper and Santana would put them onto the pots.

"When Julian was living I did most of the small pots and he did the big ones, or I would fill in after he did the outlines. When he had something to do, I would take over when people came to visit. When Julian died, Maria's grief was so deep that she did not put her hand to a pot for four years."

When Maria did make pottery again, Santana decorated for her and they signed "Marie/Santana." At the same time Santana made and decorated pottery by herself and signed only her own first name. Then she found some pots in a store signed "Santana" that were not hers and she changed her signature to "Santana/Adam." Maria's son Popovi Da began to decorate, too, in the early fifties.

During the next years it was often Popovi Da who had his mother's arm, who painted many of her wares, who traveled with her when she was to be honored, who was

frequently her spokesman, and who changed the little grocery store idea Santana and Adam had begun long ago into a grocery-pottery store. Later he expanded this into the larger art shop, which now his widow, Anita Da, operates on the plaza near the old church.

The Martinez family members today help hold the pueblo together in their own ways, one of which is pottery.

Pottery and the cooperation needed for it form the core that gives the Martinez family a center and a sense of order. Problems are discussed and thought about, but it is the routine of the pottery making to which the family members can and do inevitably return. The rhythms of the work as part of daily life are important; personal and community concerns await the proper perspective that only time can give. So it was that serious, personal conversations could be held while Santana was working, then left in the air. Perhaps my presence influenced things. But a craftsman's work-shop is a positive place, perhaps an ideal place to reflect and consider while becoming involved in a routine but creative activity.

As pieces are finished, they are carried in a cloth to shelves or put on trays and covered with cloth. Great care is taken so that nothing touches or contaminates the polished surfaces. Also on these shelves are small pots and animals made by Beverly and Sylvia, young potters in the family, one or two pieces by Barbara's mother, Anita, and several of Maria's spherical forms. Barbara works in her own home, and her pots will also be part of this firing.

I noticed two of Adam's bears, polished and ready on a shelf. The first time I saw an Adam bear, although he had already been making them for some years, was among pieces brought to our Idyllwild school for the summer exhibition. Several times at San Ildefonso, as we were photographing clay processes, I had asked Adam if he would make a bear. To each request of mine he made wrinkly smiles and said, "Oh, the bear is hibernating," or, "Bears are not around this time of year," or "He will eat me." And he did not sit down to make me a bear.

"No, I don't think Adam will make a bear," Santana said when we were standing in the kitchen. But one day when I had the cameras out, he did bring two bears, one finished and black-fired and one still in dry clay. He said nothing, but as he sat in a

chair holding and looking at his fired bear, he knew it was possible for me to take a photograph (which, unfortunately turned out a little overexposed).

I am bewildered by the complications of pueblo life, by the closeness of relationships in a small, isolated society, and by the people's personal struggles in these unsettled times. The contribution of Maria and her family at San Ildefonso has been to keep the black pottery technique alive among themselves and the other potters there, so that we in our society and they in theirs can have it.

An understanding of these native American people may be reached through their pottery, through what they have done and are doing. But the non-Indian world first must want to *see*, not just to savor. Understanding is of prime importance for the preservation of their culture. That pottery making also is bound up in a system of values that includes what men and women are or are not supposed to do is indicative of the wholeness of this culture and the interdependence of its concerns.

There is very real worry that the Indian ways will be swallowed up and contaminated by non-Indian society. Yet within the Indians' own framework are problems of evolution and change. The issue is survival, of a people and of an art. This is good pottery, good art, which has perpetuated itself over a hundred generations—through a specific way of life—and has generated new expressions. It must be continued, and comprehended by the larger community.

The blue flower basket
On the top of heaven seems.
It gleams and all is done!
Agowaha ne-e-e
Esha ha'we rana
Ma-a-si

Barbara

Barbara Gonzales, fourth generation in Maria's dynasty, is destined to carry on the tradition of her family and its craft. Her energies now are carefully and conscientiously directed toward this aim.

Barbara lived with Maria from the age of six until she was nine or ten, impressionable years in an artist's life. She watched Maria make pots. She went with Maria to Santa Fe for the Indian exhibitions. She sat with Maria in the plaza, or in the Albuquerque train depot, selling picture postcards of Maria, and was also often photographed with Maria. Those years forged a strong emotional bond with the Indian way of life and the art of pottery.

Though young, she is already a well-known artist. She uses her Indian name, Tahn-Moo-Whe, on her pottery, her stationery, and her business cards. This sets her apart. The Indian name was given her by Maria, in the traditional manner, before she received her Christian name. She has made a responsible effort to live on the pueblo and to work to conserve its values as well as its art.

Barbara and her peer Tony Da, son of Maria's son Popovi and his wife Anita Da, are the most outstanding of the young Martinez potters. Tony Da's experimentation in pottery with color, form, inlay, and carving has brought him fame, and his work is in demand. But he lives away from the pueblo, far from the cultural center that Maria has built. Barbara's destiny is more than the pottery. It is one of direct succession to Maria.

During the years the young Barbara lived with her great-grandmother, she remembers that Maria took good care of her but did not like to comb her long black hair. Maria sent the child next door, to the house of her newly married Uncle Eddie, or woke her up early to send her down to her mother's house, which was near the day school she attended. Barbara smiles as she evokes memories of the times she stood in

line with her younger sisters and with her grandmother Santana's daughter Mary Daisy, all waiting to have their hair combed and braided.

"I made some pots then, when I was about nine," Barbara says thoughtfully. "They were like Marvin's now, you know, Sunset's young boy. I also used Maria's scrap clay to make something. By third grade I was polishing. At that time everyone went to great-grandmother's house to polish."

Barbara and her sister Sylvia stayed longer at Maria's house than the other children. Her mother, Anita, was kept busy caring for her smaller sons and daughters, but she made pottery, too, and helped the other family potters. When Maria considered Barbara proficient, she gave her pots to sand and polish.

Pottery was always a part of Barbara's everyday life, and this is why she feels she learned it naturally. During Barbara's childhood, with Maria setting the example, the family's activities centered around pottery making in all its stages. This created a definite structure for their lives and a strong discipline.

"Only afterwards, it was possible to do this or that," Barbara says. "Play or go to the river or do nothing. Write poetry, maybe."

After she finished sixth grade in the pueblo, Barbara was sent to St. Catherine's School in Santa Fe. There she stayed for the next seven years until she graduated from high school. Every summer, though, she returned to the pueblo, where she stayed with Maria and helped her in her pottery workshop.

Following graduation, she attended the University of New Mexico at Albuquerque for two years, and then spent a year at Fort Lewis College, Durango, Colorado. As a student Barbara did not make pottery, except when she needed to earn money. And for some years she did not touch clay at all, not until after she was married in 1969.

"I'm glad we weren't pushed into becoming potters. We all were given our choices as to what we wanted to do after we completed our high school eduation. But there are disappointments, too. We are a large family! We feel that there can be only one potter per generation. That is, only one of us who does pottery as a primary source of income, and the others help that person."

Barbara is a lovely young woman with long, jet-black hair, which she lets flow freely about her shoulders. She usually wears blue denim jeans and a colorful blouse.

She is bright-eyed, winsome, and self-assured. The Gonzales family lives on a slight hill beyond Santana's house. Together we sit on Barbara's steps, with our feet in the dust, talking about a variety of subjects, although at the moment I am really trying to find out about Barbara's life. Her eyes light up and she speaks with animation when she discusses returning to Maria's medium.

"When I first went back to pottery, I started with animals—bears, turtles, foxes, each one a little different. Then I pinched little pots. Later I began to explore the clay surface, etch, and inlay on small bowls and spheres. I have always wanted to try different clays. I began then to experiment with red clays for use in polishing, and this led me to search for different types and colors and eventually to the clay collection I have today."

About one-third of the women at the pueblo make pottery, if not all the time, at least during the summer and fall months. There are very few pueblo members who are traditional Indian painters; Barbara was one. Before she was actively doing pottery, she had her paintings exhibited in Philbrook Art Center, Oklahoma, in Washington, D.C., and in the Heard Museum in Arizona, and was included in a book on Indian painters.

"My father, Juan P. Pino, whose Indian name is Ta-mu-yo-wa, was a well-known painter in our traditional style. As a child I watched him sketch and paint Indian dances. I have some of his sketches and I'm glad I kept them. He has stopped painting, but every chance I get I try to encourage him to continue where he left off."

Barbara's grandmother on her father's side was also a potter. Barbara watched her making pottery, too, as she grew up, watched her polishing and firing her ware. Even as a child Barbara was impressed with this grandmother's workmanship and with her style in pottery. The shapes were different, she remembers, from Maria's and the others of her mother's side of the family, and she feels she has been fortunate in inheriting these separate influences.

Barbara's school and college years were spent away from the pueblo. She married Robert Gonzales, also from San Ildefonso, but they had no land or property of their own on the pueblo, and so they had to live in a rented house in Santa Fe. Barbara is emphatic: "We both wanted to live in the pueblo, but we couldn't. In order to build

your own house, first you have to have land. You only get this from your family if they have any extra, or by some special dispensation from the tribal council.

"What about the housing projects I've heard about?" I ask. "Wouldn't they help?" She reiterates what I have heard before. The federal government has initiated special building programs, housing developments at various Southwestern pueblos, but in the beginning, at least, these were not the kind of houses Indians liked.

According to Barbara, it is very difficult for young people to have their own homes on the pueblo. In Maria's and Santana's time, young married couples often lived with their parents or other relatives. Barbara and most of her generation have not wanted to do this, despite the difficulties involved in living away. Not all members of the pueblo have land that they can use to build houses of their own. Maria's family does have land; she has it from her father and from Julian. Santana's family had land, and today Barbara has land.

"The situation until recently was that if you didn't have land you couldn't live on the pueblo. Now more community land is available, so people will return to the pueblo for the security and the closeness we have here. I would, too, if that was all I wanted. As it is, living on the pueblo is difficult for me. I am too much aware of what is going on in the outside world. I'm not dependent on anyone for an income. Where pots are concerned, there has always been a demand by tourists. Now people are beginning to come to San Ildefonso for a particular artist. I so very much want to help my people. One way perhaps, would be to have a store. Then I wouldn't need to travel so much, to demonstrate and sell, and I'd be of some more benefit to the pueblo."

Barbara muses at length about her difficulty in choosing to come back to live on the pueblo after having been exposed to life at college and in Santa Fe. She had mixed first impressions, after being away so long. One of the things that bothered her was that the pueblo seemed always to be involved in small disagreements.

"I guess my trouble is that I can see them from an angle that they cannot see themselves because I have another perspective."

Barbara understands the difficulties arising from the closeness of isolated living. There are many issues to solve. In Maria's time there were also many problems, when

the pueblo stopped farming, when the men went outside to work. Part of Barbara's determination to live here is that she believes in continuing Maria's example.

"If you live here," she continues, "you have to participate in traditional ways. If someone gets hurt or something happens, you may not want to get involved, but you do. It is nice to know that your family is there. Everybody knows where everybody is. For instance, I can always look down and see my grandparents' home, where also Maria and Clara are, and my mother's house behind, and they can always look up and see my house. That is enough. But as for visiting, I think I talked with my grandparents more often when I came home to visit from Santa Fe."

Barbara's son Cavan comes running toward us. School is out, and it is lunchtime.

"Where's Aaron?" Barbara asks, but without anxiety. Nobody knows, but he cannot be far away. Small children wander in and out of their relatives' homes casually and with safety. Despite the disadvantages of living on the pueblo that Barbara has told me about, there is the advantage for young parents of the extended family. Aaron will come home when he gets hungry or tired, or perhaps an older cousin will bring him home. Barbara and Cavan go inside. She is mother as well as potter. And she also writes poetry, whenever she can find time alone.

My next visit on this day is with Gilbert Sanchez. He is married to Barbara's sister, Kathy, and I am interested in his views because he is a member of the group with no particular stake in the pottery making.

"Pottery at San Ildefonso?" he says, with a short laugh. "One way or another everybody does it for economic reasons. Tourists want our pottery. So today pottery making is no longer just for women." His remark expresses the general feeling of the younger Martinez generation, which is pragmatic and not concerned as Barbara is with the system of roles or the intellectual aspects of preserving the value system.

"Lately the trend has been that Indian youngsters go away to make it in the white man's world," Gilbert says. "But at San Ildefonso we seem to be coming back to the pueblo. It looks that way. We want to come back, because this is where our religion is, our Indian way. I want to stay because the family unit is so close. I couldn't live away from it for very long."

"So pottery does not keep you here?"

"No, no. And not many others, either. More and more of our people are coming back. We want to stay close, around grandmother and great-grandmother. We gather around them. We all live within a twenty-six-mile radius. This is the core of the thing. We see each other almost every day. At least we are within eyesight of each other, at Grandma's house or Mama's house, where we may just see someone out the window or driving by in a car. My mother is in San Juan pueblo, and she stays in contact every day by telephone. Here, more and more of our young people are coming back. Even those with a college education. Still, there are problems," Gilbert says.

Gilbert has adjusted to the changes that are occurring as Indians interact more with outsiders, but his values do not seem to be in conflict.

"As time goes on and younger kids come up, things change. I hate to see it. Our fathers tell us to do things a certain way, but we don't obey now. I guess we'll keep on till something bad happens."

"Such as what? How?"

"For instance, it's up to me if I participate in the dances, although we are all supposed to participate when we're asked. Since 1941 we danced every saint's day and more, but now we do less. Our elders choose the days. Our elders tell us to do certain things, but if we don't, sooner or later we pay for it."

Barbara has not accommodated so easily to a formalized way of life.

She seeks me out on Santana's porch and sits down, pushing her long hair back from her face. Her whole body shows she is agitated. Among the issues being deliberated on the pueblo, one involves the revival of an old ruling directed at women only.

Men alone are involved in the secret religious work and decision making of the pueblo; women are excluded. I have already heard Adam and Santana air their views on this issue to each other and to me, then put the problem aside. The issue is complex, but involves basic problems. Who is to make pueblo laws? Why do women have no right to vote?

Barbara is very concerned about these issues. This feminine young artist has strong views and speaks emphatically. Santana joins us on the porch. They smile at each other. Then Barbara rests her arms on her knees and continues speaking her mind.

"Pueblo life is harsh on women. Our political structure is male oriented. This has been hard for me to accept, especially since I have been to college. Women are useful in our dance ceremonials, to which the public is invited, but other than that we are ignored. We are not allowed to voice our opinion on matters that affect both men and women at the pueblo. I feel we have a lot to contribute as women. Many other pueblos allow women to vote, but ours does not!"

Santana is present, and she has given me the feeling that women are strong even if they do not have the vote. When I ask her this, she nods.

"Yes, I suppose so," Barbara agrees. "But you know it isn't right that only men decide and discuss, and that only men vote. My grandfather Adam has reversed his stand on this. But men like Adam are rare, too rare. Maybe two or three out of the whole pueblo. And maybe they're too late in their realizations. It's a very sad thing. I feel there has to be a line drawn between the sacred activities of men and the political governing body of the pueblo. We are not like Indian women of the past who were allowed to remain ignorant of important issues. Many of us today have much knowledge, education, and insight into things. And we have an interest in the decisions to be made. These decisions call for a majority vote in our pueblo. This I understand to mean women, by all means to include women. I'm sure we should not have one set of rules for women and another for men. Another thing, women are not supposed to have land according to tradition, but women do have land. So I don't know why they are going back twenty-five years now to bring out an old law. For us as Indians, to progress we must go forward, not face backwards."

I nod, and Santana does not speak.

Barbara continues, her expression calm despite the intensity of her words. "We women are people. We need to express our opinions. It is time for a small step forward, for both men and women to get into the governing body at our pueblo. Even now, when only men can vote, women should talk to their men and work on decisions together. Living situations are not constant. Laws can be amended, voted against, and even that can change again. It always reflects back to the men and the women who are living and participating in the pueblo."

Maria and Clara join us on the porch. Barbara is pleased and voices a Tewa greeting.

One senses a special warmth between the matriarch and her young great-granddaughter. Maria is a factor in Barbara's understanding of the dilemma. Maria's stoic struggle has been apparent to this great-grandchild. The older woman accepted the traditional role of women in pueblo life. This contrasts with the facts of her fame and popularity, her aplomb in grasping opportunities, her artistry. All those world's fairs, and all those awards and honors. For Barbara, Maria's way is not possible. But she genuinely desires to do everything she can to be part of her pueblo and has found a forum for expression as a member of the school board for the pueblo day school.

I want to hear more about Adam from his granddaughter. I ask her why he has always had such a strong sense of responsibility.

"Remember, Adam has had very little formal education, maybe fourth grade." Barbara says.

"But he reads!"

"Yes. But it is something he taught himself." She continues, more thoughtfully. "He was the oldest son. In those days the pueblo school only went to third or fourth grade. If you wanted more education you were sent away to school and your family didn't see you for at least a year. Adam did go a year or so to Santa Fe, but he had the responsibility of farming and caring for his younger brothers.

"Adam made paintings. He was very good, like his father, but he didn't have time for it. Maria was always busy with potting from early morning until late night. And when Julian was well he was busy too. Or else he worked at Los Alamos. So Adam took care of things. Then too, those were times of strife and split in the pueblo, and some of the teaching and Indian way were not done as well as usual.

"Juan, Popovi Da, and Felip went away to school, even college. They missed much of the Indian training that Adam got from my great-grandfather Julian. Adam had longer years of participation. Of course the Martinezes were like Vanderbilts or Rockefellers in this pueblo community. The younger boys got much attention.

"It was only natural Adam had the Indian ways inside him, and the brothers didn't. They had to learn to appreciate it years later. Also Adam married my grandmother Santana, who is an unusual person herself." Barbara has been serious, but now her face relaxes and she smiles up at Maria and Clara. "Of course, I treasure them all."

Barbara says they are all saddened by the fact that Adam's brothers did not live as long as they might have. "Those men could have contributed so much more to the life of the pueblo. But Popovi was governor of the pueblo for a number of terms, and Adam too; and they both served on the council."

Barbara picks up the thread again, musing about the differences of our two ways of life, which she and I have come to examine as part of our friendship.

"In the Indian way the whole philosophy of something is silently understood," she says. "From childhood, each of us is trained to be intuitively aware of what the other person wants us to do, without words and without a yes or no. This works as long as you don't need the help of those people. Even then they don't get involved. They will stand by you but they won't voice an opinion. It is all indirect help. It is planned to make you very self-sufficient. It is true for all Indians—if you have never had something, you will never miss it."

I enjoy and admire the way the older women sit on the porch and let Barbara talk. I have seen it in other situations too. They may not agree with her views on some subjects, but as with all younger members of their large family, their attitude is one of affection and tolerance.

"Anglo stages of growing up are not applicable to Indian children. Once you try to mix Indian and Anglo there is a clash. On my mother's side of the family, this is the first time where both of us in the couple are Indian but where one of us doesn't speak Indian. My husband can't speak Tewa because he grew up in Chicago and returned to the pueblo during high school. So Cavan and Aaron have this influence, and our boys are having difficulty understanding the Indian concepts. Still, when you are brought up the Indian way, you have the feeling that everything will take its course, that each thing will come in time. Our boys feel comfortable speaking English, so Tewa is foreign. But they participate in all the other Indian things. It is hard."

Barbara believes that her people should not try to take on non-Indian ways, but she mischievously states that it would be good if some old Indian ways could be taken by Anglos!

"Maria doesn't like modern inventions such as the tape recorder," Barbara stresses. "For the same reason she doesn't like television or the telephone. When things are

189

always available they get misused. Then Indians will become less eager to concentrate on the ritual stories and dances, the songs, and creative pursuits. And I agree with Maria. It is better to learn from people than from tapes. She wishes Indians didn't have these inventions because they take away from people contact."

Maria nods, smiling.

I am reminded of an incident that happened while baking bread in preparation for the Corn Dance. One of the women made a statement about why Indians "hide." This is the way she referred to the Indian reluctance to speak about themselves. The remark disturbed me, although I was aware of its truth. I wondered if Barbara would explain this further and decided to ask her now.

We were sitting in the kitchen, waiting for the bread in the outside oven to bake, when suddenly one woman threw her hands up in the air and said that Indians everywhere received such unfair treatment that she wished everyone would go away and leave the Indians alone, including, I suppose, me. She said that because of this harassment some Indians have simply retreated to insure protection of their interests, their life, and to keep their sacred beliefs from being exploited. Her implication was that Indian groups were compelled to draw inward and become more isolated. Her second point was that the old people were not teaching the young people Tewa, and that the young ones could not learn it in the pueblo school.

I am generally garrulous; nonverbal communication is something I appreciate but cannot emulate. Indians use other ways besides words to exchange ideas. There are many such peoples in the world, but few have been subject to the same stresses and pressures as have the Indians. Even well-intentioned interest from outsiders can be and often is an eroding influence. The mutual respect involved in real friendship probably allows the most direct communication, both verbal and nonverbal.

"Do you agree?" I ask Barbara. "Is it necessary to 'hide'?"

She pauses thoughtfully, before responding to my question.

"If you write things down, then someone looks at it years later; and that may not be the way it was at all. But it is written down, and so people accept it as accurate. We don't do that. We keep it in ourselves. We live it and that is how we keep it.

"It's like this. As something gets written down by people, there are different inter-

pretations and each time it is told, more is lost. We believe that. I think you see a step backward happening now, in non-Indian experiences as well as in ours. With a search for simpler life, people are going back to old ways."

Barbara pauses for my reflection and continues. "So it is with the Indian. If we keep our way we are not lost. And *you* will find it, discover it, one day. If we told you all, and it was written down, then it might get lost. Any Indian who has lived the traditional Indian life knows that his whole essence, religion, is more important than life itself. And so he keeps his beliefs to himself."

Barbara observes that Maria, even with fame, has emphasized this importance of keeping things inside yourself all her life. Maria always showed that what you have already in you and what you continue to feel, you keep inside.

Barbara remembers, "When I first started potting again, I asked Maria to make us a large piece because we didn't have any. This is what my great-grandmother told me then. 'When I am gone, essentially other people have my pots. But to you I leave my greatest achievement, which is the ability to do it. It is not weighing the material values that is important.' " Barbara says she sensed a new awareness in herself after Maria's comment and a better understanding of the importance of total learning and of doing the craft she reveres. Again Maria and Barbara exchange glances.

The conservative path this small pueblo follows is in resisting the move toward a mixed values system, which can be seen in so many other parts of the world. American Indian pueblos are changing, but at a slow pace. They seem to be holding on more tenaciously to their own ways than any other indigenous group I have observed, regardless of the erosion from outside forces. The emotional reaction against constant pressure, the desire to be left alone by all outsiders, is natural.

Of course there are threats to the Indian's own art by imitation. Even so, Indian craftsmen are demonstrating their craft techniques in public more and more frequently. They continue to have fairs and festivals of their work, with prizes for excellence. They have come to know that one way to maintain a value or a technique is to document it. In this way, others will be aware that it still exists and where it originates. This is a very important kind of preservation.

"Make use of your third eye!" Barbara says suddenly.

"Your third eye?"

"Be aware of your surroundings and pay attention to what your senses tell you. I am constantly saying this to students. It is so important! Unless you are aware of your environment—the feedback that nature is giving you—whether it's an ant struggling to climb a tree or the particular way some snow is being blown, the message is lost! We are constantly confronted with ideas, forms, images, but too often we don't see."

"The same applies to designs on pottery; at least I think so," Barbara says. "Unless a genuine effort goes into your perception of a subject, an idea of how to put a design will not be there. We all have different ways of perceiving an object. Take an elm leaf. The way the veins stem out to the leaf edge is different each time. Some people might interpret that realistically. To others the leaf can be abstract. We are surrounded by designs, and I don't feel there is any reason to copy or for people to say they can't find their own ideas."

Barbara is mindful that the qualities of discipline and patience are legacies of Maria's art and of her diligence. Traditional techniques of Indian pottery making are demanding. Once a piece has been started, its construction must be finished in the proper time; once polishing is begun, it must be completed. Barbara knows that these qualities have other associations in daily life.

"Clay is like dough; it remembers," she says. "It is special. It has character! If you don't knead it properly, it may not rise." She laughs. "Likewise, your masterpiece could explode in many pieces in the firing. We learn that a pot doesn't forget where it was ignored. It is pretty much the same with people.

"My pottery does vary from very traditional to contemporary in style. I use my own designs plus those that my great-grandfather originated. I try to do all my work with quality of craftsmanship. That's why I cannot make many pieces. None of us can, because we are very seriously concerned with perfection. True, the market value has increased lately, but also the quality and competition as well. There are many Indians who have begun to work recently, since Indian pottery became popular. But for us, we have been doing pottery since before my great-grandparents. So whether the trend dies or continues, I will still be potting."

"And the children?"

"I am hoping that years from now my sons will take a serious interest in pottery. Cavan makes small animals already. Right now, we have four coffee cans full of pottery shards that the boys have collected as a hobby. I feel the incentive is there, but I will not pressure them."

Maria and Clara and Santana leave the porch, but Barbara remains.

Perhaps more than other members of her family, Barbara is aware of the myths surrounding Maria's reputation. She wishes to dispel certain of them. "First, she never totally stopped potting. True, when her sons passed away and she was in mourning, she didn't make pottery for some months. But she still does make pottery now, and I hope she continues a long time!

"Another false rumor is that there are no longer any Maria/Santana pots. My grandmother Santana still does designs on some of Maria's pots. Since I've become more aware of all the pottery the Martinez family has done, I wish I could have known my great-grandfather Julian. What concepts of design he used!"

Barbara intends to return to school. Her life has been involved and complicated. She longs for the structured organization college might bring.

"Through our family I have met many persons, government people from many states, people in show business, professionals like doctors and dentists and professors. I am grateful to all those, and to the many people who just plain appreciate, love, respect, and admire the crafts of us 'native Americans.' I have learned a great deal! *Koo-däa* ('Thank you') and *Sahn-kge dēē ho* ('Till later')!"

She leaps up gracefully, at the same time handing me a sheaf of papers she takes from her pocket. It is time to return to her family. She is all Indian in some respects, but because of her many interests and responsibilities, she cannot always go on "Indian time." She is a sensitive artist and potter and a woman with strong beliefs in the rights of women. See is also deeply involved in her family. I watch her disappear behind the house, her long black hair like a shawl over the blue denim shirt.

Later that night I read Barbara's poems, feeling greatly touched that she has chosen to give them to me. This is her private art. One of my favorites is dedicated to her grandmother, Santana.

Yea-ya and *Taa* . . . *Koo-da!*

You've helped my parents rear us all.
So many, so little we all were!
How we must have gotten in your way.
Yea-ya and *Taa* take me to town too . . . *Koo-da!*

Listen, I hear someone singing. The drumbeat so faint.
At last the crying has ceased. Quiet and peaceful.
My sons, soundly they sleep.
Taa has stopped singing . . . *Koo-da!*

Yea-ya and *Taa* I like that land over by the hill.
The sight is beautiful from that location.
I can even see a house on it now . . . *Koo-da!*

And *Yea-ya* could you ask *Taa* to start the fire at the store for me?
Today I'm going to sell "fry-bread" . . . *Koo-da!*

For their kindness, I'm content! . . . *Koo-da!*
For their presence, I'm fortunate . . . *Koo-da!*
I hope I will not fail you!

And two stanzas of a poem for Maria.

What large steps you did take.
The courage unmeasurable.
My pace so slow . . . I can never catch up.

Great-grandma, a title so long.
Kque-yo, more meaningful—"Lady,"
A name we all call you.
Kca-e-Kque-yo to all others—"Lady of the hill."

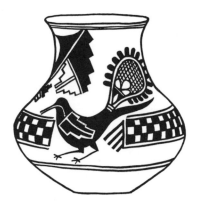

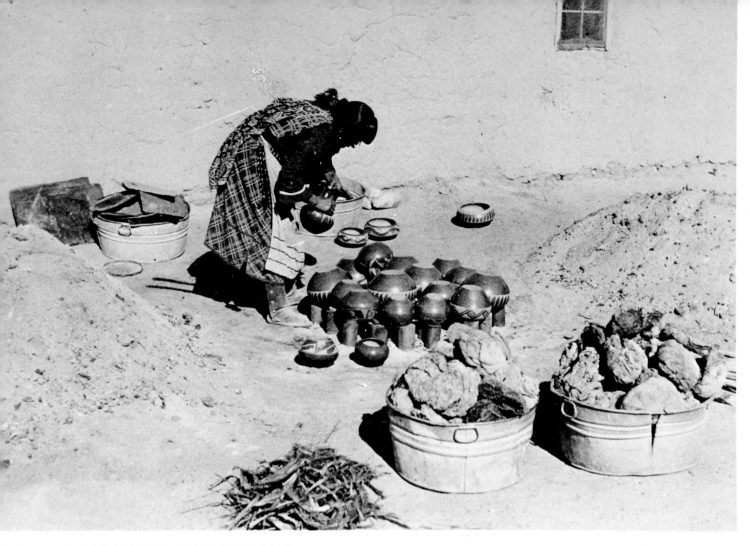

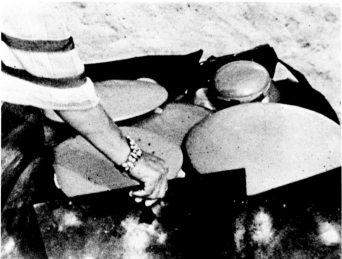

214–216. Black firing: Maria and Julian stacking pots; enclosing them with metal walls; stacking cow chips; early photos.

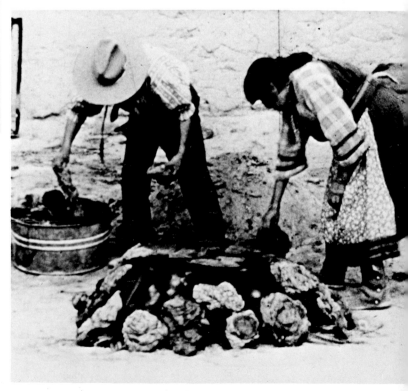

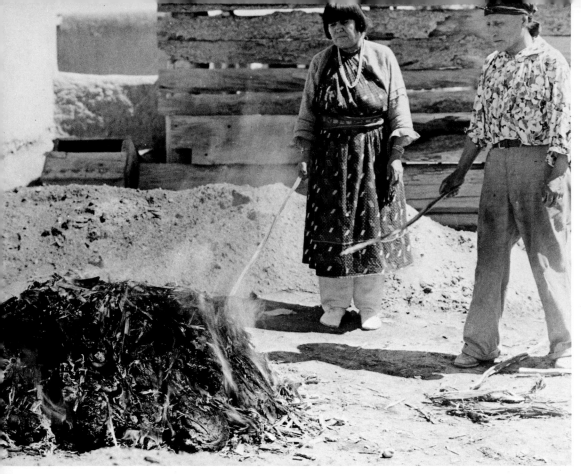

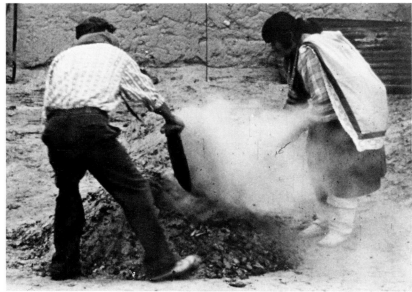

217–219. Black firing: starting the fire; (probably) smothering with ash; removing fired pots; early photos.

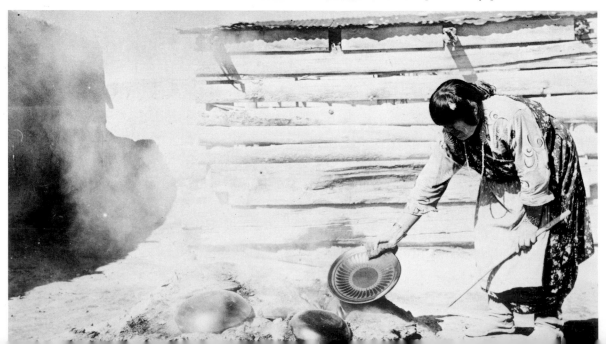

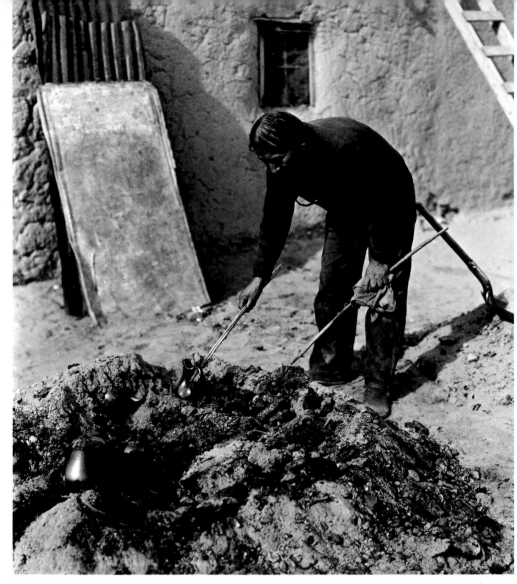

220, 221. Julian removing hot pieces after a firing, about 1930.

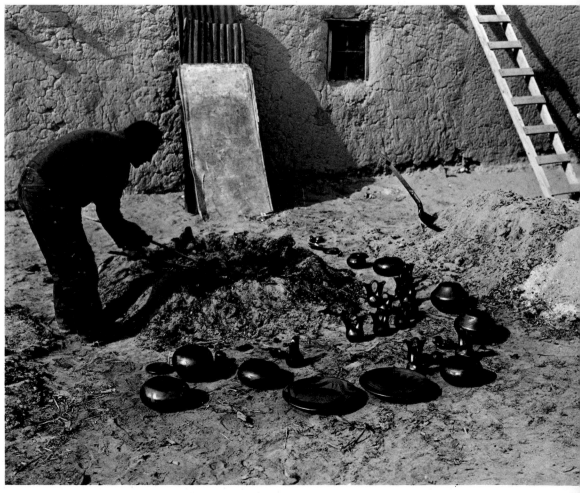

222. Shōji Hamada, Bernard Leach, Sōetsu Yanagi, and Maria, San Ildefonso, 1952.

223. Maria, Clara, and Barbara's son Aaron before the firing shed.

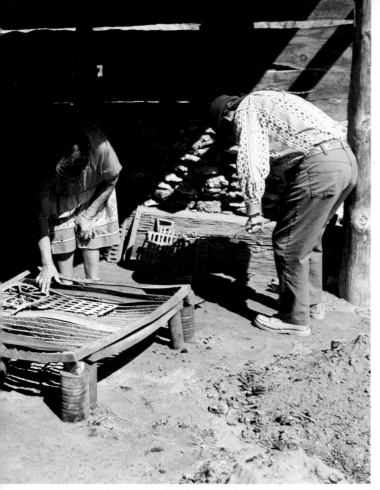

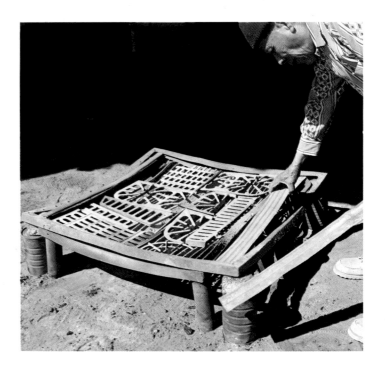

224, 225. Preparing the firing grid.

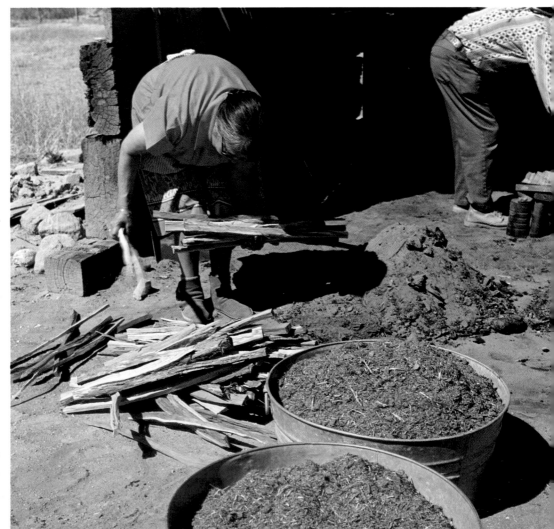

226. Wood fuel for firing, dry manure and wood ash for smothering the fire.

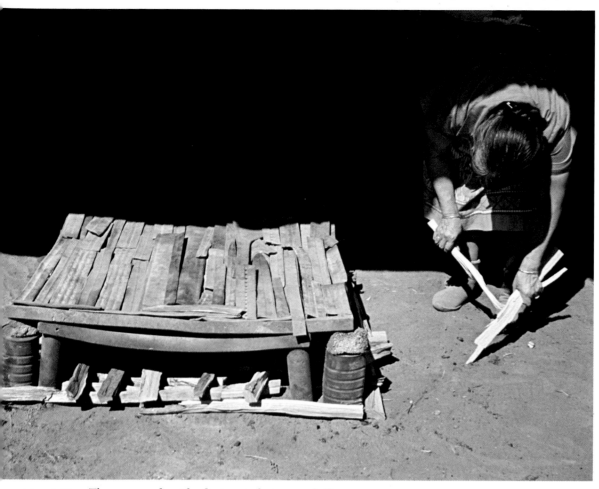

227, 228. The prepared grid; first pots being stacked.

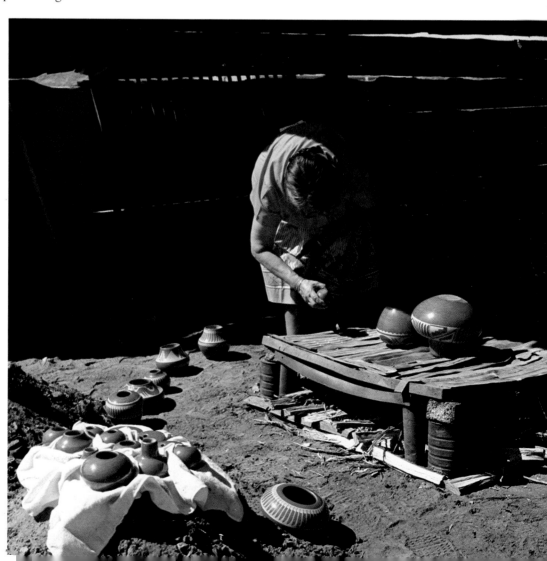

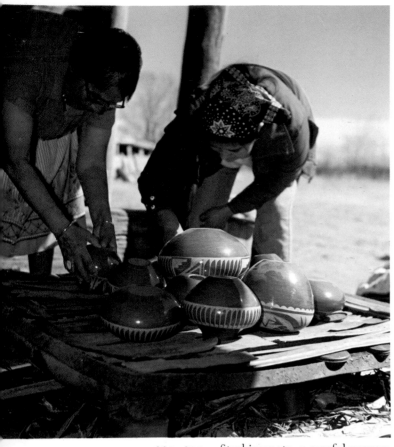

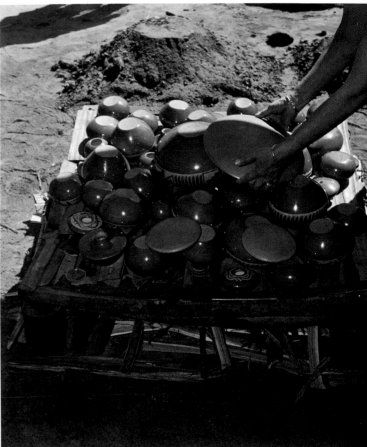

229, 230. Stacking pots, a careful process.

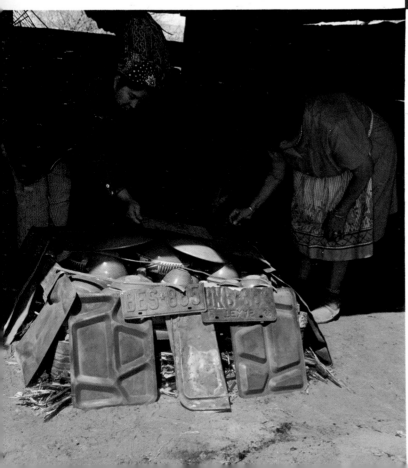

231. Covering stacked pots with license plates
and army mess trays.

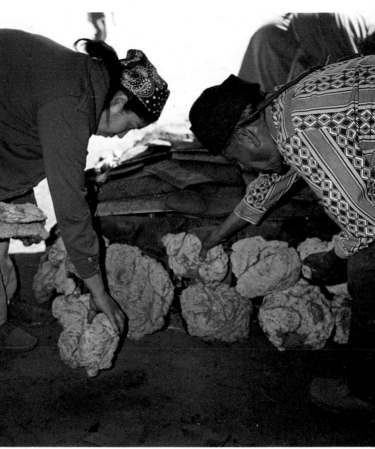

232–234. Placing the dry cow chips for firing.

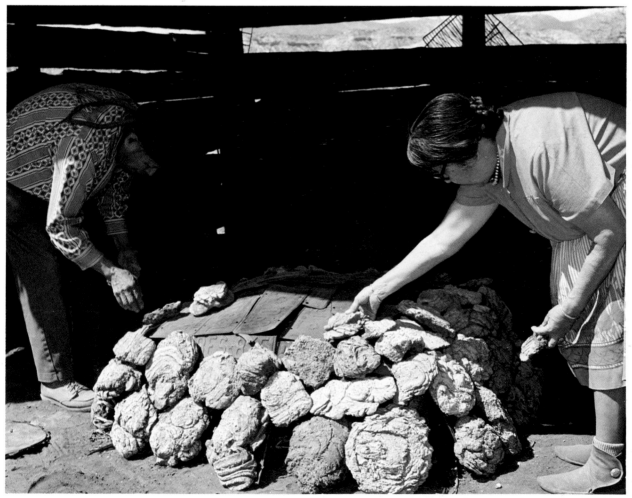

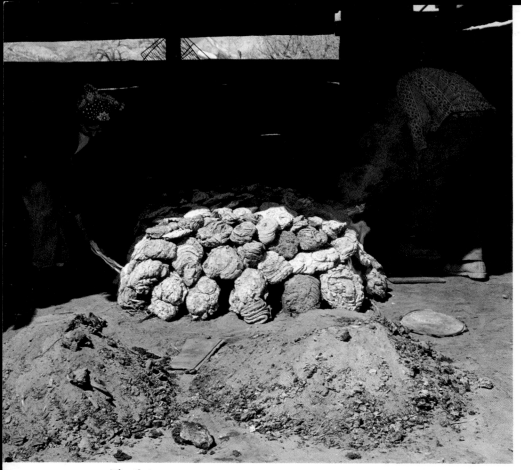

235–237. The firing.

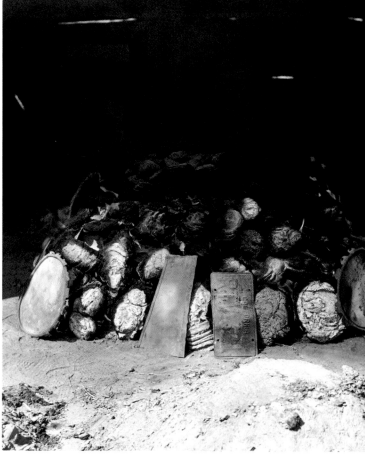

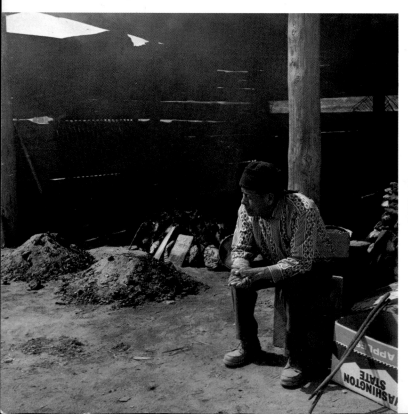

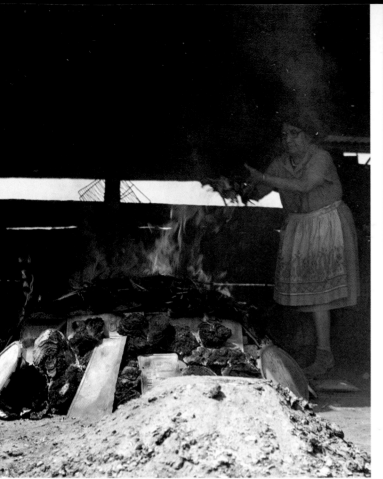

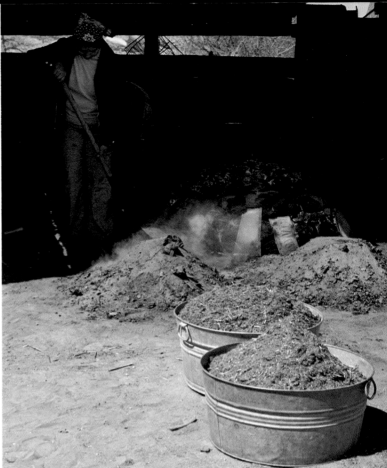

238. Adding bark and kindling.

239. Shoveling a low wall of ash around the fire.

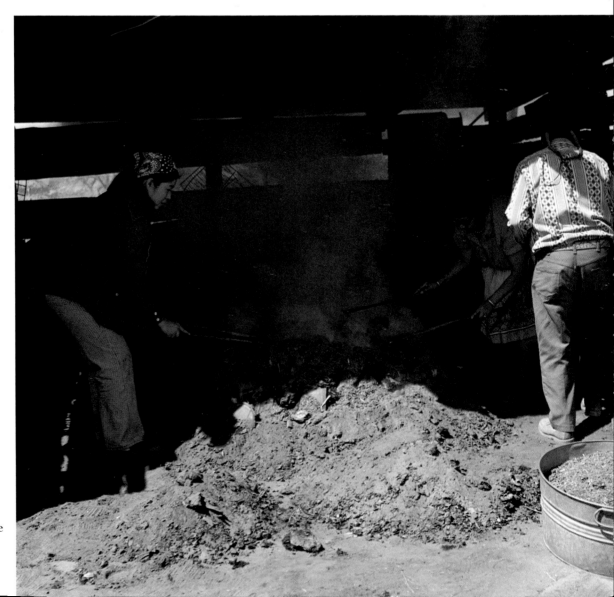

240. Smothering the fire
with dry horse manure.

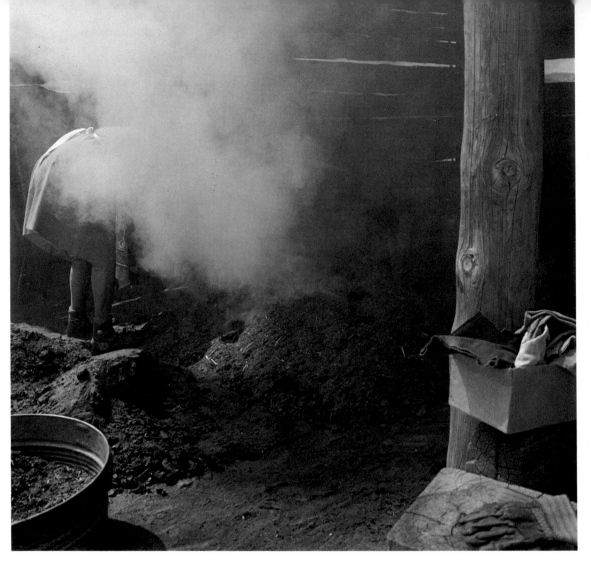

241, 242. Shoveling manure, then smothering with ash.

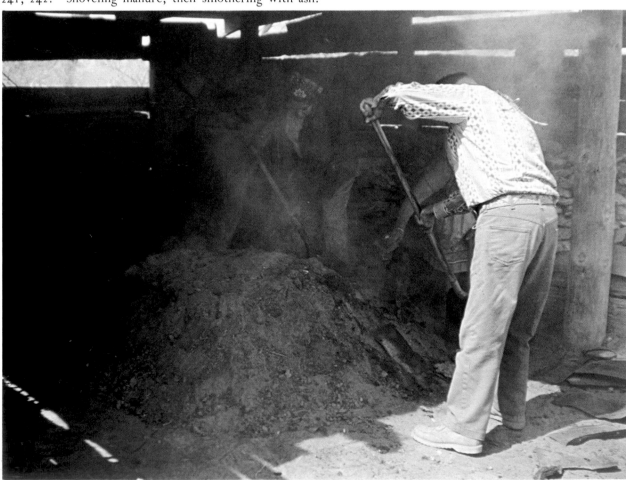

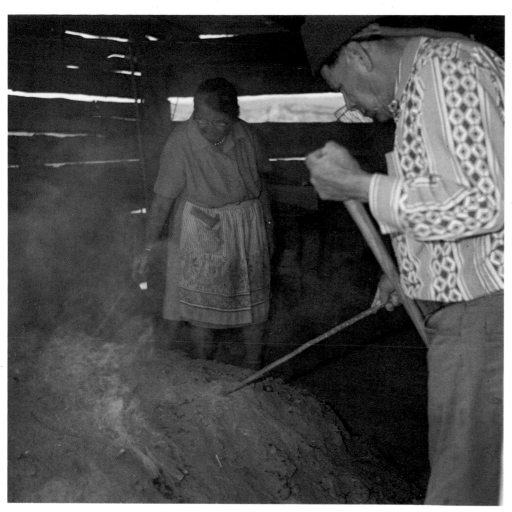

243. Making sure all holes are closed with ash, a hot and arduous job.

244, 245. A quick break; Adam with old signboard and refreshing suggestion.

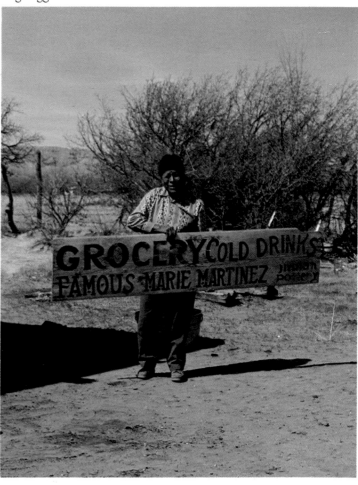

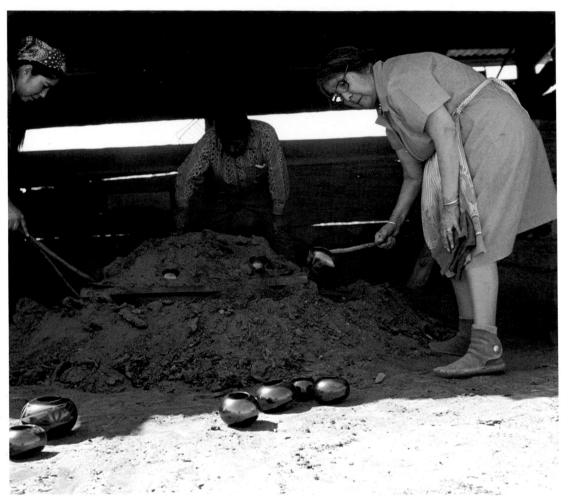

246–249. Removing the hot pieces with sticks.

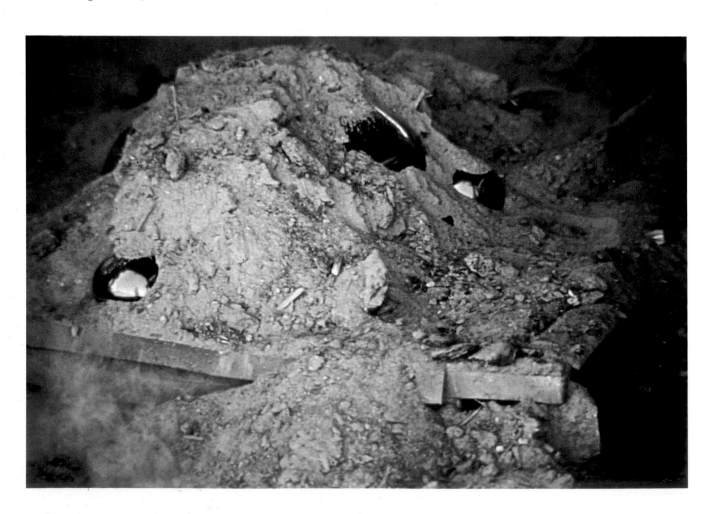

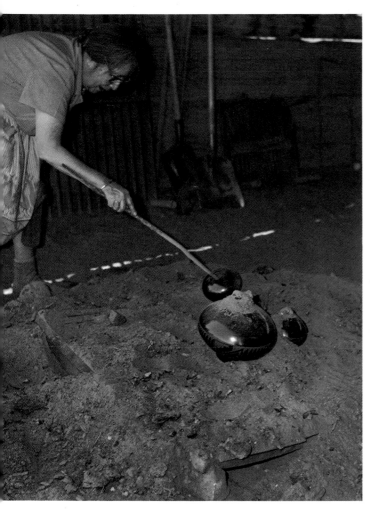

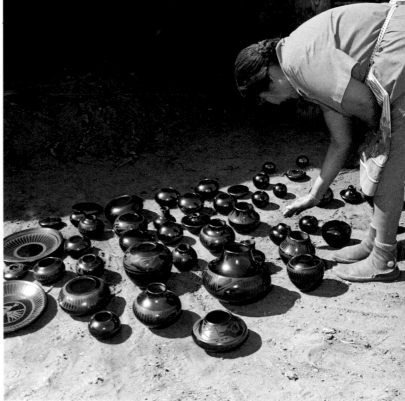

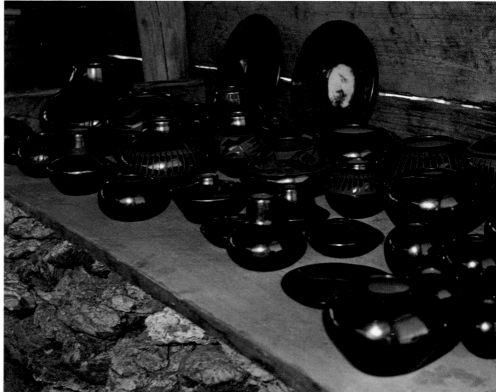

250. Gleaming, finished pieces, wiped to remove fire ash.

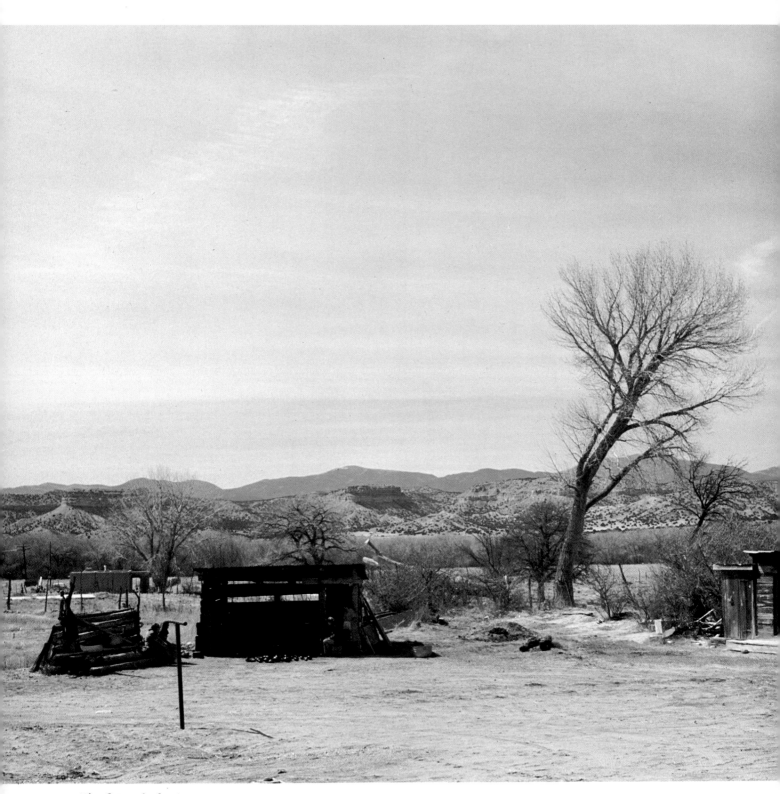

251. The firing shed.

Here and now we bring you, O our old men gods,
Sun Fire Deity and Blue Cloud Person of the North,
Sun Fire Deity and Yellow Cloud Person of the West,
Sun Fire Deity and Red Cloud Person of the South,
Sun Fire Deity and White Cloud Person of the East,
Sun Fire Deity and Dark Cloud Person of the Below,
Sun Fire Deity and All-colored Cloud Person of the Above,
Here-at we bring you now your special prayer stick,
We make for you an offering of sacred meal,
A little bit for all, we make these offerings to you!

Firing

The day is still, perfect for the firing. The early morning is clear and transparent, the sky pale blue, the light is yellow and brilliant on the hills. As usual there is no movement on the plaza, as if no one is home anywhere.

I push open the back door of the pottery room at Santana's house. Burning wood crackles in the stove, and the coffee is steaming on top. The oven door is down, and some pots are drying from the heat. Santana sits with her brown moccasined feet propped on a low stool. She holds a pot in her lap, painting the last lines. The slip for decorating is in a white restaurant coffee cup. Several yucca-fiber brushes and a small bamboo-handled one are on the table. Santana has probably been working for several hours.

I move on through the kitchen into the linoleum-floored family room. Maria sits on the green settee with her hand on her cane, tapping her fingers. Clara is bustling about. Adam is quiet. He looks out the window, his braids tied at the back of his neck and a stocking cap down on his brow. They have been waiting for me.

Polished red pots, most of them decorated and some of them not, are carefully arranged on cloth-covered trays and placed among soft wrappings in baskets on the table and on the floor. We exchange greetings. Adam, hands clasped behind his back, smiles and says: "Let's go!" He makes no secret of his eagerness to begin. Firing is the activity of the pottery process in which his help is most necessary.

It is important to begin early, when there is no wind. We walk to the old firing shed, a place hidden from view near Anita Pino's house. The area is open except for a few sere trees behind the shed. The landscape of the flat plain and the softly rounded hills is one of exploding quiet, as if it could hardly contain itself. The scene is one of inordinate peace.

Everyone carries pots, and more pots will be brought in the truck. Barbara joins

the group, coming down from her house with pots ready for the firing. She is accompanied by her smaller son, Aaron.

The shed is of weathered boards; one side is open. Along one inside wall dry cow chips are neatly piled three feet high, two feet deep, and covered by a wooden board. It is an amazing collection—cow paddies stacked like so many flat cheeses.

A square iron grill, placed in the center of the shed, is held up off the dirt by charred 46-ounce tomato juice cans eight inches high. A pile of wood ash is on the ground. Piles of split wood are neatly aligned, and there are two washtubs full of dry horse manure. I am sure it was Adam who worked it into a very fine texture, necessary to the process.

This is the first firing for black pottery that I have watched at San Ildefonso. So far it is similar to the ones we have had in the past three summers at the Idyllwild workshop except for one fact: there we had no storage of dry dung. We gathered cow chips in a valley, usually wet, and let them dehydrate in the sun or in a kiln. We collected manure from horses on the mountain. Adam spread it on the ground and, on the spot, directed his astonished students in a "manure dance," to the beat of his drum, so that their dancing feet would dry and refine the material.

Today Maria and Clara have walked along with us and have laid blankets for seats on nearby logs, in a good place to watch. The March morning is cool. Maria has a purple-blue shawl over her head, which she holds at her throat. Clara has a sweater over her cotton print dress, the favorite dress that she wears often. Maria is humming tunes, attentive to her great-great-grandson Aaron, who is dragging sticks to a pile on the ground. He has a small metal grate and is beginning to build a pottery fire like the one the adults are making. Using stones for pots, he is very carefully constructing a good replica.

Adam, Santana, and Barbara laugh and talk quietly as they work together. They are establishing the position of the grill and the wood underneath. Sometimes one of them takes a great deal of time positioning a stick, perhaps relocating it several times. Then one of the others will come along and move it elsewhere, taking the same time again in placement.

The basic iron grill is made of horizontal bars. Another old rectangular grate, a

large iron square, is set over this. Next, iron burner plates from old gas stoves and other heavy perforated metal grills are laid over those, making a delightful grid pattern of highlights and shadows in the sun. When this is accomplished after considerable time and much care, the potters take positions on each side of the "kiln" and begin the next step. Thin, long strips of tin are placed exactly, side by side, overlapping, until there are no open spaces and no fire can touch the pots from beneath.

Everyone talks half in English, half in Tewa. Maria is watching and laughing with them. Young Aaron has tired of his make-believe kiln and plays on a stack of logs, driving a forked stick and calling it a motorcycle.

The wood is set under the grill in three layers. The pieces are about two feet long by several inches square. Layers crisscross each other and are arranged to extend slightly outside the grill area. The manner in which the wood is distributed under the grill, and the quantity of it, will determine the initial impact and heat of the fire.

In speaking of firing, Maria had always called the wood used cedar. In Idyllwild we were able, through the Forest Service, to cut and chop a cedar tree. We had brought all the materials for the first firings from San Ildefonso. When they were used up, it was necessary to supply cow chips, manure, and cedar wood from local sources. After the next few firings with our wood, I noticed Maria shaking her head each time as the pots came out of the ashes. They were not quite shiny enough and not quite black enough.

Subsequently, more wood was added in each firing and longer burning time was given. Still the results were less than perfect. We learned that the horse manure was best from horses whose chief food was grass rather than hay. Apparently this provided more carbonaceous material for the desired jet black. But the mirrorlike quality of surface sheen was still missing from these firings. Finally a visitor from the Southwest gave us the answer to our problem by asking a question. "Well, did you ever see a cedar tree grow in the middle of the desert?"

Once again I had forgotten that natural substances are more diverse and more complex than commercial ones. At Idyllwild, we had not been getting as hot a fire as we could have had with a harder wood. I still do not know exactly what the San Ildefonso wood is, but it is not the same as our Idyllwild substitute.

Now Adam sprinkles twigs over the logs—three or four handfuls. Pots are brought in their baskets and trays, taken out, and set on the ground. The potters walk around assessing the ware, planning how to stack it on the grill, but not speaking. They work in harmony without needing words and directions.

Each one chooses a pot. Holding it with spread fingertips or balancing it from the inside, gingerly protecting the polish, each person places his piece carefully upside down on the grill, not in the shadow of another and never touching. The attempt is to balance the vessel properly the first time. Movement may knock or crack the fragile ware or fingerprint the burnish, but some rearranging is always necessary. Santana feels that the pots can be piled checkerboard fashion three high, not more. Metal canning jar lids, burned and charred from previous fires, are used to steady smaller shapes. The pots glisten brick-red in the sun; it is hard to imagine that they will be black after the firing.

Everyone is intent. No one speaks. Santana and Barbara bend over to select pots from the ground and bend again over the grill, holding body and arms steady as they work to position each piece a hair's distance from the next. Plates are laid last, on the top layer. They are held lightly but surely with spread fingers and set upside down over the seemingly precarious pile of pottery. Only the smallest pinpoint of edge touches another shape, so that all surfaces are free to be affected evenly by the firing atmosphere.

Adam leans over and tosses more twigs under the grill on top of the logs. Then he sprinkles kerosene over the wood so that when it is lit, a strong fire will spring up quickly and evenly with tall flames. The fire could be slower, says Barbara, or if it was contained by a hood, that might make the heating up more even. But the pueblo way is to quickly ignite the open fire around the pots by pouring kerosene onto the wood, so that the heat is immediate and even. Very few clays in the world can stand that treatment without exploding. No wonder the Indians treasure their rare clay deposit.

Now army mess trays and old license plates, blackened from many firings, are set vertically around the grate to form a shield, leaving an opening at each corner of the square and also two openings in the center of each of the four sides for draft.

"These *have* to be old New Mexico license plates!" Adam says.

The family does bring these license plates with them for the Idyllwild workshop firings. The number and size of the air vents vary with the size of the pottery pile. The size of this fire is about three feet on each side.

License plates folded over in the middle bridge the top corner edges across the open vents. Adam brings an armful of long and slender steel strips to begin the roof of this enclosure. These are laid in an open pattern across the top of the pots at an angle, coming to a peak in the center. This buttresses the crown of the "furnace," supporting the charred license plates that are laid across to form the cover. In the old days, before there were license plates and mess trays, Maria says this covering would have been built of broken potsherds.

Of course this structure of tin-can supported iron grill that constitutes an oven for pots, shielded by metal plates and cow dung, is a far cry from the type of kiln used by most contemporary potters. On the other hand, the principles involved in building this rudimentary "kiln" are basically the same as those of modern firing chambers. Wood as a fuel is not as common today as gas or oil or electricity, but it is used by stoneware and porcelain potters.

An open-fire "kiln" such as the Martinezes are constructing here has a great deal of precedent through the ages of man. Whether in a hole in the ground lined with clay or with pieces of fired pottery, or a simple pile of pots covered with stones and only with twigs for the fire, or a cave in a hillside, open fire has been used for hardening clay vessels since the beginning of the craft.

Maria and her family have improved the ancient method by adding the metal insulation and by raising the grill off the ground so that the fire has better circulation and the pots a more even atmosphere.

The last step in preparation for the fire is to lay the outside dung wall, which will form the insulation for the heat treatment. Santana and Barbara choose large round cow chips from the storage place at the side of the shed and stand them on edge against the metal. They begin with the largest ones first, big flat dollops of dung, dried and dense chunks without grass, and use smaller pieces to fill in. The chips are propped in rows around the mess trays, balanced on edge up to the top. They are

like bricks of a kiln. Holes for air vents are left as planned. More dung rounds are laid across the top, and the "kiln" is finished.

Santana and Barbara stand back to observe the total. Maria and Clara nod approval. It is time to light the fire.

Surely Maria is remembering the countless times she has lit a similar fire, with Julian or with Popovi Da. She always did the firing of her own pottery. Some potters are willing to relinquish this to others, but she never did. She was known for her firing ability, and, with her sister Desideria, she was in charge of Indian firings at the world's fairs.

Now three other members of her family are commanding this fire. Santana reaches into her apron for the fine cornmeal and throws it out silently in an Indian ritual of thanks and request for blessing. Adam and Barbara suddenly accelerate; they hurry about with torches, igniting the kerosene-soaked twigs at the corners, then the wood kindling through the air vents on each side. Flames burst up all around. Quickly, Barbara covers the air holes with hubcaps and round tin-can lids.

The time is 11:20 A.M. The fire surges upward, crackling. Black smoke swirls toward the top of the shed. A worrisome wind has appeared. The best firings are accomplished in absolute calm. Days for this work are carefully chosen, and the weather is monitored for some hours beforehand. In fact, Santana had put off this firing several times. Gusts of wind blowing through cracks in the insulation of license plates and dung chips may cause off-color blemishes on some pieces. Now as they feel the breeze, the potters all frown. Maria and Clara, on the sidelines, hunch forward as they watch the black smoke of this fire weave and churn in the breeze instead of going straight up into the air.

In ten minutes, the dung chips around the base of the mound are burned black and the edges of chips on the next rows are turning gray. Adam, Santana, and Barbara walk around the fire with long sticks in their hands. These are called simply "poking sticks," and are made from thin tree branches sanded smooth. They are burned black from use. As the dung chips smoulder, some of them fall down and are poked back into place with these sticks. Red flames burn high all around. The fire is intense.

It is surprising that raw clay can take this immediate heat without exploding. The

ash in the body and the evenness of the initial fire are part of the explanation. Even then, the wholeness of the process is indicative of centuries of learning and striving. Knowing the primitive method of firing, we can be astonished at the perfection we find in all good Southwest Indian pottery.

I am watching the tightly cooperative organization of a well-trained family. While the firing may seem a nonchalant and simple procedure, it is in fact closely coordinated. Timed within seconds, it is a ritual that, no matter how often repeated, is never the same. Natural conditions continually change. These factors are taken into account by the potters and compensated for according to the variables, so that the results are always the same or better.

Thirty-five minutes after it was lit, the bright fire dies to candle flames. Santana ponders, deciding if there has been enough heat to bring the pots to proper temperature. The black firing takes longer, takes different heat, than a firing for red or polychrome. She looks into the mass by poking several places, lifting a metal plate slightly. After some thought, she explains that when she had looked before, the pot surfaces were dull and now they have become shiny enough. I wonder how she can tell. Everything is chocolate-red hot and covered with soot. But she has given me an important clue: the pots must be very shiny before the fire is smothered.

It is the same with glaze in a conventional kiln. There are special things that happen during a firing only when glaze is maturing, when it is molten and ready. For instance we throw salt for salt glaze into a kiln at specific heats according to the clay body; copper reds are developed by reducing the oxygen in the atmosphere at special times during the fire. Although there is no glaze on the San Ildefonso pottery, the chemical importance of timing is similar. The Indians understand the need for control.

Four generations are together here today. Maria and Clara, Santana and Adam, Barbara and her son, function in a family circle symbolized by the discipline of this firing. That they are totally involved and interdependent in this undertaking gives them the opportunity for separateness in other circumstances. This is the strength of pueblo life.

As if on signal, at 12:00 noon the smoke and the fire die down. A few minutes earlier, in anticipation of this, Adam and Barbara shoveled ash from a nearby pile and

shaped it into a five-inch-high barrier all around the mound. This is to prevent air from entering the base of the dung "kiln" during the time of oxygen reduction, which will follow. Using the flat edge of the shovel, they form the ash into a smooth wall. The work must be fast, before conditions change.

It is time to smother the fire.

Adam and Barbara drop their tools and run to a washtub full of dry fine-textured horse manure. Quickly they dump this over the top of the mound. Immediately we are all engulfed in clouds of smoke. Adam and Barbara stand in the midst of the fumes, shoveling manure from the second washtub onto the places where smoke is escaping. Small flames lick up. The potters watch intently, each on one side of the mound, and quickly shovel manure to smother these sprouting last flickers of fire.

A pile of ordinary wood ash is shoveled over the manure. The blast of gray-yellow smoke begins to recede. Maria sighs and chuckles because now she can distinguish the figures and watch them again. The ash serves to seal in the smoke developing from the manure. To prevent the smoke from escaping is of prime importance in the carbonizing process. But everyone's eyes are smarting unbearably, and we are all coughing. A damp towel is passed around for wiping faces. It is necessary to stand in the smoke to keep applying ash where there are escaping whiffs. With stick or shovel in hand each person attacks the pile and pulls small amounts of manure or ash over holes where smoke puffs rise.

This is crucial. Carbon emitting from the smoking manure is being contained inside the mound. It acts by deposition to turn the originally red clay jet black. If the smoke is not kept in, the black of the pots may be marred by oxidized spots.

Maria leans forward on her log seat and taps the ground with her cane, excited and pleased as she watches Adam, Santana, and Barbara expertly catch and cover the filmy smoke streaks. All three potters tend the mound, walking, moving into the ashy pile, then stepping back to gaze intently for the culprit whiffs. If the mound of ash and manure begins to fall inward, it is shorn up with blackened cow chips.

I ask Adam where they get the manure.

"Montgomery Ward," he winks.

Maria laughs too and assures me it is from right here, even if I do not see any horses.

She tells me that one granddaughter and also a Spanish man have horses. And Santana adds that the wood, too, comes from nearby, from the mountains where they chop enough once a year for the bread ovens and the pottery fires.

It is 12:20. For the first time all of them can relax. Santana drops down on the logs by Maria and wipes her eyes. Adam perches on an unopened sack of manure, and Barbara establishes herself on the ground. The smoke is contained. The mound seems quiet, but it needs time to smoulder.

If this was to have been an oxidized firing for red or polychrome colors instead of black, it would not have been smothered. The oxidation "kiln" is built in the same way as this was today, but greater care is taken to fill the gaps, so that more of the heat can be retained while still maintaining air circulation. More kindling is used, since a hotter fire is necessary. If very large pots are to be fired, as was often the case in the early 1900s, one or two are placed at a time, with smaller ones around. The fire burns freely and hot until all the outside cow chips are charred to ash, then it is finished and pots are removed.

Suddenly a large, smoky funnel bursts up, and Adam rushes to cover it. Santana is crestfallen and moans. Now that the mound is not as hot as it was, the pots are more vulnerable than before to tiny spots of oxidation.

If a real flame ignited at the air hole, it would be the cause of a pink spot on a black pot. Of course it is disappointing to contemplate failure when a perfect black surface is desired. However, the principle of oxidation color-change on the reduced surface can be utilized and controlled for artistic purpose; and it is, in some of the work by Barbara Gonzales and Tony Da. This nontraditional process of reoxidizing the carbonized clay was first experimented with in the Martinez family by Popovi Da in the 1960s.

Suddenly Maria stands up. Clara stands, too, and bends her arm for her sister to grasp. Maria has tired of sitting several hours on the log. The sisters walk back to the house to rest while the pots are cooling in the smoke trap of ash and manure. The activity has been very demanding and the concentration intense. Now, for awhile, there is nothing to do. Often during the firings at the Idyllwild summer sessions, Santana was asked how long this waiting time will be. She would pause thoughtfully

and then reply, "About two hours." But the time for removing the pots was invariably shorter.

I find I must caution myself to remember that Indians do not count time in minutes or hours. Indian time is no time. Or possibly it can be described as "whenever." I remember Maria's answer to my question concerning when some event would take place: "Child, if the good Lord gives you the next minute, that will be time enough to consider it." I am still trying to learn that lesson.

The vigil for smoke puffs continues, but they are contained. We look out across the sandy earth, over the rooftops of the few adobe houses, to the distant Black Mesa. Adam has alluded to the importance of the Black Mesa in snatches of conversations from time to time, but he has never talked to me about it. Now our attention is caught by this dark rocky plateau, and I broach the subject again.

Adam begins slowly. When the Spaniards attacked them those few hundred years ago, the Pueblo Indians escaped to the Black Mesa. The Spaniards surrounded the base, expecting to starve the Indians, but the Tewa survived. "Maybe there is a hole in the mesa," Adam suggests. He conjectures that perhaps there are webs of tunnels underneath, like Carlsbad Caverns, from this Black Mesa to the mesa far away on the other side of the pueblo. The Spaniards could not follow because there was so much wind in the tunnels; only the Indians knew how to find their way. So the Indians were saved by this mesa.

Our thoughts return to the mound of gray ash under the shed. It has been thirty minutes since the smoke was fully contained. Santana is on her feet, looking into the pile, poking with her stick, moving the ashes to see if the manure is all burned up underneath. Without speaking, Barbara and Adam seem to know that it is and they rise too. They begin to flip the hot license plates out on to the ground with their sticks, dumping more ash in where they have removed the metal to avoid the shock of cold air.

If air reached the pots now, a fire could ignite and oxidize the pots to red again. Removing the hot license plates from the mound causes immediate cooling. All the metal pieces from the top of the crown are removed first, then those toward the bottom, and more wood ash is poured in. This appears to be a simple step, but it

requires the application of long experience. Adam removes hot unburned cow chips that also might reignite. It is now 1 : 00 P.M. Everyone sits down again to wait.

Maria walks toward us, coming back from the house. She moves her moccasined feet slowly, resting one hand tightly on Clara's arm, her other hand holding the manzanita wood cane a student at Idyllwild carved for her. She has come out because her own years of experience made her know intuitively that the pots are finished. With their sticks, Barbara, Santana, and Adam are fishing the wares out of the ashes. They lift pots from inside, wave them around, and set them down on the ground away from the smouldering ash. The surfaces are shiny black, as black as onyx. Many pots have a strange silvery glow. This unaccountable attribute is prized and means that this has been a particularly good fire.

Small pieces are removed first, leaving the larger ones covered for a longer cooling period. The black pots, gleaming in the sun, accumulate in a group on the sand. There are fifty pots, some worth $200 or more at today's prices. I am aware that whatever financial remuneration comes from their few firings a year is used for the thirty-two Martinez great-grandchildren and other pueblo needs.

Santana picks up hot pieces with a soft white cloth and holds them one at a time in her apron to dust the sticky wood ash off the surface. This is most easily done when the work is just out of the fire, but occasionally a pot is too warm to hold and she returns it quickly back to the ground.

Santana's shapes are traditional Indian forms—jars, bowls, and plates. She has decorated them with the painting of *avanyu* and eagle feather patterns she learned from Julian. Maria's small round pots, pinched in her palm with the center hole slightly larger than her thumb, are glowing little forms. They scarcely bespeak her earlier large two-foot-tall pots that people used to come from all over the world to see. In those days the variety of Maria's shapes, polychrome or black, included prayer bowls, lidded boxes, candlesticks, water jars, platters, large round and tall thin vases, and big storage vessels, cream and sugar sets, sets of dinner plates, and other table accessories.

Barbara's shapes on the ground are miniatures of the others. Some are decorated, but many are undecorated because she will do engraved designs with a special incising technique, which may take hours for each pot. Barbara's patterns are fine-line

stylized drawings of animals, squirrels, spiders, bears, birds, intricately backgrounded with geometric designs integrated with the form of the pot. Sometimes she embellishes the drawings with inlaid turquoise or bands of the tiny beads called *hishi*, and occasionally accents the jet black with reoxidized blushes.

Barbara's style is her own, and it is becoming well known. She takes her pots occasionally to Indian fairs in California and throughout the Southwest and demonstrates with other Indian craftsmen to various audiences. As her reputation becomes wider, she has more invitations for her own exhibitions in galleries and museums. These feature her, but she generally also brings the work of her sisters and her mother to show. Of course, Maria and Santana and Adam exhibit too, usually together, but increasingly the entire pottery family is included. After these excursions, Barbara returns to the pueblo, spending hours experimenting in her studio with techniques for "designing," as she calls engraving, or trying new clays she has found.

In these gleaming black pots scattered on the ground, part of the life of this pueblo is represented: the Indian way, singular devotion to their own artistic roots, and the naturally flowing repetition work that lets them relate directly to their materials. These are true craftsmen. Maria's contribution has been to revive and build on the black pottery technique of the ancient pueblo people. Other Indian women in other pueblos have become part of a similar lineage, with their own methods. But Maria's personality and her particular love for people and ability to relate to them carried her name and craft out into the Anglo world. At the same time she became a standard, held high for her own people.

In non-Indian society, the traditional male role has been protective and economic. Among Indians the male role was the same, before the drought and the war. Maria stepped from the traditional woman's role to one of providing economic stability for the pueblo. In this way, the role of men at San Ildefonso as protectors of spiritual values has been reinforced.

The young present a complex picture. Their decision-making tends to be very personal. Some members of the younger generation drop completely out of the community process. Barbara lives in a society she reveres, but it can sometimes be stifling because of her wide experience and searching intellect. Indian young people today are

torn between the historical values and authority of the tribal council and their own ideas and desires. This situation is compounded by the fact that the young want to know the traditional in order to return to its base; this is a thread in Indian pueblos as well as outside.

The more the younger generation deviates, whether in pottery techniques or in life-style, the more the older generation finds importance in the rituals, the language, stories from history, and the intricate planning and structure that keep Indian culture apart from the outside world. This fact is common to any isolated ethnic group. The older generations know the positive, cohesive power of community ceremonial.

At ceremonial times, it is Maria, dressed in some brilliant costume, who becomes the focal point. It is her contribution and it has been so for nearly all of her years.

Santana bakes bread at dawn. Adam proudly searches for parrot feathers and shells to make dance accessories. The children of Adam and Santana, who are now adults, and all their children, the cousins, aunts, uncles, brothers and sisters of this family, of this pueblo, come together in ritual. Maria knows, Santana and Adam know, and Barbara knows that in this way all is still secure.

Now Maria has time for watching the hills in the distance across the pueblo and time to be in the adobe houses, at the heart of her family. When anyone of them comes into a room, old or young, her eyes brighten and she is eager for conversation.

Maria Martinez has passed her mantle to Santana, her daughter-in-law, who has assumed her role of leader of the women in the pueblo. She has passed it to Barbara, the great-grandchild in whom she places profound trust, and to Anita Pino, Evelyn, Sylvia, and Pauline, who continue her traditional style pottery, and to their husbands and daughters and sons. She has passed it to her grandson Tony Da, famous for his new trends in her tradition, who does not live on the pueblo. And to Adam, the steadfast son who has preserved the teachings of the old men in the kiva and of his father Julian, and to Adam's sons George, Frank, Edward, and Julian, who carry on these teachings. Now she gives it to children like Beverly and Rachel, who are learning to make pottery, and to Marvin, who dances with Adam's tutelege the dances of old. To all these grandchildren and great-grandchildren and great-great-grandchildren she exemplifies and shows, even as she works, the essence of the Indian way.

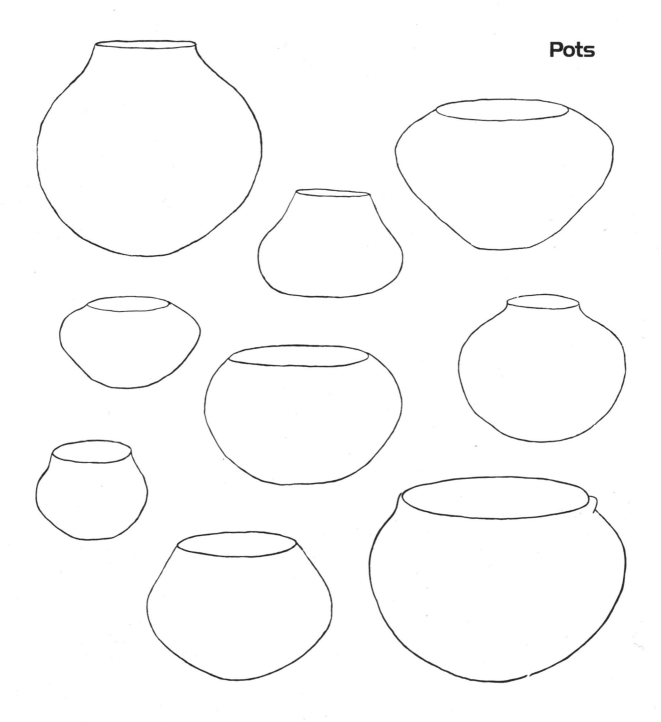

Pots

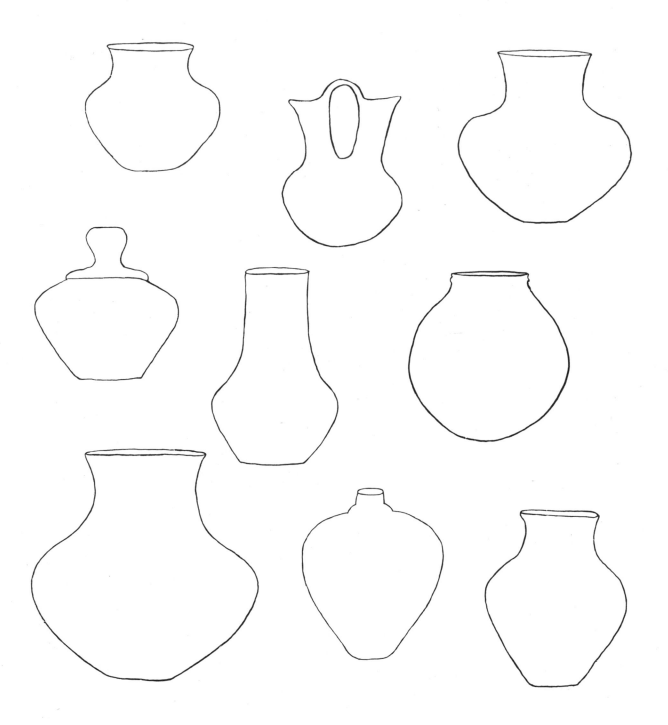

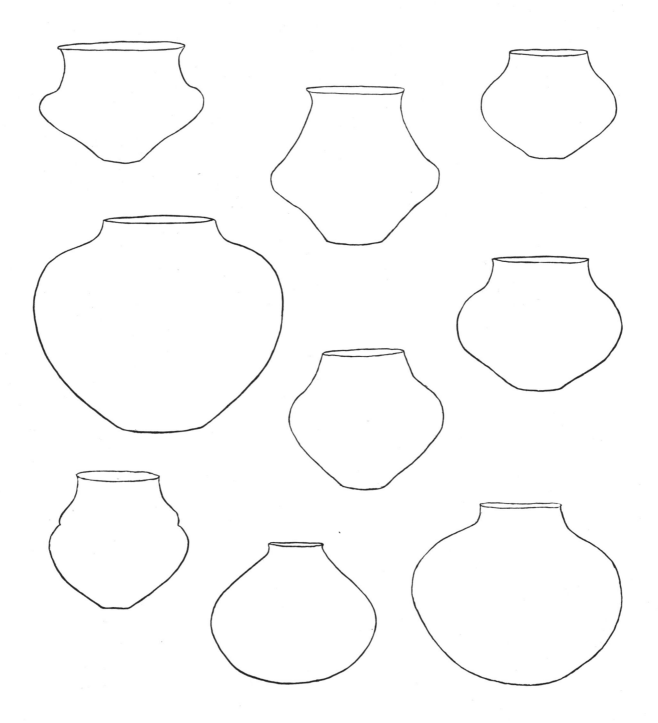

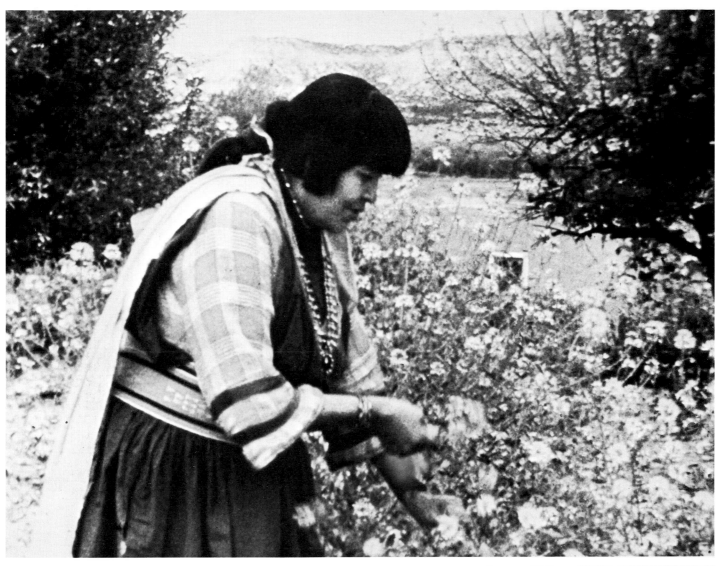

252. Maria gathering *guaco* for use as black-pigment on polychrome, 1920s.

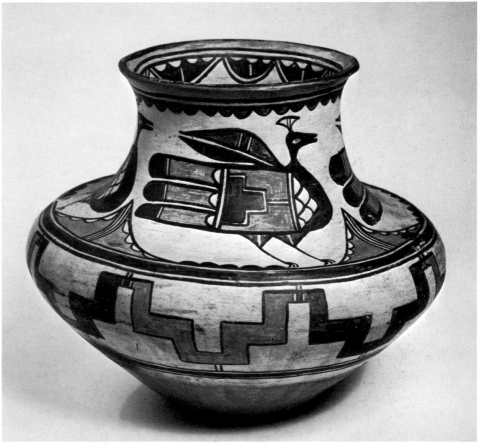

253. Water jar, Maria and Julian, ca. 1910. H. 25.4 cm.

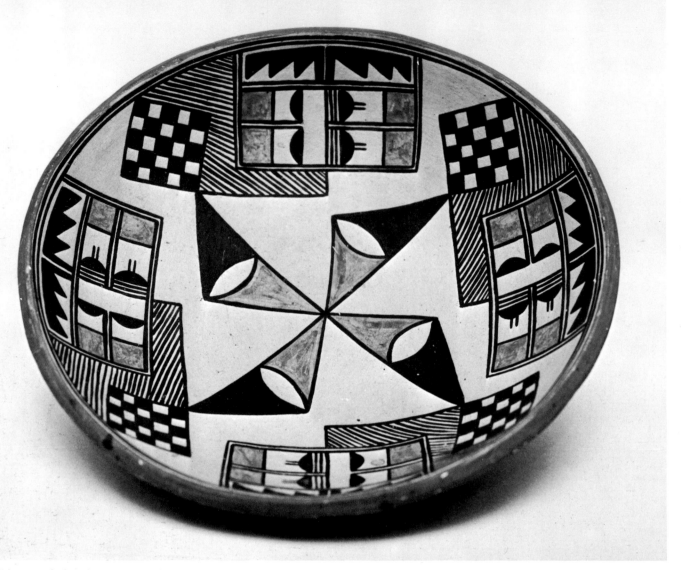

254. Ceremonial bowl, Maria and Julian, ca. 1910.
H. 20.3 cm.

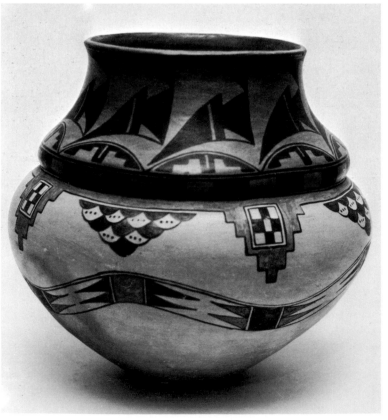

255. Storage jar, Maria and Julian, ca. 1920. H. 30.5 cm.

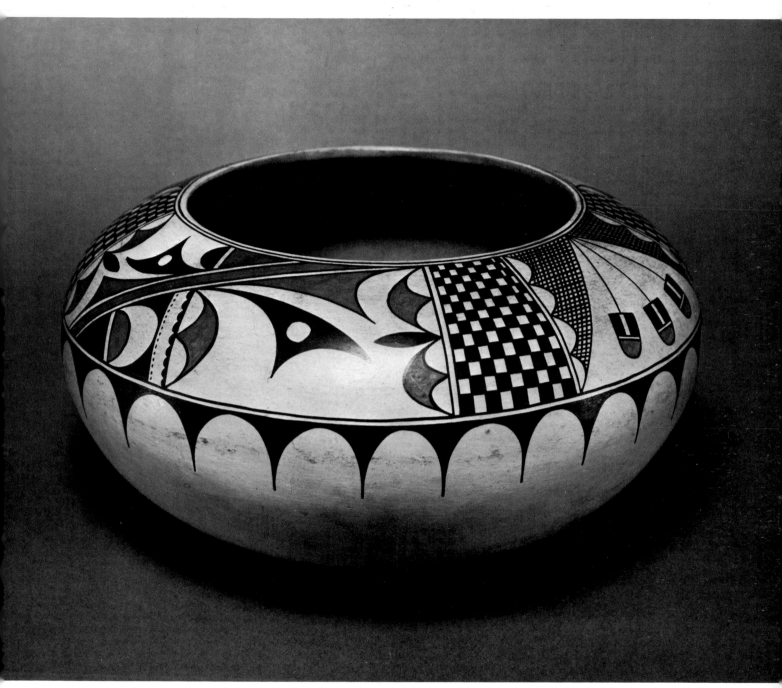

256. Ceremonial corn storage jar, Maria and Julian, ca. 1920. H. 15.2 cm.

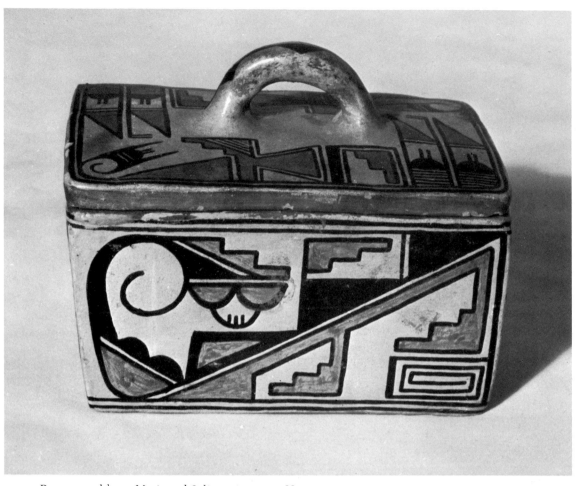

257. Prayer meal box, Maria and Julian, ca. 1920. H. 25.4 cm.

258. Bowl, polychrome revival by Maria, decorated by Popovi Da, 1958. H. 15.2 cm.

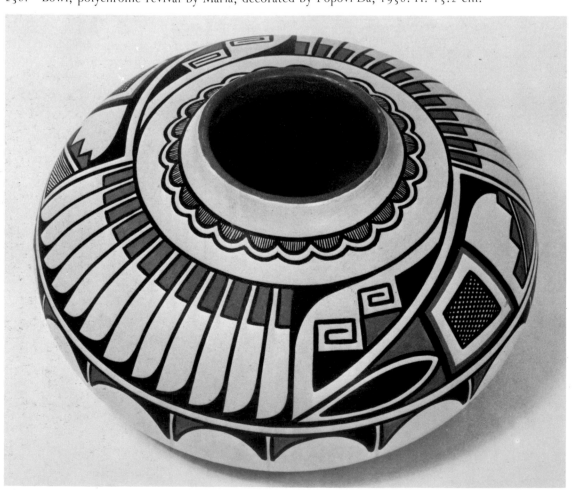

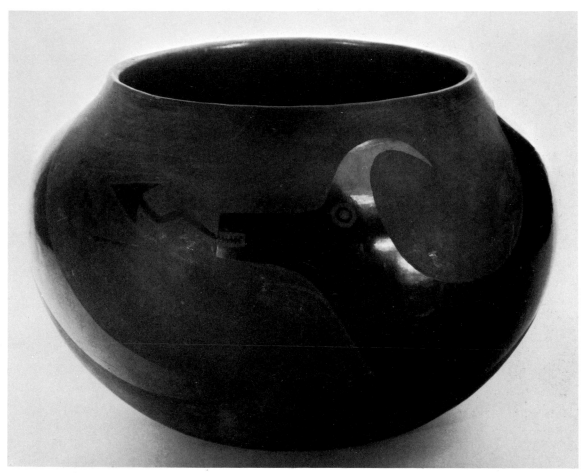

259. Storage jar, Maria and Julian, ca. 1918. H. 22.8 cm.

260. Large storage vessel, Maria and Julian, ca. 1920. H. 58.2 cm.

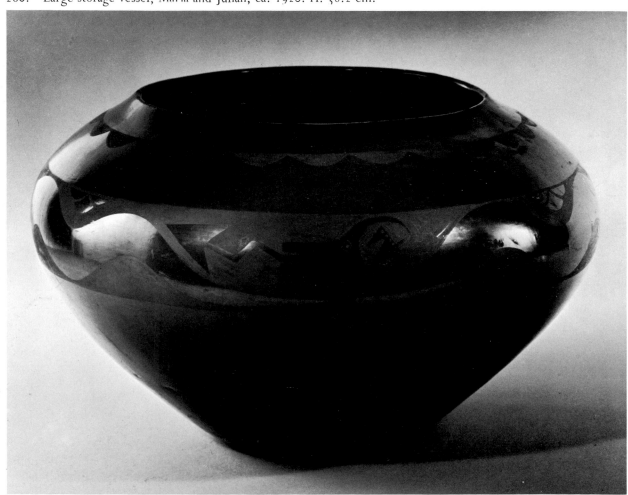

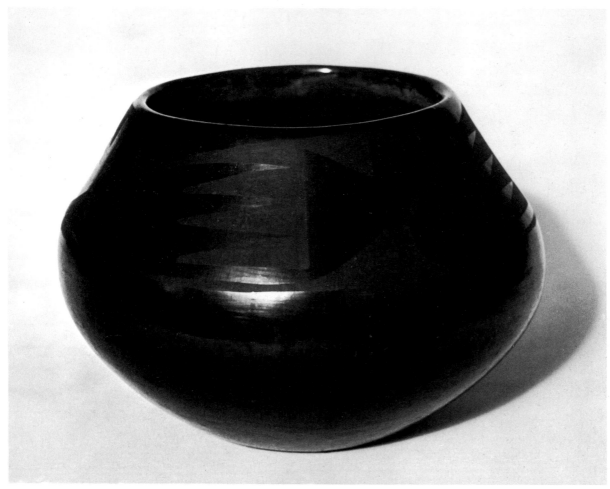

261. Jar, Maria and Julian, ca. 1920. H. 15.2 cm.

262. Bowl, Maria and Julian, ca. 1925. H. 15.2 cm.

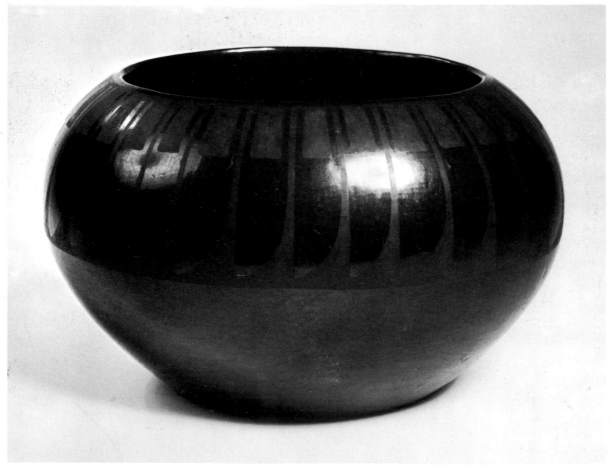

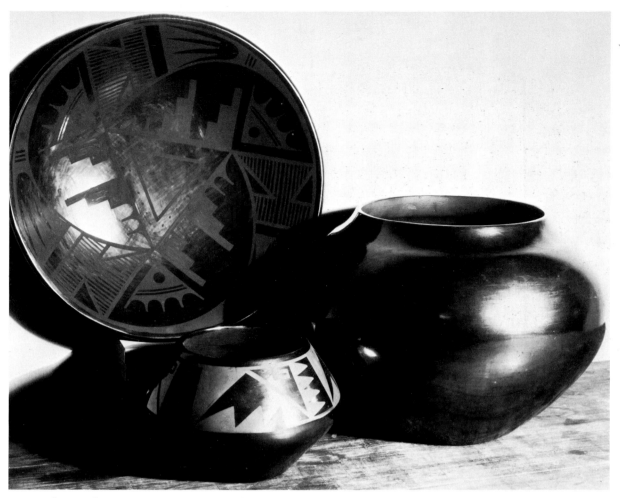

263. Plate and two jars, Maria and Julian, ca. 1925.
Plate d. 48 cm.

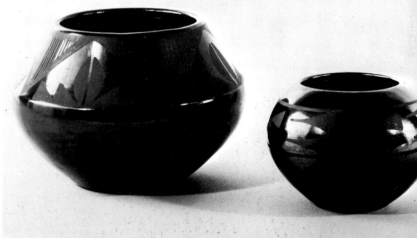

264. Jars, Maria and Julian, ca. 1930. H. 22.8 and 15.2 cm.

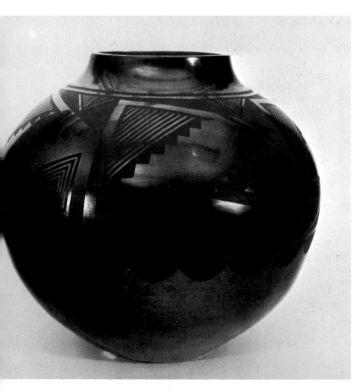

265. Storage jar, Maria and Julian, ca. 1939. H. 61 cm.

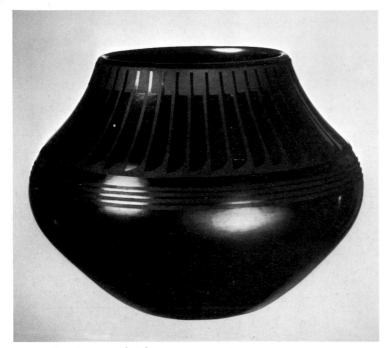

266. Jar, Maria and Julian, ca. 1930. H. 17.8 cm.

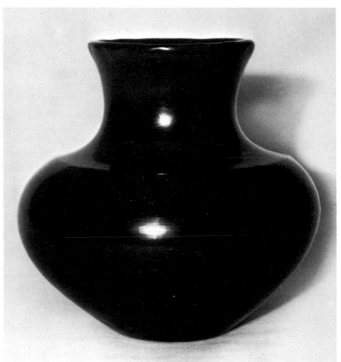

267. Jar, Maria, 1970. H. 25.4 cm.

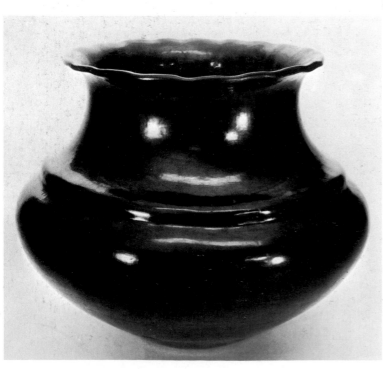

268. Jar, Maria, ca. 1930. H. 45.7 cm.

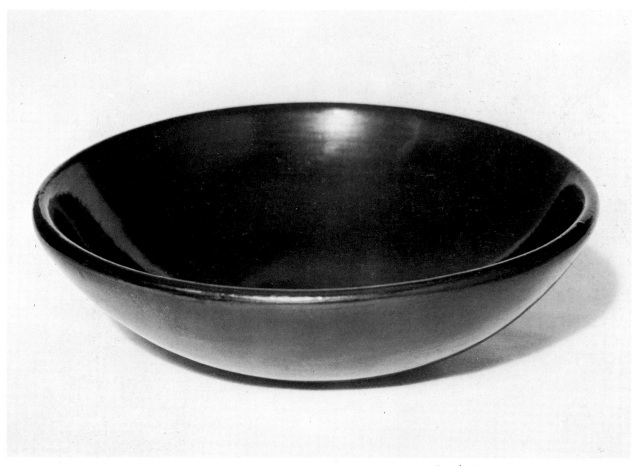

269. Bowl, Maria, ca. 1960. D. 25.4 cm.

270. Small spherical bowl, Maria, 1976. H. 10.2 cm.

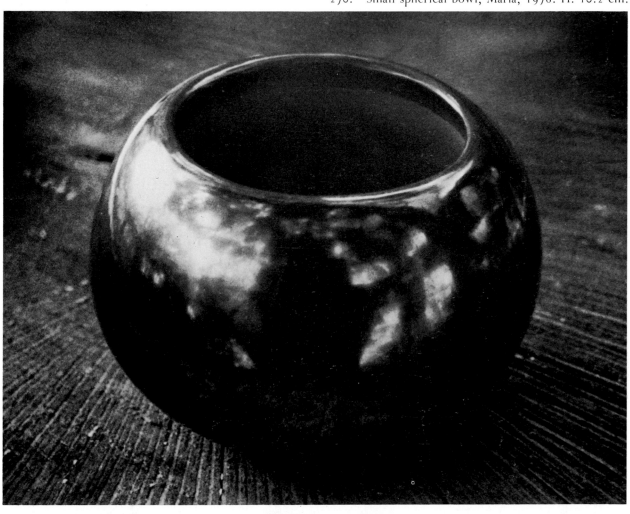

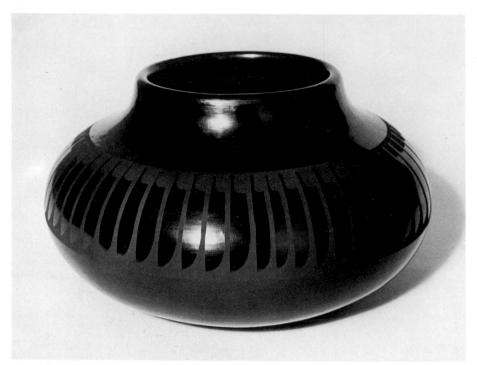

271. Jar, Santana and Adam, 1974. H. 17.8 cm.

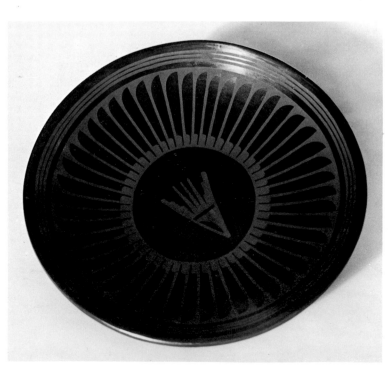

272. Lidded jar, Santana and Adam, 1974. H. 25.4 cm.

273. Plate, Santana and Adam, 1974. D. 33 cm.

274. Wedding vase, Santana and Adam, 1972. H. 25.4 cm.

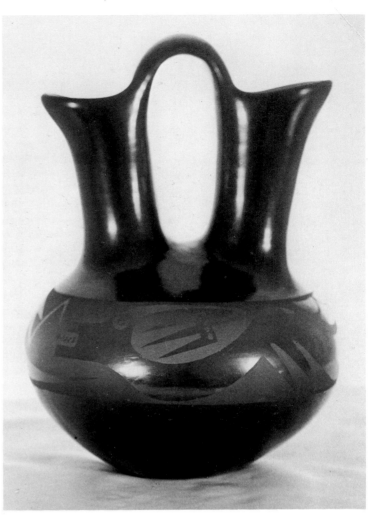

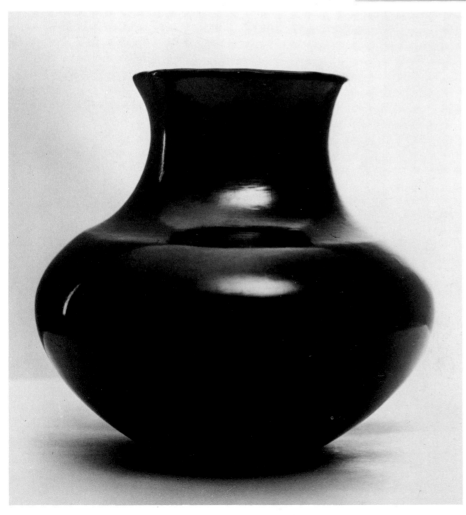

275. Jar, Santana and Adam, 1972. H. 25.4 cm.

276, 277. Bears, made and polished by Adam, 1974. H. 10.2, 12.7 cm.

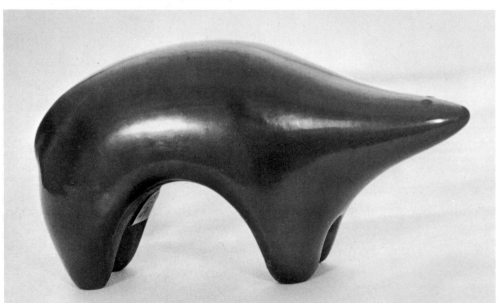

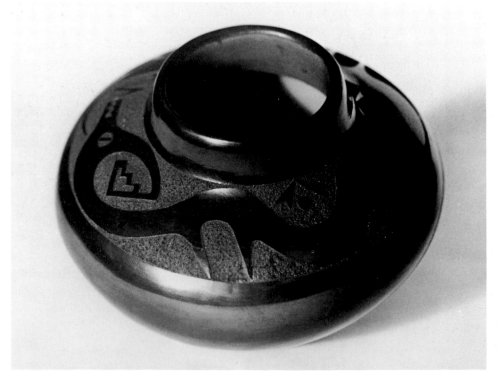

278. Jar, by Barbara Gonzales, 1974. H. 12.7 cm.

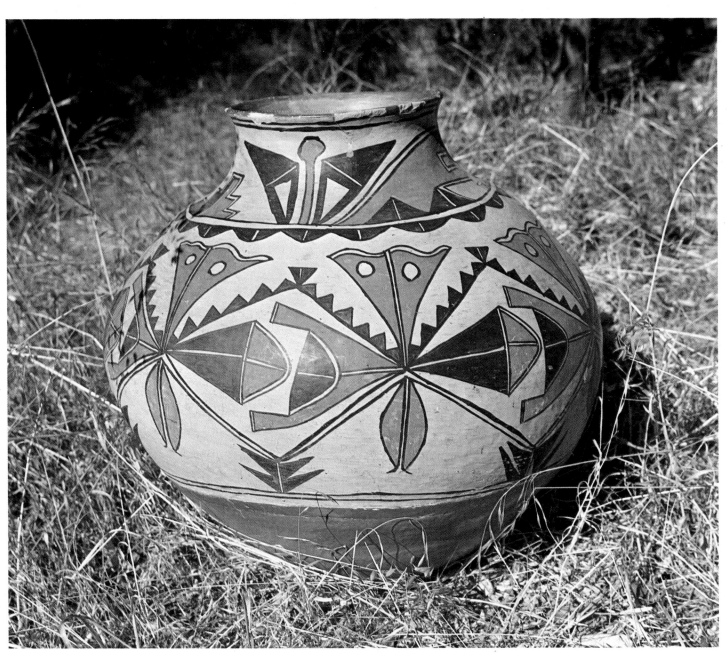

279. Storage jar, San Ildefonso polychrome, ca. 1910. H. 61 cm.

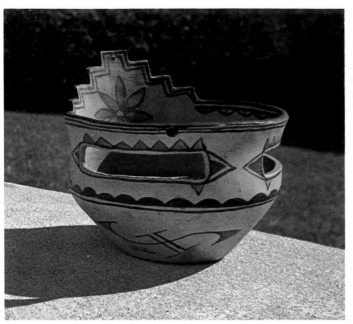

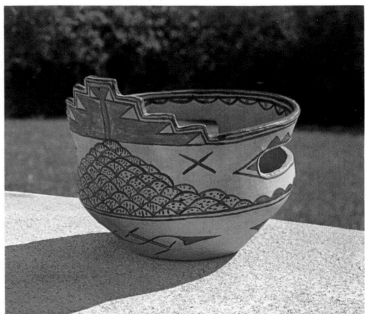

280. Prayer meal bowl, Maria and Julian, ca. 1915.
H. 20.3 cm.

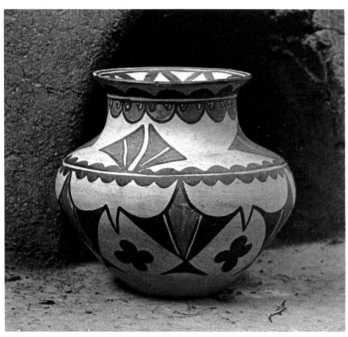

281. Water Jar, Maria and Maximiliana, ca. 1910. H. 27.9
cm.

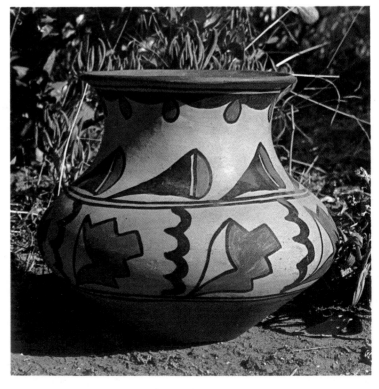

282. Water jar, Maria and Maximiliana or Juanita, ca. 1910.
H. 25.4 cm.

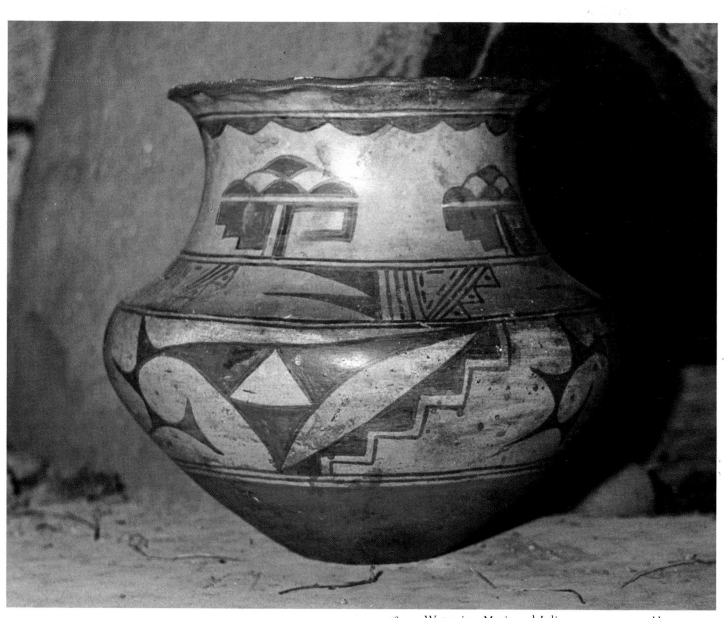

283. Water jar, Maria and Julian, ca. 1915–20. H. 30.5 cm.

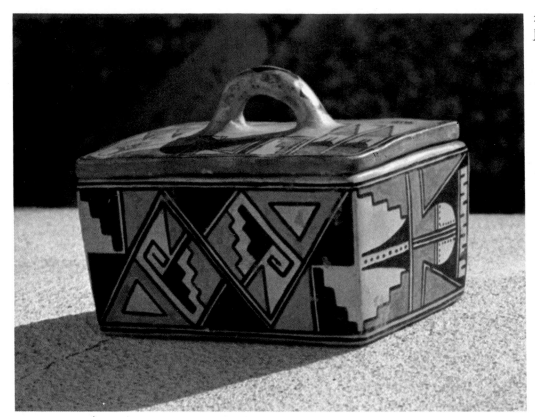

284. Prayer meal box, Maria and Julian, ca. 1920. H. 15.2 cm.

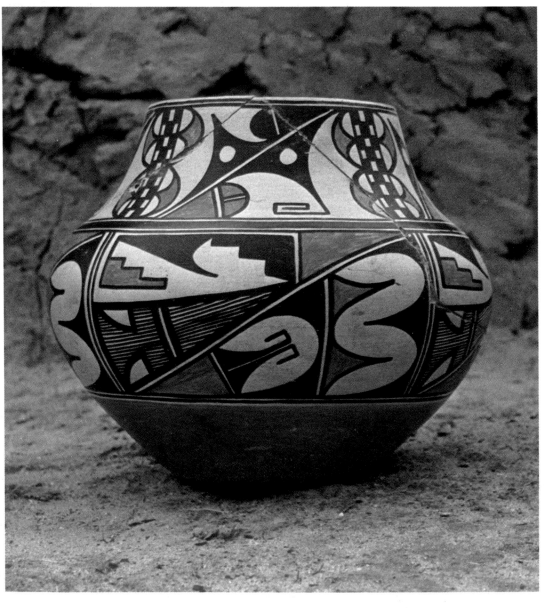

285. Storage jar, Maria and Julian, ca. 1930. H. 27.9 cm.

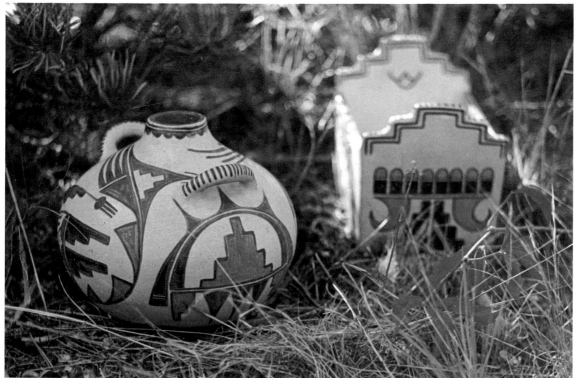

286. Canteen and prayer meal bowl, Maria and Julian, ca. 1920 (?).
H. 22.8, 17.8 cm.

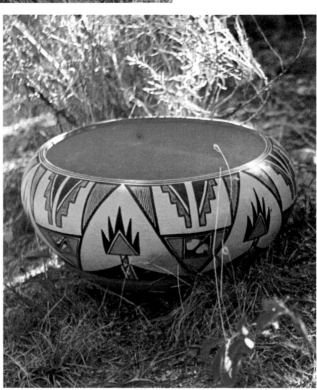

287. Bowl, Maria and Julian, ca. 1922. H. 33 cm.

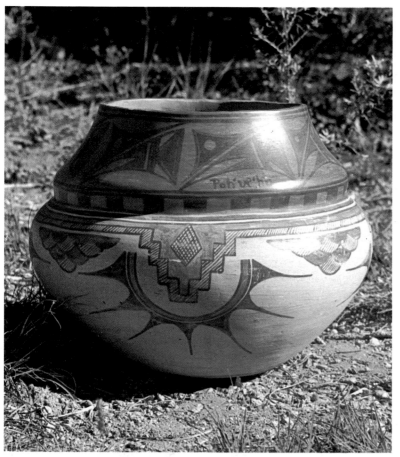

288. Storage jar, Maria and Julian, ca. 1910–15. H. 35.6 cm.

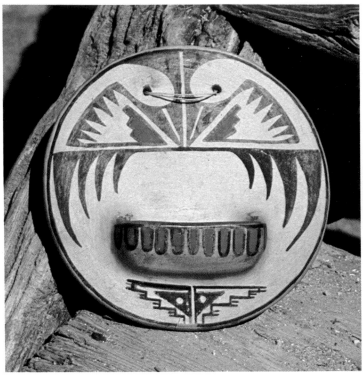

289. Cornmeal wall sconce, Alfoncita Roybal and
Awa Tsireh, ca. 1910–15. D. 22.8 cm.

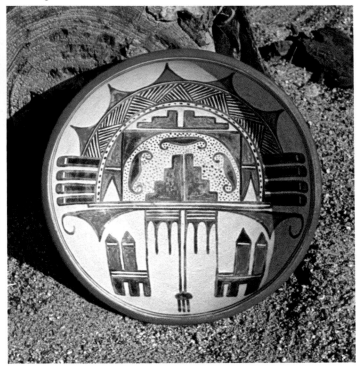

290. Ceremonial bowl, Maria and Julian, ca. 1920.
H. 20.3 cm.

291. Jar, San Ildefonso polychrome, ca. 1922. H. 25.4 cm.

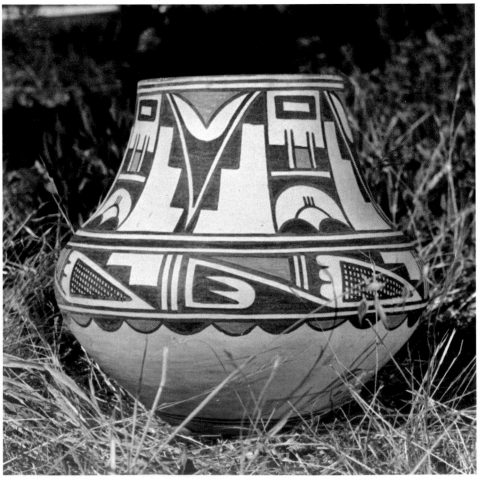

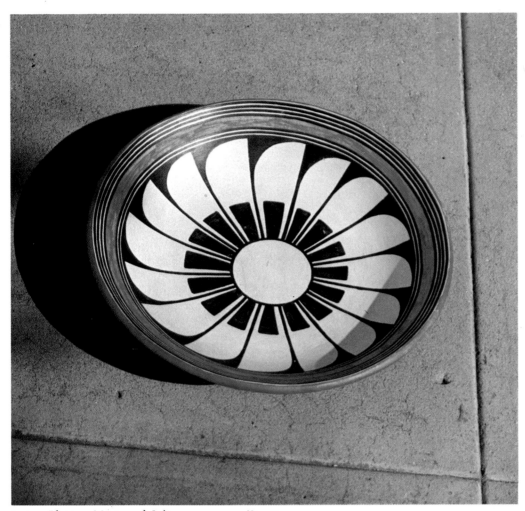

292. Platter, Maria and Julian, ca. 1940. D. 38.1 cm.

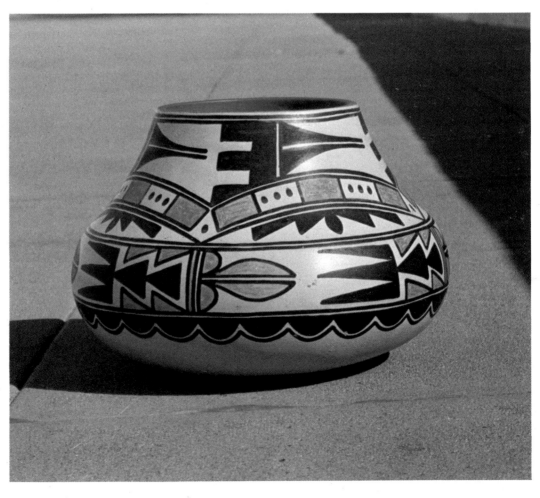

293. Jar, Maria and Julian, ca.
1935–40. H. 38.1 cm.

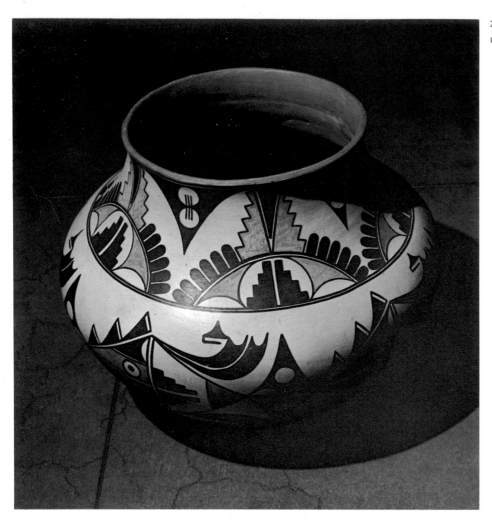

294. Storage jar, Maria and Julian, ca. 1935. H. 50.8 cm.

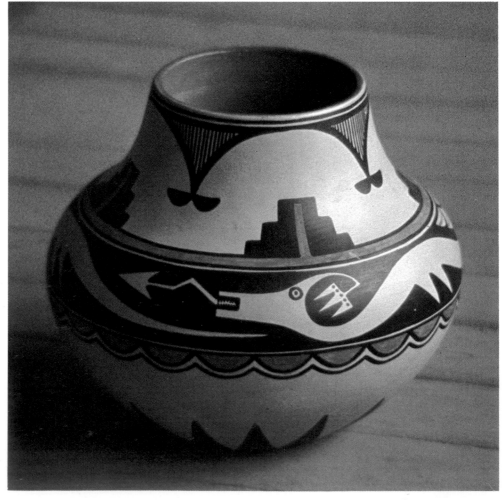

295. Jar, Maria and Julian, ca. 1942. H. 33 cm.

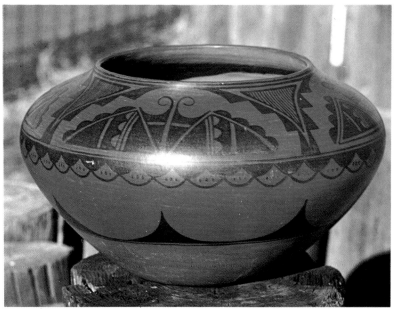

296. Storage jar, Maria and Julian, ca. 1922.
H. 33 cm.

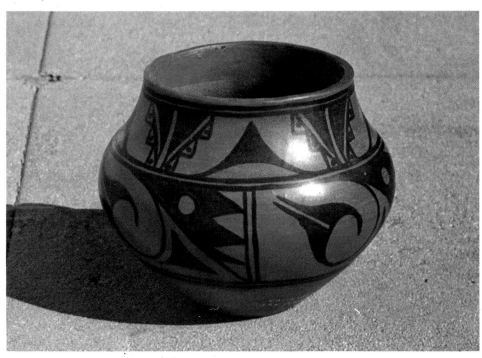

297. Bowl, Tonita Roybal, ca. 1910.
H. 12.7 cm.

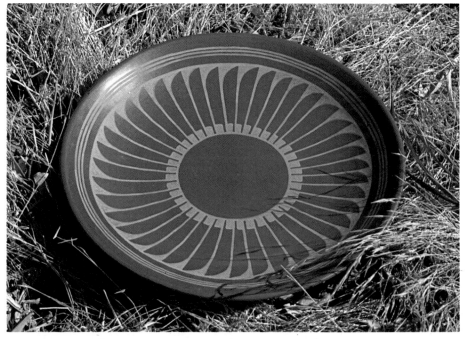

298. Platter, Maria and Santana, 1947.
D. 35.6 cm.

299.　Jars, Maria and Julian, ca. 1918. H. 25.4 cm.

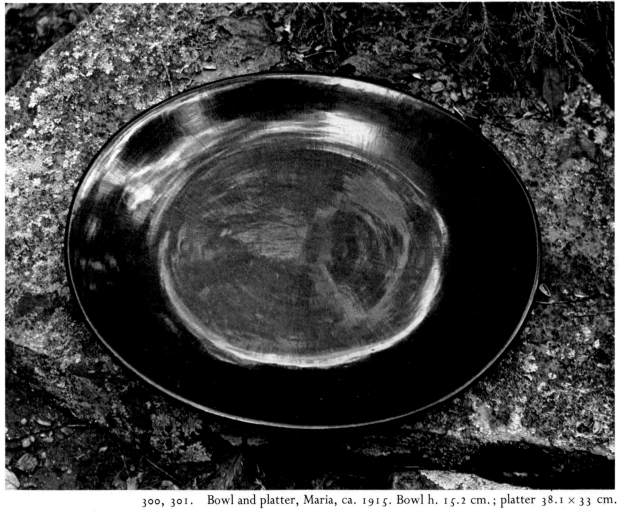

300, 301. Bowl and platter, Maria, ca. 1915. Bowl h. 15.2 cm.; platter 38.1 × 33 cm.

302. Storage jar, Maria and Julian, ca. 1935. H. 61 cm.

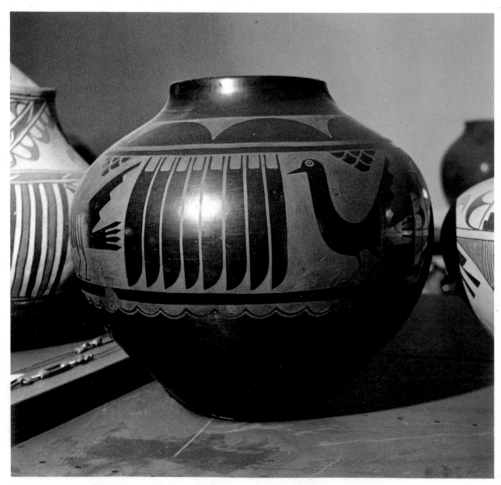

303. Storage jar, Maria and Julian, ca. 1935. H. 50.8 cm.

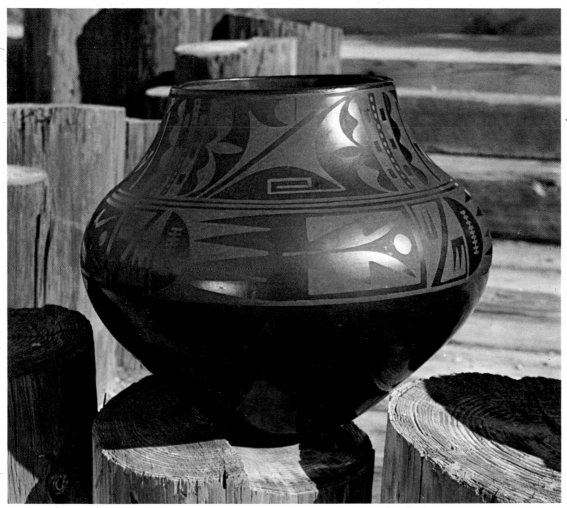

304. Jar, Maria and Julian, ca. 1939. H. 45.7 cm.

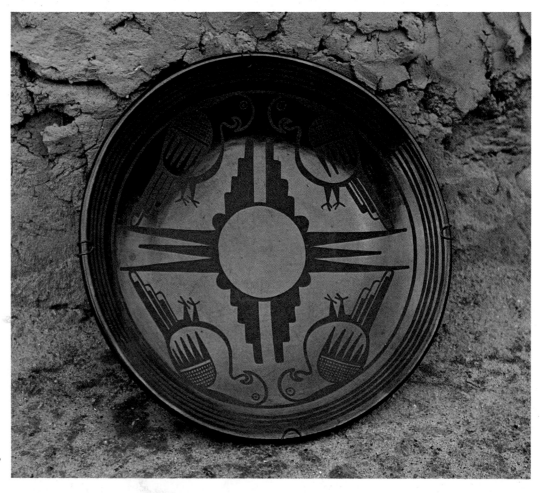

305. Platter, Maria and Julian, ca. 1936. D. 50.8 cm.

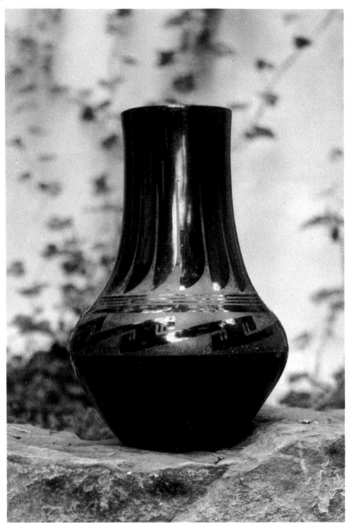

306. Vase, Maria and Julian, ca. 1922. H. 30.5 cm.

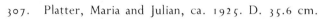
307. Platter, Maria and Julian, ca. 1925. D. 35.6 cm.

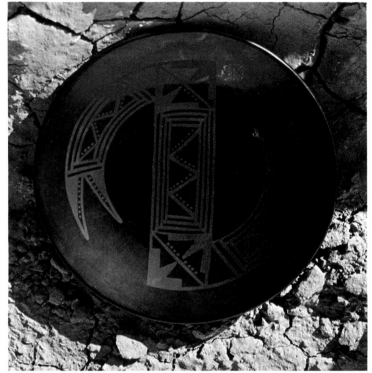

308. Small pitcher, Maria, ca. 1930. H. 12.7 cm.

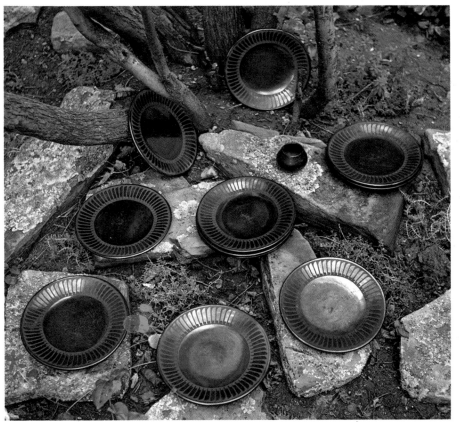

309. Set of dinner plates, Maria and Santana, ca. 1950. D. 30.5 cm.

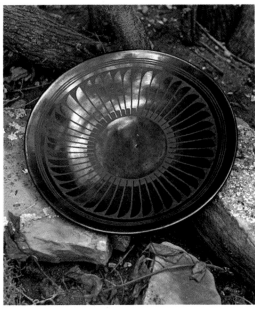

310. Platter, Maria and Santana, ca. 1948. D. 40.6 cm.

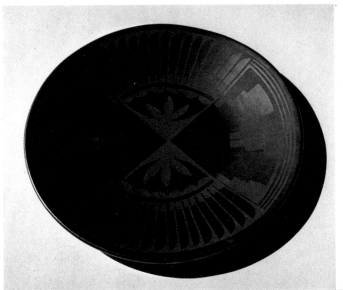

311, 312. Plate and bowl, Maria and Santana, 1949. Plate d. 30.5 cm.; bowl h. 25.4 cm.

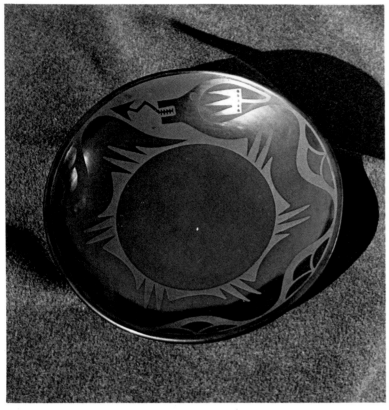

313. Plate, Maria and Popovi Da, 1956. D. 25.4. cm.

314. Jar, Maria, 1970. H. 22.8 cm.

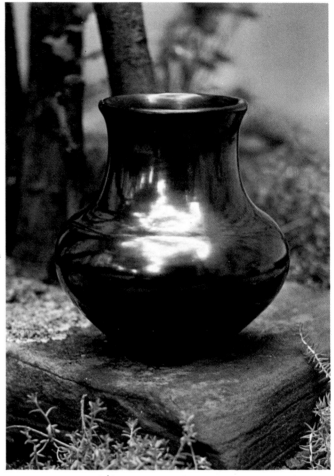

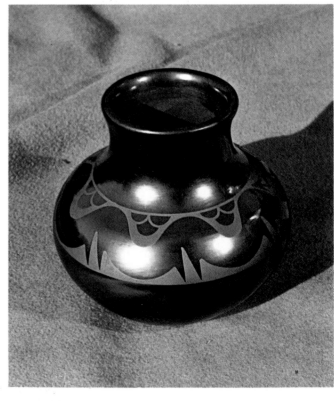

315. Jar, Maria and Popovi Da, 1970. H. 22.8 cm.

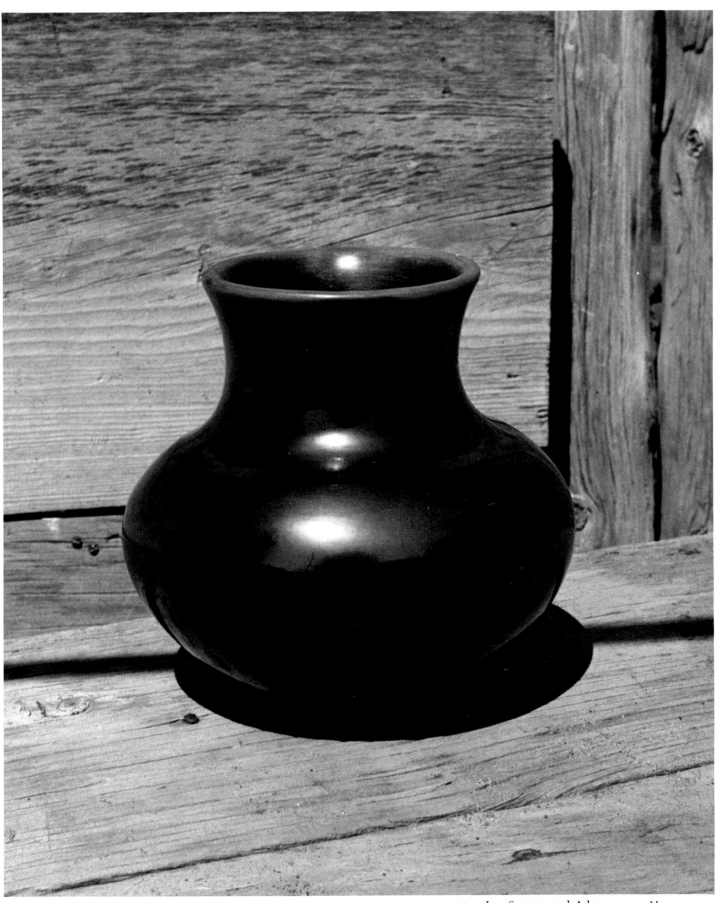

316. Jar, Santana and Adam, 1973. H. 30.5 cm.

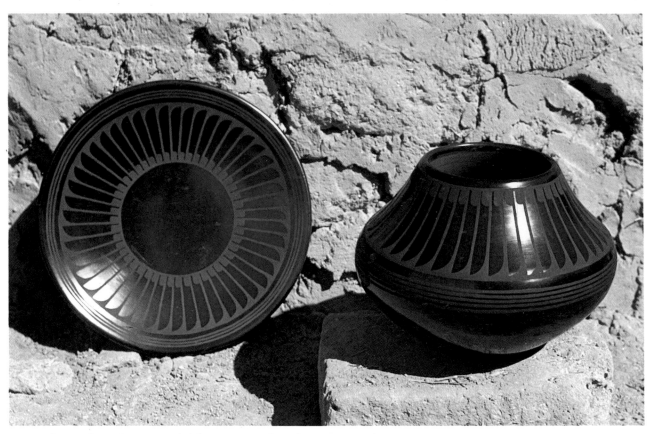

317. Plate and jar, Santana and Adam, 1975. Plate d. 30.5 cm.

318. Jar, Santana and Adam, 1970. H. 40.6 cm.

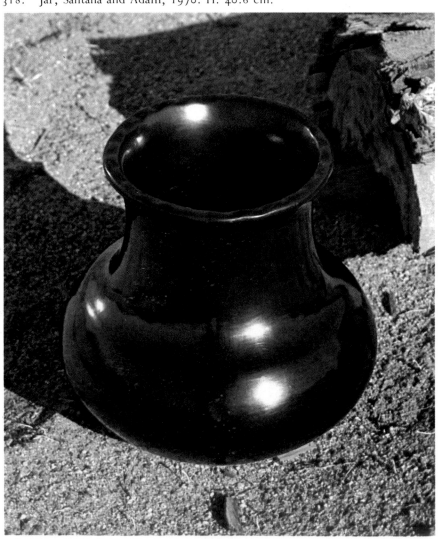

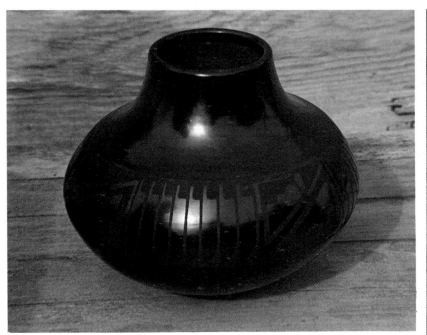

319. Jar, Santana and Adam, 1977. H. 35.6 cm.

321. Wedding vase, Santana and Adam, 1975. H. 22.8 cm.

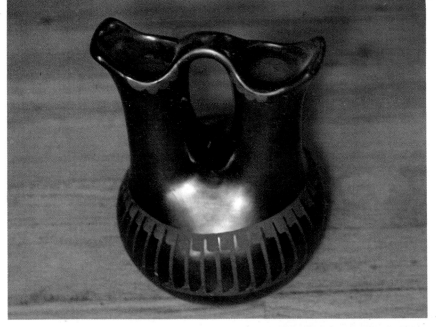

320. Lantern, Santana and Adam, 1974. H. 50.8 cm.

322. Pots made and decorated by Pauline Martinez, daughter-in-law of Santana and Adam, 1975.

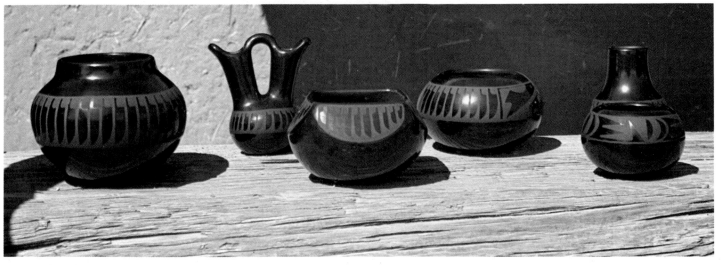

323. Turtle, by Tony Da, 1970. H. 27.9 cm.

325. Jar, by Popovi Da, 1970. H. 25.4 cm.

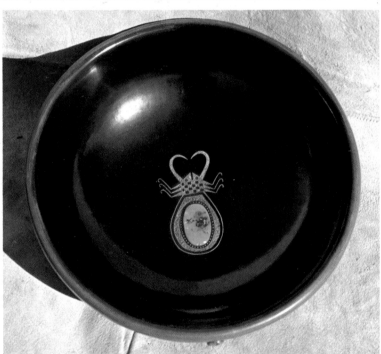

324. Bowl, by Popovi and Tony Da, 1972. H. 17.8 cm.

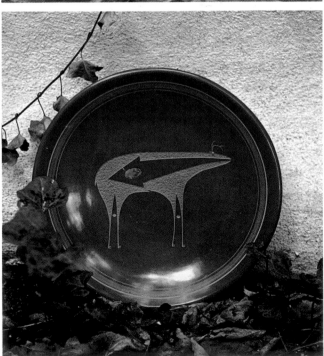

326. Plate, by Popovi Da, 1965. D. 22.8 cm.

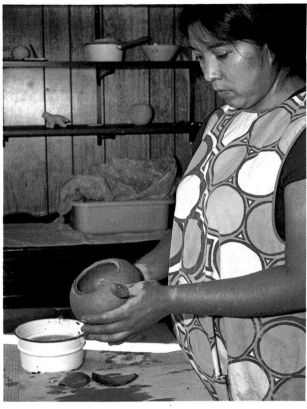

327. Barbara Pino Gonzales, great-granddaughter of Maria and Julian.

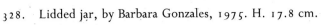

328. Lidded jar, by Barbara Gonzales, 1975. H. 17.8 cm.

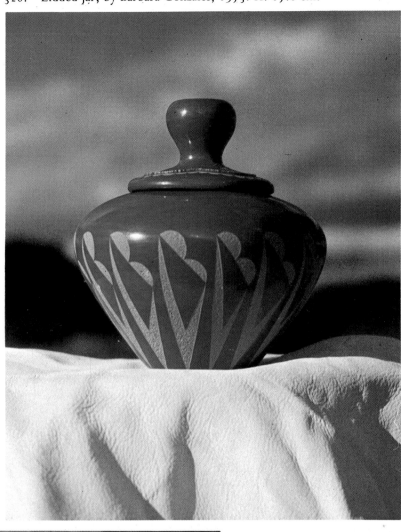

329. Plate, by Barbara Gonzales, 1974. D. 30.5 cm.

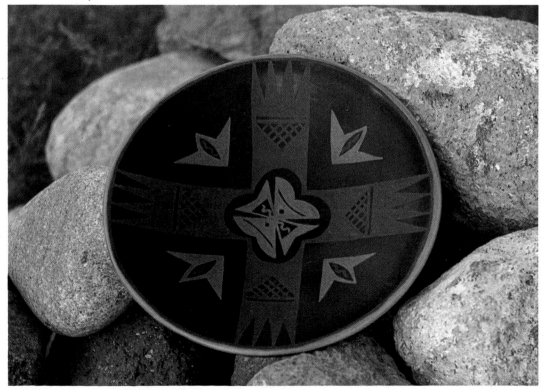

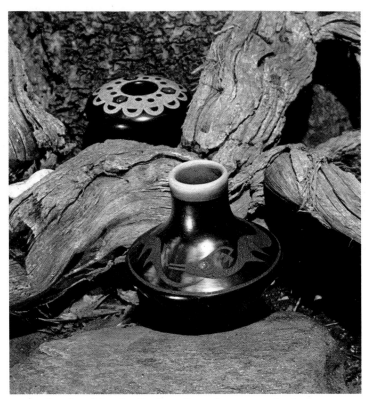

330. Bowl and jar, by Barbara Gonzales, 1974. Jar h. 15.2 cm.

331. Hanging planter, by Barbara Gonzales, 1975. H. 7.6 cm.

332. Wind bell, by Barbara Gonzales, 1976. H. 10.2 cm.

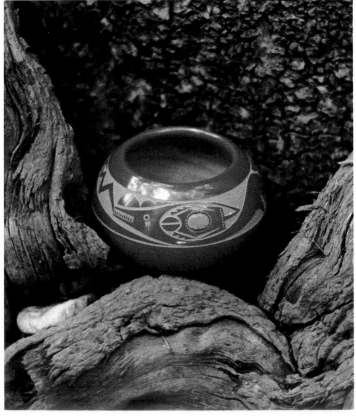

333. Bowl, by Barbara Gonzales, 1974. H. 10.2 cm.

334. Lidded jar, by Barbara Gonzales, 1975. H. 17.8 cm.

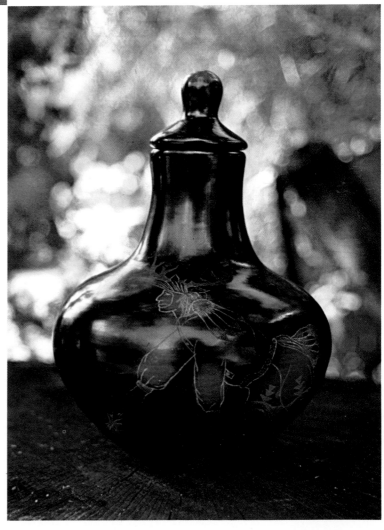

335. Lidded jar, by Barbara Gonzales, 1976. H. 12.7 cm.

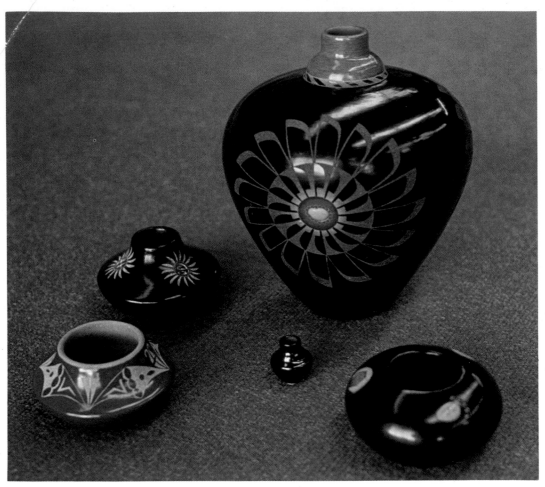

336. Pot group, by Barbara Gonzales, 1976. Max. h. 30.5 cm.

337. Jar and animal figure, by Barbara Gonzales, 1975. H. 10.2 cm.

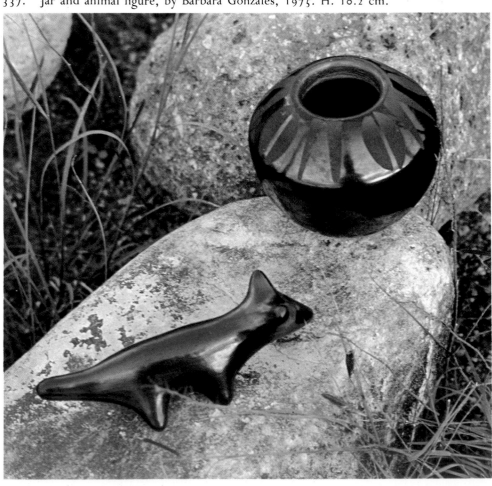

Appendix

A BRIEF HISTORICAL NOTE ON BLACK BURNISHED AND MATT POTTERY

When Susan Peterson telephoned on 10 March 1977 from New York and requested that I write a few paragraphs for inclusion in this book, she touched a key new in my experience. She cited my longevity as having made it possible for me to know Edgar Lee Hewett. That did the trick! Despite being busy with my own writing, I acquiesced.

Prior to coming to New Mexico to become an archaeologist, I had lived in the ordinary world of the Midwest. There I knew a few whom I would now term great people. In New Mexico I came to know several great people, and a particularly great man, Professor Hewett. He was then head of the department of archaeology at the University of New Mexico as well as director of the Museum of New Mexico in Santa Fe. He saw his duty as guiding the way of students. He showed me the way and, fortunately, directed me along it for a decade and four.

Now, as Professor Peterson has indicated, I am one of the "givers." It is my pleasure to pass on to others what I can of what I may know and have learned.

Professor Hewett was completely at home with the people of San Ildefonso, with some of whom this book is concerned. He knew them as friends, industrious in their own way, intelligent and kindly, fine craftspeople, sages, philosophers, and great ceremonialists. Through long, often silent hours, they communed. What the Indians told him in confidence, he never revealed. To him a trust was a trust.

In his search for learning and comprehending, Professor Hewett traveled widely in the Old World and the New. Years after his earlier trips, I traveled with him in the Southwest, in Mexico, Guatemala, Peru and Bolivia, always gaining more knowledge of the indigenous peoples of this hemisphere and always learning more from him.

When Ms. Peterson raised a question about blackware pottery, she touched a key within the sphere of my interests—one to which I had given considerable thought, and limited attention.

My concern with local blackware pottery came in 1963, when highway workers in the Cienaguitas area, located between the city of Santa Fe and Agua Fria, some fifty to seventy feet from the Agua Fria road, plowed up a plain blackware head. This was brought to my attention, and the figure given cursory study at the Laboratory of Anthropology of the Museum of New Mexico. Insofar as any of us who have seen it know, it is unique. Similarity of the specimen constituents and workmanship to ceramics of a type called *Kwahe'e Black-on-White* (Mera 1935: 5) were noted. Kwahe'e materials found at Pindi ruin at the village of Agua Fria, on the north bank of the Santa Fe River, were described as "a generalized black-on-white pottery basically very similar to the widespread type of Chaco II, from which the local Kwahe'e Black-on-White [was thought to have] developed" (Stubbs 1953: 48). Kwahe'e pottery dates A.D. 950–1200.

Having spent numerous years excavating and studying archaeological remains in Mexico and Guatemala, and in Chaco Canyon, New Mexico, I had come to know Mesoamerican traits rather well and recognized certain ones that appeared also in the Southwest, especially in the Chaco. I wondered if blackware had been found there. It had. George H. Pepper, who excavated at Pueblo Bonito, 1896–

1899, had found and mentioned undecorated blackware and some gray bowls with black decoration (1920: 38). Neil M. Judd had more to say (1954: 196). He encountered a base sherd of a bowl in Room 256 in Pueblo Bonito that showed a finely corrugated brown exterior and a polished black interior bearing a matt design (Fig. 49). Judd's description states: "The coils, eight to the inch, possess a minuteness and regularity more at home in the San Francisco River Valley of southwestern New Mexico than in Chaco Canyon. [Judd was correct in his location of this sherd's place of origin.] Previous to the finding of this fragment, we supposed, as did everyone else, that Maria and Julian Martinez of San Ildefonso originated the black-ware paint they have employed so successfully since 1921 [he cites Guthe (1925: 24)]. But theirs clearly is a rediscovery, since they could not possibly have known that the same peculiar pigment was used at Pueblo Bonito more than eight centuries earlier. . . ." Judd also found a bowl ornamented with matt paint in Pueblo del Arroyo.

At present, considerably more is known of the northern Mexico and Southwestern black wares. Charles C. Di Peso and his colleagues, from their work at Casas Grandes, Chihuahua, have brought together a body of information on the polished black vessels identifiable as *Ramos Black* (1974: 160). It appears widely in northwestern Mexico and to varying extent in ruins of the Southwest, especially those more southerly located. In every instance where such pottery is viewed directly or illustrated, any and all of it could be lost among the Tewa potters' older productions. Dr. Hewett realized this long years ago. Forms and surface appearance are remarkably alike. Both are made by the coil and scrape process. As to the Agua Fria head, it shares characteristics with Casas Grandes effigy vessels, plain and painted.

The books of Alice Marriott (1948) and Mary Carroll Nelson (1972) have related much about the influences and people that affected the lives of Maria and Julian Martinez. Countless individuals aided them with problems that arose. Since the couple lived and worked for a time at the Museum of New Mexico in Santa Fe, they had opportunities to view specimens and to see books and magazines, which broadened their horizons, as did their extensive travels. Then, too, Julian was a thinker and a problem solver. A firing accident—the smudging of two pieces of their pottery—resulted in the production of blackware.

Who knows what gave rise to the solution of the problems related to matt decoration for the polished black pottery known from the eleventh to the mid fourteenth century in Mexico, and in Chaco Canyon into the twelfth century? The practice undoubtedly moved through time from Mexico northward. It could have been transmitted person to person, or it could have been discovered independently by experimentation with an idea. Maria and Julian, however, carried their skill with burnished black and matt decorations to a height attained by no other potters. Not for some ten years following their introduction of this type of blackware did accomplished pottery makers at Santa Clara, or other Tewa pueblos, begin producing similar vessels.

Bertha P. Dutton, Ph.D.
Research Associate

Museum of New Mexico
Santa Fe, New Mexico
15 March, 1977

COMMENTS ON THE PLATES

12–14. Maria and Clara on the grounds of the Laboratory of Anthropology, Santa Fe, with early Maria and Julian pots. When I handed Maria a jar, she exclaimed that it was "like for on top of your head" and immediately proceeded to demonstrate. Clara's concern is obvious in the photo.

15. Maria in the research collection of the Laboratory of Anthropology, Museum of New Mexico, Santa Fe, with three of the large storage jars she made; decorated by Julian, about 1930.

20. Unfortunately, I have not been able to find identification of the people in this photo of the Frijoles excavation of 1908. Julian and Maria were also among the Indians employed to help.

22, 23. Maria and other ladies of San Ildefonso were invited by Dr. Edgar Hewett to come and make pottery in the patio of the Palace of Governors in Santa Fe. Note the scale and symmetry of the pot the young Maria is making, as well as the use of the *puki* for the footed piece on the right. The pots, with two exceptions, are polychrome.

25. This painting of a conventionalized kachina figure with animals is typical of the many paintings on skin and paper done by Julian and other members of the family, including Adam. Many paintings were done for guest rooms and lobbies of hotels, restaurant dining rooms, and for the Indian school in Santa Fe. Collection of the Museum of the American Indian, New York.

27. Every stage of the black pottery process is shown in this posed photo. Julian appears to be holding a brush to an already fired pot.

28, 29. The ladies in these photos are identified as Maria, her sisters Maximiliana and Desideria, and Ramona Gonzales.

31. This painting is also in the collection of the Museum of the American Indian, New York. Adam helped Julian with many of his easel paintings.

33. I strongly suspect this pose of Julian was taken before the replica kiva built at the San Diego Balboa Exposition in 1915. Julian is in Sun Dance costume.

44. This is a Laura Gilpin photograph of Bernard Leach and Shōji Hamada demonstrating in a lecture at the opening of the folk art museum, Santa Fe. Warren Gilbertson kicks the wheel for Hamada, who is trimming the foot of a tea ceremony bowl. Maria and Popovi Da are in the audience, far right. Geogia O'Keeffe stands at the back.

47. Among the various nontraditional pieces Maria made are candlesticks (see Pl. 45).

53, 54. When I asked about these two photos of Adam as a youth, he quipped that in the first he was dressed "for hiking" and in the second "for hunting." That's what he said; let serious researchers beware.

55. In this photo Santana is filling in Julian's designs; Adam is painting one of his watercolors. The undecorated pot in the center is for cooking. Photo by T. H. Parkhurst.

56. The beautiful girl here, identified as Tonita Roybal, Santana's aunt, wears a *tablita* headdress for the Corn Dance, similar to those Adam makes now for the women in his family. Photo by E. S. Curtis.

58. "After a day of plastering the house" is written on the back of this old snapshot. Maximiliana is at left; Maria in center, Tonita Roybal at right. Also pictured are Desideria's husband, Donecio Sanchez and Adam's uncle Atilano. Spanish helpers also in the photo.

59. This is an early rotogravure done from a T. H. Parkhurst photo of Isabel Atencio (seated), her daughter, and granddaughter(s?) making pottery for an exhibition in New York.

60. Santana stands on the ladder of the kiva under construction. Maria or Maximiliana is above at the entrance.

71. At Idyllwild, Adam provided the music and directed the students in a manure dance, which served the important function of breaking up and refining this gift from horses in preparation for using it to smother the black ware firing.

72. The family members present in this photo are Clara and Maria, Santana and Adam, Anita P. Martinez, Barbara Gonzales and son Cavan.

75. Back: Pauline Martinez, Adam, Barbara, Anita P. Martinez, Barbara's sister Evelyn Garcia, Clara; front: Santana, Maria, Pauline's son Stephan, Barbara's son Cavan, and dog.

83–85. The process of constructing Adam's bread oven had already taken several months when these photos were shot. This is because each course of mud-mortared adobe bricks must take several weeks to dry and set before the next course is added.

86. Adam and the finished oven after first baking, about six months after it was begun.

87, 88. While Adam was building his family's new oven, he and Santana borrowed her sister's for baking bread for the autumn ceremonial. After the oven is heated for several hours with fire in the closed chamber, the ashes are scraped out and about forty loaves are put in. The bread is said to taste better if baked directly on the hot oven floor, but loaf pans are used now for convenience.

89–91. Adam and Santana close the oven with burlap and wood and secure this with a paddle. Halfway through the baking time the oven is opened and the loaves turned. The finished loaves are loaded into a tub and taken home. The bread will be eaten on the day of the ceremonial, and some loaves will be given to visitors.

93–95. The autumn ceremonial at San Ildefonso, photographed here by E. S. Curtis in about 1905, is variously termed the Tablita, Corn, or Harvest Dance. The houses seen in these old photos have been replaced; compare the color photos that follow.

96, 97. The Corn Dance, San Ildefonso, taken at the ceremonials of 1975 and 1976. The cloudy photos are 1976.

98. The men's chorus. Julian Martinez, grandson of Maria is in purple with the blue headband. Maria's great-great grandsons are in the foreground.

99, 100. Adam makes and paints the *tablita* headdresses for the women in his family to wear in the Corn Dance. He makes all the shell pieces, bell, feather, and other decorations for the ceremonial costumes for everyone in his family. The long white rain sashes are woven now by Santana's sister Lupita. Maria watches from the porch in background.

101. The youngest children are the last dancers to mount the kiva steps, followed by the drummer and members of the male chorus. Maria stands at left.

102. Aaron and Cavan Gonzales, Barbara's sons, and two unidentified children eat on the kiva steps following the ceremonial dance.

107–111. Maria grinds the hard clay rock into dry powder (107) and mixes it with volcanic ash (108), adds water (109), and kneads it until plastic (110, 111). This series of clay preparation and pot making photographs (107–125) appears to have been taken at the pueblo, although at different times. A number of incomplete process series have been put together to give a whole picture for this book. Probably 1930s.

112. Maria flattens clay to begin a pot.

113–115. A pot is begun by placing a pancake of clay into the *puki;* the first coil is then added. Pots near Maria are drying in the sun prior to scraping the surface smooth.

116–118. The construction of a pot in the traditional Indian process involves rolling and laying coils one on top of the other, luting them together, and smoothing the wall with a tool. Plate 118 shows a casserole shape with a flanged lip for a fitted lid, but was used here to illustrate the process of expanding the shape from within.

119, 120. Round shapes are pressed out by hand and with a rib after the cylinder form has been perfected.

121. Maria applies slip for polishing to a dry pot.

122, 123. Water-smoothed stones are used to burnish the leather-hard slip to a bright shine.

124, 125. Julian demonstrates painting a polished pot with a refractory clay slip and yucca brush.

126. Santana and Adam dig clay on the reservation. The top crust of earth is swept away by hand, exposing the finer material underneath.

127–129. Adam digs clay in a second location. Apparently this clay has a different particle size. He brings a tub of it to Santana to mix and screen with the material she has already sifted from the first site.

130, 131. Coarse particles remaining on the screen are thrown away. The fine clay is reserved on the cloth. Note that the sifted clay still has a gritty texture.

132. Adam shovels the screened clay into flour sacks, which will be stored. The clay expeditions are made only once or twice a year.

133–135. Digging "blue sand." Some miles from the clay deposits, after driving as close as possible, Santana and Adam walk to a deposit of volcanic ash. Adam chops into the hard, crusty material and shovels it into sacks. This volcanic ash has been used traditionally at San Ildefonso for temper and is always mixed half and half with clay for pot making.

136. In the pottery room of her house, Santana spreads a large cloth for dry-mixing the clay body materials. She combines equal amounts of fine white volcanic ash and the reddish-brown clay that she and Adam have gathered. She mixes it together with her hands, being especially careful to avoid spilling any of the material. Clay is a sacred substance.

137, 138. When the mixture is homogeneous, she fists a hole in the center and adds enough water to make it into a paste.

139. The dry materials and water are kneaded into a plastic mass, carefully, because this is a peculiar clay body that does not tolerate much handling. Because of the high alkaline content from the volcanic ash, only as much clay as will be used at one time can be mixed. Santana began mixing the clay at the window, where there is plenty of light for her to see the quality of blending. Then she moves across the room to the other table, where the light is softer.

140, 141. Plate series (Pls. 140–149). Santana flattens a pancake of clay between her palms, flipping it back and forth between her hands; it is about 3/4-inch thick. She drops this pancake into the *puki* carefully and pats it into place. Note the grittiness of the clay mixture in the metal pan.

142. Turning the round-bottomed *puki* on a flat surface as she works, Santana pinches up a thin edge, using both hands and revolving the *puki* only once.

143. She rolls a coil between her palms and adds it on the inside of the pinched-up edge to reinforce the joint.

144. Several coils are added, one at a time, making a complete circle with each coil. They are pinched together with downward motions of the fingers. Notice the horizontal bonding on the inside of the cylinder, which joined the first coil to the base.

145. With a moistened gourd rib, Santana smoothes the outside of the cylinder as she turns the *puki* quickly. She presses the rib with upward motions, from bottom to top each time; the fingers of her left hand support the inside of the clay wall at the place where she presses with the gourd tool. These movements are very important. The wall must be kept even as well as symmetrical.

146. One of the most interesting parts of the Indian pottery process occurs between this and the previous photograph. All forms thrown on the potter's wheel begin with an even-walled cylinder; the same process is used for these hand-coiled shapes. Santana uses the gourd tool on the inside of her wide cylinder and presses it gently outward as she rotates the *puki* and supports the outside wall with her left hand.

147, 148. When the plate form is sufficiently flattened, a small coil is attached to the inside seam, where the first coil meets the flat round first inserted into the *puki*. The excess clay at the base of the plate where it joins the *puki* will be scraped off later, when the pot is removed from this support.

Santana already began the process of smoothing the clay surface of the plate sides and rim. This is continued, using several gourd rib shapes, moistened, with deft, precise motions, while turning the *puki* quickly.

149. As she works at the final smoothing of the surface in this wet stage, Santana holds the plate up in order to check the thickness and balance. This thixotropic clay body cannot be handled any more now or it will get too soft and lose its shape. Therefore it is left to dry, usually outside in the sun, and will be scraped and sanded later.

150–152. Large jar series (Pls. 150–174). The appropriate bowl-shaped *puki* is used for this jar form. Santana fists the clay into the appropriate form, flattens it, and places the pancake in the *puki*, pressing gently to make a firm fit. The clay edge is left sticking up slightly.

153. After pinching the clay up into a thin edge, she rolls a fat coil.

154. The coil is placed inside the edge she has made, insuring the stability of the joint. In this

photo the shelf where this coil will rest is clearly visible. This is the supporting joint for the rest of the pot and is particularly important on large forms.

155. Santana pinches off the first coil so that the ends meet exactly and begins a second row.

156–159. These coils are pinched together with the fingers of both hands then patted flat to receive the next coil. The motion set up by her finger-pinching also rotates the *puki*. It is nearly like throwing on a potter's wheel, except much slower and certainly more irregular. Yet note the thinness of the small bowl she has finished, in front.

160. The gourd rib is pulled diagonally up from the base in single swipes. Santana turns the *puki* after several swipes.

161, 162. She looks at the cylinder profile for balance and proportion. The inside base is bowl shaped but has yet to be smoothed. This takes place with the gourd tool as the form is expanded from the inside. As usual, the full pot form is expanded out after a cylinder is constructed.

163, 164. Santana continues to expand and round the shape. Her left hand turns the *puki* clockwise while she presses out from the inside with the gourd rib. She inspects the form again for symmetry. When a large pot that is to have a neck is at this stage, it is set aside a day to stiffen.

165. The next day, the lip is moistened and an edge is pinched up in a manner similar to the method used on the base at the very beginning of this pot.

166. The next coil is laid inside this pinched-up edge, and then another on top of it. These are pinched together and smoothed with the gourd tool.

167. Sometimes the pot is set aside again at this point to allow the shoulder to set, depending on the way the clay feels. A pinched edge is made to receive the next fat coil. The *puki* is constantly rotated while coils are applied and luted together.

168, 169. Approximately every other coil is added to the inside of a pinched-up edge. Santana's right hand rotates the *puki*; even rotation keeps the balance of the piece.

170–172. The motions used in using the gourd tool for smoothing the clay surface are always from bottom to top. The final coil is applied inside the previous one and pinched up. The lip is flattened and evened with the fingertips.

173. Santana again checks the form for symmetry.

174. At this stage pots are set aside to dry. When they can be removed from the *puki*, the heavy seam of clay will be scraped down into a rounded foot.

175. Small bowl series (Pls. 175–183). Santana flattens a clay pancake to be laid into the small *puki* for the bottom of this shape.

176, 177. The clay is pinched up and the first coil is applied inside the edge.

178. On a small piece, which does not involve the need to support a great deal of weight, the coils are applied more quickly, but still the process is slow and needs much care.

179. The wall has been smoothed with the gourd tool, and the edge is being turned up.

180. From the cylinder, Santana bulges out the pot form, pressing with her fingers from the inside and continuously rotating the shape with her gourd tool.

181. The form is slowly expanded as the *puki* is rotated a number of times. The constant upward motion of the gourd rib raises and thins the wall.

182. Again the edge is pinched and flattened, and the piece is inspected for symmetry.

183. The seam adjoining the *puki* is given some attention at this point, but this seam will be completely eliminated when the dry pot is removed from the *puki* and scraped smooth.

184. Adam draws forming tool shapes on a gourd and then proceeds to saw them out.

185. A variety of gourd rib shapes are used for different pot forms and curves. The edges of these tools are filed and sanded smooth, then they are soaked in water before use.

Polishing stones are treasured. Those used by Maria, Santana, Barbara and others of the family were handed down from Nicolasa, Tonita, Alfoncita, and Dominguita. Each stone has a unique rubbing surface appropriate for a particular curve of a pot shape. Stone burnishing was also part of the polychrome pottery process, but for the white ground.

187. Adam separates the midrib of a yucca leaf in preparation for making a yucca fiber brush.

188, 189. The tough end of the yucca midrib must be chewed a long time to make it supple enough for a brush.

190. The chewed, spiny fiber ends are teased and spread, then adjusted according to the kind of brush desired. For fine-line painting, in the style of Julian, a single long filament is desired. After having decided on the one strand that is the best of the bunch, Adam cuts the rest of them away, leaving a finished brush.

191, 192. The yucca brush is stiff, has no pointed tip, and does not hold much slip; it is perhaps the most difficult tool one can think of for painting straight and delicate lines.

193. A variety of different sharp-edged can lids, typewriter ribbon cases, etc., are used for scraping the surface of leather-dry pots. After the shoulder line is scraped true, the lid edge scrapes the belly of the pot.

194. Santana prefers the edge of old Calumet baking powder tin lids, but these are very hard to find today. She searches for them in yard and rummage sales. New lids are required constantly because the edges dull. Here Santana scrapes the shoulder of a pot to symmetrical perfection, holding the scraping edge at one contact point and pivoting the jar in her lap.

195. A foot is honed out round by keeping the rhythm of the scraping and the turning of the pot in harmony. All dry clay scrapings are caught in Santana's apron or in a paper on the floor and will be used again in a new mixture of clay.

196. The pot lip is scraped by the same controlled process.

197, 198. Trueing up the profile and smoothing the surface of a large pot is more difficult than a small one. After scraping, the piece can be further smoothed by wiping with a damp cloth.

199, 200. When the scraped pieces are completely dry, the surfaces are made satin smooth by sanding. Adam does a great deal of this work. If the pot is not of even thickness, sanding may result in a hole. Sanding is another technique requiring the intuitive perception that comes with experience.

201. A fine, iron-bearing clay, different from that of the pot body, is used for burnishing. This clay will bond and burnish well and will turn jet black in a smothered fire. A clay of this kind is rare.

Clara is the burnisher for most of the ware of the Martinez family, although Santana polishes her own large pieces and Barbara does all her own.

202. The iron-bearing slip is prepared by crushing the hard clay rock, adding water until it is of a creamy consistency, and screening, if necessary. The slip applicator is a folded piece of muslin.

203. The special slip can be stone burnished to a high shine only when it is leather hard. If it is too wet, of course burnishing is impossible; if too dry, it will mar or flake off. Therefore, only as much surface should be covered with slip as can be immediately polished. Burnishing is best done on dry days. Clara sits in her room at the pueblo, where she likes to work.

204. Clara begins to polish the leather-hard slip with short, swift motions. The burnishing motions become faster as the surface becomes shiny. It is necessary to touch the pot with the fingers as little as possible. She rotates the pot counterclockwise as she works. The entire forearm is used; there is no play in wrist or fingers.

205. Clara has nearly finished this pot. Several times during the burnishing she wipes the pot with a lard-moistened rag to keep the surface lubricated and damp, but too much will cause problems.

206, 207. Santana polishes the exterior of a small bowl, prior to doing the interior. Her movements must be very fast to avoid any marks of the stone. Obtaining a perfectly smooth surface is a toilsome job. Maria and her family have perfected the skill and pride themselves on it.

Large pots are polished in sections, slip being applied only to an area that can be handled at one time. Maria says that she used to take a day to polish her largest pieces, in two or four sections, which means that she worked with incredible speed.

Stone burnishing serves more than a decorative function. Polishing the surface realigns the platelets of the clay so that the permeability of the pot is reduced. The Indians have traditionally wiped the inside of cooking pots smooth with concerted effort as they formed the wet clay, doubtless because they found that doing so made the vessel more watertight. Actually, it is possible that the way in which the clay is worked in the plastic state influences the permeability of the fired piece. It is my opinion that the addition of volcanic ash reduces permeability also; it provides not only thermal resistant qualities but contributes to closing the pores.

The fact remains that bonfired pottery is not as durable as ware fired at higher temperatures in an enclosed kiln, though, as explained above, certain compensatory techniques can be used. Pottery produced in an open fire will not hold water well, and the surface will tend to crumble and spall if exposed to moisture for a length of time. Many persons have discovered, too late, the signature Marie/Julian on the bottom of a well-used and decomposed pot.

In the case of stone-polished ware, higher temperatures such as obtained in an enclosed kiln will increase the durability of the ware but will destroy the surface sheen due to shrinkage and rearrangement of the surface particles. Hence the Indian burnished pottery involves a limited firing temperature range and a quite awesome control of the primitive factors of heat treatment.

208–210. A different slip is used to paint the decoration. This is a refractory clay and comes from a different location than the other clays used. Santana here holds a polished bowl in her lap and decorates, being careful not to fingerprint the burnished surface.

The yucca fiber brush is always moved slowly; the angle at which it is held varies according to the

shape of the pot surface. It is more difficult to do straight lines on certain curves. After each stroke, the brush is dipped into slip and drawn across a stick to remove excess. The decorator's wrist must be steady, the arm is unsupported, and only the fingers move. The pot is held with the fingers of the left hand inside the lip. For enclosing lines and banding, the vessel is turned while the brush remains almost stationary. A long line must be done in parts, since the yucca brush does not hold much clay. For lines within a panel, the pot remains stationary and the brush moves. The precision work done with this difficult brush is always an amazement to me.

211. Santana outlines a design on a large jar. The horizontal banding at the shoulder and belly are drawn first, freehand, without the use of a banding wheel, with the same skill that was required to fabricate the perfectly round jar in wet clay without a wheel. Then the vertical lines are laid in; next, the diagonals.

212. Santana fills in the outlines with a conventional brush, although sometimes only the yucca fiber is used. She apparently plotted the organization and distribution of the motif units in the decoration mentally. No measurement marks were made on the pot, either at the beginning or as the painting was in progress.

The great skill involved in the decoration cannot be overemphasized. To appreciate the grace with which Santana handles this, I seriously recommend to the aspiring potter that all you need do is chew your own yucca brush and try to paint a straight line with a gritty clay slip.

214. Maria stacks an array of polished and decorated pots on a grill in preparation for a firing beside her house at San Ildefonso, perhaps about 1925. Two piles of wood ash on either side of the firing place denote many previous firings on this spot. Bark for fuel, old pieces of tin to shield the pots, and cow chips for insulation are seen in the photo.

215, 216. Metal sheets, then cow chips are used to enclose the pots during firing. Early photos.

217. Maria and Julian during the beginning of a firing, as the bark and wood begin to burn. If this fire was stoked and allowed to burn in this manner for forty minutes or so, without smothering, an oxidized red (or polychrome) ware would result. About 1940.

218. Here Julian and Maria have smothered the fire with fine, dry horse manure and wood ash in order to produce the black pottery, which results from carbon deposition. Photo about 1925.

219–221. Removing black pottery from the hot ashes with "poking sticks." In the remarkable group of black pots in Plate 221, note the variety of patterns and shapes, including a number of wedding vases, ashtray forms, plates, and bowls. n.d.

222. Laura Gilpin, the well-known photographer, who lives in Santa Fe, escorted Shōji Hamada, Bernard Leach, and Sōetsu Yanagi to San Ildefonso to meet Maria on the occasion of their 1952 USA tour. Maria did a special firing for them and is shown here engulfed in smoke in this photograph by Ms. Gilpin.

223. Maria, Clara, and Barbara's son Aaron watch the preparation for a black firing.

224. Martinez family firings are done at the pueblo in a shed near their house, where selected cow chips are carefully stacked to dry prior to use. Preparation of the "kiln" begins with the heavy iron elevated grating, on which a variety of iron grillwork pieces are placed.

225. Adam places metal strips on top of the grillwork. The grills and strips are rearranged many times. Barbara says she always enjoys watching her grandparents fixing and refixing this arrangement.

226. Pieces of wood, which Adam has chopped to the correct length and size, are gathered up by Santana for placement under the grill. Dry manure and wood ash for smothering the fire are ready.

227. Wood is carefully criss-crossed three levels high under the grill; the pieces extend out from the grill edge slightly. The iron grill has been completely covered with overlapping metal strips. Kerosene is poured liberally over the wood.

228. The polished red pots have been carried from the house wrapped in cloths. Fingerprints or dust will mar the fragile surfaces. Santana begins stacking the pots on the grill, large ones first, placing them upside down and not quite touching. Bark and twigs have been strewn over the wood.

229. Santana and Barbara stabilize the stacked pots with occasional insertions of jar lids or small pieces of metal. In Plate 214, Maria utilized small stones for the same purpose. It is important to stack the ware so that each piece will be evenly exposed to the heat and circulation of the "kiln" atmosphere is not obstructed.

230. Pots are rearranged many times. Here Santana tries to balance a platter on top of other pieces.

231. When the pots have been stacked and stabilized, steel mess trays are set upright to enclose the "kiln." The trays are placed so that vents are formed, generally two on each side and one at each corner. On top of these, old, folded New Mexico license plates are positioned to give a foundation for metal strips, which, in turn, support more license plates and can lids forming the crown of the "kiln."

232–234. Cow chips are arranged on edge, with the largest ones on the bottom, again leaving vents but overlapping the vents through the metal tray enclosure. The stacked dung is like laid bricks, and it does, in fact, form the insulation for the "kiln."

235. Maria often lights the fire, but today, after the sprinkling of a bit of cornmeal for the traditional blessing, Barbara, Santana, and Adam each ignite torches and begin lighting the wood at each corner.

236. Fire erupts immediately. Kerosene sprinkled on the wood insures that the fire burns quickly and surrounds the pots evenly. It is the same principle used in any type of ceramic firing.

238. When the cow chips become black, more bark and wood shavings are added to heat up and continue the fire. The temperature necessary for black ware is hotter than for a red, oxidation firing. Flames are visible inside, and Santana checks the pots by looking with her poking stick to see if they are shiny. Usually when she checks the pots at this time, a few more wood pieces are added for several more minutes of fire. This is the peak temperature, a crucial point in the black ware process. If the ware becomes too hot, the polished surface will become dull. At Idyllwild we tested a black firing with a thermocouple and pryometer, which indicated a temperature of 1500° F. at peak.

239. As the fire dies down, wood ash is shoveled into a low wall around the base of the mound. This forms a seal necessary when the fire is smothered. It is important to work quickly, so that heat is not lost.

240, 241. One tub of fine, dry horse manure is dumped over the fire. Santana and Barbara spread

it about with sticks to distribute it evenly. The smothered fire smokes furiously, but the potters must continue to spread the manure quickly and carefully, adding more when necessary.

242. After spreading the manure, the three potters work swiftly to contain the smoke by shoveling wood ash over the mound. All the smoke from the organic material must be kept inside the mound to carbonize the pots.

243. The potters work continuously with their poking sticks, filling all the holes with ash until no puffs of smoke from the inner fire remain. This is a hot and arduous job and terribly important. Any air entering the mound and reaching the pots at this point will oxidize and discolor the black surfaces.

246. Thirty to forty minutes of smoking time is enough to blacken the polished pots. After poking into the ash to determine if the process has progressed sufficiently, a number of the hot metal license plates and can lids are removed from the mound to hasten the cooling and stop the carbon deposition. The apparent simplicity of the process gives little indication of the necessity for long years of experience and the important sixth sense that comes from complete understanding.

A few minutes after the metal plates have been removed, the potters begin to take pieces out of the ash with their poking sticks.

247–250. The pots were stacked in three levels, and they are removed from the top down, until the largest ones are left on the grill.

They are a glorious spectacle in the midday sun. Still hot to the touch, they must be wiped free of sticky wood ash immediately. Santana and Barbara use aprons and cloths to dust off each piece as soon as possible. The glowing black pieces are arranged on the shelf over the cow chips.

General Note to the Pot Photos: I have not attempted to evaluate or describe pueblo polychrome or ancient pueblo pottery in this book. There are a large number of books and articles on this subject, many of which are listed in the Bibliography.

However, it is interesting to note some variations in the polychrome ware included here. First, there are different white slip backgrounds, the result of using different kinds of clays, which are either rag polished or stone burnished. Also evident are a variety of red-brown or orange hues in the decorations, resulting from the use of a number of different metallic oxide colored clays. The black pigment also shows variation among the photographs. The preparation of black *guaco* pigment is described on page 96. Depending on what clay or other earth oxides were mixed with it, the black color varied on firing.

To achieve a perfectly bonded, smooth sheen on white slip applied to a red clay body, free of surface cracks, coupled with the refinement of iron-bearing slips and black *guaco* painting, is a particularly demanding process. Polychrome was produced sporadically during the years Maria and Julian concentrated on the popular black-on-black ware. Later Maria and her son Popovi Da revived a polychrome technique for a short time, and the process is being experimented with again now by several members of the family.

Red-on-red ware, an oxidized version of the black-on-black technique with matt designs against a stone-burnished ground, was introduced in Maria's Santana and Popovi Da periods. Santana and Popovi also made and decorated their own ware.

Pots bearing the Santana/Adam signature are primarily either in plain burnished black or black-on-black style in the tradition of Maria and Julian. Popovi experimented with many techniques. Polished red wares, fired without smothering, were part of his artistic vocabulary, as well as designs formed from carving, engraving, and inlay techniques in addition to yucca brush painting. Tony Da and Barbara Gonzales continue to experiment with a number of variations, including red clay techniques in open oxidation firing and reoxidation of controlled areas on a burnished black surface.

In the following photo comments, a pot is attributed to Maria and Julian or Maria alone unless otherwise indicated.

252. Maria gathering *guaco*. Apparently *guaco* grew abundantly near the pueblo in the days when this area had rain. An old photo from a magazine.

253. Water jar, ca. 1910. A particularly handsome jar with one of Julian's rare bird designs. Coll: Museum of the American Indian, New York.

254. Ceremonial bowl, ca. 1910. A fine shallow bowl with strongly painted *guaco* black and red clay decoration, in San Ildefonso polychrome style. Coll: Laboratory of Anthropology, Santa Fe.

255. Storage jar, ca. 1920. The decoration is typical of Julian; red and black slips at the top and Domingo style polychrome begins midway. Coll: Laboratory of Anthropology, Santa Fe.

256. Ceremonial corn storage jar, ca. 1920. This pot was used for storing corn in the kiva for the next season's planting. The potting is thin and symmetrical, with intense black and red clay decoration on Domingo style white slip. Coll: American Museum of Natural History, New York.

257. Prayer meal box, ca. 1920. Coll: Southwest Museum, Los Angeles.

258. Bowl, Maria and Popovi Da, 1958. Popovi Da's typical crisp decoration identifies this polychrome revival piece. Coll: Museum of New Mexico, Santa Fe.

259. Storage jar, ca. 1918. This is one of the two decorated pots that supposedly constituted the first attempt at decorated black ware by Maria and Julian. The very difficult process of polishing only the design and leaving the background matt was not used after the first few firings. Coll: Laboratory of Anthropology, Santa Fe. See also Pl. 299.

260. Large storage vessel, ca. 1920. An early black piece of monumental scale, very thinly potted. Coll: Smithsonian Institution, Washington, D.C.

261. Jar, ca. 1920. Coll: Southwest Museum, Los Angeles.

262. Bowl, ca. 1925. Feather decoration. Coll: Museum of the American Indian, New York.

263. Platter and two jars, ca. 1925. Early photograph. Julian's decorations were always different on each piece, utilizing a playful and expert sense of pottery surface and form. Coll: Museum of New Mexico, Santa Fe.

264. Jars, ca. 1930. Coll: Smithsonian Institution, Washington, D.C.

265. Storage jar, ca. 1939. A monumental piece attributed to Tonita Roybal. Coll: Laboratory of Anthropology, Santa Fe.

266. Jar, ca. 1930. Finely done feather design. Julian always used a four-line banding, as shown in this piece. Santana uses three lines. Coll: Dr. Frederick Dockstader.

267. Jar, 1970. Done during her association with Popovi Da, this is one of Maria's last large forms. Private collection.

268. Jar, ca. 1930. Typical of Maria's large plain forms. Coll: Museum of New Mexico, Santa Fe.

269. Bowl, ca. 1960. This plain black piece is of the polychrome type used to contain ceremonial prayer meal. Private collection.

270. Spherical bowl, 1976. Maria has made only these beautiful, small globular pieces since the early seventies, burnished and undecorated and signed with her Indian name, Maria Povèka. Coll: Mr. and Mrs. Norman Tobac.

271. Jar, Santana and Adam, 1974. Santana "apprenticed directly," as Barbara calls it, under Julian from the time of her marriage to Adam in 1926. Besides decorating many of Maria's pieces after Julian's death in 1943, she also has made her own ware. At one time she signed only her own name, but after finding pieces in stores that were not hers but bearing her name, she changed the signature to Santana/Adam. She states that she has been signing pots with these two names since 1935. Private collection.

272. Lidded jar, Santana and Adam, 1974. *Avanyu* pattern. Santana is particularly known for her lidded jars. Private collection.

273. Plate, Santana and Adam, 1974. Fine feather design. Private collection.

274. Wedding vase, Santana and Adam, 1972. Such pots were made by Maria and Santana for many years, for weddings in their family and for special friends. Private collection.

275. Jar, Santana and Adam, 1972. This storage jar is of the traditional style for carrying on the head, although the black wares were made for commercial rather than domestic use. Private collection.

276, 277. Bears, made and polished by Adam, 1974. Private collections.

278. Jar, by Barbara Gonzales, 1974. Private collection.

279. Storage jar, San Ildefonso polychrome, ca. 1910. This large polychrome pot was signed by Maria in pencil in 1975 on a visit to the Southwest Museum. However, the piece is not as symmetrical as Maria usually made, and the decoration does not seem to be like Julian's or any of the family members who decorated Maria's pots. This is an example of the difficulty of making attribution of folk work that was made for utility and not as signed artist pieces. Coll: Southwest Museum, Los Angeles.

280. Prayer meal bowl, ca. 1915. The decoration on this charming piece represents Julian's early style. Coll: Southwest Museum, Los Angeles.

281. Water jar, Maria and Maximiliana, ca. 1910. This is a traditional San Ildefonso style polychrome, with rag-rubbed white slip. Coll: Laura and John Rivenburgh.

282. Water jar, Maria and Maximiliana or Juanita, ca. 1910. Coll: Southwest Museum, Los Angeles.

283. Water jar, ca. 1915–20. Domingo style polychrome with typical Julian decoration. Coll: Fenn Galleries, Santa Fe.

284. Prayer meal box, ca. 1920. Coll: Southwest Museum, Los Angeles.

285. Storage jar, ca. 1930. This piece, decorated by Julian ("when his decoration was very strong," Maria says) is in Santana's and Adam's house at San Ildefonso above the fireplace.

286. Canteen and prayer meal bowl, ca. 1920(?). The unsigned canteen was recorded as having won a prize at the Santa Fe Indian fair in 1922. Coll: Laboratory of Anthropology, Santa Fe.

287. Bowl, ca. 1922. Coll: Laboratory of Anthropology, Santa Fe.

288. Storage jar, ca. 1910–15. This very interesting pot is a good example of Maria and Julian's frequent experimentation with a variety of clays and effects. Here the traditional red-and-black (top) style is combined with polychrome style (bottom). The white slip and ochre and eggplant-colored slips on the polychrome are experimental and quite different from the colors of clays used for decoration on other typical pieces. Note the use of Maria's Indian name as part of the design, but spelled differently than she does now. Coll: Laboratory of Anthropology, Santa Fe.

289. Cornmeal wall sconce, Alfoncita Roybal and Awa Tsireh, ca. 1910–15. The potting is by Santana's mother, Alfoncita Roybal and the decoration by Santana's artist brother Alfonso (Awa Tsireh). Owned by Santana.

290. Ceremonial bowl, ca. 1920. The finely potted symmetry by Maria is remarkable, with painting by Julian in experimental slips; Domingo style polychrome. Coll: Jerry Collings.

291. Jar, San Ildefonso polychrome, ca. 1922. This piece is attributed by Santana to her aunt Tonita Roybal, with decoration by Tonita's husband, Juan, although some experts think it could be a Marie/Julian piece. Coll: Southwest Museum, Los Angeles.

292. Platter, ca. 1940. Domingo style polychrome. This platter and the next three photographs are examples of the virtuosity and precision of Maria and Julian's late polychrome technique. The sheen of the white slip, the sharp and bold iron-red clay and black *guaco* decoration are flawless. These rare late examples of Maria/Julian polychrome present a strong contrast with the softness and spontaneity found in the early pieces. Coll: Southwest Museum, Los Angeles.

293. Jar, ca. 1935–40. Coll: Southwest Museum, Los Angeles.

294. Storage jar, ca. 1935. A monumental piece by Maria and Julian; note the thinness of potting and symmetry of form. The motifs on this piece are very like the ones Julian used on his deerskin paintings (see Pl. 25). Coll: Laboratory of Anthropology, Santa Fe.

295. Jar, ca. 1942. Maria and Julian late polychrome. Here is a polychrome example of the *avanyu* design. Private collection.

296. Storage jar, ca. 1922. A very large piece with polished red slip and black *guaco* decoration. This very unusual pot is documented in an old E. S. Curtis photograph. Coll: Jerry Collings.

297. Bowl, Tonita Roybal, ca. 1910. Polished black-on-red pot by Santana's aunt, who was known for her black-on-red ware. Coll: Southwest Museum, Los Angeles.

298. Platter, Maria and Santana, 1947. A rare oxidized red platter with feather decoration, signed Marie/Santana. Coll: Southwest Museum, Los Angeles.

299. Jars, ca. 1918. The two pieces said to be from the first firing of decorated black ware by Maria and Julian. Coll: Laboratory of Anthropology, Santa Fe. See Pl. 259.

300, 301. Bowl and platter, ca. 1915. Examples of the black-fired wares made in response to the request by Dr. Edgar Hewett that Maria fabricate pieces similar to shards he had found in nearby excavations. Coll: Fenn Galleries, Santa Fe.

302. Storage jar, ca. 1935. A spectacular piece of monumental scale. Coll: Laboratory of Anthropology, Santa Fe.

303. Storage jar, ca. 1935. An excellent piece with feather pattern and Julian's bird design. Coll: Laboratory of Anthropology, Santa Fe.

304. Jar, ca. 1939. Coll: Jerry Collings.

305. Platter, ca. 1936. Parrot design. This is one of the few Marie/Julian black pieces remaining in the possession of Maria's family.

306. Vase, ca. 1922. An example of an early nontraditional piece showing a freshness and simplicity that was later sometimes replaced by virtuosity. The relation of design to form is excellent. Coll: Fenn Galleries, Santa Fe.

307. Platter, ca. 1925. Coll: Gila River Arts and Crafts, Arizona.

308. Small pitcher, ca. 1930. This creamer is typical of the many table and household items Maria made to order in black ware. These included cream and sugar sets, candlesticks, casseroles, ashtrays, wall sconces, dinner plates, salad bowls, and platters, etc. The usual price paid in the early days for such objects was $0.50 to $2.50. These pieces were in daily use by many people in the Santa Fe area, as well as being ordered by visitors from all over the country. Raconteurs in this area of New Mexico recall travelers who visited Maria at San Ildefonso one summer and returned for their finished orders the following year.

Since these bonfired pots are not waterproof and are fragile, very few that were in constant use survive today. Private collection.

309. Set of dinner plates, Maria and Santana, ca. 1950. This set of one dozen plates is typical of what Maria says are the "hundreds and hundreds" she made; shown here with a small Maria and Julian pot. Coll: Fenn Galleries, Santa Fe.

310. Platter, Maria and Santana, ca. 1948. Coll: Fenn Galleries, Santa Fe.

311, 312. Plate and bowl, Maria and Santana. Collection of the author; purchased at the pueblo in 1949.

313. Plate, Maria and Popovi Da, 1956. Coll: Gila River Arts and Crafts, Arizona.

314. Jar, Maria, 1970. Coll: Laura and John Rivenburgh.

315. Jar, Maria and Popovi Da, 1970. Coll: Jerry Collings.

316. Jar, Santana and Adam, 1973. Burnished and black fired, with reoxidized lip. Owned by the artists.

317. Plate and jar, 1975. Typical of Santana and Adam pieces, with especially well-executed feather pattern.

318. Jar, Santana and Adam, 1970. Coll: Jerry Collings.

319. Jar, Santana and Adam, 1977. Owned by the artists.

320. Lantern, 1974. One of Santana and Adam's favorite pieces, with bird motifs. Owned by the artists.

321. Wedding vase, Santana and Adam, 1975. Coll: Covered Wagon, Albuquerque.

322. Group of black pieces made and decorated by Pauline Martinez, daughter-in-law of Santana and Adam; typical of the work done today by members of the family who maintain the forms and designs established by Maria and Julian. Photographed at San Ildefonso, 1975.

323. Turtle, by Tony Da, 1970. Burnished red slip with carved design and turquoise inlay, oxidation fired. This is a lidded pot with a perfectly fitted inside cup of sterling silver, also by Tony Da. Coll: Jerry Collings.

324. Bowl, begun by Popovi and finished by Tony Da, 1972. Burnished black ware with reoxidized lip, engraved design, and inlaid turquoise inside and outside. Coll: Jerry Collings.

325. Jar, by Popovi Da, 1970. Burnished red slip, oxidation fired, with hishi (small bead) and turquoise inlay. Coll: Fenn Galleries, Santa Fe.

326. Decorative plate, by Popovi Da, 1965. Burnished red slip, oxidation fired, carved design, with inlaid turquoise. This type of decoration is a secret technique of the young Martinez family potters. Note the difference in color between this piece and the previous jar. Many clays have been tried by Martinez family potters, but only a few are suitable to the demands of application, burnishing, and bonfiring. This constant experimentation is indicated by the variety of iron-red colors that result. Coll: Fenn Galleries, Santa Fe.

328. Lidded jar, by Barbara Gonzales, 1975. Barbara signs her pots with her Indian name, Tahn-Moo-Whe. Burnished red slip, oxidation fired, carved decoration.

329. Plate, by Barbara Gonzales, 1974. Black decorated piece with reoxidized rim.

330. Bowl and jar, by Barbara Gonzales, 1974. These pieces are typical of Barbara's innovative experimentation with variations on the traditional forms and patterns of Maria and Julian. Note her interpretation of the *avanyu* design and of cloud scallops. The vase has a reoxidized lip, which is different in color from oxidized lips in other photos, probably because the clay bodies are from different locations. The small pot has incised decoration and gem-quality coral inlay. Coll: Indian and I Gallery, Los Angeles.

331. Hanging planter, by Barbara Gonzales, 1975.

332. Wind bell, by Barbara Gonzales, 1976. Black ware with reoxidized rim and clapper, inlaid with turquoise and strung on leather. Coll: Indian and I Gallery, Los Angeles.

333. Bowl, by Tony Da, 1974. Burnished red slip, oxidation firing, carved decoration with turquoise inlay. Coll: Indian and I Gallery, Los Angeles.

334. Lidded jar, by Barbara Gonzales, 1975. Burnished black ware with hishi and turquoise inlay. This piece won high critical acclaim at the Santa Fe Indian Market.

335. Lidded jar, by Barbara Gonzales, 1976. Black ware with reoxidized areas and engraved deer dancer. Prize winner at the Indian Fair, 1976. Coll: Mr. and Mrs. Norman Tobac.

336. Pot group, by Barbara Gonzales, 1976. These pots show a range in scale from miniature to twelve-inch height and a variety of styles of red and black burnished ware, including engraving and carving, reoxidized areas, and gemstone inlay.

337. Jar and animal figure, by Barbara Gonzales, 1975.

GENEALOGY

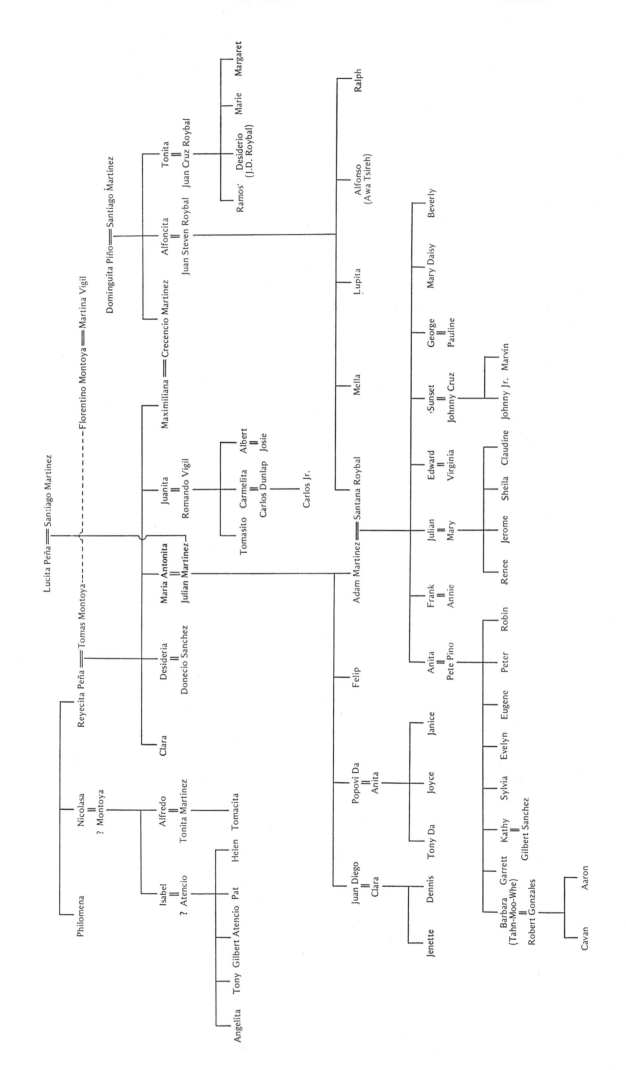

BIBLIOGRAPHY

This annotated bibliography is intended to be as comprehensive as possible in the following areas: the family of Maria Martinez; San Ildefonso pueblo, past and present; pottery and painting of the Martinez family; and selected titles pertaining to Tewa Indians and pueblo pottery.

This extensive collection has been compiled from the Libraries of the following institutions: Laboratory of Anthropology, Museum of New Mexico, Santa Fe; University of New Mexico Library, Albuquerque; Library of Congress, Washington, D.C.; Museum of Natural History, New York; Museum of the American Indian, Heye Foundation, Bronx division, New York; Smithsonian Institution, Washington, D.C., and others. In addition to my own investigations I have had the research assistance of Mrs. Mildred Wolkow, Linda Metzger, and Laura Michel, for which I am very grateful.

Many of these texts are old and not easily available. There are wonderful descriptive and pictorial sources as background for Maria and related subjects, dating from 1880 to the present, but much of it is in obscure places. However, most of the following titles can be found in each of the libraries listed above as well as in many others.

BOOKS AND PERIODICALS

Alexander, Hartley Burr. *Pueblo Indian Painting*. Nice, France: Szwednicki, 1932.
> This is a limited edition that contains fifty reproductions of watercolor paintings by San Ildefonso Indians.
> Among artists included are Julian Martinez and Awa Tsireh. The folio-sized plates are very good.

Arizona Highways. May 1974.
> Entire emphasis is upon current artists and their pottery.

Bahti, Tom. *Southwestern Indian Ceremonials*. Las Vegas: K. C. Publications, 1970.
> Descriptions of the major ceremonies illustrated in color with photographs and paintings.

———. *Southwestern Indian Arts and Crafts*. Las Vegas: K. C. Publications, 1966.
> Illustrated introduction to the major Indian arts currently produced.

———. *Southwestern Indian Tribes*. Las Vegas: K. C. Publications, 1968.
> A description of the culture and history of contemporary Indian settlements in the Southwest. Color photographs of the villages and their typical crafts.

Bandelier, Adolph F., and Hewett, Edgar L. *Indians of the Rio Grande Valley*. Handbook of Archaeological History. Albuquerque: University of New Mexico Press, 1937.
> Interesting details of the artists of San Ildefonso, such as Crecencio and Awa Tsireh, with explanations as to how these two remarkable people used their ability.

Brandon, William. *The Last Americans—The Indians in American Culture*. New York: McGraw Hill Book Co., 1974.
> Includes the latest archaeological data and current studies of Indian life and culture; a special feature is a section on Indian poetry.

Bunzel, Ruth L. *The Pueblo Potter, a Study of Creative Imagination in Primitive Art*. New York: Columbia University Press, 1929.
> A good presentation of the state of the art among the pueblos in the 1920s, with particular emphasis upon design. The text is illustrated with drawings and photographs.

Burton, Henrietta K. "The Re-establishment of the Indians in their Pueblo Life Through the Revival of their Traditional Crafts; A Study in Home Extension Education." Teachers College, Columbia University, New York (1936).
> A thesis using San Ildefonso and Nambe pueblos as case studies.

Chapman, Kenneth M. "Casa Grandes Pottery," *Art and Archaeology* 16, nos. 1 and 2 (August 1923).
> Photos of ancient pots that are antecedents of contemporary pueblo pottery; includes pictures of all-black wares.

————. "Life Forms in Pueblo Pottery Decoration," *Art and Archaeology* 13, no. 3 (March 1922): 120–122.
> A brief, illustrated article on the use of representations of various life forms as decoration on ancient and modern pueblo pottery.

————. *The Pottery of San Ildefonso Pueblo*. Supplementary text by Francis Harlow. Albuquerque: University of New Mexico Press, 1970.
> A description of the history of San Ildefonso and of the techniques of various kinds of pottery. Many plates of designs. An outstanding posthumous publication.

————. *Pueblo Indian Pottery*, 2 vols. Nice, France: Szwedzicki, 1933.
> A limited edition of one hundred plates illustrating the pottery and decoration of the pueblos.

————. *The Pueblo Indian Pottery of the Post Spanish Period*. Laboratory of Anthropology Bulletin, General Series no. 4. Santa Fe, 1938.
> A short essay on pueblo pottery since 1600; there are many illustrations.

Collier, John. *On the Gleaming Way*. Chicago: Sage Books, The Swallow Press, 1949 and 1962.
> A poetically written discussion of Indian tribes of the Southwest, their land, and their significance to the world.

Colton, Harold S. *Potsherds: An Introduction to the Study of Prehistoric Southwestern Ceramics and Their Use in Historic Reconstruction*. Museum of Northern Arizona Bulletin no. 25, Flagstaff, 1953.

Crane, Leo. *Desert Drums: The Pueblo Indians of New Mexico, 1540–1928*. Boston: Little Brown and Co., 1928.

Curtis, Edward S. *The North American Indian*. Vol. 17. Norwood, Mass.: Plimpton Press, 1926.
> A unique series of books, famous for the quality of its photographs and observations about American Indians in the first third of this century. In this volume are Curtis's observations of cultural traits in San Ildefonso, San Juan, Nambe, and Zuni.

Douglas, Frederick H. *Pueblo Indian Pottery Making*. Denver Art Museum, Department of Indian Art Leaflet no. 6, 1930.
> This and the following are definitive descriptions of the pottery process of Pueblo Indians.

————. *Modern Pueblo Pottery Types*. Denver Art Museum, Department of Indian Art Leaflets nos. 53 and 54, 1933.

————. *Pottery of the Southwestern Tribes*. Denver Art Museum, Department of Indian Art Leaflets nos. 69 and 70, 1935.

Dozier, Edward P. *The Pueblo Indians of North America*. New York: Holt, Rinehart and Winston, 1970.
> A general text of the Pueblo Indians, by an anthropologist who is a Santa Clara Indian.

————. "Rio Grande Pueblos." In *Perspectives in American Indian Culture Change*, edited by Edward H. Spicer, pp. 94–186. Chicago: University of Chicago Press, 1961.
> A description of the events that have affected the cultures of the Pueblo Indians from 1350 to date.

Dunn, Dorothy. *American Indian Painting of the Southwest and Plains Area*. Albuquerque: University of New Mexico Press, 1968.
> Discusses American Indian painting of the Southwest and Plains, its development from prehistoric times to the present. Elaborately illustrated, with references to San Ildefonso artists.

Dutton, Bertha P. *Indians of the American Southwest*. Englewood Cliffs, N.J.: Prentice-Hall, Inc., 1975.
> An informative book covering all of the Indian groups of the Southwest. There is a section on arts and crafts.

Ellis, Florence Hawley. *Field Manual of Prehistoric Southwestern Pottery Types*. University of New Mexico Bulletin no. 291. Albuquerque, 1950.

A manual used to classify pottery types; culture groups, descriptions of styles, designs and colors, and construction.

Exposition of Indian Tribal Arts, Inc. *Introduction to American Indian Art*. New York: Exposition of Indian Tribal Arts, Inc., 1931.

A presentation of American Indian art forms from painting through crafts, with illustrations.

Fitzpatrick, George, and Sinclair, John L. *Profile of a State*. Albuquerque: Horn and Wallace, 1964.

A pictorial essay of New Mexico with scenes of Indian life and large color photographs of Maria and Popovi Da and their pottery.

Fox, Nancy. "Poveda, A Signature of Maria Martinez." *Papers of the Archaeological Society of New Mexico*, no. 3 (1976): 259–264.

A short article discussing the signatures used by Maria on her pottery, particularly the rare "Poveda" signature.

Frank, Larry, and Harlow, Francis H. *Historic Pottery of the Pueblo Indians, 1600–1800*. Boston: New York Graphic Society, 1974.

A general discussion of the pueblos and the pottery. Excellent photographs of pottery.

Gilpin, Laura. *The Pueblos: A Camera Chronicle*. New York: Hastings House, 1941.

A readable text and dramatic photographs, the history of the pueblos.

Gridley, Marion E. *American Indian Women*. New York: Hawthorn Books, Inc., 1974.

Includes an article on Maria.

Guthe, Carl E. *Pueblo Pottery Making: A Study of the Village of San Ildefonso*. New Haven: Yale University Press, 1925.

A definitive and interesting study of the pottery making; particularly of Maria Martinez, with vivid descriptions and analyses; many photographs of the period.

Halseth, Odd S. "The Revival of Pueblo Pottery Making." *El Palacio* 21, no. 6 (1926): 135–154.

The article is concerned with the efforts of the School of American Research to encourage quality pottery, and the economic effects. It also describes the prerevival conditions. Some photographs of pottery and pottery making.

Harlow, Francis H. *Historic Pueblo Indian Pottery*. Santa Fe: Museum of New Mexico, 1970.

A booklet illustrating and describing pottery typical of the various pueblo groups from 1600 to date.

———. *Matte-Paint Pottery of the Tewa, Keres and Zuni Pueblos*. Albuquerque: University of New Mexico Press, 1973.

A study of historic period ceramics of the Tewa and a description of the ceramics of the late prehistoric period.

———. "Tewa Indian Ceremonial Pottery." *El Palacio* 72, no. 4: 13–23.

A history of the ceremonial pottery of the Tewa; drawings and photographs.

Harlow, Francis H., and Young, John V. *Contemporary Pueblo Indian Pottery*. Santa Fe: Museum of New Mexico, 1965.

Describes the Pueblo Indian pottery for sale in the Southwest.

Harrington, John Peabody. *The Ethnogeography of the Tewa Indians*. Washington, D.C.: Government Printing Office, 1916.

Discusses the geographical knowledge of the Tewa Indians, cosmography, the concept of the universe, meteorology, periods of time, geographical concepts, place names and names of minerals as they are known to Tewa Indians.

Hartley, Marsden. "The Scientific Esthetic of the Redman." *Art and Archaeology* 13, no. 3 (March 1922): 213–219.

 A philosophical discussion of the interdependence of art and religion in the Pueblo Indian culture.

Henderson, Junius, and Harrington, John Peabody. *Ethnozoology of the Tewa Indians*. Washington, D.C.: Government Printing Office, 1914.

 A listing of the animals in the Tewa area, Tewa names, and the attitudes and beliefs about those animals, from man to insect.

Hewett, Edgar L. *Ancient Life in the American Southwest*. Indianapolis: Bobbs-Merrill Co., 1930.

 The first section is a summary of the history of the Indians in America. The second is a more detailed examination of the history and current status of Indians in the Southwest, and the last section is about the remains of pueblos that were ruins before the Spanish arrival.

————. "A General View of the Archaeology of the Pueblo Region." *Smithsonian Annual Review* (1904): 583–605.

 This was written to "aid in the campaign for the preservation of American antiquities," according to Hewett. It defines the area and generally makes a case for government action in the protection and restoration of the ruins.

————. "Native American Artists." *Art and Archaeology* 13, no. 3 (March 1922): 103–112.

 A statement on the nature of Indian dancing and a brief summary of Indian painting, including the work of Awa Tsireh and Crecencio Martinez. Illustrated by a painting of Awa Tsireh.

Hewett, Edgar L, and Dutton, Bertha P. *The Pueblo Indian World*. Albuquerque: University of New Mexico Press, 1945.

 A descriptive compilation of the elements of the Pueblo Indian way of viewing the universe and the relation of this to the natural phenomena around them. It is followed by an analysis of the languages of the Pueblo Indians.

Highwater, Jamake. *Song From the Earth: American Indian Painting*.

 Reproductions of paintings by Julian Martinez and Awa Tsireh.

Hodge, Zahrah Preble. "Maria Martinez, Indian Master Potter." *Southern Workman* 62, no. 5 (1933).

Holmes, William Henry. *Pottery of the Ancient Pueblos*. Fourth Annual Report of the Bureau of American Ethnology. Washington, D.C.: Government Printing Office, 1886, pp. 257–360.

 Many illustrations.

Hyde, Hazel. *Maria Making Pottery*. Santa Fe: Sunstone Press, 1973.

 A picture essay of Maria and Julian making pottery in the 1930s; a juvenile book.

Indian Land Research Unit. *The Indian Pueblos*. Vol. 1. In the *Tewa Basin Study*. 3 vols. Albuquerque: U.S. Soil Conservation Service, 1935.

 This work gives a first-hand, if subjective, account of the pueblo of San Ildefonso, the thirty families living there, geographical land distribution, health, economics, and a basic description of the lives of the Indians.

James, Ahlee. *Tewa Firelight Tales*. New York: Longmans, Green & Co., 1927.

 Ahlee James has here retold Tewa stories as he heard them when he lived and taught for three years at San Ildefonso. The color illustrations are mostly by Awa Tsireh.

Johnson, Lady Bird. *White House Diary*. New York: Holt, Rinehart and Winston, 1970.

 This book has a warm and vivid description of her trip to visit Maria at San Ildefonso pueblo.

Kidder, Alfred Vincent. "Pottery of the Pajarito Plateau and of Some Adjacent Regions in New Mexico." *American Anthropological Association Memoirs*, 1915, pp. 407–462.

 A description of the pottery found in the ruins of the Pajarito Plateau. There are illustrations of shards, reconstructed pots, and designs. This is the excavation that Julian and Maria worked on.

Kurath, Gertrude Prokosch, and Garcia, Antionio. *Music and Dance of the Tewa Pueblos.* Museum of New Mexico Research Records no. 8. Santa Fe: Museum of New Mexico Press, 1970.

 This is a very thorough recording and analysis of the forms of the Tewa ceremonies. It is illustrated with photographs, drawings, diagrams, and musical notations.

Lafarge, Oliver. *A Pictorial History of the American Indian.* New York: Crown Publishing Co., 1957.

 A text and photographs tell the story of the American Indian. There is an excellent picture of Maria and Julian decorating pottery on page 255.

Lambert, Marjorie F. *Pueblo Indian Pottery: Materials, Tools, and Techniques.*

 A booklet describing the whole process of a Pueblo Indian woman making pottery.

Laski, Vera. *Seeking Life.* Philadelphia: American Folklore Society, 1958.

 About Tewa beliefs as practiced at San Juan pueblo, New Mexico.

Letterhouse, M. D. "Revival of Tribal Arts as a Factor in Pueblo Economic Independence." *Mission Fields at Home* 4, nos. 10–11 (July–August 1932).

Manley, Ray. *Southwestern Indian Arts and Crafts.* Tucson, Ariz: Photography Inc., 1975.

 Large-format, all-color, photographs of Maria and her family's pottery. Also short articles on jewelry, pottery, basketry, weaving, kachinas, and painting by famous individuals in each area.

Marriott, Alice, and Raklin, Carol K. *American Epic: The Story of the American Indian.* New York: G. P. Putnam's Sons, 1969.

 A description of the history of the American Indians with special attention to the effects of European influence.

————. *American Indian Mythology.* New York: Mentor Books, 1968.

 Narrations of ancient myths, particularly of Southwest Indians, recorded by a woman who lived among them many years.

Marriott, Alice. *Maria of San Ildefonso.* Illustrated by Margaret Lefranc. Norman, Okla.: University of Oklahoma Press, 1946.

 Maria's life until Julian's death in 1943. A story of the pueblo and of her influence and impact on it.

Maxwell Museum of Anthropology. *Seven Families in Pueblo Pottery.* Albuquerque: University of New Mexico Press, 1974

 This small book traces developments in pottery style and technique by various members of seven families of pueblo potters including Maria; family trees, and statements by the potters. Illustrated with color and black-and-white photographs.

McGregor, John C. *Southwestern Archaeology.* 2nd ed. Urbana, Ill.: University of Illinois Press, 1965.

 An introductory archaeological text on the Southwest; the chapter on pottery is very helpful in understanding techniques as well as archaeological use of pottery finds.

Mera, Harry P. *Style Trends of Pueblo Pottery in the Rio Grande and Little Colorado Cultural Areas from the 16th to the 19th Century.* Laboratory of Anthropology Memoirs, vol. 3. Santa Fe, 1939.

————. *Pueblo Designs: 176 Illustrations of the "Rain Bird."* New York: Dover, 1970. Drawings by Tom Lea.

 First published in 1937. The development of the rain-bird motif is traced from its prehistoric origins to the present day.

Nelson, Mary Carroll. *Maria Martinez.* Minneapolis, Minn.: Dillon Press, 1972.

 A biography of Maria, written for children.

Ortiz, Alfonso, ed. *New Perspectives on the Pueblos.* Albuquerque: University of New Mexico Press, 1972.

 A wide range of new ideas and information of the Pueblo Indians, by a member of the San Juan pueblo. Traditional ideas are noted; newer fields such as ecology and ethnomusicology are also included.

Ortiz, Alfonso. *The Tewa World.* Chicago: University of Chicago Press, 1969.

 A scholarly analysis of the Tewa world concept and the self-image of the Tewa Indians. The particular

pueblo discussed is San Juan, where the author was born; observations pertain generally to the Rio Grande pueblos, including San Ildefonso.

Parsons, Elsie Clews. *Pueblo Indian Religion*. 2 vols. Chicago: University of Chicago Press, 1939.
 A thorough study of the religion of the Pueblo Indians in all aspects; some photographs.

———. *The Social Organization of the Tewa of New Mexico*. Menasha, Wis.: The Collegiate Press, 1929.
 This details the elements of culture of the Tewa pueblos, indicating variations where known.

Parsons, Elsie Worthington. *Tewa Tales*. American Anthropological Association Memoir no. 36, 1926.
 The social organization of the Tewa of New Mexico.

Robbins, Wilfred William; Harrington, John Peabody; and Freire-Marreco, Barbara. *Ethnobotany of the Tewa Indians*. Washington, D.C.: Government Printing Office, 1916.
 A list of plants in the environment of the Tewa Indians with the Tewa name of each plant.

Roediger, Virginia More. *Ceremonial Costumes of the Pueblo Indians, Their Evolution, Fabrication and Significance in the Prayer Drama*. Berkeley: University of California Press, 1941.
 Discusses aspects of culture in relation to dances. The author gives materials of costumes and their significance; with color drawings.

Scully, Vincent. *Pueblo—Mountain, Village, Dance*. New York: Viking Press, 1975.
 Good photographs and descriptions of San Ildefonso pueblo dances.

Sides, Dorothy Smith. *Decorative Art of the Southwestern Indians*. Santa Ana, Calif.: Fine Arts Press, 1936. Rev. ed., New York: Dover, 1962.
 Black-and-white reproductions of design motifs, dating from the thirteenth century to the present day. The emphasis is on ceramic decoration.

Simpich, Frederick. "New Mexico Melodrama." *National Geographic Magazine* 73, no. 5 (May 1938): 529–569.
 Description of early and contemporary New Mexico, photos of Indian life and Maria making pottery.

Smith, Anne M. *New Mexico Indians: Economic, Educational and Social Problems*. Santa Fe: Museum of New Mexico, 1966.
 A general sociological study of the Indians in New Mexico.

Snodgrass, Jeanne O. *American Indian Painters, a Biographical Directory*. Contributions from the Museum of the American Indian, 1968. Vol. 21, part 1.
 This contains complete biographical information of Indian painters, with lists of all important exhibitions; includes Martinez family painters.

Spicer, Edward H., and Thompson, Raymond H., eds. *Plural Society in the Southwest*. Albuquerque: University of New Mexico Press, 1972.
 These are papers that grew out of a conference held in Arizona in 1970, dealing with the coexistence of the three cultures of the Southwest: Indian, Mexican, and Anglo-American.

Spinden, Herbert J. *Fine Art and the First Americans*. New York: Exhibition of American Indian Art, 1931.
 Symbolism and such subjects as poetry, painting, sand painting, pottery, sculpture and carving, masks, basketry, weaving, and quill and beadwork.

———. "The Making of Pottery at San Ildefonso." *American Museum of Natural History Journal* 11, no. 6 (1911): 192–196.
 A brief discussion of San Ildefonso pottery with a few illustrations.

Spinden, Herbert J., ed. and trans. *Songs of the Tewa*. New York: Exposition of the Indian Tribal Arts, Inc., 1933.
 Discusses Indian poetry and its elements. A compilation of Tewa poetry with explanatory notes.

Stevenson, James. *Illustrated Catalogue of the Collections Obtained from the Indians of New Mexico and Arizona in 1879*. Second Annual Report of the Bureau of American Ethnology. Washington, 1883.

Tanner, Clara Lee. *Southwest Indian Craft Arts*. Tucson: University of Arizona Press, 1968.
 Profusely illustrated up-to-date survey of the arts and crafts of the various tribes of Arizona and New Mexico, including two pages on San Ildefonso.

————. *Southwest Indian Painting*. Tucson: University of Arizona Press, 1973.
 A comprehensive examination of the history of Indian painting from its prehistoric antecedents through the watercolor painting of the earlier 1900s to the many styles and media of today.

Terrell, John Upton. *Pueblos, Gods and Spaniards*. New York: Dial Press, 1973.
 A history text covering the sixteenth and seventeenth centuries.

Toulouse, Betty, "Pueblo Pottery Traditions: Ever Constant, Ever Changing." *El Palacio* 82, no. 3 (Fall 1976): 14–47.
 A good overview of the development of pueblo pottery. It helps put San Ildefonso and Maria into perspective.

Tyler, Hamilton. *Pueblo Gods and Myths*. Norman, Okla.: University of Oklahoma Press, 1964.

Underhill, Ruth M. *First Penthouse Dwellers of America*. New York: J. J. Augustin, 1938.
 About pueblos and pueblo living. This is a story of Taos, which is Tiwa, not Tewa, but the book explains the philosophy that new ways are resisted because they may endanger the old; which has a bearing on a general Indian understanding.

Vaillant, George C. *Indian Arts in North America*. New York: Harper & Bros., 1933.
 General discussion on the background and origins of Indian culture and the significance of the art before and after white contact. Well illustrated.

Washburn, Wilcomb E. *The Indian in America*. New York: Harper & Row, 1975.
 Traces the story of the American Indian from prehistory to the present day. The author uses recent conclusions in archaeology, anthropology, and history to present an interdisciplinary picture.

————. *Red Man's Land/White Man's Law*. New York: Charles Scribner's Sons, 1971.
 Describes and analyzes in legal, social, and political terms the relationship between Indians and the European aliens.

Whitman, William III. *The Pueblo Indians of San Ildefonso, A Changing Culture*. Columbia University Contributions to Anthropology no. 34. New York: Columbia University Press, 1947.
 This is the result of an ethnological investigation of San Ildefonso in the 1930s. The author's observations are from his stay in the pueblo.

Wilson, Olive, "The Survival of an Ancient Art." *Art and Archaeology* 9, no. 1 (January 1920): 24–29.
 The process of making pottery and of the traditional and modern styles.

Wormington, H. M., and Neal, A., photographer. *The Story of Pueblo Pottery*. Denver Museum of Natural History Pictorial no. 4. Denver: Museum of Natural History, 1951.
 Traces the development of pottery in the pueblos from the Basket Maker cultures to the writing of the book. Liberally illustrated.

FILMS

Hands of Maria. RMI Films Production, 1967. Color, sound, 19 min.
 This demonstrates how Maria shapes, decorates, and polishes the black pottery; also shows the materials and firing methods.

Maria of the Pueblos. Coleman Enterprises, 1971. Color, sound, 15 min.
 This features Maria, Popovi Da, and Tony Da and the creative artistry and traditional skills that combine to produce their pottery.

Maria the Potter. Stuart Roe Productions, Los Gatos, California. Color, sound, 20 min.

This film was made at the University of Southern California, Idyllwild campus, in 1974, during the Martinez family pottery workshop.

Maria, the Potter of San Ildefonso. McIntyre Productions, 1973. Filmstrip, 54 frames, 35 mm, color, phonotape cassette, 8 min.

Shots of Maria making a pot, decorating, and firing it. There are closeups of the finished pieces.

Maria the Potter of San Ildefonso. Department of Interior, 1967. Color, sound, 30 min.

Shows Maria and Popovi Da in the complete pottery process.

STAMPS

U.S. Commemorative Stamp Issue 1977. "Pueblo Indian Pottery."

This issue, which first appeared on April 14, 1977, is a four-stamp block of Zia, San Ildefonso, Acoma, and Hopi. The San Ildefonso stamp features a black-on-red pot.

reduction fire: a fire in which the oxygen is limited, resulting in incomplete combustion; at San Ildefonso, the smothered dung fire allows carbon to impregnate the clay surface; *see* firing

refractory clay: a clay that resists the effects of high temperatures.